P9-BYB-949

Crafting

MAYA

Identity

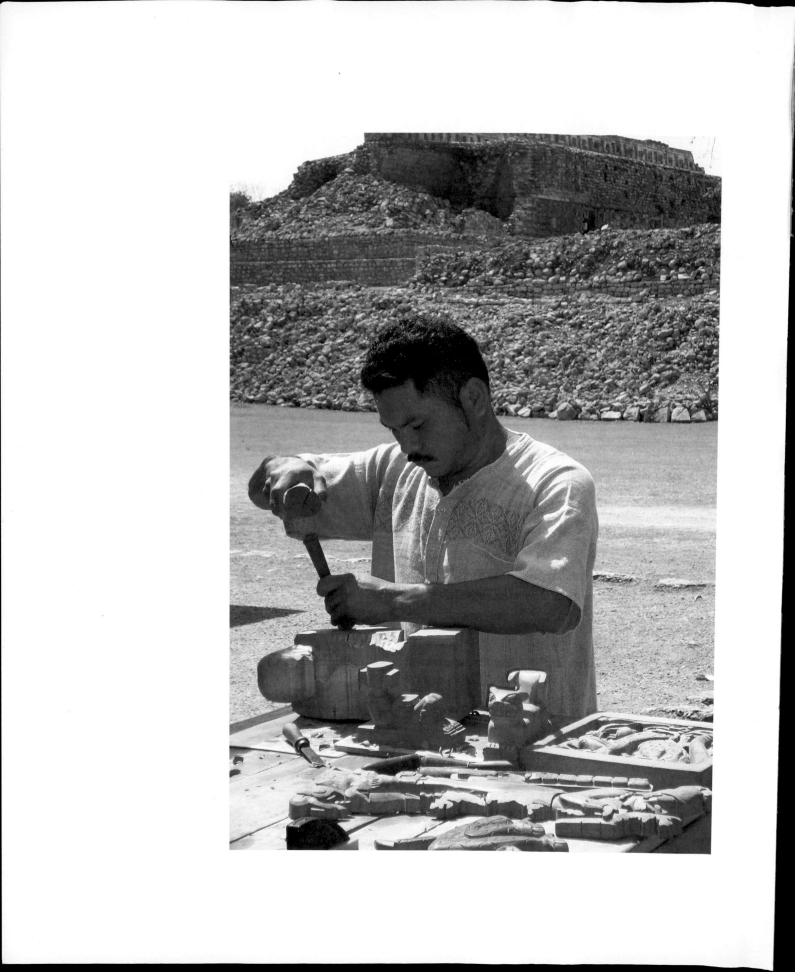

Crafting MAYA Identity

Contemporary Wood Sculptures

from the Puuc Region of

Yucatán, Mexico

Jeff Karl Kowalski, editor

NORTHERN

ILLINOIS

UNIVERSITY

PRESS

Catalog for an Exhibition of Carvings by the Artisans Miguel Uc Delgado,
Jesús Marcos Delgado Kú, Angel Ruíz Novelo, and Wilbert Vázquez

➤➤ **Jack Olson Gallery**—School of Art, Northern Illinois University, DeKalb, IL,
August 31–September 25, 2009

➤➤ **Teatro Peon Contreras**—Mérida, Yucatán.
September–October 2010

This exhibition was organized and curated by Jeff Karl Kowalski and Mary Katherine Scott
in collaboration with Peter Van Ael, Coordinator of the Jack Olson Gallery, NIU.

Support for the exhibition and catalog is made possible by generous grants
from the following sources:

➤➤ Venture Grant, The NIU Foundation
➤➤ Target Corporation, USA

◉

Copyright © 2009 by Northern Illinois University Press
Published by the Northern Illinois University Press, DeKalb, IL 60115
Manufactured in the United States using acid-free paper

All rights reserved. No part of this publication may be reproduced or transmitted in any form or by
any means, including photocopy, recording, or any other information storage and retrieval system,
without prior permission in writing from the publisher.

Design by Julia Fauci

FRONTISPIECE:—Jesús Delgado Kú's outdoor workshop. Jesús often carves parts of his wooden
replicas at a small table outside at Kabah and near the site's entrance.

FRONT COVER: *upper left:* **1.2**—The Main Palace at Sayil, Yucatán.; *lower left:* **1.21**—Angel Ruíz
Novelo, Seated ruler ("Bird Jaguar IV") holding a two-headed serpent 'ceremonial bar'; *center:* **1.1**—
Angel Ruíz Novelo, Lady K'abal Xook with a 'vision serpent' and royal ancestor; *right:* **1.25**—Miguel Uc
Delgado, three-dimensional portrait head of the ruler K'inich Janaab Pakal II.

BACK COVER: *top:* **1.5**— Hacienda Yaxcopoil, located south of Mérida; *below:* **1.45**—Miguel Uc
Delgado, Yum Kaax, the Maize God or Lord of the Forest Field.

Library of Congress Cataloging-in-Publication Data
Crafting Maya identity: contemporary wood sculptures from the Puuc Region of Yucatán, Mexico /
edited by Jeff Karl Kowalski.
p. cm.
Catalog of an exhibition held at the Jack Olson Gallery, School of Art, Northern Illinois University,
DeKalb, IL, Aug. 31–Sept. 25, 2009 and at Teatro Peón Contreras, Mérida, Yucatán, later 2010.
Includes bibliographical references and index.
ISBN 978-0-87580-630-3 (large-format pbk.: alk. paper)
1. Indian art—Mexico—Puuc Region. 2. Maya sculpture. 3. Wood sculpture, Mexican.
4. Wood-carving—Mexico—Puuc Region. 5. Mayas—Mexico—Puuc Region—Ethnic identity.
I. Kowalski, Jeff Karl, 1951–. II. Jack Olson Gallery. III. Teatro Peón Contreras (Mérida, Mexico)
IV. Title: Contemporary wood sculptures from the Puuc Region of Yucatán, Mexico.
F1435.3.A7C734 2009
732'.2—dc22 2009028198

Contents

Figures

* color photograph (indicated [**1.1** *col.*] in text) / Photo credits: page 239

Foreword

Alfredo Barrera Rubio

The Maya have been the subject of study and admiration by scholars, particularly during the nineteenth century, when early travelers and explorers made the academic world of that time aware of the intellectual and artistic manifestations of this civilization. From then to the present time, knowledge of this culture has been widely extended, which has generated an important stream of visitors from Mexico and from abroad, who journey through the principal archaeological sites that have now been explored, investigated, and restored.

Archaeological intervention at the pre Hispanic sites and accompanying tourist promotions have had an important impact as a source of income. Although the principal benefit of the tourist activity is realized by major private investors, this activity also has a reverberating impact on communities in the vicinity of the visited sites, which is registered in the services performed by, and in other economic activities of the local inhabitants. In the Mexican state of Yucatán, the archaeological zones of Chichén Itzá and Uxmal are notable as sites that attract the most tourists to the state.

Chichén Itzá, located in the eastern part of Yucatán, is one of the most heavily visited archaeological zones of Mexico. The juridical protection of this cultural heritage site began on December 5, 1986 when a presidential decree was promulgated that established "The Zone of Archaeological Monuments of Chichén Itzá," and two years later a new decree established with greater clarity the perimeter of the official archaeological zone and included not only the conservation of the archaeological monuments, but also of the fauna and the flora of the area.

Based on the exceptional character of the archaeological remains of Chichén Itzá and considering the increasing interest of the international community in the protection of this cultural heritage site, diverse national bodies, including the National Institute of Anthropology and History, in 1987 proposed to UNESCO that Chichén Itzá be included in the list of sites belonging to the world patrimony. This initiative was favorably received, and the pre-Hispanic city of Chichén Itzá was inscribed on the list of UNESCO World Heritage Sites in December, 1988. This action, without replacing the responsibility of the Mexican government for the protection of this zone, signaled the involvement and support of the international community, while maintaining respect for national sovereignty.

Despite the fact that Chichén Itzá has international recognition as part of the cultural heritage of the humanity, in recent times we have witnessed a campaign organized by the New 7 Wonders Foundation to designate to the structure known as the Castillo as a "marvel of humanity" a designation that it obtained by popular vote in July 2007. The fact that Chichén Itzá was identified as one of the new Seven Wonders of the World undoubtedly generated a promotional campaign without precedent, which has had repercussions in a further increase in tourism.

In the southwest of the state of Yucatán, in the region known by the Yucatec Mayan term "Puuc," which refers to a range of hills, there developed ancient Maya cities that reached their florescence during the period known as the Late Classic.

The pre-Hispanic Maya artisans of the Puuc region realized an extraordinary refinement in the architectural decoration, which permitted them to incorporate important ideological and religious symbolism in their buildings.

Uxmal is one of the most representative of the sites located in this region, owing to the fact that in the past it was the regional capital and an important center of economic, political and religious power.

In contrast with influx of tourists that come to Chichén Itzá, in the Puuc region only Uxmal has a substantial number of tourists, making it the second most visited archaeological zone of the state of Yucatán. Other nearby sites, however, have a minor number of visitors.

Uxmal is a part of a circuit of archaeological sites known as Ruta Puuc (Puuc Route), incorporating the zones of Uxmal, Kabah, Sayil, Xlabpak, Labná and the caves of Loltún. These archaeological zones, with exception of Xlabpak and the caves of Loltún, were also promoted by the Instituto Nacional de Antroplogía e Historia for recognition by UNESCO as part of the patrimony of the humanity, a status that they were granted in December, 1996.

The tourism associated with this route is not as commonly the type of mass tourism, but tends to have the character of a cultural tourism, the conditions of whose development have been influenced by the particular artistic forms inspired by the pre-Hispanic Maya civilization.

It is in the Puuc region where over the years a "school" of wood carving has been generated that differs from those that have developed in other regions of Yucatán, in that it does not involve mass production. The practitioners of this activity cannot properly be qualified simply as "craftsmen," since

this work has allowed them to express creative elements and aspects of cultural identity in the wooden sculptures that exceed this social category.

The individuals who dedicate themselves to this activity do not support themselves solely from this work, since they are, or have been, employed as custodians of the local archaeological sites or as tourist guides.

The images in these wood carvings are principally deities of the pre-Hispanic Maya pantheon or depictions of personages represented in bas-reliefs that come from sculptures from other places in the Mayan area, principally from of the region of the Petén. Occasionally we find other types of motifs that have their origin in the personal inspiration of the creators.

The fact that it is most common to carve representations based pre-Hispanic Maya sources represents a response to the general over-evaluation of this ancient culture by tourists, who have little interest in contemporary Maya groups, who remain in socially subordinate positions.

In this catalog, we are permitted to gain knowledge of the great variety of the sculptural works in wood produced by the "school" of the Puuc region, which represents the recognition by scholars of the history of the art, as well as by anthropologists, of their value as manifestations of the cultural identity of the social group that produces them, in addition to their artistic value of a certain level.

We hope that this work will also serve as a recognition of Maya creators of the past and of the present.

Preface

Jeff Karl Kowalski, with Mary Katherine Scott

▸ Based on field research conducted between 2006 and 2008 by Mary Katherine Scott, a doctoral candidate at the University of East Anglia, England, this exhibition represents the first sustained study of a representative selection of artworks by Miguel Uc Delgado, Angel Ruíz Novelo, Jesús Marcos Delgado Kú, and Wilbert Vázquez, all of whom live and work in the Puuc region of northwest Yucatán, Mexico.

The exhibition stems from discussions between Mary Katherine and myself, as her academic mentor, during her studies for her masters degree. When she was considering whether to enter the art history program at Northern Illinois University, Mary Katherine and her mother had dinner with me and my wife, Mary, at a very good and reasonably priced (and now unfortunately closed) Greek restaurant. During the conversation about the program structure and requirements, aspects of student life, and housing costs, possible Masters Thesis topics were also bandied about. Mary Katherine mentioned that she had a strong desire to learn as much as possible about Latin American art, from ancient times to the present, but was particularly interested in the possibility of writing on a topic involving contemporary art and artists. In an effort to avoid false advertising, I explained that my primary specialization was in pre-Columbian art of Mesoamerica and the Andes, and did not teach contemporary Latin American art. However, with a little thought, I mentioned that I knew a sculptor, Miguel Uc Delgado, a Yucatec Maya speaker who lived in the town of Santa Elena, Yucatán, and whose works, though not contemporary in the conventional art world sense, were extremely well crafted examples of what has typically been categorized as tourist art. Beyond that, I suggested that a thesis on

such artworks could pose intriguing questions about how images of Maya identity are portrayed in such carvings, about how such identity is understood and negotiated as part of the confluence of aesthetics and commerce that motivates artists to create artifacts with specialized forms and meanings, and how such objects are classified in larger systems of value determined in places far from the small village in which Miguel lives and carves. I also suggested that since much of the subject matter depicted in the wood sculptures was based on ancient Maya imagery, and because the sculptures are produced for sale to tourists visiting nearby Maya archaeological sites, I could be of some help providing background information that Mary Katherine would need to pursue the topic. Apparently, the effort to find a link between ancient Maya art and a topic that would deal with issues relevant to contemporary debates regarding the very nature and definition of art struck a chord, because Mary Katherine enrolled in the program. With energy and diligence, a great deal of wide-ranging study, and with considerable active fieldwork in the Puuc region where Miguel Uc Delgado lives and works, as do Jesús Marcos Delgado Kú, Angel Ruíz Novelo, and Wilbert Vázquez, the other artisans whose work is considered in this exhibition, she successfully completed her masters thesis at NIU.

Her enthusiasm for and growing knowledge of this subject matter led her to propose that these wood carvings might be suitable for an exhibition at the university. Working together we wrote a proposal for the exhibition, including a recommendation that it include not only the display of the artworks, but also demonstrations by the artisans themselves, as well as a scholarly symposium devoted to the topic of tourist

arts, cultural identity, authenticity, and transcultural global contact. The proposal was approved in the fall of 2007 by the members of the School of Art Exhibition and Visiting Artists Committee, and was scheduled for August 31 through September 25, 2009, in the Jack Olson Gallery of the School of Art.

Since then the two of us, in close collaboration with Peter van Ael, Coordinator of the Jack Olson Gallery, have been busy organizing the exhibition, working with the NIU Press to arrange for publishing the catalog, writing the catalog text and essays, contacting and confirming participation in the symposium and contributions of essays to the catalog by the scholars Quetzil Castañeda, Janet Berlo, and Christopher Steiner, as well as arranging for participation in the symposium by Nelson Graburn.

The general text for the exhibition catalog was written by Mary Katherine Scott and myself, Jeff Kowalski. Mary Katherine provided the basic comprehensive text, based on her fieldwork and adapted from her Masters Thesis, with additional research completed during her doctoral work. To this I added an introduction, the sections on pre-conquest and colonial to modern history of northern Yucatán, some sections on the subject matter of the wood carvings, and various supplemental comments in the sections on Maya identities and issues regarding the carvings and categorizations of "art." I wrote a synopsis of the catalog text with assistance from Mary Katherine, who then translated it into Spanish. Because of my location in DeKalb, I have served as general editor for scholarly content of the catalog, and have worked with NIU Press to coordinate its production, with some assistance from Mary Katherine.

We have worked to ensure that as many members of the NIU university community and interested individuals throughout the DeKalb and northern Illinois region as possible will have an opportunity to see the exhibition, or to have aspects of its subject integrated into classroom curricula. Beyond this, we have worked to find venues for the exhibition at the University of North Carolina at Chapel Hill, and

in Mérida, Yucatán. We have also been putting our noses to the grant-writing grindstone to help make the exhibition and related events as successful as possible. We sincerely hope that visitors to the show, audience members at the symposium, and readers of the exhibition catalog find the carvings by Miguel Uc Delgado, Jesús Marcos Delgado Kú, Angel Ruíz Novelo, and Wilbert Vázquez as visually engaging and worthy of sustained looking, learning, thinking, and interpretation as we have.

Acknowledgments

There are many individuals and institutional donors we would like to thank for the support they have provided that have helped make this exhibition, catalog, symposium, and associated community and educational activities a reality.

We thank Adrian Tió, former Director of the School of Art, NIU, and Douglas Boughton, current Director of the School of Art, for their support for this exhibition, for providing advice, and for their willingness to identify and commit School funds to make the project a success. We are also grateful to members of the School of Art Exhibitions and Visiting Artists Committee, who originally heard our "pitch" for the exhibition and approved it, setting planning and organizing for the exhibition in motion.

Thanks are due to Michael Gonzales, Director of the Center for Latino and Latin American Studies, who has worked to help with the organization of events connected with the exhibition, and has committed funding to the effort. Likewise, Emily Prieto, Director of the Latino Resources Center at NIU, deserves thanks for committing funding for the exhibition and for helping Jeff Kowalski establish ties with community groups and schools with which we are collaborating to sponsor outreach events and educational activities. We also acknowledge the financial support provided by Judy Ledgerwood, Chair of the Anthropology Department at NIU. Ann Wright-Parsons, Curator of the collections of the Anthropology

Museum at NIU has been a strong supporter, and is organizing a complementary exhibition on tourist arts in her venue.

Mary Quinlan, Head of the Art History Division, deserves recognition for working with Doug Boughton to identify and secure funds from the Elizabeth Allen Visiting Lecturers Endowment Fund and from the School of Art Visiting Artists and Scholars Fund to facilitate the bringing of the artisans and the symposium scholars to campus. Thanks also to my colleagues in the Art History Division who supported this effort by agreeing to devote the majority of our visiting artist monies during the 2009–2010 Fiscal Year to this project, and also to members of the ArtLab committee who recognized the importance of this project and made it the kick-off event for a year of School-wide interdisciplinary research creative artistry and curricular emphases devoted to the theme of globalization and cultural identity.

We recognize Professor Sharon Mújica, Director of the Yucatec Maya Language and Culture Program (UNC and Duke Consortium), and staff member of the Institute for the Study of the Americas at the University of North Carolina at Chapel Hill. She worked diligently to arrange for this exhibition to be shown at UNC from January 8 to March 8, 2009. Just prior to printing this catalog she informed us that this venue would not be available because anticipated grant support was not funded.

We also acknowledge the assistance of Alfredo Barrera Rubio, archaeologist and former Director of CRY-INAH (Yucatán Regional Center-National Institute of Anthropology and History). He helped us secure travel documents for the artisans, and facilitated meetings with Mtro. Renán Guillermo González, Director of the Instituto de Culturas de Yucatán, and Mtro. Manuel May Tilan, Director de Artes Visuales of the ICY, to identify the time and venue where this exhibition will be seen in Mérida, Yucatán following its appearance at Northern Illinois University.

We appreciate the enthusiasm that members of the Board of Directors for Conexión Comunidad Latino community organization in DeKalb, Illinois have expressed for this exhibition, and for their willingness to work with us to arrange for a fiesta-style event that will take place at their meeting hall and will permit the visiting artisans, NIU faculty and students, and members of the local community to get to know one another.

We are grateful to Lindsay Hall, Principal of DeKalb High School (District 428) for her support of this project and her cooperation in arranging to transport DeKalb High School students to the exhibition and to facilitate contacts with faculty who would like to incorporate aspects of the exhibition's themes into classroom teaching and lesson plans. We also wish to thank Amy Crook, Coordinator of Bilingual Programs for DeKalb School District for her interest in working with us to facilitate contacts with Latino students and student organizations to ensure that they are able to benefit from this exhibition. DeKalb High School teachers Liz Gidaszewski and Gail Cappaert are also cooperating in these outreach efforts.

We appreciate the collaboration of Sheila Conrad, Principal of East Aurora High School (District 129), who is working with Jeff Kowalski to facilitate bus trips to the exhibition and NIU campus for high school students in Aurora, Illinois, and will help identify other faculty with whom we can plan additional ways to integrate aspects of the subject matter of the exhibition into classroom curricula.

Thanks also are due to Alexander Martínez, Coordinator of the Escalera Program of the Instituto del Progreso Latino in Chicago, Illinois. He is working with Jeff Kowalski and Emily Prieto to arrange opportunities for Latino students from Chicago to visit the exhibition and the NIU campus, and to maximize its educational benefit for the students he serves.

Janie Wilson-Cook, Assistant Curator of the School of Art Visual Resources Center, deserves special thanks for helping to produce visual materials necessary both for illustrating the catalog and for signage in the exhibition, as well as for working with Jeff Kowalski to design a website for the exhibition. Using

the magic of Photoshop, she has worked to transform our photographs of the wood sculptures, and those by the artisans themselves, into cleaner, more legible images. Jason Lamb, an art history graduate student and assistant in the Visual Resources Center also deserves credit for his assistance preparing the photographs for publication.

Our thanks go to Bill Vine, a PhD student in Electroacoustic and Sonic Arts at the University of East Anglia (UK), for composing musical pieces to accompany both a digital projection within the gallery space and also the exhibition's website. In addition, he was instrumental in helping Mary Katherine Scott assemble the images for the digital projection and edit the artisan interviews for a looping video component also used in the gallery space. We are grateful for his vision and creativity in creating pieces that evoke the spirit of Yucatán and further contextualize the artworks in this exhibition.

Giuliana Borea, a masters student in the Sainsbury Research Unit at the University of East Anglia (UK), deserves credit for helping Mary Katherine Scott with the translation to Spanish of the Introduction and main catalog text. We appreciate her keen eye and insight into this project, which helped the nuances as well as the more complex ideas make an elegant transition from English to Spanish for our Spanish-speaking readers. A brief addition to this translation was reviewed by Charles and Maria Stapleton, students at NIU.

We are particularly grateful to J. Alex Schwartz, Director of the NIU Press, who has enthusiastically supported the plans to publish this catalog, despite the fact that it would involve a relatively short production schedule. One of the press's Editors, Amy Farranto, has been extremely helpful by keeping us mindful of that schedule, and providing sound guidance regarding the overall parameters for the form and content of the catalog. Julia Fauci, Design and Production manager, has collaborated with us to discuss and produce the general layout of the volume, and worked to assure that we have an adequate number of illustrations of sufficient quality. Susan Bean,

Managing Editor, has worked with us to ensure that the copy is clean and accurate and that all is in good order before the catalog goes to press.

We are grateful to the NIU Office of Sponsored Projects (OSP) for assisting us with identifying possible grant opportunities and funding sources. David Stone, Director of OSP, met with Jeff Kowalski to discuss the project, and Kristin Duffy worked closely with him to put together and submit several proposals. She also provided valuable editorial and logistical assistance. Andrea Buford was particularly helpful during the latter stages of the exhibition planning, identifying other possible grant opportunities, and collaborating with Jeff Kowalski in the editing process, determining budgets, and completing necessary paperwork. We appreciate the hours members of OSP have spent fine-tuning our funding proposals.

At the time this catalog went to press we had been successful in obtaining the following financial support. We wish to acknowledge and are grateful for a $10,000 Venture Grant from the NIU Foundation that provides support for catalog publication, and travel and accommodations for the visiting artisans and scholars. We also recognize and wish to give special thanks to the Target Corporation, for $3,000 provided through their Community Relations grant program. This grant is providing support for travel and accommodations for the visiting artisans.

Many thanks also to Heeshun Majcher, Director of the International Student and Faculty Office at NIU for helping us with the preparations and proper paperwork involved in bringing the artisans from Yucatán to NIU, and working to help us arrange proper documentation for shipping the carvings. We also gratefully acknowledge the assistance of the Consulate General of Mexico in Chicago. Sra. Beatríz Margain Charles, Cultural Attaché for the Consulate worked to facilitate the proper documentation for the visiting artisans and their art works, and provided general support for our project.

The process of peer review provides an important "quality check" on volumes of this sort. Mindful of

this, we want to give our special thanks to Traci Ardren, an archaeologist who has written on related topics and worked to find ways for the people of Chunchucmil, Yucatán to more directly participate in and benefit from decisions regarding touristic development in their community, for her thoughtful comments and constructive criticism of an earlier version of this manuscript. Her suggestions for ways to improve our arguments and incorporate some additional research have helped to make this a better piece of scholarship. We have worked to incorporate her suggestions, but remain accountable for the final outcome.

We also want to acknowledge and thank our visiting scholars, Janet Berlo (Professor of Art History and Visual Culture Studies, University of Rochester), Christopher Steiner (Lucy C. McDannel Professor of Art History, Associate Professor and Director of Museum Studies, Connecticut College), Quetzil Castañeda (Founding Director and Professor, OSEA; Research Associate in Anthropology and Visiting Faculty in Latin American Studies, Indiana University), and Nelson Graburn (Professor, Dept. of Anthropology, Curator of North American Ethnology, Phoebe A. Hearst Museum of Anthropology University of California Berkeley), for agreeing to participate in and present papers at the scholarly symposium on issues related to globalization, tourism, cultural identity, authenticity, and art, scheduled for September 19, 2009. Particular thanks go to Berlo, Steiner, and Castañeda for contributing essays to the catalog. We are especially grateful to Castañeda and Berlo for reading sections of the catalog text and providing helpful suggestions regarding how to improve its style and strengthen its content. Quetzil Castañeda provided invaluable advice and information regarding the artworks of Pisté and on issues discussed in section on Maya identities. We have integrated their suggestions whenever possible, but remain responsible for the content.

Jeff Kowalski wishes to recognize the advice on his essay on Uxmal provided by Janet Berlo (she suggested an alternate title that appears in the published version), and for her editorial suggestions on the general introduction. He also thanks Barbara Jaffee, of the NIU Art History Division, for reading and providing thoughtful comments on the introduction. In addition, he is also grateful to Susan Milbrath for permitting him to use her photograph of the Chaak mask from Mayapan Structure Q-151 in his essay. In addition, he particularly wants to thank his wife, Mary Kowalski, for understanding and supporting him during periods of long hours spent at the computer as deadlines for publication approached. In addition, he is grateful for her reading several sections of the catalog prior to publication. As a nonspecialist (at least in art history, she is an expert in early childhood education) she helped make sure his writing was accessible to general readers.

Of course, this exhibition would not be possible without the cooperation and collaboration of Miguel Uc Delgado, Angel Ruíz Novelo, Jesús Marcos Delgado Kú, and Wilbert Vázquez. It is their wood carvings—the product of their talent and artistry—that are the organizing core of the exhibition. Jeff Kowalski remembers fondly time spent with Miguel and Estela when he and his family lived in Yucatán and he was working at Uxmal in 1988. Mary Katherine Scott is especially grateful for the many hours the artisans spent with her discussing their lives and their works, and we are both thankful that they agreed to have their sculptures made the subject of this type of exhibition, and to be discussed and illustrated in this catalog.

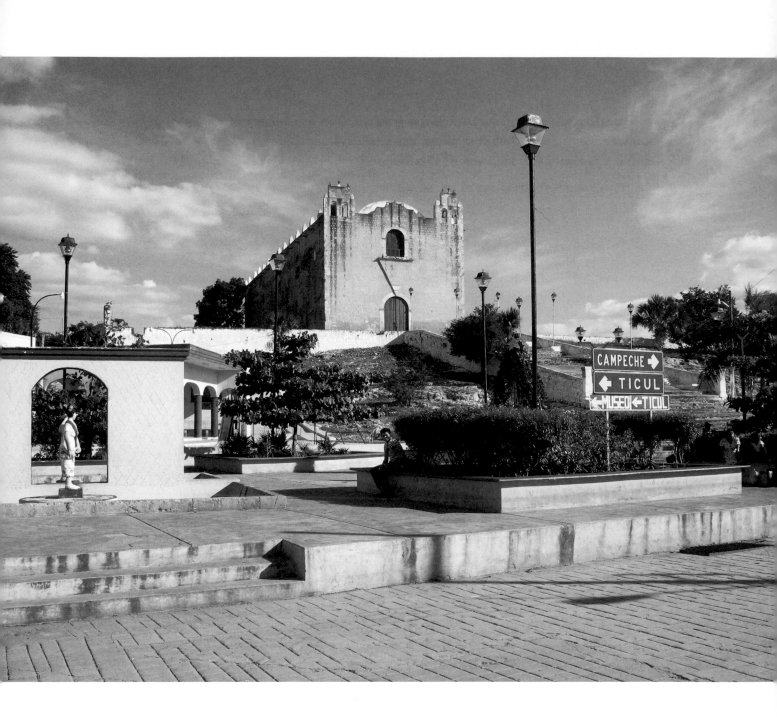

1.6—The east side of the central plaza at Santa Elena, Yucatán, dominated by the local church that rests on the remains of an ancient temple of the pre-conquest Maya town of Nohcacab.

Crafting

MAYA

Identity

1.22—Angel Ruíz Novelo, the ruler K'inich Janaab Pakal II entering the underworld, cedar, H-W, 31 x 17 inches (79 x 45 cm), based on the sarcophagus lid from Palenque, Chiapas.

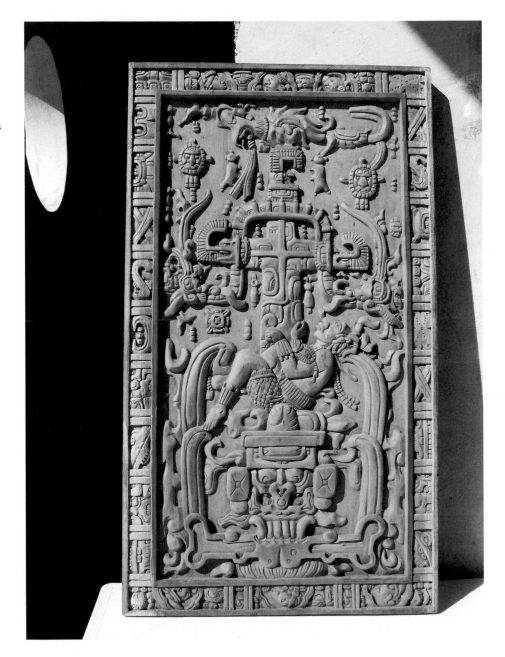

IMAGING THE MAYA

Carvings, Carvers, Contexts

and Messages

Mary Katherine Scott and

Jeff Karl Kowalski

▸ "Crafting Maya Identity: Contemporary Wood Sculptures from the Puuc Region of Yucatán, Mexico" features wood sculptures by four contemporary Yucatec Maya artisans: Miguel Uc Delgado, Jesús Marcos Delgado Kú, Angel Ruíz Novelo, and Wilbert Vázquez. These exceptionally detailed, hand-carved, and aesthetically engaging works are replicas of subjects based on ancient Maya sculptures, ceramics, and manuscripts. Produced for sale at archaeological sites in northern Yucatán, they are purchased principally by "cultural tourists" who visit these sites on organized educational trips. These carvings are particularly striking versions of the types of art forms that have emerged due to the dramatic increase in tourism in Yucatán as a result of globalization. In this sense, these carvings represent a manifestation of "tourist art," a specialized category of visual expression that has emerged as a serious field of art historical and anthropological investigation.

The exhibition catalog, complemented by a group of essays by Quetzil Castañeda, Mary Katherine Scott, Jeff Kowalski, Janet Berlo, and Christopher Steiner, explores issues at the intersection of art, visual culture, cultural identities, authenticity, and globalization. We consider the broader role of artists and the visual arts in society and the study of such art forms in the context of changing conceptions of art and aesthetics, in the hope that this study will further scholarship on tourist arts in general, while presenting the first comprehensive examination of the distinctive artworks produced by these Yucatec Maya carvers.

In contemporary usage, globalization refers to the increased interaction and integration of the political economies and cultural practices of national states through trade, foreign investment, flow of capital, migration, and use of new technologies (computing, electronic communication, visual culture) that have speeded the exchange of information and commerce.[1] In addition to more rapidly and widely moving capital, goods, and information, globalization has also resulted in the movement of people, either through immigration or in the form of tourism.[2]

As Janet Berlo points out in her essay in this volume, such cultural interaction among different societies is not new. Cross-cultural contacts and the sharing of goods and ideas have been important driving forces of change and innovation from ancient times,[3] and these processes have increased from the age of European exploration, expansion, and colonization, resulting in complex and often violent processes of acculturation, accommodation, and resistance.[4] These forces have intensified dramatically during the late twentieth and twenty-first century, often producing repercussions that have profoundly affected the political economies and cultures of major nation states as well as those of smaller and less developed countries.[5] The recent "tradition" of carvings

produced by the Puuc artisans has emerged in the context of profound economic, social, and cultural transformation associated with international contacts and globalization in northern Yucatán, many aspects of which are considered in the recent volume *Yucatán in an Era of Globalization*.[6] Aspects of these processes are discussed later in this catalog.

Related to the broader phenomenon of globalization is the growth of long-distance travel and international tourism. Tourism, at least in its mass-tourism form, is often considered to be a more democratic and modern development that differs from the aristocratic travel of the ancient world or the "grand tour" of the eighteenth century.[7] This modern tourism is associated with expanding opportunities for middle-class travel in the twentieth century, particularly after World War II.[8] Explanations of the reasons for such travel vary, ranging from interpretations that see tourism as "modern leisure" centered on entertainment, pleasure-seeking, and recreation, to more theoretical perspectives that view tourism as a modern version of a traditional pilgrimage in which travelers seek "authentic experiences" comparable to a quest for the sacred.[9] In addition, many anthropological and sociological studies have focused on the nature of the encounter between tourists ("guests") and local peoples ("hosts") in visited zones, with special emphasis on the various acculturative effects on local cultural practices.[10]

An important sub-category of tourism has often been called "cultural tourism." Although all tourism involves a kind of cultural interaction,[11] the term "cultural tourism" suggests that the traveler has designed at least a significant portion of the trip to deliberately seek out experiences that provide an opportunity to make direct contact with and experience aspects of a foreign culture and/or places of historical significance. This often takes the form of organized trips and may involve special visits to "heritage sites," places of historical interest, museums, special performances, and exhibits.[12] Generally speaking, the tourism industry is neutral toward this emphasis on "culture," but stresses the opportunities for travel to distant locations to provide visitors with unique experiences.[13] In this sense, the ruins found at Uxmal, Kabah, Sayil, and Labna, the key tourist destinations in the Puuc region, provide the experience of a direct encounter with standing vestiges of ancient Maya civilization that the visitor has traveled to see. However, as heritage sites, they also become a kind of cultural commodity that is economically valuable to the tourist industry that promotes them and develops an infrastructure that will house, feed, and otherwise entertain visitors to return a profit.[14]

Accompanying the growing interest in tourism as an economic, sociological, anthropological, and psychological phenomenon has been an increase in studying the aesthetic artifacts produced in zones of inter-cultural contact and the processes by which they are consumed by outsiders. Such objects are commonly called "tourist arts," although it has been suggested that this designation be abandoned because it lumps many different types of artworks under a single, somewhat derogatory heading.[15] The sustained academic study of these types of art forms is generally traced to the 1976 anthology edited by Nelson H. H. Graburn, *Ethnic and Tourist Arts: Cultural Expressions from the Fourth World,* which Ruth Phillips and Christopher Steiner call "the first major publication to pay serious scholarly attention to the art commodities of marginalized and colonized peoples and to recognize their importance in the touristic production of ethnicity."[16] In this seminal work, Graburn assembled a selection of insightful essays by anthropologists and art historians whose work explored these issues in the context of particular art forms made in different societies throughout the world. In his introduction he proposed an analytical scheme for classifying such art work (summarized in the main catalog text) that recognized that there was a wide variety of such art forms, ranging from traditional objects produced for local use but collected by outsiders, to more recently developed genres that used new forms, subject matter, and media. Graburn

also noted that such aesthetic products were often designed to feature forms and/or images that conveyed a message correlated with the cultural background and ethnic identity of the artist/maker.

Until the appearance of Graburn's book, many such aesthetic products were omitted from serious academic discussion because they were seen as lacking in quality, not grounded in local tradition, or produced primarily for commercial purposes. Art historians did not consider them to be "Art," and anthropologists did not consider them to represent authentic indigenous culture. Since Graburn's book was published, however, a growing abundance of individual studies and articles, as well as scholarly anthologies, have dealt with this subject. In general, they note that these objects have many of the characteristics of other artifacts characterized as "art" (e.g., deliberately determined specialized and meaningful form), while pointing out that they must be analyzed and interpreted in the context of a wider field of production that reflects their position in complex networks of cultural contacts, economic exchange, and societal and institutional discourses regarding the classification and assigning of value to commodities.[17]

Shelly Errington notes that the types of carvings featured in this exhibition can be examined using alternative perspectives or "frames." One, a more traditional art historical approach, is to focus on the carvings themselves and to center discussion on their individual form and subject matter. Another is to approach the carvings as "objects" or examples of material culture that is "to be explained and treated as any other widget whose meanings are projected upon it and accrued in practice."[18] In essence this describes the dichotomous character of such objects as both art and artifact. Along with related aesthetic artifacts that emerged in situations of culture contact and transformation, and that were produced for trade or sale to outsiders, the carvings by the Puuc artisans thus fall into a problematic category that touches on issues related to notions of cultural identity, authenticity, and the nature of art itself.[19]

Culture and Identity

The phenomenon of tourism involves contact between people(s) of different cultural backgrounds and raises questions of cultural identity. Discussion of cultural identity requires a brief discussion of "culture," a word that Raymond Williams, a founder the field of cultural studies, pronounced to be "one of the two or three most complicated words in the English language."[20] In its restricted nineteenth-century humanistic sense, enunciated by Matthew Arnold, culture refers to "a pursuit of our total perfection, by means of getting to know, on all the matters which most concern us, the best that has been thought and said in the world."[21] Like others of its time, Arnold's definition presumed that a particular set of elite manners, opinions, and tastes (largely those of European and American elites) provided a standard by which to assess value of all human accomplishments. In contrast, Raymond Williams asserted that culture must be understood and examined in its totality, as a "whole way of life," involving the complete range of meanings and expressions, from those that are considered common and broadly shared, to those that reflect advanced learning and arts.[22]

During the nineteenth century, anthropologist Edward Tylor, attempting to find a definition that would cover many different human societies, wrote of culture as "that complex whole which includes knowledge, belief, art, morals, law, custom, and any other capabilities and habits acquired by man as a member of society."[23] This approach emphasized producing accounts of, or assembling lists of, a society's core beliefs, practices, and range of artifacts (tools and arts) that together constituted its shared culture.[24] More recently, anthropologist Clifford Geertz offered a more ideational or semiotic definition of culture, describing it as "an historically transmitted pattern of meanings embodied in symbols by means of which men communicate, perpetuate, and develop their knowledge and attitudes toward life."[25] Like others, Geertz argued that the use of shared symbols

instilled a sense of common social identity and could motivate cooperative action that facilitated human survival. More recently, the culture concept has been questioned and critiqued from various quarters, often by those who point out that it is both too reified and too vague, as well as noting that aspects of culture are experienced differently by various sub-groups within any human society. In this connection, Dirks, Eley, and Ortner (1994: 1) have noted that:

> One of the core dimensions of the concept of culture has been the notion that culture is "shared" by all members of a given society. But as anthropologists have begun to study more complex societies, in which divisions of class, race, and ethnicity are fundamentally constitutive, it has become clear that if we speak of culture as shared, we must now always ask, "By whom," and "In what ways?"—and "Under what conditions?"[26]

In recent approaches, culture is seen as constructed from a combination of formal teaching and experiential learning, and is both carried on and modified by members of a particular society. In this sense, cultural identity refers to the sets of beliefs and habitual behaviors and practices that become integrated into a self-image by the individual. This identity will differ based on factors such as class, race, ethnicity, gender, education, and socialization, and is constantly being negotiated, challenged, and reaffirmed through interactions with others, while also being autonomously reaffirmed through the reintegration of a personal psychological "biography."[27] To outsiders with only a passing acquaintance and infrequent contact with, or limited knowledge of, the history and culture of a particular group, notions of their cultural identity may be reduced to several key traits (e.g., particular beliefs, clothing, cuisine, or level of technological and/or sociopolitical complexity) that represent the culture in ethnocentric ways that are at best limited and partial, and that may also present stereotyped

notions about different cultures. Because they have a distinctive appearance, and often are small enough to be transported physically or transmitted visually (in print or electronic media), aesthetic artifacts (i.e., art works) have often come to represent their entire culture in an iconic manner.

Discussion of cultural identity also brings up the issue of identity itself. As Stuart Hall and Paul du Gay note, discussions of the nature of identity have never been more intense and varied. As the result of postmodernist critiques, many disciplines have accepted the demise of an earlier "integral, originary, and unified identity."[28] The firmness and stability of individual identity is questioned, and yet the term remains, if only as a shorthand reference to the complex intersection of influences that affect the behaviors and self-conceptions of individual human beings. Relating this to the conceptions of culture discussed above, one facet of individual identity involves "identification" with a broader group of which a person considers himself or herself to be a member. As Hall and du Gay put it, "In common sense language, identification is constructed on the back of a recognition of some common origin or shared characteristics with another person or group, or with an ideal, and with the natural closure of solidarity and allegiance established on this foundation. In contrast with the 'naturalism' of this definition, the discursive approach sees identification as a construction, a process never completed—always 'in process'. . . ."[29] Hall and du Gay note that the symbolic or semiotic aspects of culture play a powerful role in this ongoing process, noting that, identities are "constituted within, not outside representation. They relate to the invention of tradition as much as to tradition itself, which they oblige us to read not as an endless reiteration but as 'the changing same': "not the so-called return to roots but a coming-to-terms-with our 'routes.'"[30] This observation is particularly relevant to the carvings in this exhibition, which are in fact one such "representation" of Maya

culture, although the way in which they are understood as a reified reference to "authentic" ancient Maya culture by tourists differs from the more complex notions of personal identity of their makers.

Cultural Identity, Authenticity, and Art

Related to the discussion of cultural identity is the notion of "authenticity." The wood carvings in this exhibition raise questions regarding the use of this term, and demonstrate how equivocal it is as a concept. In traditional art historical frameworks, authenticity has been the concern of connoisseurs or curators who are interested in documenting whether a work of art is the genuine product of an artist, culture, or period to which it is ascribed. Yet, in anthropological discourse it has often been associated with questions of ethnicity and used to gauge the extent to which a people, culture, or art form adhered to well-established and commonly held understandings about what are correct, appropriate, or traditional beliefs, practices, or forms of material culture.[31] When dealing with aesthetic artifacts from non-western cultures, the common understanding was that if they were produced and used locally, and stemmed from a relatively continuous tradition of producing such objects, that they were "authentic," while those that were made for trade or sale to outsiders, or that represented formerly unknown forms and imagery, were contaminated and "inauthentic."[32] However, Graburn noted that respondents judged Inuit soapstone sculptures—a wholly new form—as more authentic, and replicas of older Algonkian artifacts sold as Cree craft inauthentic, thereby suggesting that a layperson's definition of the inauthentic might be "something mislabeled, or purporting to be something it was not."[33] By this definition, some of the types of replicas of African masks and figures discussed in the essay in this volume by Christopher Steiner, or the mass-produced Southwest silver jewelry described by Janet Berlo, could be considered

inauthentic. Insofar as the Puuc wood carvings in this exhibition recall and are based closely on the images of another cultural and period style, they flirt with being labeled as inauthentic or "fake" by standards of connoisseurship (or perhaps as "kitsch" according to Castañeda in his essay in this volume). On the other hand, since the detailed replicas of ancient Maya artistic imagery seen in these wood sculptures are not produced with an intent to persuade viewers that they are antiquities, nor do buyers understand them as such, they could pass Graburn's common sense authenticity test. As Erik Cohen has noted, these assessments tend to become more acute depending on the beholder's depth of knowledge about the culture and art forms in question.[34] Yet this awareness is not always value neutral. Those who possess specialized knowledge are able to use their "discriminating taste" not only to determine factual matters of history and authorship, but also to establish the definitions of what counts as real art and what doesn't, and whose art is shown and whose isn't.[35] As Marvin Cohodas has observed:

> . . . labeling all these works "tourist arts" foregrounds a particular circumstance of consumption that not only denies the importance of dealers in constructing and authenticating significations and relational values on which market valuation and ethnic classification are often based, but also invokes all the notions of the inauthentic the term "tourist" has come to entail.[36]

Clearly, we should be careful in using terms such as "tourist arts," or in evaluating the authenticity of carvings like those that are the subject of this exhibition. Produced primarily for sale to visitors from outside of Mexico or the Puuc region, they could be considered "mere" tourist art, and, as examples of a type of artwork that was developed only recently, they could be considered "inauthentic" on several counts according to what have, again until fairly

recently, been considered standard evaluative criteria. However, we prefer to approach them as intriguing examples of aesthetic objects produced in a particular context of globalization and cultural contact, and as reflecting the mixture of personal creativity, pride in artisanry, and entrepreneurial ability of their makers. By discussing both the objects themselves and their broader historical context, we have striven to examine their interpenetrating identities as both art and as artifact.

The Essays

In the following series of essays, the contributors provide individualized studies of aesthetic artifacts in relation to many of the issues outlined above, as well as introducing some of their own observations and perspectives on these problems.

In her essay "Native American Artistic Creativity and Commodity Culture," Janet Berlo examines several types of aesthetic artifacts that were primarily produced by Native North Americans for collection by outsiders. She discusses a series of representative objects, including Plains Indian drawings, Haida argillite carvings, Alaskan tourist arts (including miniature replicas of functional objects, as well as ivory carvings), basketry of the California Karuk weaver Elizabeth Hickox, Iroquois beadwork, and tourist arts of the Southwest. She examines issues of commoditization, commercialization, and cultural identity, outlining the distinctive character of these works as each emerged from a matrix of historical change and culture contact that affected but was also consciously utilized by Native people to create new types of aesthetic expressions aimed at new audiences. Often taking hybrid forms, these expressions represent various combinations of both older and newer techniques, materials, or subject matters. Although they often cater to white expectations about what "Indian" arts and crafts should look like, they also permit their creators to maintain a sense of their ethnic identity and agency, as well as

affording them opportunities to make a living doing more creative and less menial labor. Berlo's discussion of the circumstances in which silver jewelry is produced for sale by vendors beneath the portals of the Palace of the Governors at Santa Fe pointedly addresses the complex nature of creating the effect of "authenticity," noting that the Spanish colonial-style building itself is a twentieth-century edifice and that much "handmade" silver work is produced in a factorylike workshop kept carefully concealed from potential buyers. In conclusion, she observes that "throughout the history of inter-relations between Indigenous artist and non-Native buyer, the social practices involved in the production and marketing of such works have been complex and multivalent. Tradition *and* innovation, collective values *and* individual vision, economic *and* ideological values are all played out in the arena of tourist arts."

Christopher Steiner, in his essay "The Image of Africa and its Relationship to Commerce," focuses attention on the exchange of two types of aesthetic commodities—commercially produced European trade cloth, and more recent African wood sculptures created specifically for sale to outsiders—as examples of two different ways in which views of Africa have been constructed by the West. He notes that Europeans have had both positive and negative attitudes toward Africa: at times stressing an idyllic and romanticized (though stereotyped and demeaning) view of an unspoiled "primitive" continent, while at other times expressing disdain and fear, stressing the savage aspects of African peoples and cultures. He makes a case that although European colonial conquest and control of Africa depended on mixtures of both attitudes, economic realities of the textile trade for a period compelled Europeans (primarily the British and French) to suspend their racist and ethnocentric views in order to further capitalist expansion. Manufacturers, realizing that African peoples had distinctive tastes and based their aesthetic preferences on predictable criteria, were forced to redesign their own product to enhance its market appeal. On the other

hand, the more recent production of replicas of well-known and often illustrated wooden masks, figural sculptures, and other artifacts represents the survival of the view of Africa as an unchanging and largely undeveloped continent. Recognized as "primitive art" in the earlier twentieth century after its adoption and appropriation by modernist artists, such pieces speak to a continuing "invention of Africa" that stresses the supposed rawness and the uncivilized or pre-industrial aspects of its "traditional" cultures. He points out that many tourist visitors, or buyers in foreign boutiques, have preconceived image of authentic African art based on art books and exhibition catalogs, and that local entrepreneurs, like the Kulebele carvers he has chronicled in his book *African Art in Transit* and other studies, replicate both their own art and that of their neighbors to satisfy foreigners' desire. As a coda in his conclusions, he discusses ways in which the contemporary artist Yinka Shonibare, who often uses trade cloth of the type considered in the essay as a visual symbol of African identity, investigates questions regarding lingering colonialist attitudes and cultural stereotypes in his work.

In the essay "Aesthetics and Ambivalence of Maya Modernity: The Ethnography of Maya Art," Quetzil Castañeda reviews the development of wood carving and stone carving traditions in Pisté, Yucatán, located adjacent to the archaeological site of Chichén Itzá. He considers this *arte pisteño* tradition, first developed by Vincent Chablé, to be the principal origin point for a plethora of regional forms of tourist arts, ranging from the detailed fidelity to ancient Maya sources seen in *réplica* style of the Puuc region (discussed further in the catalog text and Mary Katherine Scott's essay), to other handicraft arts of Yaxuna. Based on mixtures of ancient Maya (or other Mesoamerican) visual sources (e.g., codices, stone monuments, iconic Chichén Itzá images such as the Chacmool or feathered serpent), but lacking a long-lived local heritage, the Pisté carvings were at first disparaged as a kind of inauthentic hoax. As these tourist souvenirs have become more popular, in part through official recognition by INAH, and also abetted by the scholarship and promotional support provided by Castañeda himself, some carvers have been able to explore another identity, that of an artist-entrepreneur, although the expression of this identity is "subtle and resides materially in the quality of their work and the recognition by Pisté artisans and artists of this qualitative difference in their work and abilities to produce more beautiful pieces." Castañeda also notes that the continuing disputes about when and where artisans (or their vendors) can sell their works at Chichén Itzá raises important questions about who "owns" and who benefits from archaeological heritage sites.

The opportunities for Pisté artisans to demonstrate their artistry is largely conditioned by market forces. Thus, many of the pieces are produced quickly with an eye toward attracting the tourist's gaze and securing a sale. However, a number of Pisté carvers have been able to create more ambitious and aesthetically developed works, either as the result of having obtained specialized commissions or simply to express their personal skill and creativity, demonstrated by a combination of inventiveness of form and mimetic carving of life forms that convey a sense of energy and lifelike presence. Unlike other regional arts produced for sale to tourists (e.g., in Oaxaca or the Maya highlands) that strive to maintain a "folk art" quality, those of Pisté (and by extension the Puuc carvings featured in this exhibition) are more carefully finished and bespeak the naturalism favored both by the ancient Maya and tourist visitor. Castañeda makes an important point that simply labeling an object "tourist art" does not do justice to explaining how it is evaluated and situated in a system of artistic production, since the sale of aesthetic objects can range from inexpensive souvenirs to high-end works purchased by tourist visitors in the galleries of major world capitals. He ends with a discussion of the Pisté (and Puuc) carvings as kitsch, but with a recognition that kitsch is based on and reflects the viewers'/purchasers' fascination with cultural icons

that have become so familiar as symbols (in this case of Maya civilization) that they permit the tourists to take home a piece of their own pre-conditioned representation of Maya/Mexican culture.

In "'Thrice Built': Uxmal and Constructions of Maya Identity," Jeff Kowalski examines the site of Uxmal and its role in the construction of Maya identity from pre-Columbian times to the present. Today this identity is shaped by forces of tourism and stresses Uxmal as a world heritage site. However, the site's identity has been constructed and contested from the time of its foundation, and has regularly taken shape in the context of its connections with broader world systems. These begin with the rapid population growth in the Puuc region in the eighth century and the foundation of new polities whose rulers were involved in both regional and long-distance trade. Later, during the Postclassic period and early colonial times the Xiu family's claim to have founded Uxmal bolstered its political authority, first as members of the joint government at Mayapan and later as "natural lords" under Spanish dominion.

More recently, Uxmal, like other major sites, has become a symbol of Maya identity and civilization. This process began with prominence given to Uxmal and the Puuc region in popular accounts of Maya exploration (e.g., Stephens and Catherwood's *Incidents of Travel in Yucatan*), and includes the use of Uxmal as a model for Maya sections of World's Fairs (the 1893 Columbian Exposition and the 1933 "Century of Progress" World's Fair in Chicago) and its impact on the architecture of Frank Lloyd Wright and Robert Stacy-Judd. It continues through frequent emphasis on Uxmal and the Puuc region in popular accounts of ancient Maya culture, ranging from coverage of Maya archaeology in popular journals, to references to Uxmal's architecture in the Disney EPCOT theme park and in the recent spectacular and hyper-violent motion picture *Apocalypto*. As Uxmal has become a heritage site and destination for different types of tourists (cultural tourists, backpackers, new age groups), the tourist infrastructure that

supports it has expanded. As the visitors themselves arrive their experience has been colored by their own aims and background knowledge, so that the meanings of Uxmal continue to be a contested cultural resource, neither completely contained or defined by those encompassed by academic archaeological studies.

Mary Katherine Scott's essay, "Representing the Maya: When Is It Appropriate to Call "Appropriations" Art?," looks more closely at production among the artisans working in the Puuc region. She discusses how these artisans are receptive to the way their culture is perceived by tourists, and how they emphasize certain aspects of popular representations of their culture to conform to the tourist's ideal. By visiting a Maya region, tourists hope to encounter the "new" or "exotic." Consciously or not, tourists have preconceived notions of the Maya well before they visit because they are influenced by the way popular culture and the media portray both ancient and contemporary Maya culture. Scott outlines how Western perceptions of the Maya have changed over the centuries based on various scholarly or popular media sources in order to contextualize the market in which the Puuc wood carvings are produced and sold.

Thus, the Puuc artisans' focus on aspects of their Maya culture (as it is perceived by cultural outsiders) is used as a marketing strategy, as is reproducing in wood and other media more portable replicas of some of the most famous ancient stone sculptures for sale to the tourist market. As is the case with many of the *artesanías*, or handicrafts, in Yucatán, these replicas are often skillfully made, high-quality reproductions, but their function as "tourist art" relegates them to categories of "low art" or "non-art," making them a controversial class of objects within the field of art history. Although they are a form of "appropriation," as examples of "tourist art" they are generally considered less complex than appropriations of originals in contemporary or ancient Western art. The ancient Maya prototype, on the other hand, is regarded as

"high art," exemplified in the fact that these "origi-nals" are displayed in premier art and anthropology museums around the world. The ancient Maya, how-ever, would not have conceived of these spiritually and politically charged sculptures as "fine art" in the Western sense of the term, so their recontextualiza-tion by modern Western scholars raises questions regarding the Western systems of aesthetics and the categorization of art into binary categories (e.g., high art vs. low art, craft vs. fine art, and original vs. repro-duction). Considering the ambiguities and possible contradictions involved in such labeling practices, Scott suggests that it is more productive to examine aesthetic artifacts as arising within historical contexts and complex fields of production.

The Approach of the Exhibition

A museum or gallery exhibit is always "contested terrain,"[37] involving decisions about how to choose, display, and discuss objects based on cultural assump-tions that vary over time, place, and institutional context. Lavine and Karp note that exhibitions were the focus of heated debate during the 1980s and onward, as "Groups attempting to establish and maintain a sense of community and to assert their social, political, and economic claims in the larger world challenge the right of established institutions to control the representation of their cultures,"[38] and that curators, even those working with good intentions, may find the underlying premises of their exhibition and interpretations hotly debated, or even their motives questioned.

As Lavine and Karp observe, Duncan Cameron "distinguished between two distinct museum-related stances," a traditional one that considered the "museum as a temple,"[39] a place where standards of value and objective interpretations are established and maintained, versus a newer model of the museum as a forum for "confrontation, experimentation, and debate."[40] In this new paradigm, the emphasis on Western art, which once served as the arbiter for

evaluating aesthetic quality and significance, is now regularly being challenged by the incorporation of arts from non-Western traditions and types of arts from groups in the United States that have tradition-ally been ignored or underrepresented.

In this exhibition and in the discussion to follow, we are aware of these issues, and we endeavor to pro-vide the historical and theoretical frameworks that are necessary for a more complete understanding of the significance of the carved wooden sculptures presented in this exhibition. We begin by providing background on the historical and cultural setting of the Puuc region and northern Yucatán in which the Maya artisans represented in this exhibition live and work. We continue with a discussion on the his-torical and social context of the artisans and their carvings by considering how the Puuc "tradition" can be situated within the larger craft industry in Yucatán. We also consider the historical significance of wood carving in pre-Columbian times. We present biographical information on each carver, providing an opportunity for them to speak in their own words of their work and their notions of their cultural and artistic identity. This is followed by a summary of the carvings themselves, the historical development of the Puuc carving "tradition," the key source imagery the artisans use for their carvings, and how these subjects are geared to the specialized tourist market that consumes them. We also compare the Muna-Puuc "School" with the carving tradition found at Pisté (discussed in detail in Castañeda's essay, this volume), to further explore this idea of how the carv-ings are created and modified to appeal to tourists' preferences, as well as how they come to embody the tourists' perception of what Maya culture in Yuca-tán should look like. In the next two sections, we transition to a discussion on how the carvings are related to notions of Maya identity in Yucatán, both as expressed by the Maya insider and as perceived by the cultural outsider. We frame this discussion with both early twentieth century and current anthropo-logical theory and research.

We strive to recognize that the notions of cultural identity conveyed by the subject matter of the sculptures represent a contemporary yet reified vision of "Maya Culture" that is anchored in the pre-conquest past. However, we emphasize that the makers of such objects, while taking pride in themselves as descendants of this ancient civilization, fully recognize the differences between themselves and their distant ancestors, and create their carvings as part of an "invented tradition" (comparable to that found in pieces produced in Piste, Yucatán discussed by Quetzil Castañeda in his essay in this volume) that is calculated to catch the eye, appeal to the taste, and persuade tourist visitors to purchase their products.

Finally, we place these discussions within a framework of changing interpretations of aesthetics and art. Art is now less frequently defined by a group of canonized objects whose value is universal and immutable. Rather it is open to previously ignored categories of artifacts and expressions whose significance resides in the interrelationship between their form and content and wider historical and cultural contexts from which they emerge. The value of art works is recognized not as inherent, but as something determined by institutional frameworks within which they circulate and are discussed. Although we recognize that the approaches we use, and our own knowledge and interpretations are still partial, we have striven to produce a study that remains self-critical and open to further discovery, and provides useful information regarding the context(s) and content(s) of the wood carvings fashioned by Miguel Uc Delgado, Angel Ruíz Novelo, Jesús Marcos Delgao Kú, and Wilbert Vázquez.

The Wood Sculptures and Artisans of the Puuc Region—Contexts, Cultural Identities, and Contested Meanings

Tourism has been increasing in Yucatán for the past three decades due to the construction of luxurious resorts on the East Coast beaches and the relatively easy accessibility to numerous restored Maya archaeological sites. The rise in tourism has promoted a vibrant industry of art and handicraft production and affects the economies of many communities whose residents depend on visitors to nearby tourist destinations as a significant source of income. Handicrafts (*artesanías*) may be purchased by tourists as souvenirs in various settings, including during the visit to a nearby Maya archaeological site. The best of these display a mastery of technical skill and complex subject matter that distinguish them from most touristic keepsakes.

Making "tourist art" the subject of serious academic discussion is a fairly recent development within the discipline of art history, whose traditional methodology has largely omitted this form of visual expression from its discourse. Because it is produced for audiences outside the museum and gallery setting, tourist art is not considered "high" art and is often relegated to the category of "non-art." However, regardless of their "quality" as measured by their complexity of form, fineness of finish, or "authenticity," tourist arts communicate important messages about the changing nature of a group's cultural identity, and how such identity is represented and negotiated in the context of contacts with members of other cultural backgrounds.

The wood sculptures displayed and considered in this exhibition convey these types of messages. They also display finer craftsmanship and technical skill, greater elaboration of form, and more complex subject matter than other mass-produced touristic keepsakes. Such markers of aesthetic quality, using a Western model of the term, permit them to be viewed as particularly specialized and complex examples of traditional handicrafts and investigated along with other sculptural works typically considered "fine" art. In this exhibition, and in the scholarly symposium that accompanies it, we reconsider the issues of "high" and "low" art from a more contemporary perspective and treat tourist art as a subject that merits serious art historical investigation. The focus on wood carvings from the Puuc region permits us to discuss how this and related handicraft traditions

throughout the state fit into the broader context of Mexican folk and tourist arts. In addition, we examine and clarify how the "invented tradition" that the *artesanías* in this exhibit embody originated and what meanings these objects have both for the artisans who produce them and for the visitors who purchase them.[41]—**1.1** *col.*

Before continuing with our discussion, however, we should discuss our usage of the terms "artist" and "artisan." Even though we consider study and interpretation of the Puuc wood-carving tradition to be a valid form of art historical enterprise, and feel that these sculptures display a level of craftsmanship, and complexities of form and meaning that could identity them as "fine art" expression in other art world contexts, it should be noted that the Puuc region sculptors refer to themselves as *artesanos* (artisans) rather than *artistas* (artists). In English, the term "artisan" denotes a craftsperson or other skilled worker, the kind of occupation that is relegated to the category of "low" art among Western art historical traditions. However, Mary Katherine Scott's fieldwork in the Puuc region and research on art production in non-Western cultures suggests that such Western categories of "high" versus "low" do not apply so readily, and that the term "*artesano*" does not necessarily carry the same negative connotations as it does among Western visual traditions.[42] Thus, while we recognize their artistry, in the discussion that follows we will refer to the Puuc wood-carvers as artisans, except in those cases where a distinction between the Western and Yucatecan meaning of the term is needed for clarification.

The Puuc artisans live, work, and produce their sculptures in an area that forms part of a broader region occupied by various Maya-speaking peoples who have undergone processes social, political, and cultural transformation from pre-conquest times to the present. Before considering the individual artisans and their works, we provide a brief overview of the history of northern Yucatán to provide context for the artworks shown in the exhibit.

Northern Yucatán and the Puuc Region before the Conquest

The low range of hills that stretches across the northwestern part of the Yucatán peninsula is known as the Puuc, or Sierrita de Ticul. South of the Puuc range are rolling "haystack" limestone hills, known as *Wits* (*Witsob*, plural) to the local inhabitants. Nestled among the *Witsob* are numerous ancient Maya towns and cities, including better-known centers such as Uxmal, Kabah, Sayil, Labná, Itzimté, and Xcalumkin, as well as scores of smaller ruins. These sites belong to a longer and broader heritage of pre-conquest Maya sociopolitical evolution and cultural achievement perhaps best known from its expression during the so-called "Classic period" (c. AD 250–900). During that time the Maya peoples throughout lowlands regions of Guatemala, the Yucatán peninsula of Mexico, Belize, Western Honduras and El Salvador lived in settlements ranging from small villages to large urban centers (e.g., Tikal, Calakmul, Copan, Palenque, Yaxchilan), many of which served as the capitals of "city-states" that controlled wider territories and were governed by divine kings (*k'uhul ajaw'ob*) and a small hereditary nobility consisting of elite families. The material remains that embody "Classic Maya Civilization"—the towering pyramid temples, residential-administrative palaces, ball courts, carved stone monuments, and elaborate decorated ceramics, now considered to be ancient Maya "art"—were largely produced for the use of this small elite segment. Although there was some occupational specialization, evident from the professional planning and construction of stone buildings, carving of sculptures, and painting of ceramics and manuscripts, these activities and the lives of the elite were made possible by the broad mass of ordinary people, who lived in more perishable housing and focused on farming and production of household goods.[43]

Although there is evidence for early occupation in the Puuc region from the Preclassic period at Loltún Cave, and Early Classic period remains (c. AD 250–600) at Oxkintok and Chac II located near Sayil,

archaeological evidence indicates early centers such as Xcalumkin and others in the western Puuc flourished from about AD 600–800, while the largest and most impressive Puuc cities, such as Uxmal, Kabah, or Sayil, located in the eastern Puuc were established and began a period of rapid growth toward the end of the eighth century. The rapid upsurge in population, settlement size, and architectural construction in the eastern Puuc region probably began as the result of the improvements made in the construction of chultuns, artificial cisterns that captured and held rainwater over the dry season. With more secure water supplies, new groups began to exploit the rich agricultural potential of the area. Some of the new inhabitants surely came from the western Puuc region, while others may have immigrated from more distant regions to the south and southwest.[44] —**1.2** *col.*

During the Terminal Classic period between about AD 750 to 950/1000 there was a tremendous burst of architectural and artistic creation in northern Yucatán. During the latter part of this time, the two powerful Maya cities of Uxmal and Chichén Itzá both became capitals of regional states. The latest buildings at Uxmal, such as the Nunnery Quadrangle, the Main Ballcourt, or the House of the Governor, are associated with dates between AD 895 and 907. At Chichén Itzá, hieroglyphic lintels from the Puuc-related buildings such as the Monjas, the Temple of the Three Lintels, the Akab Dzib, and the Temple of the Hieroglyphic Jambs feature dates between AD 832 and 881. There is evidence that these two powerful cities were in contact with one another and may have entered into a political and military alliance with the rulers of nearby cities such as Kabah and Nohpat, as well as with the Itzá (the leadership group at Chichén Itzá), who helped Uxmal consolidate its power in the Puuc region.[45] —**1.3** *col.*

Uxmal and other sites are noted for their impressive architectural remains and monumental structures, many of which have ornately sculptured exteriors that differ markedly from earlier Maya architectural facades. The lower walls are sometimes given a sculptural treatment (often taking the form of groups of inset columns with spools at top, middle, and bottom), but the architectural sculpture is concentrated on the upper facades to form vivid contrasts between smooth lower walls and elaborately patterned upper zones. There, masons assembled hundreds of pre-carved separate design elements to create a type of "stone mosaic" that incorporated complex symbolic patterns and motifs. Geometric elements such as step-frets, inset columns, banded colonnettes, and X-shaped stones combined to form latticework predominate. In addition, long-snouted masks, thought to represent the Yucatec Maya rain god Chaak (as well as other deities in some cases) often were placed above the doorways or at the corners of the buildings. Naturalistic sculptures of human figures of stone or stucco also appear on some Puuc buildings, including several at Uxmal, Kabah, and Labná.[46] The size of the eastern Puuc cities, the scale of their monumental edifices, and the elaborate architectural sculpture seen on their facades signaled the political power of their rulers in the past and are now one of the principal attractions for tourists who visit the Puuc region today. Their sculpture sometimes appears in the wood carvings by the Puuc artisans as well. (See Figure 1.44) —**1.4** *col.*

The major Puuc sites were largely abandoned between AD 950 and 1000, although there is evidence of modest occupation at several of them. Chichén Itzá—which maintained active trade and political ties with various Mesoamerican centers, such as Tula, Hidalgo and El Tajín, Veracruz—continued to thrive for a considerable time thereafter, developing a new syncretistic style of architecture and art. This is exemplified by well-known structures such as the Castillo, Great Ballcourt. or Temple of the Warriors, that conserved aspects of Classic Maya symbolism while integrating influences from polities with which it was in contact.[47] Various motifs from Chichén Itzá also appear as subject matter in the Puuc region wood carvings. (See Figures 1.51–1.53)

Chichén Itzá was followed by Mayapan, founded in the 1100s or early 1200s by the Cocom, a subdivision of the Itzá, and occupied by other prominent families as well. The Xiu family established itself as a component of the polity centered at Mayapan during the Late Postclassic period between about AD 1200–1450. After organizing a revolt against the Cocom family, who were the overlords of Mayapan, around 1450, the Xiu moved to Mani, which became the capital of the province of the same name.

After the fall of Mayapan and the breakup of more centralized political organization, northern Yucatán split into some sixteen independent provinces, each governed by a different prominent family or families in more centralized to collective forms of sociopolitical organization. Although the last phase before the conquest was earlier referred to as a "decadent" period, because of the lessened interest in erecting massive pyramid temples, palaces, and elaborate carved stelae, more recent interpretations stress that ordinary Maya may have lived relatively well, continuing to benefit from long-distance trade evident in the construction of east coast centers such as Santa Rita Corozal and Tulum and in the remains found on the offshore islands of Isla Mujeres and Cozumel.[48]

Northern Yucatán from the Conquest to Recent Times[49]

The first contact between Spaniards and the Maya of the Yucatán peninsula occurred in 1511, when a voyage of Juan de Valdivia was blown off course with the survivors making landfall on the east coast of the peninsula. Most survivors were soon slain, but two of them, Gonzalo Guerrero and Gerónimo de Aguilar, were taken to the village of Nachan Kaan, the ruler of the province of Chetumal. Aguilar refused to accommodate himself to this new life, and remained a prisoner, while Guerrero adapted to the customs of his captors, and eventually married a noble woman, who bore him children who were effectively the first "mestizos" of Mexico.

In 1517 and 1518 two other Spanish expeditions explored the Yucatán coast but encountered Maya resistance and withdrew. In 1519, Hernan Cortés stopped at Cozumel on his way to Veracruz. Cortés was able to rescue Gerónimo de Aguilar, who had learned the local Maya language well enough to serve as a translator. Gonzalo Guerrero had become Nachan Kaan's trusted war captain (*nacon*), and provided him invaluable advice about how to resist the eventual Spanish invasion and efforts to subjugate the Maya.

Cortés eventually departed Yucatán to focus his attention on the conquest of the great Aztec empire, which was accomplished in 1521, resulting in the formation of a new Spanish colonial vice-regal government with its capital, Mexico City, built over the rubble of the former Aztec capital city of Tenochtitlan. The subsequent conquest and colonization of Yucatán began in 1527, when an expedition led by Francisco de Montejo the elder mounted an invasion from the east coast. This effort proved unsuccessful, but the elder Montejo organized another *entrada* (armed entrance) from a base in Tabasco in 1529, assisted by Alonso Dávila and by his son, Francisco Montejo the younger. In 1531 Montejo returned with a larger army and briefly established a fortified capital at Chichén Itzá, but facing formidable resistance and lack of supplies, he again retreated in 1535. Despite initial successes at Champoton (in Campeche) and Chetumal (on the east coast), Montejo was forced to evacuate his armies from Yucatán again in 1534 as his soldiers began to desert to serve in the newly discovered and richer territory of Peru.

In 1540 Montejo's son and nephew organized a new *entrada* to conquer the peninsula. Perhaps aided by the demoralization and decimation of local populations due epidemic disease, this effort was more successful, resulting in the foundation of Mérida in 1542, and of Campeche, Valladolid, and Salamanca de Bacalar (near Chetumal) in 1544. The elder Montejo turned the rights to the peninsula over to his son, Francisco de Montejo the younger, who led a

larger invasion force in 1540, and established a new capital, Mérida, on the site of the ancient Maya city of Jo' (a.k.a. Tiho).[50] In the process, Montejo gained the support of the Tutul Xiu lord of Mani, who converted to Catholicism and provided military support. With Xiu assistance, the Spaniards were able to defeat the eastern Maya forces, resulting in effective Spanish control of much of the northwestern and northcentral sections of the peninsula, including the Puuc zone that formed part of the province of Mani.

The conquest involved both physical subordination and spiritual transformation of earlier Maya society and beliefs. Perhaps the best-known incident in the effort to convert local people to Catholicism and suppress traditional religious beliefs occurred in 1562 at Mani, where the Franciscan friar, Diego de Landa, sponsored an auto-da-fe to extirpate idolatries, including public humiliation of local Maya accused of heresy (i.e., continuing to follow indigenous religious practices) and the burning of many Maya codices.[51]

In the areas subjugated by the Spanish, the conquerors were granted *encomiendas,* officially involving the right to collect tribute from native communities located on territory under the control the landowner. Although Maya inhabitants officially owed annual tribute to the Spanish Crown, they rendered it to the landowner or *encomendero,* who retained a portion for private use. In turn, the *encomendero* was responsible for indoctrinating local Maya in the Catholic faith (which involved providing support to priests who staffed local churches and convents), and to pay a modest salary and provide adequate sustenance. The *encomendero* typically lived in a head city (Mérida was the most important of these in the case of Yucatán, but others included Valladolid, Campeche, and Salamanca de Bacalar), and left management of the estate to surrogates. Often these were Maya whose background and education fitted them to serve in secondary administrative positions. Complementing the *encomienda* was the *repartimiento* system, under which local Maya were compelled to provide labor

for public projects and agricultural cultivation, ostensibly in return for pay, although Spanish officials and the *encomenderos* abused the system to use workers for private gain and often shorted their wages.[52]

Dissatisfaction with the burdens imposed by the *encomienda* and *repartimiento* system led most Maya to engage in forms of passive resistance, but many also fled to areas not under firm Spanish control in the south and east, from which periodic raids and rebellions were launched. The most effective of these was the rebellion of 1761, organized by Jacinto Kan Ek', a Maya leader from Sotuta who took the name of the former Itzá kings of Tayasal. Kan Ek's espoused goal was to free his people from Spanish control and to "throw off their yoke of servitude."[53]

Due to gradual decline in income and decreasing populations in the seventeenth century in northwestern Yucatán, the *encomienda* system was gradually replaced by *estancias* (cattle ranches) owned by wealthy Creoles (individuals of Spanish descent). These gradually transformed into *haciendas,* large estates worked by local Maya, who raised maize for local consumption and tended the cattle. After Mexican independence was declared in 1821, larger estates, whose principal crop was sugarcane, were established in productive areas in the central peninsula. These *haciendas* expropriated "vacant" land that had been the communal *milpa* (cornfields) of the local Maya, who subsequently became *peones* (indebted servants) and were no longer able to practice their traditional slash-and-burn agriculture.[54] The destruction of long accepted life ways, along with other ethnic and class differences, provided the impetus for a major native uprising, known as the Caste War. Beginning in 1847, this armed conflict reached its peak in 1848, when Maya rebels succeeded in laying siege to Mérida, only to return to plant their cornfields before final victory could be won. Creole forces regrouped and were able to defeat the Maya, many of whom fled to the thinly occupied forested eastern area of the peninsula in what is today Quintana Roo. There, rebel Maya established an independent society

under indigenous leadership, with institutions and organizational structures based on a mixture of pre-conquest, colonial, and nineteenth-century forms. Known as the *Cruzob*, because of their devotion to a talking cross located at the town of Chan Santa Cruz (now Felipé Carrillo Puerto), the independent Maya continued to wage low-scale guerilla warfare until defeated by Yucatec forces in 1901.[55]

The Caste War and subsequent conflict greatly decreased sugarcane production. However, the soil and climate of northern Yucatán is also well suited to growing henequen, a variant of the agave cactus family, whose large fibrous and spiny leaves could be used to produce cordage and textiles. Used on a limited basis in earlier times, henequen was grown as a major export crop on large *hacienda* plantations during the late nineteenth to early twentieth century. Known as sisal (from the name of the older port located west of modern day Progreso), the fibers were manufactured into rope and cordage for industrial and maritime purposes. The focus on henequen production increased commerce and contacts between Yucatán and the United States, which purchased a substantial amount of cordage (particularly after the invention of the McCormick twine-binding reaper in 1878), as well as exported machetes from the Collins Company of Chicago. As a cash crop, henequen produced an economic boom for wealthy *hacendados* (plantation owners), who built magnificent mansions along the Paseo de Montejo, the broad street leading north from Mérida and designed to recall the Champs Elysees in Paris. Such wealth was bought by the crushing labor of the Maya *peones* who worked the hacienda lands under harsh and impoverished conditions, decried in the book *Barbarous Mexico* by John K. Turner. Land reforms instituted after the Mexican Revolution of 1910 were designed to give native peoples the right to farm on communal fields (known as *ejidos*), but this system was only imperfectly adopted in Yucatán in the 1930s under the presidency of Lazaro Cárdenas.[56]—**1.5** *col.*

The twentieth and early twenty-first centuries have seen major transformations in Maya life in northern Yucatán and the greater Maya region. The decline of a monocrop economy based on henequen production had a strong adverse economic impact. The decline was the result of multiple factors, including the expropriation of all but small private haciendas (*pequeñas propiedades*) and redistribution as *ejidos* (communally owned and worked lands) in the 1930s, the Great Depression, the nationalization of cordage mills (culminating in the formation in 1964 of Cordemex, a multiplant national cordage producer), and competition from synthetic fiber-based rope and cordage, which captured about half the world's markets by the 1970s.[57]

As a response to the loss of income from henequen, Yucatán has made an effort to diversify its economy. Raising livestock and cultivating of specialty crops has become more common in the countryside, while commercial fishing has become a more important trade among many who live in communities near the coast. In addition, Yucatán has made a strong bid to attract maquiladoras (assembly factories for production of export goods) from the 1980s onward, a process intensified by the passage of NAFTA in 1993, but now slowed by competition for low wage jobs in other parts of the world. Many of these efforts were promoted by Victor Cervera Pacheco, who served as interim governor of Yucatán from 1984–1987 and then as elected governor of the state from 1995–2001, and who worked to expand port facilities and the state electrification grid. Tourism has also played a major role in providing a growing stream of revenue and created a variety of new jobs for the Maya of Yucatán. Erik Baklanoff notes that "In contrast to Cancún's mega-tourism, with its emphasis on 'sun, sand, and sex,'" the state of Yucatán has capitalized on its cultural heritage, particularly emphasizing its impressive and dramatic archaeological sites such as Chichén Itzá and Uxmal, while seeking to identify and advertise others such as Ek Balam, as well as its colonial heritage and traditional Maya culture.[58]

Grant Jones notes that that these changes have led to:

> . . . increases in the rate of rural-urban and rural-rural migration, the stimulation of new forms of employment related to tourism, the introduction of new and improved roads and electric power, and the growth of craft industries such as hammock making. In some areas where the rural subsistence economy has been replaced by cash crop production, whether in the hands of larger capitalist producer-employers or in the hands of rural "peasants" themselves [as in the case of fruit production in the area around Oxkutzcab in the Puuc region], the resulting cultural changes have been deep and irreversible. As more subsistence farmers among the lowland Maya shift to alternative sources of income, observers sometimes witness losses in the use of Maya languages and in the practice of traditional ceremonies, the recognition of traditional religious and secular community offices, participation in noneconomic community and ritual obligations, and the commitment to remain loyal to rural community roots.[59]

The growing pressures and changes created by increasing globalization, trade compacts (NAFTA), and an influx of foreign visitors are all affecting Maya's cultural identity and sense of self. Until fairly recently, for those living in smaller rural towns and hamlets, this was countered by their relative isolation and conservatism. There, old ways of "being Maya"—such as the regular use of Yucatec Maya language, the importance of the local (J)Meen (a.k.a. h-men) (shaman and healer) and religious practice and field rituals that blended Catholic and traditional Maya concepts—were maintained despite adaptation to, and to some extent the welcoming of, modern improvements such as electrification, improved roads, and ability to purchase labor saving machinery and appliances. More and more, however, the traditional agricultural system can no longer support people in these more distant places and they have been forced to seek sources of cash income in larger cities and towns (such as Mérida, Campeche, Vallodolid, or Chetumal) or in the tourist zone on the east coast, where "modernization," communication, and a desire to adopt new fashions diminish identification with the "old ways."

Nevertheless, the Maya have been remarkably successful in negotiating and adapting to severe disruptions to their cultural traditions in the past, and the formation of various indigenous cultural organizations that have sought to promote a contemporary pan-Maya consciousness and pride in Maya cultural achievements from pre-conquest to the present indicate that they will continue to conserve an awareness of their past, while striving for effective political, economic, and social recognition in the present.[60]

Contemporary Life—Santa Elena, Muna, Oxkutzcab

Today the Puuc region is occupied by a handful of villages and mid-sized towns with a scattering of ancient Yucatec sites, often in various stages of archaeological reconstruction. The villages tend to be farming-based communities, while the larger towns may specialize in a number of service-based or craft industries in addition to the growing of maize, fruit, tobacco, and other staple crops such as squash and chilies for both personal and commercial consumption. However, as the tourism industry continues to grow and attract villagers, especially the younger generation, to work in the more lucrative tourist zones as construction workers, waiters, janitors, bar tenders, gardeners, maids, and the like, local economies are strained as men struggle to maintain their fields without the help of their sons or younger male siblings. Increasingly, the "milperos" (farmers who work a milpa, or cornfield) tend to be middle-aged men who have been working the same field with their brother, father, cousin, or other relative for the better part of thirty years or more, while perhaps dabbling in some secondary occupation during the agricultural off-season. The milpa has histori-

cally been a communal plot of land, but nowadays is more often shared between family members rather than non-relatives, so the milpa would pass to the milpero's son or younger sibling once he became too old to continue working it. Today, however, it is typical for the milpero's son to have found work outside of the village or to be receiving training in a nearby technical school for a field in high demand, such as information technology or graphic design, so the prospect of him returning to take over his father's milpa looks bleak at best. It leads one to wonder what will happen to the milpas when the current generation of milperos is no longer able to work them.

Like the traditional agricultural life of the village, the mother tongue or *lengua madre*, Yucatec-Maya, is starting to strain under pressure as the younger generation wants to learn Spanish and even English to improve their marketable skills. With an estimated 700,000 speakers throughout Yucatán, Quintana Roo, and Campeche, Yucatec-Maya, one of the largest of the Maya languages still spoken in the Maya region today, could look very different in two generations' time if the current generation of youth prefers to speak Spanish to their children rather than Maya. Already one will encounter teenagers in the smaller Puuc villages who will affirm that they understand Maya but cannot speak it. This is commonplace in comparable villages throughout Yucatán. In most Puuc municipalities, small and large, classes in the local primary school are typically taught in Spanish rather than Maya, and some English vocabulary and phrases are often interspersed in lessons as well. Children may still speak to their grandparents in Maya, but their parents tend to use a mixture of Spanish and Maya, having become proficient at the former through work outside of the village, as discussed earlier.

To take just a few examples of contemporary life in Puuc communities, we will focus on the villages and towns of the four artisans in this exhibition. To begin, Santa Elena, a village of around 2,500 inhabitants, lies at the heart of the Puuc region between the

archaeological zones of Uxmal and Kabah. Its location along the major highway to Campeche and a number of the restored ancient Puuc sites makes it a convenient and quaint rest stop for the tourist in search of a "typical" Yucatecan meal at one of the local restaurants before heading to another archaeological zone.

Upon entering Santa Elena, one is greeted by a large sign with bold lettering that reads "Bienvenidos a Santa Elena" (Welcome to Santa Elena). Below this heading are three images: the Castillo (a large radial temple at the ancient site of Chichén Itzá), the colonial church of San Mateo (located in the *k'iwiik* or central plaza of Santa Elena), and San Francisco's Golden Gate Bridge. It's as if this sign represents a kind of past-present-future juxtaposition: the Castillo representing ancient times, the colonial church standing for present day Santa Elena, and the Golden Gate Bridge alluding to the future. The association requires some explanation. The Castillo, even though located well outside of the Puuc region in the eastern part of Yucatán, is such a well-known Maya structure that it has in many ways become synonymous with the ancient Maya, especially now with its recent status upgrade as a New Wonder of the World.[61] The church of San Mateo in Santa Elena, although it is a colonial building, is an iconic and important structure both for its function as a house of worship and for its status as a major generator of tourism for such a small village. It was constructed on the ruins of one of the principal pyramids of the ancient Maya site of Nohcacab[62] and is visible from several kilometers away as you approach Santa Elena. Its attached museum houses antique *retablos* (small paintings of religious scenes), furniture, and other objects, including a couple of mummies (now encased in a humidity-stabilized box) that were found beneath the floorboards during an excavation and renovation.[63] You can even find postcards of the church in cities as far away as Mérida. But the Golden Gate Bridge seems a bit enigmatic or out of place, until you learn a little about the local population.

Walking around Santa Elena, one quickly realizes just how few young (i.e., 18–35) men are around, and it is because the majority of this demographic emigrates to San Francisco, usually illegally, to work in the agricultural fields for a number of years outside the city until they have saved up enough money to return home.[64] Thus, Santa Elena's welcome sign serves as a nexus between ancient and modern, Maya and the West. —**1.6**

The people of Santa Elena are warm and welcoming, being used to a steady stream of foreign visitors throughout the year, yet they maintain many of their traditions with respect to agricultural practices (planting of their milpa, slashing and burning of their fields, spiritual preparation and ritual offerings to the forest prior to planting, etc.), syncretic religious beliefs, knowledge of medicinal plants, style of dress (many women continue to wear the traditional Maya *huipil,* a white dress-length tunic with colorfully embroidered borders), and continue to live in a typical *guano y paja,* or pole and thatch house (*nah* or *otoch* in Yucatec) that the Maya have constructed for centuries. Most villagers, both young and old, speak Yucatec-Maya as a first language, but are equally proficient in Spanish. In addition to the various shops and cantinas that line the major street to the main plaza, there is also an internet café on a side street that has increased residents' connection to life outside of the Puuc region. Indeed, despite there only being two public pay phones in the entire village, residents can increasingly be seen carrying mobile phones, a phenomenon that has occurred quite rapidly just in the last few years.

Some members of the older generation, such as Don Hernán, a respected village elder who runs what he calls a "Maya Museum" out of his home, lament the modernization of Santa Elena. Located near the intersection of the main highway to Campeche and Santa Elena's "Main Street," Don Hernán's home consists of several pole and thatch houses—one for sleeping, one for cooking, one for washing, etc.—and he has set up a number of what one might call "workstations" where

visitors are invited, for instance, to try their hand at separating the fibers of a henequen stalk using a traditional scraper and then twisting it into a rope. Don Hernán will also show you around his *solare,* or garden of medicinal plants and fruit trees, talking about the different medicinal properties and remedies that one can make from them, and if you're lucky, his wife will prepare some handmade, fresh tortillas that have been prepared over a traditional three stone hearth. If you ask Don Hernán about his reasons for wanting to open up his home and share the traditional ways of Maya life with visitors, he'll tell you that he thinks it's important for others to know how it was before new technologies, popular media, and aspects of Western culture began to creep into village life and local people began to change the way they lived so they could be part of the "modern" world.[65]

Just north of Santa Elena and the Puuc hills lies Muna, a small town of approximately 11,000 people. Pole and thatch houses are interspersed with the newer concrete-block houses, and there is never a shortage of the so-called "trici-taxis" about, waiting to cart people from the market to their home for a few pesos. The town boasts an internet café, bank branches, lots of shops, and a Pemex gas station, the only one for miles around. The main plaza is always bustling with handicraft and fruit vendors, and it backs up to a small market lined with any number of booths selling a variety of goods. Muna is also home to the *Escuela Secundaria #16 Doctor Jaime Torres Bodet,* the vocational school where three of the four artisans represented in this exhibition studied wood carving under Antonio Salazar, the individual who is said to have introduced the craft to the region (more discussion below). On the outskirts of the city is a string of handicraft shops housed in traditional pole and thatch houses selling embroidered *huipiles, guayaberas* (traditional men's cotton or henequen tailored shirts), and other local goods. Just around the corner from these shops on a side street is a shop called "Los Ceibos" where a resident ceramicist makes reproductions of Late Classic polychrome ceramic vessels that

are virtually indistinguishable from the originals. In addition to selling her pots in Muna, she also sells them in at least one gallery in Mérida, where they are priced at thousands of U.S. dollars each. Her competition lies with a similar ceramic shop in neighboring Ticul, where a husband and wife team has established an impressive gallery space and workshop where they produce vessels nearly identical to the ancient examples, right down to the cracks, stains, and flaking pigment. But as intriguing as a study of these contemporary Maya ceramic replicas would be, including a discussion of "real" vs. "fake," or the notion of authenticity, it is not the central focus of this exhibition devoted to wood carvings, and so must remain the subject of future research.

To the east of Muna and Santa Elena is the small city of Oxkutzcab, the largest municipality of those mentioned here, with a population of around 21,000 people.[66] As Peter Hervik notes from his fieldwork in this city, local inhabitants of Oxkutzcab specialize in a number of commercial crops, especially in fruit production, but also raise a variety of other commercial crops including maize, beans, root vegetables, tobacco, chilies, watermelons and cucumbers, many of which can be found at the central market (El Mercado de 20 de Noviembre).[67] The most common cash crop is the *naranja dulce*, which is called "*china*" by locals, a sweet orange, celebrated locally in a local "Festival of Oranges." As Hervik points out, however, this is not a staple in the local diet, as "[m]any people would drink coke rather than freshly squeezed orange juice. Children do not "eat" oranges." Instead oranges, especially the *naranja agria*, or sour orange, is used an essential ingredient in marinades and other Yucatecan dishes.[68] —**1.7** *col.*

Depending on the nature of the crop, milperos in Oxkutzcab (and those larger cities in general with more of a commercial agricultural base) use a variety of growing methods in addition to the traditional milpa, such as diversified orchards (*huertas*) for fruit production,[69] irrigated plots (*parcelas*) for cedar trees and limes,[70] or "small milpas" known locally as *conu-*

cos that provide microclimates and patches of very fertile soil, being located in the Puuc hills, and they yield exceptionally good harvests.[71]

Although Oxkutzcab is not located on a direct route to major reconstructed Puuc archaeological sites, it has a local tourist attraction in the Loltún Cave, one of the largest and most impressive caverns in northern Yucatán. In addition, archaeology has had an economic impact on the town, which is known for its excellent stonemasons, many of whom, such as Wilber Castillo Cante, who directed a crew of Oxkutzcabeños in the reconstruction of a round temple structure at Uxmal, have become experts at restoring ancient Maya buildings.

Historical and Social Context of the Artisans and Their Carvings

For those who know Mexico, the state of Yucatán might not come to mind as a principal producer of traditional "folk arts." Although women can still be seen wearing embroidered huipiles (long cotton dresses) in some smaller towns or on special occasions, Yucatán has a dearth of marketable traditional arts and crafts compared to those created in other parts of Mexico.[72] Even state-sponsored vendors, such as the official *Casa de Artesanías* (House of Handicrafts) in Mérida, the state capital, are hard-pressed to stock their shelves with high-quality, locally made goods, which results in the importation of crafts from neighboring states.[73]

Today, most contemporary craft producers across Mexico are sustained by the tourism industry, and in some cases, by the international buyers who purchase and resell Mexican folk arts in shops and art galleries in Europe, the United States, and Canada. In addition to present-day economic incentives, however, some Mexican craft industries, such as the complex textile designs of Chiapas, are rooted in pre-Hispanic traditions. Such artisans find additional motivation in preserving a part of their indigenous culture that has been perpetuated from ancient times.[74] With some

adaptation, they continue to use many of the same techniques, styles, and designs that their ancestors did generations before.[75] Others, like the Oaxacan tradition of brightly painted, carved wooden animals or the Puuc wood-carving tradition that is the focus of this exhibition, are "invented traditions"[76] in that they have no direct pre-Columbian predecessor and came into being only in recent decades.[77] In the years following the Mexican revolution of 1910, however, the Mexican government promoted the concept of *indigenismo,* celebrating both its pre-Columbian past and its regional cultures and "folk" traditions to help forge a new national identity in an effort to integrate the diverse indigenous population into *mestizo* society.[78] In another sense, tourists also rely on a knowledge of ancient Mesoamerican imagery, as well as more recent handicrafts and other indigenous "tourist arts," whether the result of "invented" or more long-lived traditions, to connect them to a perceived authentic indigenous culture.

The elaborate and carefully finished wood carvings from the Puuc region featured in this exhibit do not represent a continuous, unbroken craft tradition in northern Yucatán. Rather, as is discussed by Quetzil Castañeda in his essay in this catalog, they are closely related to the fairly recent burgeoning of wood carvings representing various "Maya" subjects that emerged at the town of Pisté as a response to increasing numbers of tourists visiting the nearby site of Chichén Itzá. Because such carvings lacked a long heritage, however, they were not considered genuine examples of "folk art" or Yucatec popular culture, and therefore were dismissed as lesser art forms and inauthentic expressions of Maya culture. General public opinion viewed wood carvings from Pisté as meretricious replicas or fabrications of ancient monuments, and thus not only an "invented," but also a "false" tradition. Such attitudes were challenged at a public meeting in the 1980s at which Alfredo Barrera Rubio, then regional director of the Yucatán Regional Center of the National Institute of Archaeology and History (CRY-INAH), helped to shift the negative associations

of the wood-carvers at Chichén Itzá and served as a historical turning point for craft producers across the state. Castañeda summarized the details of Barrera's speech to the assembled artisans, saying that they "should stop calling themselves 'chac mooleros,' that they were legitimate artesanos; not only should they recognize themselves as such, but they should also insist that others treat them with respect."[79] These remarks were in an effort to ensure that the work of local artisans at Chichén, and by extension, other craft producers throughout the state, was publicly recognized as a legitimate form of artistry by Mexican government agencies.[80]

Although the Chichén wood-carving tradition, and by extension that of the Puuc region, have only recently gained acceptance into the artisanal mainstream by the INAH, in a very broad sense they represent a revival of a pre-conquest wood-carving tradition. The making of wood sculptures was documented by the sixteenth-century Franciscan priest, Diego de Landa, who noted that one of the things the Maya

> regarded as most difficult and arduous, was to make idols of wood, which they called making gods. And so they had fixed a particular time for this and it was the month of Mol, or another month if the priest told them it was suitable. Therefore those who wished to make some consulted the priest first, having taken his advice, they went to the workmen who engaged in this work. And they say the workmen always made excuses, since they feared that they or someone of their family would die on account of the work, or that fainting sickness would come upon them.[81]

This describes not only the ritual significance of the carving process but also the care with which the idols were created, since the misrepresentation of a god could result in the carver's misfortune. Indeed, Elizabeth Newsome notes that ancient carvers so feared "the act of realizing the gods' images in material form that few craftsmen seem to have entered this unpopular profession."[82] Examples of such

carved wooden artifacts, including idols and other figures, have been recovered from the sacred Cenote at Chichén Itzá. In some cases, the wooden lintels of temples and "palace" structures were carved with depictions of rulers and/or hieroglyphic texts. The best known of these come from Tikal, Guatemala, but an example was also discovered by John Lloyd Stephens at Uxmal, as well as a carved figural lintel at Kabah.[83] Thus, there are ancient precedents for modern wood carvings by Maya artisans in Yucatán, but the tradition of making such sculptures was abandoned after the conquest. As Castañeda's essay mentions, the more recent carvings produced at Chichén Itzá or in the Puuc region represent a relatively recent phenomenon, and are not a continuous tradition. The modern carvers at these sites produce their works primarily for sale to outsiders and do not consider them to be sacred, differing from those created by their pre-conquest counterparts created for their own community. Nevertheless, despite the fact that there has been a centuries-long and multigenerational lapse in the ancient practice of carving deities, idols and other figures from wood, the modern Yucatec Maya wood-carving tradition, in addition to having characteristics of an "invented" tradition, also deliberately replicates the symbols of their ancient ancestors, which take on multivalent meanings in a modern context. —**1.8**

The Artisans

The four artisans whose work is central to this exhibition represent the highest level of master carvers currently working in the Muna-Puuc region. Because all four of these men work only part-time as wood-carvers, while also having other fulltime employment, they are able to maintain a very high level of quality in their craft since they are not dependent on the sale of their wood carvings as their main source of income. This affords them greater pleasure and freedom of expression in their artistic output. While the principal reason for producing the carvings is to supplement their income, Puuc artisans are able to reproduce the ancient figures that they find most appealing, rather than only those that are most popular among tourist-buyers. Furthermore, they are freer to choose subjects with which they feel a personal connection, and which they recognize as representing the beliefs, values, and important artistic and scientific accomplishments of their ancestors. The Puuc artisans are aware that these monuments are valued as expressions of ancient Maya art and culture and, to a greater or lesser extent, are familiar with the subject matter of these ancient sculptures, which, like their own wooden reliefs, were carefully carved by a skilled artisan hundreds of years ago. This respect for their Maya past is part of the reason why Miguel, Angel, Jesús, and Wilbert chose to take up wood carving professionally. However, it was their relationships with more recent relatives who first got them interested in carving.

JESÚS MARCOS DELGADO KÚ

Jesús Marcos Delgado Kú is the first cousin of Miguel Uc Delgado (whose work is also featured in this exhibition). Jesús lives in Muna, a mid-sized town northeast of the Puuc archaeological zone, where he owns a *parcela* (parcel of land that is irrigated) on which he grows cedar trees and limes for extra income. At Kabah he gives tours to Spanish-speaking visitors. When not offering his services as a guide, he attends to his wood carvings, as he is the only artisan displaying his sculptures on-site. Jesús is interested in his Maya heritage and the ways of his ancestors, and has striven to learn about the historical background of the subjects he carves, both in terms of their ancient history as well as interpretations by modern Mesoamericanist scholars. Jesús, like the other Puuc artisans, appreciates the fact that he has more-or-less free access to the various scholars and archaeologists who work at the Puuc sites throughout the year, a relationship that he has taken full advantage of while working at Kabah. —**1.9** *col.*

For Jesús and Miguel, it was their grandfather, a carpenter in Muna, who sparked their interest in carving.[84] Jesús remembers that his grandfather used to carve horses in his spare time, a subject he liked very much.[85] After watching his grandfather, Jesús began to make his own designs when he was around 10 or 11 years old, and he would borrow his grandfather's carving tools since he had none of his own.[86] His first carving was of Itzamnaaj, the father of the gods and medicine, because "he contained a lot of circles,"[87] which not only presented interesting design elements but also gave the young Jesús an early education in the process of carving. Even with his successes in wood carving as a boy, Jesús admits that learning to carve before learning to draw probably wasn't the best method, which is why he later enrolled in the *Escuela Secundaria #16 Doctor Jaime Torres Bodet* to gain technical training from Antonio Salazar.[88] But it was his original personal desire to create, with or without the technical "know-how," that motivated him to become a professional carver.

MIGUEL UC DELGADO

Miguel Uc Delgado of Santa Elena is outgoing and has a knack for business. He works for the local municipal government as a council member, but he is also an elected officer in the National Institute of Anthropology and History (INAH) where he works as the Secretary General for Workers of Yucatán.[89] In the past, this office has only been occupied by individuals living in Mérida, so Miguel is very proud to be the first person residing in the Puuc region elected to this position.[90] Collectively, his grandfather, his father and Miguel (with his own 26 years of work), have put in over 100 years working for INAH, which is a source of family pride.[91] Miguel also owns and operates the Chacmool restaurant and hotel in Santa Elena with his wife, Estela. The full-service restaurant is open from 8 am to 9 pm, and, with the recent addition of two rooms, the hotel currently has eight double rooms. There is also a small *artesanía* shop

attached to the restaurant, where Miguel sells not just his wood carvings but also Jaina-style ceramic figurines, mold-made figures, and leather drawings by other artisans (generally members of his extended family). He also sells hammocks and embroidered *huipiles* made by Estela, as well as postcards, decorative ceramic boxes, and beaded jewelry. Miguel is also one of several *guardians* or caretakers at the Puuc archaeological site of Sayil, where he sells a few of his pieces. The majority of the wood carvings for sale at Sayil, however, are made by his nephew, Edwin Mas Uc, who lives in Muna. —**1.10** *col.*

Like Jesús, Miguel also remembers his grandfather's skill at carpentry and his wooden creations, but in Miguel's childhood home, his father also carved and worked in both stone and wood to create figures. He also recalls that both his father and his grandfather were "fanatics for the archaeological zones."[92] As a boy he traveled with them to many sites that had not yet been reconstructed and developed for the tourism industry.[93] This early exposure to the culture of his ancestors instilled in him a pride for his Maya heritage and an appreciation for the Maya aesthetic, which has carried over into his own work. Miguel notes that it was because of this generational legacy that he began to carve, since he had a kind of nostalgia for what his father and grandfather had created.[94] Like Jesús, he went on to study with Antonio Salazar at the *Escuela Secundaria #16 Doctor Jaime Torres Bodet* as a teenager.

WILBERT VÁZQUEZ (SHIBATA)

Wilbert Vázquez, also of Muna, is known locally by his nickname "Shibata" (after the famous Japanese wrestler) for his trademark haircut. He is a tour guide who travels regularly throughout Mexico, and he speaks German, Italian, and English in addition to his native Spanish and Yucatec Maya. Wilbert is a fine wood-carver who, although he has carved panels based closely on ancient prototypes, also likes to completely reinvent Maya imagery by reinterpreting

the ancient Maya forms. Like Miguel and Jesús, Wilbert also studied with Antonio Salazar at the *Escuela Secundaria #16 Doctor Jaime Torres Bodet* when he was younger. Due to his busy tour schedule, Wilbert currently has less time for his own sculptural creations, but he acts as a kind of handicraft dealer for other artisans in Muna. He doesn't have a formal gallery, but rather relies on word of mouth to sell out of his home. Wilbert continues carving, making wooden frames for the works of the other artisans he represents. These frames are beautifully carved and depict the geometric and symbolic design elements visible on many Puuc architectural monuments. He also has a keen interest in archaeoastronomy,[95] which often influences his carving designs and the subjects he chooses to reproduce. —**1.11** *col.*

Wilbert, who does not work at a Puuc site like the other artisans, is somewhat of a special case both for his role as a third party vendor as well as the fact that Muna is not located within the Puuc region proper, but rather is part of the general area (it lies approximately 20 minutes north of the site of Uxmal). There are no major excavated archaeological zones in the immediate vicinity of Muna. However, it is a relatively short distance between the town and the Puuc archaeological sites and the tourist crowds they bring, and the road to the Puuc region passes through Muna, and tourist groups often stop there briefly to view displays of traditional embroidered *huipiles*, ceramics and other crafts. Both Muna and the neighboring town of Ticul, known as a center for shoe manufacture and production of popular, inexpensive pottery, also are centers where many local artisans make and sell crafts out of their homes, workshops, or retail spaces. Given that three of the four artisans whose works appear in this exhibition studied with Antonio Salazar at the *secundaria*, Muna can be considered the local source of the Puuc carving style, although it also has connections with and represents a regional variant of a comparable type of *réplica* carvings developed at the town of Pisté.[96] Such *réplica* carvings are distinguishable from other carving

styles in Yucatán by their emphasis on skillful duplication of subject matter taken from specific ancient Maya sources. Thus, the sculptures featured in this exhibition can be considered as part of a Muna-Puuc "school" or recognizable style, which are related to aspects of, but can also be distinguished from other styles in the state, such as the Pisté "school."

ANGEL RUÍZ NOVELO

Angel Ruíz Novelo lives in Oxkutzcab, a town southeast of Muna and Ticul, that is known as a center of commercial fruit production.[97] Angel is the *guardián*, or caretaker, at the Puuc archaeological site of Labná, where he also has a small thatch-roofed structure that serves as his on-site workshop. Angel's story differs a bit from that of Jesús, Wilbert, and Miguel. Since he did not receive formal training with Antonio Salazar at the *secundaria*, he considers himself to be self-taught.[98] As several pieces in this exhibition demonstrate, Angel is capable of carving complex compositions with exquisite detail. Nevertheless, his lack of more formal training is sometimes evident in the squat proportions of his figures and somewhat rougher surfaces of his sculptures. This more rustic quality gives his carvings a certain charm and emphasizes their "hand-made" quality. For Angel, being able to supplement his income through his wood carvings is a great boon. He also feels proud to further the local carving tradition started by Antonio Salazar and to have the opportunity to represent the sacred iconography of his distant ancestors. —**1.12** *col.*

Over the years Angel has worked in the vicinity of other artisans at Labná and learned and sharpened his artistic and technical carving skills by watching how these individuals worked. He considers it important to pass on what he knows to the next generation, as Miguel's and Jesús's grandfather did for them. When his son first started carving iguanas and serpents, Angel used to tell him, "You will be the next one," and his son would ask, "Why?" to which Angel

would respond, "Because I won't always be here, and there has to be a continuation, which is you."[99]

The pride that Angel feels for his craft and the legacy that Jesús, Wilbert, and Miguel believe they must uphold may not be obvious to all members of their tourist audience, who might purchase one of these sculptures as an attractive memento of their visit to a Maya site. However, sitting down and talking with these four artisans—not the superficial explanations offered to the passing viewer, but a real conversation—reveals how important it is to these men that they continue to carve. The pride they take in their work is manifested in the product: the complex and carefully finished carvings in which the skill and talent of these artisans is evident to sensitive viewers.

The Carvings

DEVELOPMENT OF THE TRADITION

Due to the Puuc region's relative isolation from other tourist areas in Yucatán, handicraft production in the area has developed fairly independently from that of other major production centers. Whereas the stylistic trends originating from the handicraft producers at Pisté and Chichén Itzá have spread throughout Yucatán,[100] the Puuc variant or the *réplica* carvings has remained the dominant "style" in this area, although Castañeda (in his essay in this volume) notes that comparable examples of *réplica* style carvings began to be produced in Pisté in the 1990s. In some cases, these similar carving styles being produced elsewhere in the state can be linked to individuals who are somehow connected to Muna or the Puuc region (e.g., a brother or cousin who has relocated, etc.)

With this in mind, the origins of the Puuc carving tradition can be examined as part of a larger economic trend and the growth of travel to Mexico. Tourism increased dramatically from 1970 to 2000, so that today it is the second largest source of employment in Mexico, and regularly ranks as one of the top three sources of foreign exchange.[101] According to Alfonso Escobedo, Director of Ecoturismo, a travel agency

in Mérida, annual tourism in Mexico has steadily increased from 1968, when the XIX Olympic Games were held in Mexico City.[102] Historically, the only nations considered as potential hosts of the Games were those that could afford such a high profile and costly event. Awarding the privilege to less developed nations could prove devastating to their economies. Escobedo asserts that prior to 1968, Mexico was not a major tourist destination for affluent European and U.S. travelers, due to the country's largely underdeveloped economy, substandard infrastructure, and widespread poverty. International media coverage linked to the Olympics portrayed Mexico as capable of competing with other industrialized nations across the globe, although contradictions between this public image and the reality of life for most Mexicans led to contemporary protests, culminating in the tragic shootings of students at Tlatelolco.[103] Despite the darker side of the 1968 Olympics, they can be considered one of several important catalysts in the development of many service and commercial sectors linked with Mexico's tourism industry, including the booming market for handicrafts.[104]

As with some other craft traditions throughout the state, the wood-carving "tradition" of the Puuc region seems to have originated from the artistic practices of a specific individual living in the area, who subsequently taught his process and technique to others. As mentioned previously, a man named Antonio Salazar is responsible for the spread of the craft in the Puuc region and its development as a tourist commodity. According to Escobedo, one of his close friends, Salazar began carving as a young man in the 1960s without any formal instruction.[105] Escobedo remembers that Salazar enjoyed carving figures from ancient Maya monuments, especially faces and glyphs, and the popularity of these subjects among tourist buyers enabled him to open a shop close to the main road into Muna.[106] Later, as his corpus of works and his reputation as an artisan grew, Salazar began delivering carvings to Uxmal to be sold in an on-site gift shop.[107]

In time, Salazar was hired at the local technical school in Muna, the *Escuela Secundaria #16 Doctor Jaime Torres Bodet,*[108] where he taught students wood-carving techniques. As an unmarried man with no family to support, Salazar's financial needs were minimal, and with the security of a fixed income from the government, he no longer had to rely on the sale of his *artesanía* to survive.[109] As a result, shortly after obtaining the teaching position in the *Secundaria,* Salazar closed his shop and dedicated himself solely to teaching his craft to others.[110] Miguel Uc Delgado, Wilbert Vázquez, and Jesús Marcos Delgado Kú, as well as numerous others in Muna studied with Salazar in the *Secundaria* before going on to work independently.[111] Escobedo noted that they, in turn, "taught others, so it became a trade in the Muna-Puuc region."[112]

Jesús recounts that the *Secundaria* "was really a wood-carving workshop," where individuals came together to learn how to draw, basic wood-carving techniques, and the proportions of the body.[113] He points out that while Antonio Salazar is generally considered to be self-taught in that he had no formal artistic training at a school like the one where he taught, he may have had some kind of training with the famous Colombian-Italian artist, Rómulo Rosso.[114] Rosso is best known in Yucatán for his 1956 commission, *Monumento a la Patria* (Monument to the Fatherland) in Mérida, a large semicircular sculptural wall in a *glorieta* (traffic roundabout) on the Paseo Montejo, a major thoroughfare that is meant to evoke the Champs Elysees. Jesús states that at one point, Rosso bought an old *hacienda* in Muna as a vacation home, and he employed Antonio's father and grandfather to do work around the property, and the young Antonio may have accompanied them.[115] Jesús speculates that Salazar may have even received informal art lessons from Rosso himself, fanning his creative spark and helping him to develop his natural talent, which would later influence an entire generation of artisans in the Muna-Puuc region.[116]

SUBJECT MATTER AND SOURCES

The Puuc wood-carving tradition can be distinguished by the kinds of subjects that local artisans choose to reproduce, and by the style in which they are executed. Where elaborate and brightly painted masks creating a kind of hybrid image composed of multiple pre-Columbian elements make up much of the work regularly available to the "day tourists" visiting Chichén Itzá (see Figures 2.5–2.7 for "high end" versions), the majority of wood carvings that Puuc artisans create are fairly close replicas of Late Classic Maya imagery. Favorite subjects include the stone relief carvings from the lowland sites of Yaxchilán, Palenque, or other centers, as well as deity images from the Dresden codex and scenes from various polychromed ceramic vessels. Chichén Itzá also provides some models, and, on a more limited basis, the artisans also reproduce some examples of Terminal Classic imagery from the Puuc sites, such as the long-snouted Chaak mosaic mask panels. Due to their more geometric and stylized appearance, reproductions of these architectural masks are generally more difficult to sell to tourist buyers, who prefer the more naturalistic figural renderings of the southern lowland sites.[117] Moreover, the artisans themselves find the curvilinear forms and intricate designs seen on the more complex lintels and stelae of the Late Classic lowland Maya sites more interesting to carve than their northern Maya counterparts.[118]

In the case of Yaxchilán, some of the best-known carved lintels are now part of the British Museum's permanent collection,[119] although many of the stelae and lintels can be seen in the National Museum of Anthropology in Mexico City, or remain in situ on the various structures at the site.[120] These sculptures depict scenes of personal blood sacrifice and sacred warfare, some of the most important events and duties associated with a Maya ruler's accession and reign.

Two of the most intricately carved monuments, Lintels 24 and 25, are among those in the British Museum's holdings, and they are also favorites

among the Puuc artisans to reproduce in wood.[121] These lintels (among others) were carved by the Elegant Knot Artist and were commissioned by Yaxchilán ruler Itzamnaaj Bahlam III (also known as Shield Jaguar II) to span the doorways of Structure 23, constructed around AD 725 to honor his principal wife, Lady K'abal Xook (also known as Lady Xoc).[122] They portray the important narrative themes of sacrifice, warfare, and accession that entitled Shield Jaguar II to remain in power. Lintel 24 is generally considered one of the masterpieces of Maya art.[123] An accomplished interpretation of it by Jesús Delgado Kú is included in this exhibition. It shows Itzamnaaj Bahlam III and Lady K'abal Xook participating in a ritual involving bloodletting. The large torch held by Itzamnaaj Bahlam III suggests that the event takes place either inside a building or during the night. Both of the figures wear jade jewelry, cotton garments with elaborate designs, and other accoutrements that mark their elevated social status. Their headdresses feature motifs related to sacrifice and bloodletting, such as depictions of the Teotihuacan Storm God (known to the later Aztecs as Tlaloc) in Lady K'abal Xook's headdress, or the possible shrunken head of a captive in that of Itzamnaaj B'alam III.[124] Carolyn Tate suggests that the bloodletting was performed either to celebrate the 80th anniversary of Itzamnaaj B'alam III's father or the birth of an heir by Lady Ik Skull sixty-two days earlier.[125] Lady K'abal Xook has already begun the bloodletting ritual; she runs a thorn-studded rope through her tongue in an act of self-sacrifice, allowing the basket of bark paper below her to catch her blood. According to the date glyphs present on the carving, this event took place on 28 October AD 709, even though the carving wasn't created until AD 725. —**1.13** *col. and* **1.14** *col.*

Angel Ruíz Novelo has created a detailed version of Yaxchilan Lintel 25 (see Figure 1.1) Originally placed over the central doorway of Structure 23, the scene shows the aftermath of such bloodletting rituals, namely the conjuring of a vision serpent and ancestor (who wears Tlaloc military insignia, which relates him to this war complex) by Lady K'abal Xook on the date of her husband's accession to the throne, 23 October AD 681. Tate notes that while the vision serpent is part of a long tradition in Maya monumental art, its representation on Lintel 25 is its first appearance at Yaxchilán.[126] Evidently, the ruler's accession was legitimized by various sacred rituals, like the auto-sacrificial bloodletting that his principal wife had performed in his honor to summon these past ancestor spirits. —**1.15**

Wilbert Vázquez, Angel Ruíz Novelo, and Jesús Marcos Delgado Kú have fashioned other compositions based on Yaxchilan sources. Delgado Kú has created a panel based on Lintel 8 from Yaxchilan that depicts a common scene in Maya art, the taking of captives in battle. The eighth-century king known as Bird Jaguar IV appears on the right, and K'an Tok Wayib, his principal secondary lord (*baah sahal*), here serving as a war captain, is shown on the left.[127] He also has adapted a related scene from the stone sculpture known as the Kimbell Panel, thought to be from the site of Laxtunich located near Yaxchilan.[128] Here the late eighth-century king known as Itzamnaaj Bahlam IV (Chel-Te) sits on a bench-type throne beneath a curtain (indicating a palace setting), while a secondary lord (an office known as a *sahal*) presents humiliated captives at the base of the palace platform. —**1.16** *and* **1.17** *col.*

Angel Ruíz Novelo has created a version of Lintel 17 from Yaxchilan. This lintel depicts bloodletting rites carried out by Bird Jaguar IV and one of his wives, Lady Mut Bahlam, a Lady Ajaw, of Hix Witz, to celebrate the birth of their son, Chel-Te, the eventual heir to the throne (who then adopts the royal name Itzamnaaj Bahlam IV). In a scene related to that on Lintel 24 discussed above, the king is shown drawing blood from his genitals with a stingray spine, while Lady Mut Bahlam pulls a cord through her tongue.[129] —**1.18**

Yaxchilan Lintel 15 shows a variant of a visionary scene in which another of Bird Jaguar IV's wives (Lady Wak Tun of Motul de San José) summons an

ancestor from a looming "vision serpent." From this monument, the Puuc artisans commonly choose to reproduce only the serpent motif, creating either a three-dimensional, stand alone-figure, or a low relief carved figure meant to hang on the wall.[130] An example of an in-the-round version of this motif carved by Jesús Delgado Kú is included in the exhibition. Miguel Uc Delgado noted that the reason he isolates some figures, such as this vision serpent, is because they exhibit certain elements (e.g., detailed patterns, curvilinear contours, etc.) that make them more interesting to carve than other figures in the scene.[131] Separating figures from more complex compositions in Classic Maya stelae and lintels from sites such as Yaxchilán, Palenque, and Copán is common among the Puuc artisans. In addition to permitting the artisan to accentuate the aesthetic quality of a principal figure, it can also save material and labor time by eliminating the need to reproduce an entire monument. —**1.19**

Wilbert Vázquez's image of the king known as Bird Jaguar IV (Yaxun Bahlam IV) has been extracted from the larger composition on Stela 11 from Yaxchilan, Chiapas. It depicts the ruler holding the familiar K'awiil scepter and wearing a mask of the deity known as Chak-Xib-Chaak, associated with rain and the watery underworld. On the original monument he stands facing a group of captives who kneel at his feet. —**1.20** *col.*

A carving by Ruíz Novelo, adapted from Lintel 39 at Yaxchilan, Chiapas, portrays the ruler Bird Jaguar IV (Yaxun Bahlam IV) in a semirecumbent pose holding a sinuous two-headed serpent bar across his lap and chest.[132] Variants of this two-headed serpent often appear as a more rigid bar as an insignia held in front of the chest by Maya rulers on stela monuments. Emerging from the gaping reptilian jaws are heads of the powerful royal patron god K'awiil. —**1.21** *col.*

In addition to reproducing some of the best-known imagery of Yaxchilán, Puuc artisans have also created their own versions of the major monuments at Palenque, another Late Classic lowland site

located northwest of Yaxchilán.[133] One of the most recognizable monuments from Palenque is the carved limestone lid covering the sarcophagus found in a vaulted tomb within the Temple of Inscriptions. This tomb, discovered by Mexican archaeologist Alberto Ruz in 1952,[134] contained the burial of the Palenque ruler known as K'inich Janaab Pakal I (or simply Pacal).[135] The stone relief carving on the sarcophagus lid depicts K'inich Janaab Pakal I on the threshold of death as he is descending into the open maws of a skeletal earth monster and entering Xibalba, the underworld. Behind him rises the world tree, or *axis mundi*, which places the dying ruler at the center of the universe and simultaneously connects the upper and lower worlds.[136] Different interpretations of the sarcophagus lid have been carved by Angel Ruíz Novelo, who has left the motifs attached to the solid cedar panel but carved them in bolder relief than on the original, and by Jesús Marcos Delgado Kú, who has altered the original to create an openwork composition. —**1.22** *and* **1.23**

Another depiction of K'inich Janaab Pakal I that has been illustrated countless times since its discovery is the stucco portrait head that was found beneath his sarcophagus in his burial chamber within the Temple of Inscriptions.[137] This portrait bust originally may have adorned the wall inside the palace at Palenque. It is a naturalistic (though somewhat idealized) rendering of the king, executed with careful modeling and attention to detail. Details such as the stepped haircut, steeply sloping forehead with cranial deformation, pronounced aquiline nose, youthful facial features, and forward flowing "ponytail" (symbolizing maize foliage) indicate that Pakal is the earthly embodiment of the Maize god, the same deity with whom his identity is merged on his sarcophagus lid.[138] —**1.24**

Various interpretations of Pakal's portrait head appear in the exhibition. Miguel Uc Delgado has created a boldly carved three-dimensional rendition that is based more loosely on the famous stucco portrait, but in which more naturalistic features and

smoother planes of the original are translated into more forcefully defined volumes and bold rhythmic patterns. Jesús Delgado Kú has created another volumetric interpretation of the famous profile that stresses somewhat more angular masses and exaggerates the ruler's famous flattened forehead. Angel Ruíz Novelo based his carving on a profile view of the famous stucco head. In this version the solid and compact masses of the ruler's head and neck muscles are emphasized, conveying a sense of energy and strength. In all depictions based on the original model, the composition also focuses on the large, forward projecting hair arrangement that alludes to the maize god. Recalling the portrait of Pakal but based on another ruler is Wilbert Vázquez's striking cameo portrait taken from the much larger relief sculpture known as the Tablet of the Slaves at Palenque. Now known to represent the eighth century king K'inich Ahkal Mo' Nahb III, the full composition shows the king seated on a throne composed of two subjugated captives, and flanked by his father and mother.[139] They present their son with a "drum major" headdress and an elaborate Tok-Pakal (flint shield) insignia associated with his war-making powers. A more complete version of this panel by Jesús Marcos Delgado Kú also is included in this exhibition. —**1.25** *col.,* **1.26,** **1.27** *col.,* **1.28,** *and* **1.29** *col.*

The sloping forehead and prominent nose can also be found in other representations of K'inich Janaab Pakal I at Palenque, such as in the Oval Tablet above a bench in Structure E of the Palace Complex, a sculpture that Miguel also carves.[140] The Oval Tablet depicts K'inich Janaab Pakal I's mother, Lady Sac K'uk', as she presents to her son a version of the tall cylindrical, mosaic-covered "drum-major" headdress, perhaps given to Palenque kings during their accession to power as a symbol of their role as a war leader.[141] —**1.30** *and* **1.31**

Wilbert Vázquez has carved another subject based on the art of Palenque that portrays a standing ruler and a kneeling figure, an image based on Pier C of the western corridor of the Palace.[142] The Palace is an extensive, multiroomed administrative-residential complex that housed Palenque's royal family and their retainers from the late sixth through the eighth centuries. Along with various temple structures at the site, it boasts numerous modeled, carved, and painted stucco and stone relief sculptures that portray aspects of courtly life. —**1.32**

Beyond the "iconic" images from Yaxchilan (e.g., Lintels 15, 24, 25) and Palenque (e.g., Sarcophagus Lid, Pakal stucco portrait, Oval Tablet) and other subjects from those sites mentioned above, the Puuc carvers are familiar with and draw on a wide range of images from Classic Maya art. Miguel Uc Delgado has carved a tondo composition, based on Altar 8 from Tikal, Guatemala, that depicts a bound captive lying on a reptilian earth monster whose headdress takes the form of a tied-and-knotted bundle that is the main sign of the Tikal emblem glyph. The circular format probably represents the rubber ball of the ritual ballgame, implying that the prisoner will be sacrificed at the end of the game.[143] —**1.33** *col.*

Wilbert Vázquez has fashioned a finely carved interpretation of the depiction of the king Aj Bolon Haabtal (formerly known as Ah-Bolon-Abta Wat'ul Chatel) seen on the mid-ninth century Stela 10 from Seibal, Guatemala. This depicts the ruler wearing a headdress that is adorned with woven mat designs that symbolize his royal authority and holding a serpent-headed ceremonial bar.[144] The more florid and exuberant scrollwork on this monument is found on other late Maya sculptures and provides an eye-catching design that demonstrates the detailed finish found in Puuc region *réplica* style pieces. —**1.34** *col.*

Sculptures from the Puuc region are used as subject matter less frequently than those from southern lowlands sites, probably because the figural style on the northern monuments is somewhat more simplified and less fluid than that of the monuments mentioned above. Nevertheless, a representation of a jamb from Kabah, carved by Miguel Uc Delgado is included in this exhibition (see "Other Carvings in the Exhibition"). It depicts a ruler menacing a kneel-

ing captive with a club studded with stone blades. An image of this sculpture appears in Stephens' *Incidents of Travel in Yucatan*,[145] still a popular read and source of background information for contemporary travelers to the Maya region. A favorite motif is the so-called "Reina de Uxmal" (Queen of Uxmal), representing a human head (probably a founding ancestor) emerging from the open jaws of a stylized serpent,[146] as seen in the example by Jesús Delgado Kú (see "Other Carvings in the Exhibition").

In some cases, more generic references to subjects in Classic Maya art are reinterpreted, as in the case of a panel by Miguel Uc Delgado that depicts a common motif in Classic Maya sculpture, a K'uhul Ajaw (Sacred Lord) holding a shield and a small effigy scepter of K'awiil, a lightning and storm deity who was a patron of Maya royalty. Wilbert has created a "Maya Mask" based on personal reinterpretation and combination of elements drawn from different monuments. The human face has a headband composed of rectangular plaques. The eyes, with "feathered" eyelids and large suborbital plates, resemble those of various Chaak masks seen on ancient buildings in the Puuc region. —**1.35** *and* **1.36** *col.*

Although figural motifs are the favored subject matter, some pieces focus on glyphic texts. Miguel has carved an inscription on Stela F of Quirigua, Guatemala, representing the type of long calendrical statement that often leads off a Maya hieroglyphic text. Known as an Initial Series date, it records a "Long Count" of progressively higher cycles of time that have passed since the creation of the present world and beginning of the current era. This is the text used to illustrate the working of this time-keeping system in the various adaptations of Sylvanus Morley's *The Ancient Maya*.[147] Individual glyphs may also be carved, like the Ajaw sign by Angel[148] or interpretations by Wilbert and Miguel of full-figure glyphs adapted from calendrical texts, providing both complex figural compositions, as well as talismanic references to the Maya "cult of time."[149] (See 2:"Other Carvings in the Exhibition.") —**1.37** *and* **1.38**

The polychrome painted ceramics of the Classic Maya also furnish easily recognizable subject matter. One example is seen in the Jaguar Dancer by Miguel. This image, adapted from a well-known vase from a royal burial at Altar de Sacrificios, Guatemala, shows a figure in an ecstatic performance, assuming the identity of his feline animal alter ego or *Way*.[150] Angel has based several of his compositions on ceramic models. One is the piece showing a dancing, axe-wielding image of Chak-Xib-Chaak, taken from a larger composition showing the sacrifice of an anthropomorphic baby jaguar and gleeful death god on a frequently published codex-style cylinder vase.[151] Another of his carvings is based on the now iconic scene on the "Resurrection Plate." Depicting Hun Ajaw and Yax Balam (the Classic period versions of the Hero Twins of the *Popol Vuh*) restoring their father, the Maize God, to life as he emerges from a cleft in a turtle carapace (see "Other Carvings in the Exhibition").[152] Freely adapted from a ceramic source is Wilbert's panel depicting the elegant standing figure with a raised arm. Commonly known as the "presentador" (the speaker), this is based on a well-known ceramic figurine from the island of Jaina.[153] —**1.39**, **1.40**, *and* **1.41**

Other motifs are adapted from small-scale media. An example is Miguel's carving based on an incised human femur bone from the burial of Jasaw Chan K'awiil, the early eighth century king of Tikal, Guatemala. This carving portrays the Maize God (central figure) in a canoe accompanied by various supernatural animals and birds. The two old deities in the bow and stern, known as the Paddler Gods, are transporting the Maize God into the murky depths of the underworld. Pictured in various popular books on Maya art and archaeology, this has become another popular image of Classic Maya culture.[154] —**1.42** *col.*

In addition to using well-known "iconic" images from Classic Maya sculptural sources and several familiar scenes from polychrome ceramics, the Puuc artisans also base many of their carvings on the images of deities from the Maya codices, particularly

the Dresden Codex, whose more curvilinear treatment of the figures lends itself to the preferred style of the carvers.[155] Particularly numerous are low-relief portrayals of Chaak (Schellhas' God B), the Yucatec Maya god of rain and lightning. A favorite representation of the rain god comes from page 33b, as seen in a version carved by Angel Ruíz Novelo.[156] In Terminal Classic architecture of the Puuc region, Chaak is represented on the facades of various architectural structures in the form of carved stone mosaic mask panels in which his long curling snout is plainly visible (see Figure 1.3). These geometric and rectilinear mask panels line massive stairways (like that at the Pyramid of the Magician at Uxmal) and adorn upper areas or corners of roofs (as can be seen at Uxmal's House of the Governor and Labná's palace). In the case of the Palace of the Masks (Kotz Pop in Maya) at Kabah, they cover the entire west façade, a unique example in the Puuc region. Although there is still some debate as to the identity of these mask panels. A number of scholars have identified them as Chaak, based in part on representations of God B's long and downward curling nose in the Dresden and Madrid Codices. However, it is also possible that some were modeled on other deities such as God K (*K'awiil*), the Principal Bird Deity, or on the creature earlier known as the Cauac Monster and now identified as a personification of a *wits* (mountain).[157] The Puuc artisans, however, do not identify these masks as either *wits* mountains or variants of Itzamnaaj, but rather refer to them as representations of the rain deity, Chaak, so they will be described as such in this study. The Puuc stone mosaic masks are always shown frontally and are rendered more geometrically than the Postclassic codex depictions of Chaak. Consequently, the Chaak mask represents one of the few subjects taken from the Puuc region that is used widely by artisans in the area. Examples of carved wooden and stone masks that are faithful to the originals at the Puuc sites attest to the importance of this deity and can be seen in the collections of Wilbert, Miguel (though carved in local stone), and Jesús.—**1.43** *and* **1.44**

The maize god, or God E, is another important ancient Maya deity who still resonates with local people in Yucatán, and appears in a carving by Miguel Uc Delgado. Among Yucatecos, he is known as the Dios del Monte in Spanish and *Yuum K'áax* in Yucatec Maya. This identification suggests that his role is not limited to the cyclical life of maize, but that he also oversees wider areas of agriculture and vegetation. Taube notes that depictions in the Dresden Codex (page 12a, for instance) of the maize god show him as a youthful deity who not only holds a maize plant in his hand but whose head also terminates in a maize cob (see Figure 1.45).[158] Accordingly, Miller and Taube imply that referring to the deity strictly through a translation of his current Maya name downplays his connection with this important crop.[159] Further complicating this deity's identification, Taube notes that in Yucatán he is conflated with other deities, such as "diving gods" (e.g., at Tulum and in the Dresden Codex) and God C (as seen in the Madrid Codex), who are also connected to agricultural fertility and maize.[160] Regardless of the controversy surrounding this deity's role and name, the Puuc carvers title their carvings of this deity either *Yuum K'áax* or "*dios/señor del monte*" rather than "*dios del maíz*," which corroborates that local belief associates this deity as overseeing a broader agricultural realm.[161] Mary Katherine Scott's studies indicate that the *Yuum K'áax* or maize deity was one of the most commonly reproduced carvings among wood-carvers.—**1.45** *col.*

A number of other popular images taken from the Dresden Codex include the old creator god Itzamnaaj (God D) and his wife, the old goddess Ixchel (Goddess O, or Chak Chel, as she is named in the codices). According to J. E. S. Thompson, Itzamnaaj was the "Lord of the Heavens," a priest, and the god of medicine during the month of Zip.[162] Taube believes that Itzamnaaj may have in fact been the most important god of the Maya pantheon during the Classic and Postclassic period.[163] Itzamnaaj was also charged with the invention of the hieroglyphic writing system and

screenfold manuscripts in which the Maya recorded some of their most important historical and cosmological beliefs.[164] Using as a model the representation of Itzamnaaj on page 5c of the Dresden Codex, all four artisans keep sculptures of this god on hand, as he is a popular subject among tourist-buyers.

As the wife of Itzamnaaj, Ixchel (also now known as Chak Chel, based on the reading of her glyphic name in the codices) is associated with divination and medicine as well as the traditional female roles and occupations of childbirth and weaving.[165] Although an aged goddess, she is portrayed not as a kindly grandmother, but rather as a fearsome thing to behold since she is frequently represented with claws, fangs, or other symbols associated with death.[166] Like her husband, Itzamnaaj, Ixchel is depicted throughout the Madrid and Dresden codices, especially during scenes of a great flood, since she is simultaneously associated with the forces of creation and destruction.[167] The most common illustration that is reproduced in Puuc wood carvings, as in the version by Jesús Delgado Kú, is from page 39b of the Dresden Codex, where she is shown pouring water from a jar. —**1.46** *and* **1.47**

The image of the Death God by Angel Ruíz Novelo is also based on a depiction in the Dresden Codex. The Maya depicted death gods with skeletal features, prominently showing the rib cage and leering skull-like heads and faces. They are often shown wearing a distinctive fringed collar with circular "death eye" motifs that represent extruded eyeballs, and may be marked with crossed-bones symbols, a *cimi* (death) symbol that resembles a percentage sign, or with black spots representing decomposing flesh. Death gods ruled the gloomy and fearsome underworld, known to the highland Maya of Guatemala as Xibalba, and referred to as Mitnal in Yucatán at the time of the conquest.[168] —**1.48**

In the case of Chaak, the maize god, Itzamnaaj, Ixchel/Chak Chel, and Death God reproductions, as well as some other figures such as Ix Tab (a goddess associated with death by hanging) or God K

(K'awiil), contemporary representations of these figures are almost exact facsimiles from the Dresden Codex, although, as with other figures, each artisan modifies and simplifies these figures according to his personal carving style. For instance, the artisan may simplify aspects of the figure's headdress, modify facial features, adjust costume elements, or change the position of the figure's hands. Though much of this reflects aesthetic preference, each artisan also makes these modifications to reinforce the carving's design so that the latter is less susceptible to breaking or cracking in the more fragile areas.[169] For example, even though Jesús' carved figure is different from the representation in the Dresden codex, he makes the maize god's fingers touch the object he carries, rather than just his thumb, and he extends the deity's jade necklace all the way down to his knee so that the figure's outstretched arm is more stable. Jesús also anticipated the potential instability of the projecting noses of his wooden Chaak masks, so he carved the nose separately from the mask so it could be removed to prevent breakage during travel (see Figure 1.44). Another benefit of the removable nose is that it can be inserted right side up or upside down to emulate masks at Uxmal and Labná (curled snout down) or at Kabah (curled snout up), according to the buyer's preference. Jesús also creates interesting "hybrid" works that combine the form of incense burners from Palenque with Puuc-style Chaak masks as their headdress (see "Other Carvings in the Exhibition").

Motifs and figures found less frequently in the artisanal imagery than those discussed above include hieroglyphs, diving gods, jaguars, God L, and chacmools, among others. Diving gods (*dios descendente*) represent another common subject in Postclassic sculpture of Yucatán.[170] As seen in an example by Wilbert, these gods get their name from the fact that they appear to be diving headfirst from the sky. The most notable examples come from Tulum (in Quintana Roo) and Mayapán (in Yucatán). Arthur G. Miller believes that these beings show the link the Maya believed existed between Venus and the sun,

manifested in Venus as the Morning Star, which falls back into the Underworld at the dawn of each day after first bringing the sun to light from the darkness.[171] Venus as the Morning Star is likewise associated with the god Quetzalcoatl-K'uk'ulkan (the feathered serpent deity), so Miller surmises that the deity, like the celestial body, would have to change its form to carry out this daily cycle.[172] Thus, Miller argues these diving gods are the visual expressions of this transformation of Quetzalcoatl-K'uk'ulkan into the feathered serpent, just as Venus as the Morning Star gives way to the sun.[173] —**1.49** *col.*

According to other scholars, such as Karl Taube, however, these deities may represent God E, the maize god or a Venus deity.[174] Taube notes that most representations of diving gods generally have explicit maize foliage growing from their heads, as well as feather ornaments coming out of their arms (as seen on the Tulum examples), characteristics they share with a specific representation of the maize god from the Madrid Codex.[175] An example from the Puuc region comes from the great palace at Sayil, though only the figure's legs peek out from behind the larger mask element. Since the most popular examples of diving gods in the Yucatán peninsula are often in a poor state of preservation, the artisans seem to combine elements of several of them into one cohesive design, and also provide any missing information to complete the figure. Wilbert credits one of the Tulum diving gods (that from Tulum Structure 25) as the inspiration for his own design of this figure (see Figure 1.49). He points out that his design is unique among the Muna and Puuc artisans because he has replaced the missing hands in the original monument and has placed a Venus symbol in them. He has been careful not to share his design with any of the other carvers so that it is not reproduced without his permission.[176] While competition is less of an issue in the Puuc-Muna region than in other areas of the state, artisans prefer to keep their designs to themselves since it is their individual rendering of the ancient monuments that distinguishes them from one another.

As God L is represented on the jambs from the Temple of the Cross at Palenque, the aged black deity serves as the subject of carvings among Puuc artisans. Both Wilbert Vázquez and Jesús Marcos Delgado Kú have versions of this motif in this exhibition (see "Other Carvings in the Exhibition"). According to Taube, God L is "a complex deity having both mortuary and life-giving attributes" and is generally identified by jaguar characteristics and a large, square eye, and he is often shown smoking a cigar as is the case with the relief sculpture from the Temple of the Cross at Palenque.[177] It is this image that serves as the main source image for his depiction among Maya carvers. Because he is frequently represented with a cigar, God L has the nickname *"el fumador"* or "the smoker" in Yucatán. Although he is a lord of the Underworld, Xibalba, as reflected in his association with *moan* (or screech) owls and jaguars, creatures of nighttime and caves, he has a dual nature in that he is associated with water, agricultural fertility, and material riches as well, evident in the merchant bundle he carries in many examples from antiquity.[178] —**1.50**

Jaguar (*balam* in Maya) imagery appears to a lesser degree among Puuc wood carvings. An openwork version of this motif by Jesús Marcos Delgado Kú is included in this exhibition. The jaguar, associated with night and the Underworld, was one of the most feared and respected creatures in all of Mesoamerica.[179] Since this feline was associated with shamanic ecstasy and states of ritual transformation, many Maya deities, such as God L and Ixchel (Goddess O) take on aspects of this animal to allude to their connection with death, the nighttime sky, and the Underworld.[180] Jaguars are also known for their connection to royalty and their power to govern. Maya rulers (and Mesoamerican rulers in general) frequently wore jaguar pelts, sat on carved stone double-headed jaguar thrones or jaguar pelt cushions, and also wore necklaces strung with jade beads carved in the shape of jaguar teeth.[181] While not identical, most jaguar carvings Mary Katherine Scott observed among Puuc wood carvings featured a seated and spotted cat with

one paw raised to its mouth that was similar in composition to the jaguar relief figures from the Platform of the Eagles and Jaguars at Chichén Itzá dating to the Postclassic period. On this monument the jaguar images are paired with those of eagles clutching human hearts, suggesting that the two animals are the patrons of warrior orders and associated with conquest warfare.[182] —**1.51**

A significant number of relief and full-round carvings depict motifs from Chichén Itzá. Quite popular are images of chacmools, distinctive figures in a recumbent pose holding a plate or bowl on their stomach, as seen in the example carved by Miguel Uc Delgado. *Chac mool,* or "red jaguar paw," was the name given to this figural type by Augustus Le Plongeon in 1875, when he discovered the first of fourteen such figures known from Chichén Itzá.[183] The name "chacmool" is a misnomer, since these figures have little to do with red paws, but the name stuck and has been applied to similar figures discovered throughout Mesoamerica.[184] They have been interpreted as intermediaries that carry messages to the gods, with the circular plate perhaps holding sacrificial offerings, or serving as a platform for drilling sacred fire.[185] The chacmool's prominence at Chichén Itzá, along with its use in advertising for the site as well as for Cancún, has made this figure a popular image to reproduce in various types of craft media, and the Puuc artisans typically have multiple chacmools for sale, both in carved low relief and freestanding three-dimensional varieties. —**1.52** *col.*

Another motif based on Chichén Itzá and carved by Puuc artisans is represented by a "Jaguar-Bird-Serpent" figure by Wilbert Vázquez (see "Other Carvings in the Exhibiton"). Depicting a frontal saurian creature with jaguar pelt markings and winglike fans projecting from the arms (a so-called "jaguar-serpent-bird"), such figures are seen on building facades and in the lower panels of carved pillars at Chichén Itzá. They closely resemble figures seen in the art of Tula, Hidalgo in Central Mexico. According to some scholars, the human face emerging from the creature's open mouth may refer to the emergence of Venus from the interior of the earth at dawn.[186] Vázquez has also produced a relief carving portraying a tree with a flowering vine and seed pods (possibly intended to represent cacao pods that contain chocolate beans), an image adapted from relief sculptures on the alfardas (ramps) flanking the stairway of the North Temple of the Great Ballcourt at Chichén Itzá. Drawing nectar from the flowers are birds and butterflies that may refer to the souls of dead warriors.[187] —**1.53**

Another popular carving motif, versions of which were carved by Wilbert Vázquez (see "Other Carvings in the Exhibition") and Angel Ruíz Novelo, is based on imagery from a gold disk dredged from the sacred cenote at Chichén Itzá. This depicts a "Toltec" warrior wearing a stylized butterfly pectoral and holding a spear-thrower (*atlatl*) and bundle of darts, and emerging from the open mouth of a celestial Cloud Serpent (*Mixcoatl*). For many years the emphasis on military themes, such as this one, in the art of Chichen Itza was attributed to its conquest by Tula, Hidalgo. Today, however, more scholars view it as the result of shared warrior cults at both sites.[188]

Some motifs represent "hybrid" images, based on modern representations of the ancient Maya, rather than ancient images. A good example of this is the Calendar Wheel with Kneeling Figure by Miguel. Based on a well-known diagram in the book *The Rise and Fall of Maya Civilization* by J. E. S. Thompson, this illustrates the working of the 260-day ritual prophetic calendar known as the *tzolk'in* (a concocted name).[189] The figure in the center represents the concept of a deity carrying or bearing a time period. Although the image of the central bearer figure (Cargador) stems from Classic period full-figure date glyphs, the circular calendar wheel does not appear in Classic Maya art. Yet, due to the popularity of Thompson's book, this has become a common and easily recognized shorthand reference to ancient Maya civilization. Related to this is the Cargador (burden bearer) figure, seen in an example by Miguel (see "Other Carvings in the Exhibition"). This kneeling figure carries a large date glyph (an Ajaw

sign probably referring to the end of a 20–year k'atun period) on his back. Adapted from representations of such full figure glyphs in Maya inscriptions, images of figures bearing the "burden of time" have become well-known references to the intellectual, scientific, and astronomical knowledge associated with ancient Maya civilization by writers such as Sylvanus Morley and J. E. S. Thompson.—**1.54**

Related to the carvings above is a sculpture by Miguel that takes the form of the more common calendar wheel sculptures that illustrate the intermeshing of the 260–day divinatory cycle and 365–day solar-agricultural calendar, but that has been simplified to give greater visual prominence to the seated Maya lord in the center (see "Other Carvings in the Exhibition"). A small assortment of bar and dot numbers and more freely invented glyphic signs as an ornamental border are not based on a particular glyphic text, but evoke the idea of Maya civilization's intellectual achievements.

Also portrayed by the artisans is the feathered serpent, associated with the multivalent creator deity known as Quetzalcoatl among the Aztecs, and as K'uk'ulkan among northern Maya of the Postclassic period.[190] Interestingly, the distinctive two-headed version of this motif carved by Miguel Uc Delgado is based on a small wood sculpture encrusted with turquoise mosaic from central Mexico, rather than one from Chichén Itzá.[191] For the ordinary buyer, however, it represents a well-known icon that is related to the feathered serpents seen in the architecture of Chichén Itzá or Uxmal (see Figure 1.3).

Although most carvings are designed to be recognizable to tourist visitors (either as references to specific iconic images or as emblems of Maya civilization), the Puuc artisans also create pieces for more personal expression. For example, a tablet by Miguel depicts the Maya princess Sak Nikté and her suitor (Chak-Xib-Chaak of Chichén Itzá?) in front of the freestanding arch at Labná. Jesús has created an image of a baby in the palm of a hand, to illustrate the miraculous nature of birth and divine

creativity. A panel by Angel depicts X'tabay, known in Yucatecan legends as a seductress who lures and slays hunters in the forest. He also has fashioned a humorous Freudian image of a man with a "woman on his mind" (for these pieces see "Other Carvings in the Exhibition"). A variation of this theme appears, in a more concealed form, in the striking openwork Maya profile carved by Wilbert. While the principal focus is on the bold contours of the face, there are also references both to maize vegetation and to a female figure in the headdress. —**1.55**

The sources of the imagery for the artisans' carvings come from predictable references such as popular scholarly texts or exhibition catalogs on Maya art and archaeology and personal photographs from the sites during their own travel experiences, but they also use less conventional sources such as children's coloring books or more popular guidebook with drawings of Maya monuments and motifs.[192] Puuc artisans generally have a basic knowledge of the meaning and history of the images they carve, based on a mix of personal study as well as from their contact and conversations with scholars working in the Puuc region and elsewhere in the Maya region. This intimate relationship with individuals who are personally involved in Maya archaeological studies puts the Puuc artisans in a special position that provides them with a substantial understanding of Maya iconography that is reflected in their work.

The Puuc Region Style and Comparison with the Pisté School

In addition to displaying subject matter based closely on models in Classic Maya art or Postclassic Maya codices, the majority of the wood carvings from the Puuc region feature a specialized local carving style characterized by meticulous attention to detail, fine finish, and the use of hardwoods, such as cedar, mahogany, and chico zapote. However, these careful wooden reproductions of ancient Maya deities and elite historical individuals are not carbon copies of

the ancient monuments, but are rather reinterpretations of these figures through the artisan's choice of materials, artistic process, and personal carving style. Yet, despite evidence of personal treatment in the selection and emphasis on particular forms and motifs, there is a marked difference between the Puuc replications and many of the more simply carved, brightly painted, and stylistically innovative hybrid wood carvings exhibited and sold by vendors at Chichén Itzá, as well as similar carvings produced and sold in other parts of the state (e.g., Mérida, Valladolid, etc.). Noting that this difference exists does not demonstrate that Puuc wood carvings are somehow intrinsically better or more worthy of contemplation than other examples of wood carving in Yucatán. Nor, conversely, do we believe that while the Puuc sculptures are based closely on ancient models but do not represent an unbroken heritage, this makes them less "authentic" or inferior to traditions with longer local histories (e.g., embroidered huipiles). Instead, these differences reflect their emergence in and response to different types of social, economic, and political circumstances and opportunities presented within a context of greater globalization and increased tourism.

The Puuc artisans, while aware of and attentive to the pressures of market trends and consumer preferences, also have a personal interest in developing and refining their craft, rather than succumbing to external forces by creating poorly carved pieces. As commendable as this all seems, however, the reality is that Yucatán is an area not known for its crafts, which is an additional challenge these Puuc artisans have had to face in their efforts to produce marketable goods and a sustainable livelihood at the same time as they try to maintain certain artistic standards. The tradition that Salazar began in the 1960s is still practiced among contemporary wood-carvers in the Muna-Puuc region, and they continue to use many of the same carving techniques and materials that Salazar used a generation before. Puuc artisans continue to maintain the high level of quality and

careful attention to detail in which Salazar prided himself in his own creations. However, the types of materials that Puuc artisans use vary from those used in other handicraft productions centers of Yucatán, such as Mérida and Chichén Itzá. For instance, Puuc artisans never use the *chakah* (balsam) wood that, until recently, has been the common material for many of the less expensive carvings sold at Chichén (see Castañeda's essay for the depletion of *chakah* around Chichén Itzá, and the use of cedar to carve *réplica* style panels comparable to those of the Puuc artisans). Angel Ruíz Novelo says that *chakah* is "too soft. I don't like it because you can't treat it the same way [as harder woods]. It breaks too easily."[193] Instead, cedar is the wood of choice among most artisans due to its natural golden color and pleasant aroma. Since it is a hardwood, cedar also lends itself well to the intricate high and low relief carvings that typically characterize Puuc carvings. On the other hand, it is also a very expensive wood, due in part to its slow growth rate, but also due to the over-harvesting of the trees throughout Yucatán in the past few decades.

As mentioned, Puuc wood carvings tend to exhibit a very high quality in their craftsmanship and materials used when compared with the less expensive typical handicrafts from other production centers in Yucatán. However, while Puuc artisans have been able to fully develop their craft and refine their carving skills, many artisans outside of the Puuc region in high-traffic tourist zones (e.g., Chichén Itzá, Mérida, etc.) are under intense economic pressure to sell, since a more developed tourism industry produces more handicraft vendors and greater competition among them. In many cases, this has resulted in more mass-produced handicrafts that display simplified forms and figures, instead of the highly detailed and individualized subject matter found in the Puuc region. Puuc artisans are not subjected to the same economic pressures since there are fewer artisans working there. Competition is a less pressing issue, so more labor intensive and finely detailed sculptures are created and more individual artistic styles have emerged.

Having looked at some of the ways that the Puuc artisans distinguish themselves and their work from other craft traditions in the state, it would be useful to know exactly who their audience is and why their wood carvings appeal to the type(s) of tourists at which they are aimed. Generally speaking, many (though certainly not all) individuals who come to the Puuc region have a particular interest in its history and archaeology. As "cultural tourists" of the type defined at the beginning of the chapter, they often arrive as members of tours guided by scholars or archaeologists affiliated with universities or other institutions, the most elite category of tourism, according to Adolf Ehrentraut.[194] Further differences between the two carving traditions can be explained by noting that tourists to the Puuc region generally have a better understanding of the local culture and its history,[195] leading them to place higher standards on the souvenirs that they intend to purchase. Miguel Uc Delgado believes that visitors to this region buy a wood carving because they are "interested in the culture. Sometimes they just want a souvenir or *recuerdo* from the place where they visited, but I think it's because the culture is important to them. They really appreciate it."[196]

Although such "cultural tourists" also visit Chichén Itzá, its location on the northern plains of the peninsula means that it also caters to larger numbers of day-tourists traveling from Cancún or the other east coast beach resorts. Those tourists' interest in the site is largely secondary to other vacation activities, and their background knowledge of ancient Maya society and art tends to be limited. Understanding the different nature of the tourist audiences is crucial because the wood carvings and other handicrafts sold in the respective areas are adjusted to appeal to consumer preferences.[197]

Where the majority of day visitors to Chichén may be satisfied with eclectic and inventive, yet somewhat kitschy and unhistorical representations of Maya iconography and hybrid images that conflate cultural references, many of the visitors to the Puuc region know the monuments well enough that they want faithful reproductions. We want to stress, however, that although these general distinctions exist between the types of carvings sold in each zone, they are not meant to imply that the more detailed and archaeologically "accurate" carvings sold in the Puuc region are "good" whereas the simpler and more eclectic pieces from Chichén Itzá are "bad" or vice versa. Such differences reflect the fact that the carvings in each region are designed to appeal to and attract an appropriate audience, and their artistic and cultural merits should be valued independently of each other. The artisans in both regions purposefully "appropriate" and adapt imagery based on sources from ancient Maya and/or Mesoamerican art, but in somewhat different ways that represent different combinations of their personal creativity and the tourist market (the issue of appropriation is discussed more fully in Mary Katherine Scott's essay in this volume).

At first glance, it would be tempting to conclude that wood carvings available at Chichén are of a lesser quality than those produced in the Puuc region. It is true that a large number of the wood carvings produced in Pisté and sold at Chichén Itzá are rapidly produced in an assembly line fashion, which results in a rustic if not rudimentary appearance in the final object. As Castañeda has noted in his essay and in other discussions,[198] many of them are also generally made from softwoods like *piich* (a local softwood) or *chakah* (balsam), which doesn't allow for the fine detail work that harder woods permit. These woods also chip and splinter easily, and due to demand and financial concerns, the wood is often purchased from vendors or gathered from the forest before being completely dried out. The resulting "green" wood is easier to carve, but it has a tendency to crack and warp once it fully dries out, which disfigures the object. Nevertheless, the larger, more elaborate *máscaras* discussed below are often carved in cedar instead of the cheaper softwoods that are used for smaller masks, so the "quality" argument, at least in terms of materials, is further weakened.

In addition to being made from cheaper materials, many of the carvings for sale at Chichén take the form of boldly, often garishly painted composite or hybrid figures known as *máscaras* (masks) or *mascarones* (figureheads) that combine multiple pre-Columbian elements into one image (see Castañeda's essay for additional discussion). Such hybrid images lose their significance as replicas of unique historical images, but one could argue their mélange of different motifs permits them to take on new meaning, with the fusion of forms redefining the symbols of Mayan, or more generally, Mexican pre-Hispanic culture in a modern global context. Viewed from this alternate perspective, such carvings can be seen as dynamic, innovative images that communicate complex messages about contemporary cultural identity in Yucatán. Such notions are expressed through the combination disparate motifs, creating a bricolage that reflects outsiders' perceptions of "Maya-Mexican" culture based on limited knowledge and expectations created from representations of pre-Columbian societies and cultures in popular media (e.g., films such as Apocalypto or the Indiana Jones series).[199]

Although the comparisons between the subject matter and style of the Puuc and Chichén Itza "schools" apply in a broad sense, the simpler types of carvings at the latter site do not represent the entire corpus of wood carving produced. As Quetzil Castañeda notes in his essay, the forms of aesthetic objects produced at Chichén Itzá have undergone transformations over time: new types are added while old forms are discarded, modified, or updated. In addition, some Pisté artisans are producing more formally inventive and finely finished carvings based on the more widespread types of *ídolos, máscaras,* and *mascarones,* as well as creating ambitious and more personal works such as the large Tikal canoe or the Archer figure by José León Tus Kituc (see Figures 5.1 and 2.1). He also has documented a realistic and finely finished carving style (known as *réplica*) similar to that produced by artisans of the Muna-Puuc

"school" that exists and is practiced by select wood-carvers from the town of Pisté, located adjacent to the Chichén Itza archaeological site. (See Figure 2.2 and the *réplica* style *tabla* of based on La Pasadita Lintel 2 in "Other Carvings in this Exhibition.") These Pisteño carvings take two forms, *réplica* style panels that are based closely on motifs from Classic Maya art and are nearly identical in style, form, scale, subject matter, and materials to those produced by the Puuc artisans; and *réplica tabla* style panels that feature a similar highly detailed carving style, but that adapt figural poses, scenes, and motifs from ancient sources in more inventive and personal combinations. Such *réplica* carvings were being sold in Pisté in the 1990s, and aspects of the *réplica tabla* style were then incorporated in the headdresses of *máscaras* and *mascarones* produced for sale in Pisté and at Chichén Itzá in the period from about 2000 to 2005, although more recently *mascarones* have been largely discontinued, replaced by *máscaras* with elaborate carved relief, but not in the *réplica* style.[200]

Some of the more ambitious pieces by the Pisté artisans/artists are created on a commission basis, as entry pieces for arts and crafts competitions, or are sold in galleries and tourist art/craft shops in Mérida. The fact that such pieces are specially produced for sale in different venues is especially intriguing, since it indicates that these more technically refined and nearly identical reproductions of ancient Maya imagery are more desirable among a more specialized and discriminating audience of tourists (or perhaps locals) in cosmopolitan Mérida than the thousands of international tourists who descend upon Chichén Itzá each month. This situation reflects a correlation between art style, tourist audience, and economics. Once more specialized and unique *réplica* carvings, or even more developed versions of *máscaras, mascarones,* and *ídolo* type pieces, are placed in a gallery setting in Mérida, their price margin increases exponentially above what the same carving would fetch in either Chichén and its surrounding villages, or the Puuc region.[201] Mérida is significantly more

affluent than either of the latter areas, and boasts the luxury accommodations, fancy restaurants, and entertainment venues that attract tourists with the personal wealth to pay these higher prices for more distinctive and personalized pieces. Again, however, the fact that the strikingly similar reproductions of Yaxchilán or Palenque imagery made by Puuc artisans and sold at their shops in the Puuc region are priced well below those of the Pisté artisans' examples in Mérida does not imply that the Puuc artisans are less talented or skilled, but rather reflects the opportunities presented to a few artisans through their ability to find sales networks that enable them to benefit from economic trends in an increasingly globalized international art market.

Maya Cultural Identity and the Puuc Carvings as Images of the Maya

To further contextualize the production of handicrafts in Yucatán, specifically in the Puuc region, we will now examine some of the social categories, ethnic markers, and outside influences that continue to mold perceptions of "Mayaness" for both local residents and cultural outsiders. The question of Maya cultural identity is complicated and difficult to define because, to the extent that a Maya cultural identity exists, it has continuously transformed itself in response to external political, cultural, and economic factors. For instance, when the small fishing village of Cancún was reconstructed as a resort destination in 1971, it transformed traditional Maya farming communities in the eastern part of the Yucatán Peninsula by providing comparatively high-paying construction, service ,and other jobs, such as those in the handicraft industry, which were appealing alternatives to the low wages of the typical village farmer.[202] Cancún's economic success attracted mainly unskilled workers and *milperos* (farmers who work a *milpa*, or cornfield), who split their time between Cancún and their home village. Those who stayed in their villages struggled to maintain their fields since traditional farming practices are achieved through the collective and reciprocal efforts of many *milperos*.[203] This migration of the Maya worker from the *milpa* to the city (or more urbanized cosmopolitan east coast resort zone) results in what Edward Said calls a "traveling culture," where individuals cross cultural and socioeconomic boundaries in an increasingly borderless world.[204] The prospect of better wages entices male villagers to commute to the coast (or any metropolitan area for that matter), in effect to chase the "peasant dream of becoming rich in the city."[205] However, the absence of men to work the fields in the villages restructures the economies of rural communities and the agricultural sector suffers accordingly.

The shift from agriculture to tourism and service industries is being felt across Yucatán, as villages and small towns all over the state are experiencing similar phenomena to that which began in Cancún just a few decades ago. Thus, factors such as the periodic absence of men and the shift from traditional farming to jobs related to the tourism industry such as handicraft production or non-local service-oriented occupations have redefined what it means to be "Maya" within these communities.

Maya Identities in Yucatán

In the following section, to contextualize the objects produced by the artisans featured in this exhibition, we discuss the question of Maya identity from two points of view. To begin, we consider some of the ways Maya peoples, particularly those living in the northern Maya region, self-identify, and we include information regarding how the Puuc artisans conceive of their own identity. This reveals that Maya-speaking groups from various regions have different conceptions of and emphasize disparate aspects of their ethnic identity. Many of those living in Yucatán simultaneously consider themselves and/or their neighbors "Maya," yet view this as only one aspect of their broader personal identity.

They also generally recognize that a clear distinction exists between themselves and their ancient "Maya" predecessors. Following this idea, we briefly discuss what types of conceptions of Maya identity tourist visitors to the area may have formulated as a result of various paradigms that arose from archaeological and anthropological studies. We discuss how these in turn have been presented to the public in more simplified or distorted forms through popular media and promotional materials associated with the tourism industry.

In the 1980s, scholars such as Nancy Farriss argued that one's Maya identity depended largely upon the relationship Maya peasants had with the dominant class within the respective community: the ruling indigenous lineage or dominant polity in antiquity, the Spanish town officials and encomenderos during the colonial period, or the *mestizo* government officials and power holders of present day Mexico and Guatemala.[206] Even though the character of the ruling elite changed throughout the centuries, Maya peasants (farmers) were conditioned to support and obey the laws of those in positions of political authority.[207] Thus, as external forces created changes of regime, what affected the vast majority of Maya people was not that they were subservient to a certain governing body (since this had been a practice for generations), but that their position within society (i.e., class distinction) would change depending on who was in power and the kinds of social categories they imposed. Such variable categories of class and social status over the centuries have had a major impact on formulating an accepted definition of Maya identity.

Following this discourse, in addition to the social categories introduced by the ruling elite, the nature of political organization among the Yucatec Maya prior to the Spanish conquest also had an effect on Maya identity, at least in the sense that all Maya in Yucatán necessarily shared a common identity. As Farriss points out, the political structure of pre-conquest Maya society in Yucatán was highly autonomous, unlike the centralized imperial authority that characterized the Aztecs of Tenochtitlán in Central Mexico.[208] At the time of the conquest, Yucatán was divided into at least sixteen independently governed provinces, and some were further subdivided at the village level. This not only made conquering the northern Maya region difficult for the Spaniards (since each polity's rulers had to be negotiated with individually, or conquered separately[209]), but it also meant that a shared sense of "Maya" identity did not exist among the residents of the different provinces in Yucatán.[210] Instead, Maya cultural identity in Yucatán was, and to some degree still is, rooted in local place, family, community, and the experiences that are part of one's personal history. Of course, these experiences are shaped by the encroaching external forces associated with globalization and modernization. Such forces also affect notions of Maya identity as individuals respond to and adopt aspects of the modern world. Yet despite the infiltration of external cultural, technological, economic, and political forces, maintaining traditional Maya customs, language, and beliefs is possible, and it is this type of internal preservation and purposeful adaptation that largely determines what is "Maya" and what is not.

Latin American historian Ben Fallaw notes that Lázaro Cárdenas, President of Mexico from 1934 to 1940, sought to unify and mobilize the rural Maya peasants of Yucatán based on social class and ethnic identity but was largely unsuccessful.[211] Even with the introduction of cultural projects that promoted indigenous identity as well as incentives (in the form of land grants and educational opportunities) for those who identified themselves as Maya, popular interest was minimal.[212] Fallaw suggests that this limited response was due to the fact that "the rural poor in Yucatán lacked a single, unifying indigenous identity which the expanding national state could tap."[213] Furthermore, "[d]efinitions of Mayaness were not absolute or universal, and resisted easy incorporation into the Cardenista project," even though ethnic markers such as language, traditional costume, and other traditional elements persisted

in Maya communities.[214] Preserving, promoting, and supporting the traditions of Maya people is the mission of the Instituto Nacional Indigenista (INI), a government affiliate founded in 1948.[215] However, as Wolfgang Gabbert points out, INI's cultural projects were "restricted to the preservation of 'holy sites', 'traditional' medicine, dances, rites and other practices, the dissemination of myths and legends, etc.," which promoted the idea that the Maya and their traditions were "static" and unchanged by the passage of time.[216] In effect, the INI was advancing the same "backward" and essentializing relationship between ancient and modern Yucatec Maya culture that had dominated elitist discourse among government officials and non-Maya intellectuals interested in indigenous affairs.[217] But as LaBrecque observes, "it is in the interest of the state, now more than ever, for populations to be static while simultaneously being part of the process of globalization—that is, to remain "Maya" but not too "Maya."[218]

Even with Cárdenas' attempts to mobilize Yucatán's Maya peasants and the later efforts by INI, a universal ethnic consciousness or "pan-Maya" identity (as it exists in Guatemala) has never really existed in Yucatán, even if government officials and "Indianist" scholars have promoted the romantic idea of a unified nationalism based on certain shared cultural characteristics.[219] Any kind of ethnic or social division from the time of the Conquest forward came mainly from class distinctions (e.g., *indio*, *mestizo*, *criollo*, etc.) rather than perceived ethnic difference. While some of these designations remain useful in a broad sense, Hervik has reexamined certain of these social categories as they currently exist in Oxkutzcab, the same town where Angel lives in the Puuc region of Yucatán. As one of the few ethnographies that focuses on the Puuc region, we summarize some of Hervik's findings, although it should be noted that not all the categories he defines either exist or are used in the same way elsewhere in the northern Yucatán peninsula.[220] Where the term "*mestizo*" formerly denoted a person of mixed race (Spanish and

Maya Indian), Hervik argues that it is the preferred term among people in the Puuc region of Yucatán today to describe someone who is Maya (although Western researchers and scholars still refer to them as "Maya"),[221] since the terms "*indio*" and "*indígena*" are nowadays considered to be somewhat offensive.[222] However, he also notes that some Mayas who were raised in rural areas of the Puuc but left to pursue wage-labor jobs in the more urban centers also reject the term "*mestizo*" because the cities and tourist centers where they work similarly attach a derogatory meaning to this term.[223] Gabbert states that in Yucatán it is mainly a growing segment of educated middle-class people—teachers, government employees, and development workers—who most readily accept "Maya" as a self-identification rather than "*mestizo,*" and it is with this idealistic and more politically active group that "the notion of pan-Mayan ethnicity is most developed."[224]

It should be understood that while pan-Mayanists in Guatemala and other scholars might refer to all twenty-plus ethnolinguistic subgroups (e.g., Quiché, Kaqchikel, Yucatec, Lacandón, etc.) as "Maya," the ways that these groups differ largely outnumber the characteristics they share.[225] In the words of Carol A. Smith, "Indian identity is rooted in community rather than any general sense of 'Indian-ness'."[226] This focus on the local practices and "folk culture" of smaller, more rural communities represents an approach used by Redfield with his ethnographic fieldwork at Chan Kom. More recently, however, a number of scholars, such as Hervik and Kahn, have argued that the focus on community-based identity studies wrongly assumes a kind of cultural cohesion that applies to other areas in the Maya region.[227] Scholars who argue that a more localized community identity exists among Maya peoples in Yucatán observe that it is typically defined by region and is dependent upon the local traditions, belief systems, language, dress, home construction, agricultural practices, diet, and food preparation that a community shares. Variations in these same cultural markers

exist and can be defined in the Puuc region, and they are what distinguish the Maya of Yucatán from the Maya of areas of Chiapas, Quintana Roo, Campeche or from those of other areas and communities.

In some ways, we can argue that a more common "Maya" identity that cuts across and unites those living in different regions does exist, but its very being is a result of the outside forces and circumstances that have been imposed on Maya communities. These external factors include the periodic efforts to organize widespread resistance to the more onerous aspects of Spanish colonial rule (e.g., the Can Ek rebellion or 1761), the appropriations of land, and the harsh labor conditions of the hacienda period (resulting in the Caste War of 1847).[228] More recently, a kind of common "Maya identity" has been imposed by the way in which anthropologists and archaeologists and, in a somewhat different way, tourist visitors, see the Maya-speaking peoples as the descendants of a pre-conquest Maya "civilization." Yet, according to Gabbert, a true sense of one's cultural identity is not fully formed among the Maya in Yucatán, and he notes that, Yucatec Maya identity "is still ethnic consciousness in the making."[229] In Yucatán, local traditions are highly idiosyncratic, and most customs do not extend beyond the northern reaches of neighboring states Campeche and Quintana Roo. These traditions—language, dress, agricultural practices, belief systems, language, diet, etc.—have been upheld in some form through the centuries, but they are continually adapted to adjust to the realities of modern life. Thus, it is up to the Maya to consciously and consistently practice the ways of their culture, impart them to their children, and confirm the value of this traditional way of life within their community in order for them to continue beyond the current generation.

Based on these cultural markers and traditions, how do the artisans from the Puuc region identify themselves? Angel considers himself "Maya-Yucateco," that is, he is first and foremost Maya while the "Yucateco" simply designates the region where

he lives.[230] Miguel calls himself a "Maya-*mestizo*" because what he speaks is a "mestized Maya" that is not the original form of the language, but he notes that he is "still proud to be Maya, a Maya-Yucateco."[231] Like Angel, this designation of "Yucateco" refers to the geographical location of Yucatán rather than an implied ethnicity. Wilbert admits that people from Yucatán are "Mexicans" in the sense that they live in the Republic of Mexico, but like Angel, Wilbert identifies himself as a "Maya-Yucateco."[232] He considers the designation "*mestizo*" to be merely a cultural aspect, that is, related to the mixing of the Spanish and Maya languages and customs, rather than any kind of ethnic identity.[233] Wilbert also points out that when he says he is "Yucateco," he prefers to say that he is from Muna because of his connection to his family and friends there.[234] "I feel that I am deeply tied to my hills of Muna," he says.[235] This connection to "place" comes back to the idea that Maya identity is embedded in a sense of community at the local level, rather than some more universal sense of "Mayaness." Jesús seems to be the odd man out, since his self-identification is "Yucateco-Maya," and he emphasizes that he is very proud to be "Yucateco."[236] In this case, "Yucateco" seems to be both a regional designation as well as a cultural identifier. Jesús feels that he is Maya, but not directly. Even though he possesses a Maya surname ("Kú," like Miguel's "Uc") that shows his family's direct descent along a Maya lineage, he does not feel as strong a connection to his Maya heritage as Angel does, for example.[237]

As can be seen from the Puuc artisans' self-identification, notions of Maya identity in Yucatán are not clear-cut nor universally agreed upon, even among cultural insiders. This conforms to Watanabe's contention that the Maya "fashion their own identity" in the face of impinging external influences and that they "must constantly demonstrate their Mayaness to one another or risk losing it."[238] It should be noted that Watanabe was discussing the importance of ethnic identity in the context of Guatemala, where there has been great pressure for Maya-speaking peoples

to "modernize." There, the retention of traditional practices (*costumbre*) and dress (*traje*), although celebrated in tourist advertisements, is often seen as backward by political authorities. Consequently, retaining one's "Maya identity" has been part of a struggle not just for cultural continuity, but for physical survival.[239] As Quetzil Castañeda has pointed out, however, the identity politics and cultural revitalization projects that exist among the Maya of northern Yucatán do not compare with the larger and more highly organized programs of Guatemala (with the pan-Mayanists) and Chiapas (with the Zapatistas).[240] This is due to that fact that the historical trajectory and present-day circumstances of the Maya of northern Yucatán differ considerably from those of other groups in Guatemala or Chiapas. Although their history has certainly been marked by periods of persecution, harsh labor, and political and cultural marginalization, the Maya of Yucatán "have a dramatically different history of conquest, colonization, independence and incorporation into a larger nation-state" and thus "a different relationship to the world" than those of their Maya neighbors to the south.[241] Castañeda observes that "the discourses that celebrate the Maya as a culture and people surviving oppression, modernity, and capitalism through struggles against the national (and racialist) elite, create a monolithic stereotype that erases the heterogeneity and cultural diversity of the Maya."[242] He recalls that one of his friends who lives in Pisté, and who self-identifies as "Maya," in response to the 2001 Zapatista march on Mexico City, stated that "We [i.e., Yucatec Maya like him] are not indigenous!"[243] This response represents his rejection of an identity that sees all Maya peoples as oppressed, engaged in political protest, and cultivating a pan-Maya identity.[244] Nevertheless, recognizing that the Yucatec Maya live in a different country and political context, it may still be true, as Watanabe suggests, that "Maya is what Maya do, as long as other Maya acknowledge it as such."[245] Although this assertion seems vague, such a matter-of-fact definition is actually quite coherent since it

recognizes that one's personal "identity" is shaped by and reconstituted as part of a social practice. In this sense, an individual's "Mayaness" depends on recognition and affirmation by others, rather than simply resting on self-assertion.[246] However, given the relatively small number of "insider" ethnographical or scholarly studies of Maya identity exist at the village level, identifying a definitive and invariable set of the cultural beliefs and practices that confirm a sense of "Mayaness" and "authenticity" within a specific group remain debatable.[247] Castañeda proposes that "Maya" is "an embattled zone of contestation of belonging, identity, and differentiation."[248] He further notes that "Too often the public eyes of the international media and academic community assimilate all Maya to a homogenizing category of a uniform identity," which the tourism industry uses to "construct an image of the Maya as mysterious and living outside of time."[249] These problematic constructions demonstrate the necessity for serious efforts based on field research to be made to interrogate the way the designation of "Maya" is used as a "sign, symbol, substance, political codes, and boundary of identity and belonging."[250]

Although tourism does misrepresent or over-simplify some aspects of pre-Columbian and contemporary Maya culture, it may actually be responsible for the preservation of some Maya cultural traditions "otherwise doomed by the modernization of wider society."[251] Maya people find new reasons to preserve these traditions in the context of the tourism industry, which stimulates economic development in rural and impoverished areas. However, some of this "preservation" takes the form of events organized for "heritage tourism," which often represent instances of "staged authenticity" performed or created for visitors rather than for local purposes.[252] Accordingly, Ehrentraut posited that, "the more successful the touristic development of La Ruta Maya, the more complex, intense and widespread will become the ethnonationalism [i.e., collective cultural identity] of the Maya themselves."[253] In other words, Ehren-

traut argues that the mass tourism made possible by globalization encourages an increased sense of Maya cultural identity. This idea conflicts with the model of acculturation laid out by Redfield and supported by many scholars since that posits that modernization and globalization increase homogenization toward Western culture. Other scholars such as Castañeda, Hervik and Kahn, and Castillo Cocom have countered this argument with fresh perspectives and research on Maya identity in the Yucatán peninsula.[254] They have looked at the ways in which Maya identity is first and foremost a self-conscious designation rather than being so dependent on the pressures and developments of the modern world. Any emphasis on celebrating the achievements of pre-conquest Maya cultures, and awareness of striving to preserve the "traditional" aspects of the "folk" culture in Yucatán, is limited. While external pressures have led to some grassroots activities (that could be related to a kind of "pan-Maya" cultural reclamation) among Yucatec Maya, they do not represent a widespread trend among the broad spectrum of Maya-speaking peoples living in Yucatán today.

Tourism and Representations of the Maya

A number of anthropologists, such as Castañeda, Hervik and Kahn, and LaBreque, have begun to take a more self-critical and reflective approach to their work, moving away from objectifying the Maya (or other non-western peoples) as "other" to exploring how Maya identity is constructed, both by insiders and outsiders.[255] This brings up the issue of how Maya identity is represented by and for cultural outsiders, and the complex nexus that exists between the practice of archaeology (and the history of art) and popular media through which perceptions of Maya identity are transmitted to a broader public. There is also the practical side in which state and private interests merge in the promotion of heritage tourism (discussed further in Kowalski's essay in this volume).[256]

For many tourists who visit Yucatán, their notions of Maya identity are centered on contrasting or overlapping visions of the distant past (that have been presented to them by the media, the tourism industry, and some wide-reaching scholarly material). Insofar as they have an interest in cultural or heritage tourism (as opposed to recreational sun and surf vacationing), it is that past made visible in the present that draws them in. This temporal collapse of past and present is helped along by visitors being in the presence of impressive pre-Columbian buildings and sculptures at archaeological sites such as Chichén Itzá and Uxmal. To a lesser degree, visitors' perceptions of Maya identity are also shaped by the preservation of older traditional "folk" culture, which is displayed in these "contact zones" of cross-cultural encounter.[257] Quetzil Castañeda notes that "Too often the public eyes of the international media and academic community assimilate all Maya to a homogenizing category of a uniform identity. Many have noted the way archaeological and touristic discourses construct an image of the Maya as mysterious and living outside of time."[258] This has led to the formation of various conceptions of the pre-conquest Maya, all of which are organized around particular tropes, some of which could be characterized (in an admittedly shorthand manner) as a "lost civilization," the "magnificent Maya," the "mysterious Maya," and most recently the "militaristic Maya."[259]

What we here term the "lost civilization" paradigm refers to the speculations about the origins of pre-Columbian societies and peoples during the colonial period and the "discovery" of lost cities in the jungle by nineteenth-century explorer-archaeologists. The complementary "mysterious Maya" concept refers to the wonderment that "civilization" could emerge from a tropical forest environment and then be swallowed up by it in the perplexing "collapse," as well as to the "mystery" of the then unreadable hieroglyphic texts.[260]

The "magnificent Maya" vision of ancient Maya society and culture began to emerge with the projects of the Carnegie Institution of Washington (C.I.W.)

in the early twentieth century centered on the Maya civilization's extraordinary practical, scientific, astronomical, and cultural achievements. The latter were exemplified by the remains of sites such as Tikal, Copan, Palenque, Yaxchilan, and other imposing archaeological sites whose visible structures and monuments defined the so-called "Classic period" (placed at AD 300 to 900). The founder of the C.I.W. Maya program at Chichén Itzá, Sylvanus G. Morley, popularized the concept of the Maya as the peaceful and prosperous "Greeks of the New World." In *The Ancient Maya* (1946) he celebrated their architecture, artistry, and inventions, declaring that the Maya were responsible for the greatest contributions to Mesoamerican civilization and were "the most brilliant aboriginal people on this planet." This cultural characterization was furthered by J. E. S. Thompson, whose popular books spoke of ancient Maya civilization as a peaceful priest-governed society, centered on astronomical observations and the celebration of cyclical period endings in a cult devoted to the worship of time itself.

This "magnificent Maya" paradigm of Classic society (coupled with some continuing emphasis on its "mysterious" nature) was complemented by ethnographic studies of the Maya. Robert Redfield's work on Chan Kom, Yucatán, for instance, stressed the ways in which the Maya retained aspects of a "folk culture," but even these "survivals" represented a decline from the greatness of their predecessors. According to this view, rural Maya culture was a syncretistic blend of pre-conquest and Spanish colonial beliefs and practices and it was seen as relatively conservative and unchanging. Morley saw the genealogical link between modern Maya and their ancient predecessors as indicating an implicit cultural continuity, at least at the "folk level," an attitude that still pervades more popular representations of contemporary Maya culture (see Hervik 1999).

The 1960s and 1970s witnessed a changeover from the Morley-Thompson paradigm (our "magnificent Maya" tag), to the development of "New Archaeol-ogy," which focused on studying the development of ancient Maya society within a framework of cultural ecological evolution. It involved the mapping of larger settlements and "humble house mounds" instead of only the monumental core architecture and monuments. This made it clear that the Classic Maya centers were cities with large populations, and were embedded in complex hierarchical networks of other settlements within their vicinity. Coupled with the new information provided by hieroglyphic studies (which indicated that the inscriptions recorded the history of the royal dynasties that governed these cities), the period of the 1960s and 1970s led to the recognition that Maya society did not exist as an idyllic priestly society, but adapted and changed as it coped with internal pressures and challenges posed by growing populations (e.g., the need for more intensive agricultural production, competition among different city-states, and even factional disputes and jockeying for power within polities). On the one hand, this could be described by a catchphrase such as the "historical Maya" or the "competitive Maya." However, a case can be made that the aspects of the new research that have most broadly affected popular perceptions of ancient Maya society are those associated with warfare and various forms of sacrifice (particularly ritualized personal bloodletting of the type performed on the Yaxchilan monuments replicated by the Puuc artisans). This shift in popular consciousness is reflected in T. Patrick Culbert's statement regarding the impact of Tatiana Proskouriakoff's discoveries on the historical nature of the inscriptions. Proskouriakoff recognized the emphasis on warfare and capture events in the inscriptions of Yaxchilan, and in Culbert's words, the "gentle priest leaders disappeared to be replaced by hereditary rulers as bloodthirsty and egomaniacal as the kings we know and love from elsewhere in history."[261]

As Castañeda notes, these tropes are systematically reinforced upon entering the tourist zone and archaeological sites themselves through deployment

of texts, guides and guidebooks, tourist arts, and souvenirs.[262] When used to promote the Mundo Maya to tourists, they conform to Richard Wilk's "modernization" paradigm mentioned previously. As Magnoni, Ardren, and Hutson observe, "One aspect of marketing tourism in the Mundo Maya has been to stress the millenarian nature of Maya culture characterized by cultural continuity between contemporary Maya speakers and the prehispanic population."[263] They note that "The Mundo Maya, . . . markets the Maya through unreconstructed essentialism, glossing over the discontinuities between contemporary and prehispanic Maya people. . . . These notions of continuity draw on essentialized and exoticized interpretations of past and present Maya that fulfill Western fantasies instead of focusing on the complex processes of cultural and historical change that social groups undergo through time."[264]

Although the Mundo Maya and La Ruta Maya projects were designed primarily to encourage tourist travel and spending throughout the Maya region, and tourist promotional brochures portray rather reified images of the Maya people and culture designed to appeal to outsiders, the promoters of such imagery can also include local Yucatec Maya. This situation seems contradictory; why would a Maya want to promote ideas that exoticize and present only a partial picture of his present-day life and culture? The obvious answer is that it is financially advantageous to do so, since tourists visit the archaeological sites of Yucatán in search of the images of, and encounters with, "authentic" Maya culture they have seen in promotional brochures, in the pages of *National Geographic,* or in popular scholarly books.[265] A visitor who has read texts that focus on general history and iconography of the Maya, such as Michael Coe's *The Maya* and *The Blood of Kings* exhibition catalog, arrives with certain assumptions regarding what constitutes a more genuine and uncontaminated "Maya culture," whether that of the pre-Columbian past, or embodying the "folk culture" that maintains traditions resistant to change.

The archaeological sites become markers of "living culture" in that they embody, for the tourist, the collective identity of the modern indigenous groups whose ancestors were responsible for their construction. Modern Maya thus become "invisible" for the inquiring tourist; they are seen through the lens of antiquity as the descendants of their ancestral civilization rather than embodiments of a contemporary Maya culture.

To some degree, this state of affairs permits Maya artisans working at the archaeological zones to capitalize on their Maya identity and cultural heritage. For instance, some artisans will intentionally promote the idea of the Maya as being part of a "living culture" by emphasizing their connection to the past. This is accomplished by sharing bits of their indigenous heritage and knowledge of Maya history with potential buyers of their wood carvings. For example, to attract buyers, Jesús Delgado Kú likes to converse in Maya with the other guides at Kabah as a marker of his indigenous identity. Watanabe states that speaking a Maya language doesn't necessarily define what is "Maya," but it does differentiate Mayas from Spanish-speaking non-Mayas and helps them to transmit their cultural identity to outsiders.[266] Along these lines, Jesús even likes to teach visitors a few Maya words or phrases to take back with them to enhance their cultural experience. Following Hervik's notion regarding *National Geographic's* tendency to portray a culture based on its audience's preexisting understanding of it,[267] Jesús' technique may not further a true understanding of contemporary Maya culture to cultural outsiders, but his efforts help to secure a sale if the buyer doubts his heritage and thus the object's "authenticity" as the artistic product of a "real Maya." Of course, as Graburn notes, if the stereotypes that are perpetuated by cultural outsiders are not corrected or clarified by cultural insiders, there is a danger that members of the local group "may come to believe the same things about themselves or their past as the outside world does."[268]

The Carvings and Contested Understandings of Art

A final issue to consider is how the categorization of "tourist art" affects the way we value, interpret, and attach meaning to objects created by artisans outside of the Western world, and thus affects how we view the Puuc and other Yucatec Maya wood carvings in this exhibition. Briefly tracing the history of how art has been studied and understood by scholars, critics, museums, and artists, permits us to recognize the boundary between "high" and "low" art is no longer clear, and that traditional "non-arts" (e.g., commercial art, tourist art, etc.) increasingly are recognized valid and vibrant expressions of visual culture and alternatives to the elitist attitudes of the art world.

For the average person, there exists a romantic stereotype that ethnic and folk arts must emerge from a continuous "living" tradition and still serve a ritual or utilitarian purpose to be "authentic." Moreover, although it is recognized that they are not created purely as "art for art's sake," there is also an expectation that they are created to embody indigenous cultural concepts, and certainly not made only for the sake of commercial gain. However, as is discussed in Christopher Steiner's essay in this volume and his related work on the Senufo carvers of Cote d'Ivoire, or in the references in Janet Berlo's essay to various innovative types of Native American arts produced primarily for outsiders, the reality in both past and modern craft-producing communities reveals vibrant commercial markets, savvy and experienced vendors, and artful and innovative objects that, although they may or may not be based on traditional forms, serve no "traditional" purpose outside of their creation for sale to foreign visitors and buyers.[269] To better understand why modern indigenous peoples produce types of aesthetic artifacts and crafts for economic gain rather than indigenous cultural or spiritual purposes, and perhaps to put to rest the most stubborn stereotypes, Nelson Graburn proposed that the following seven categories could be used to analyze and classify the production of ethnic and tourist arts: (1) extinction of traditional arts, (2) traditional or functional fine arts, (3) commercial fine arts, (4) souvenirs, (5) reintegrated arts, (6) assimilated fine arts, and (7) popular arts. These categories certainly are not mutually exclusive, as a number of tourist arts incorporate aspects of several of them. Applying them to the various types of Maya artifacts featured in this exhibition, we might consider the more simply carved and mass-produced contemporary wood carvings from Chichén Itzá to fall within the category of "souvenirs," which Graburn defines as objects produced with the potential for economic gain in which aesthetic standards are overridden and when "satisfying the consumer becomes more important than pleasing the artist."[270] However, although this would preclude such artifacts from being classified as "fine art," according to traditional Western definitions, it does not eliminate their value as subjects of study for the sociology of art and aesthetics. As Castañeda demonstrates in his essay, the particular combinations of form and subject matter seen in the *máscaras*, *mascarones*, and *ídolos* type figures illustrate that such aesthetic traditions have particular histories conditioned by specific cultural, social, and economic factors that provide opportunities at the same time they both constrain and/or expand the possibilities for artisans. Although the predominantly financial motivation of many Chichén Itzá artisans has led many of them to invest less effort in careful finish and more in visual flash, it has now also resulted in the construction of a vibrant art market working on several levels that challenges existing Western categories of "art" versus "craft" and obliges us to reconsider how we value and understand the artistic expressions of other cultures.

Before we move forward with this discussion, however, we will briefly consider the traditional understandings and definitions of art and aesthetics against which Graburn and others were reacting. As Phillips and Steiner have noted,[271] the standard Western definition of art, and the system for clas-

sifying the arts, emerged during the Renaissance, expressed in sixteenth-century biographical art histories (e.g., Vasari's *Lives of the Painters*) that celebrated the personal creativity and genius of individual artists. The philosophical field of aesthetics, a term originated by Alexander Baumgarten, was given seminal expression in the work of Immanuel Kant, who stressed that judgments regarding art and beauty differ from those based either on pure reason or practical outcomes, and that aesthetic experience constitutes a separate domain centered on a universally shared sense of taste. Kant's concepts, although challenged and modified to some degree, had a profound impact on the German critical historians who established the discipline of art history in the nineteenth century. According to Michael Podro, their studies were based on "the Kantian opposition between human freedom and the constraints imposed by the material world."[272] Thus, the role of art "was seen as overcoming our ordinary relations with the world," resulting in the creation of "higher" and purer self-expressive forms liberated from "lower" practical functions, an interpretation often summarized as "art for art's sake."

The study of self-expressive forms was exemplified in Heinrich Wölfflin's *Principles of Art History*, which was published in 1915 and became a widely read and highly influential statement of formalist aesthetics. Wölfflin's ideas regarding the inherent affective power of forms were grounded in enlightenment theory, and they greatly influenced the discipline of art history as it was developing in the United States.[273] His concept of aesthetic experientialism finds common ground with Kantian aesthetics in that both are interested in the intuitive experience of sensation. In Wölfflin's theory, "the importance of form is not the shape, but the breath of life that brings frozen forms into dynamic motion."[274]

Aesthetic experientialism became newly relevant for the generation of art critics concerned with abstract painting in the 1950s, particularly Clement Greenberg. In his seminal essay, "Avant-Garde and Kitsch," Greenberg set out to define the boundaries not only between avant-garde and kitsch, but between "high" and "low" art as well. For Greenberg, painting and sculpture belonged to the former category and decorative arts and crafts to the latter. Kitsch was thought of as not just "low" art but the industrialized and mass-produced commercial imagery of popular culture. Its opposite, the avant-garde, represented "high" art not only in terms of its media but because it represents the "advanced" forms of painting and sculpture that, for Greenberg, were thought to move society forward as the product of an educated elite.[275]

As though to visibly embody Greenbergian discourse regarding advance high art, Abstract Expressionism emerged during the 1950s as the new avant-garde. Greenberg championed the work of Jackson Pollock, championing his famous "drip paintings" as the pinnacle of creative "authenticity" in modernist art and its search for pure expressive form. Pollock and fellow Abstract Expressionists such as Willem de Kooning and Mark Rothko were elevated to celebrity status. Greenberg felt that abstract expressionism and a subsequent color field movement represented a kind of "end of art" that had found its truest self-realization.

Pushing against these ideas, Pop art developed as a response and reaction to hyperbolic celebration of personal expression, as well as the over-commercialization of art produced by the Abstract Expressionists.[276] Perhaps following the ideas presented by Lawrence Alloway in his 1958 essay "The Arts and the Mass Media," Pop artists supported the premise that industrialized and mass-produced arts could be a redeeming rather than a threatening aspect of culture. As a consequence, these artists, who included Roy Lichtenstein, Andy Warhol, and Robert Indiana among others, drew inspiration from, and in some cases freely borrowed or "appropriated" imagery from Hollywood and entertainment icons, advertising, and objects of popular culture for their art creations. As a result, the movement came to be

known as "Pop," and critics such as John McHale and Alloway promoted the movement and challenged the conventional definitions of "high" and "low" art.[277] Alloway contended that the rejection of kitsch and the mass produced does not preserve culture, as Greenberg argued, but it is instead responsible for cultural demise. He further argued that the mass arts and kitsch promote the culture of the industrial age.

In some important ways, these challenges to the long accepted aesthetic definition of art, and categorizations delineating "high" art from "low" art are related to changing evaluations of Western art versus non-Western art.[278] Since the way Western critics place value on categories like kitsch and mass-produced (i.e., "low") arts is similar to the way they view non-Western and "primitive" art, what happens when critics are left to comment on the unfamiliar styles, subjects, and formats inherent in contemporary non-Western art? For instance, does "high" art include non-Western visual culture? Is Indian basket weaving art? Does geographical location or economical development necessarily determine what can be viewed as fine art? Carolyn Dean, a pre-Columbianist scholar, notes that "calling something art reveals nothing inherent in the object to which the term is applied; rather, it reveals how much the viewer values it."[279] Similarly, Susan Vogel, a specialist in African art, believes that designating a non-Western object as "art" is problematic, given that such "aesthetic recognition . . . depends on changes in Western taste."[280]

These shifts in taste reflect the way objects are classified in a hierarchical system of cultures that emerged as part of the history of European colonial expansion, scientific discovery and exploration, and the emergence of modern academic disciplines such as art history and anthropology. James Clifford has discussed these issues and proposed that they have resulted in the establishment of an "art-culture system, . . . through which in the last century exotic objects have been contextualized and given value in the West."[281] In this system particular objects are categorized and evaluated either as "art" which is

seen as something more original and singular, or as "artifact," which is traditional and collective, and represents a "culture." He subdivides this binary art-artifact/culture opposition into four "semantic zones": (1) authentic masterpieces; (2) authentic artifacts; (3) inauthentic masterpieces, and (4) inauthentic artifacts. In general, the types of carvings shown in this exhibition until recently would have fallen in the latter category. However, as Clifford notes, it is possible for such work to migrate upward, transforming from "tourist art" into more authentic expressions of "cultural-artistic" strategies.[282] In many cases, this involves new recognition of the aesthetic quality of previously ignored traditions, although in many cases it is valued not simply, or even primarily, as the product of an individual artist, but for its association with a particular cultural group or historical tradition (e.g., Shaker furniture, Inuit stone carvings, Aboriginal Australian paintings, Haitian paintings, etc.). One could argue that this process is being implemented in this exhibition centered on the display and analysis of elaborate carvings by the four Yucatec Maya artisans. We recognize that this is so, but also note that Clifford's purpose in describing his art-culture system was to indicate that various types of aesthetic artifacts that arose from and are embedded in larger historical and social matrices, and that classifications and values assigned to objects in the system have regularly undergone change.

Clifford proposes that once the aesthetic object is recognized as "art" among the general Western public, it is no longer at risk of being relegated back into a "lesser" category, such as folk art or craft.[283] However, many contemporary scholars recognize that the distinctions made between these categories are not hard and fast, but somewhat arbitrary and contingent, depending on how they are framed and discussed within an institutional discourse, rather than being an inherent quality. Such a sociological approach has been taken by the Pierre Bourdieu in *Distinction: A Social Critique of the Judgment of Taste*, as well as by Howard Becker in *Art Worlds*.[284] Both of

these writers observe not only that the production of artworks depends on social networks and collective activity, but also that they are categorized according to aesthetic criteria that are determined and applied by members of social sub-groups who share mutual, or at least, symbiotic economic and "class" interests, as well as having the same "taste."

Clifford brought this critical approach to bear in his commentary on the Museum of Modern Art's Primitivism in 20th Century Art show of 1989, noting that supposed "affinities" between modernist artworks and non-Western aesthetic objects with which they shared formal resemblances favored the narrative of "creative" European artists appropriating what they perceived as primal, exotic, erotic, or violent aspects of such "tribal" works, even as most of the catalog essays largely ignored the role of colonial enterprises in acquiring such goods, or their original social functions and meanings.[285] As Steiner observes in his essay in this volume and elsewhere, these stereotyped "representations" of "authentic" African art have conditioned the type of art works that are produced for sale to tourists, or searched out (even if only through the pretense of finding them in the "back region" of a tourist art shop).[286]

The influential Magiciens de la Terre exhibition co-curated by Jean Francois Lyotard at the Pompidou Centre in Paris in 1989 also brought issues of categorization and framing to the fore. Although Magiciens attempted to place primitive "low" art alongside Western "high" art in a way that did not intentionally imply hierarchies, for the most part, critics still evaluated the non-Western work in Western terms, and exhibiting such objects in a museum setting clearly contextualized them as "art."[287]

The art world of the late 1980s and early 1990s was concerned with altogether different issues than the Greenbergian interest in distinguishing "high" from "low" or the avant-garde from kitsch. Sociopolitical in nature, the issues dealt primarily with the politics of identity on race, gender, and sexual orientation. The heated debates surrounding them spilled beyond the art world to society at large, becoming the focus of the controversial period known as the "Culture Wars." It is from this turbulent period that terms that we readily employ today such as "political correctness," "postmodern," and "postcolonial," came into being.[288] This "politics of difference," as the Culture Wars were sometimes called, was an effort by marginalized groups to assert their identity through the articulation of their diverse interests rather than continue to allow themselves to be lumped under one umbrella category of "other" by the dominant members of society, social conservatives, or the political right. It was marked by controversies, including Andres Serrano's provocative piece, *Piss Christ* consisting of a large-scale photography of a plastic crucifix floating in a vat of the artist's own urine, as well as the exhibition *Robert Mapplethorpe: The Perfect Moment*, which included several blatantly homoerotic photographs by the artist, an openly gay man who had recently died of AIDS. Because Serrano had received funding from the National Endowment for the Arts, his work caused an uproar among social conservatives in Congress and triggered a chain of events that was capped by the Corcoran Gallery's cancellation of the Mapplethorpe show, followed by the arrest and trial of Dennis Barrie, the Director of the Cincinnati Art Center, when he showed Mapplethorpe's work, including the contested images.[289]

The Culture Wars also affected the way that the art world values and understands underrepresented forms of art previously considered "low art" or "non-art." Even kitsch, the epitome of lowbrow bad taste for Greenberg, "now reads like a set of instructions for today's avant-garde [i.e., leading contemporary artists], for whom the 'fully matured cultural tradition' is, of course, modernism."[290] The boundaries between "high" and "low" are less clearly defined than they once were, and this blurring of categories, which Susan Sontag observed as early as the 1960s, continues to erode them.[291] Kenneth Wahl concurs: "Art now makes the boundary between high and low, avant-garde and kitsch, pointless."[292]

In his essay for this volume, Castañeda suggests that insofar as the Puuc *réplica* style carvings featured in this exhibition are based on well-known images of pre-conquest Maya monumental and elite art traditions, but are designed to appeal and are offered for sale to tourist visitors, they meet the standard definition of kitsch. This is certainly true, although he also points out that the types of carvings made by the artisans at Pisté and in the Puuc region are breaking down the old boundaries between "high" and "low." This issue is considered from a different perspective by Scott in her essay. Briefly affirming points she makes regarding the current interest in artistic "appropriations," we note that artists have been actively and deliberately "appropriating" aspects of the form and subject matter of other art works for their own purposes for millennia, although the specialized use of the term to describe projects like those of Sherrie Levine, Jeff Koons, and others have invested it with greater relevance in contemporary discussions of aesthetics. The Puuc artisans knowingly and skillfully utilize pre-existing images that they understand are references to a pre-conditioned "representation" of the Maya past to those who visit the "Maya World" in the present. What prevents them from receiving the same recognition as some other postmodernist appropriations clearly hinges as much (or more) on their background and location in a field of cultural production, or what George Kubler would have called the nature of their artistic "entrance," as it does on their ability, skill, talent, or intelligence.[293]

Beginning in the 1970s, but burgeoning in the 1980s and 1990s at the height of the Culture Wars, Visual Culture Studies emerged as an interdisciplinary school of thought that aimed to broaden serious study of a wide range of objects and media typically considered to fall outside the established categories of "fine art."[294] Visual culture generally refers to all visual aspects of culture that we interact with and respond to, including "fine arts, tribal arts, advertising, popular film and video, folk art, television and other performance, housing and apparel design, computer game and toy design, and other forms of visual production and communication."[295] Thus, it is not limited to the traditional art historical category of fine or visual art (e.g., painting, sculpture, etc.), but can be considered to encompass it, since, as Kerry Freedman notes, all art forms "have visual culture characteristics."[296] According to Freedman, visual culture provides context for the visual object at the same time it draws connections between fine art and the popular arts, categories that until recently have been so strictly defined in the discipline of art history that they have traditionally not allowed for any mobility of objects between them.[297]

Concurrently with the growth of visual culture studies, the discipline of art history itself was undergoing significant change, resulting in what has sometimes been called the New Art History, a catch-all term for "a range of developments in academic art history related to issues of disciplinary methods and approaches, theories, and objects of study."[298] These new developments were less concerned with fine-grained studies of style and iconography, and more focused on what had at one time been termed "extrinsic" approaches grounded in Marxist studies, the "social history of art," psychoanalytic discussions of how visual representations constructed social and sexual identities, and semiotic concepts and methods for analyzing the meanings of signs. In many cases, the books and articles produced represented an "activist" scholarship, interested in challenging traditional hierarchies and canons, both by laying bare the historical forces that had created them, hidden assumptions underlying them, and class, gender, or racial and ethnic biases they concealed, as well as by bringing to fore the previously underexamined artists, movements, themes, or media.[299]

As theories pertaining to the visual world continue to shift, it has become more common to consider individual artworks within the "experience" of a visual event rather than just as a stand-alone visual object. Some scholars argue that the experience of the visual "does not stop with the optical,"

since experience is defined by the shared interaction of all the senses as well as the psychological understanding of the individual as spectator.[300] In this view, what is most important in Visual Culture Studies, and to an increasingly greater extent in art history as well, is not the art object but its role in the production of socially and culturally constructed meanings and messages and the way(s) they are transmitted and perceived by the viewer/consumer, as well as the part they play in constructing identity.[301] Such an understanding of visuality can also be applied to studying the visual productions of other cultures, including the types of wood sculptures produced for sale to tourists considered in this exhibition.

With the end of modernism, notions of social order, beauty, and good taste were redefined to include disparate genres and styles and art forms not typically considered art at all (e.g., graffiti, commercial art, etc.), and "the art of all peoples [became] equally worthy of preservation and presentation."[302] As Arthur Danto has pointed out in *After the End of Art*, the modernist notion that art has a central narrative (exemplified by the formalist aesthetics and 'truth to materials' conceptions of Albert Barr or Clement Greenberg) has been replaced by the notion that art may draw on multiple sources and create a plethora of styles.[303] Instead of consisting of just one all-encompassing art world that reigned over and defined the appropriate category and value for all artistic production, the postmodern art world is now seen as "many different art worlds, each with a different relationship to the larger culture, each with a different agenda, a different manner of speaking, and a different audience."[304]

Noting the positive impact of these new critical perspectives, Stephen Westfall observes that "fifty years later one finds that kitsch and high culture coexist and intermingle with little real damage to, and probably a great deal of reinvigoration of the latter."[305] Like other types of marginalized and underrepresented expressions of visual culture, "tourist arts," like those on display in this exhibition, have benefited from the more inclusive paradigms that have replaced older Greenbergian models for the categorization of art.

Concluding Thoughts

This exhibition strives to make the distinctive wood sculptures produced by four carvers—Miguel Uc Delgado, Angel Ruíz Novelo, Jesús Marcos Delgado Ku, and Wilbert Vásquez—from the Puuc region of Yucatán understandable from several perspectives. Although the technically refined and visually complex carvings of the Puuc region are often described as handicraft or "tourist art," it no longer seems appropriate to tag them with the pejorative connotations associated with such terms. Rather, they provide important information regarding how a relatively recent artistic "tradition" emerged in and responded to particular historical context, and communicate significant messages about the changing nature of Maya cultural identity, and how such identity is constructed, represented, and understood by both the artisans themselves and tourist visitors in the context of cross-cultural contact and global interconnections.

The wood sculptures carved by the Puuc artisans, as well as other carvings produced by those who work elsewhere in Yucatán, can be appreciated both for their carefully finished and personal reinterpretations of ancient iconography as well as for the syntheses of form and meaning that result from such inspiration. The emergence of this vibrant tradition of art making demonstrates that the effects of tourism are complex. The influx of cultural tourists to archaeological sites in the Puuc region, coupled with the inspiration provided by related recent tradition of wood carvings developed at Pisté, provide the impetus for a group of entrepreneurial local artisans to combine opportunities for economic gain with creative expression.

The Puuc carvings are a complex phenomenon, and they present problematic images of "Maya" identity.

Many tourists recognize them as being accurate facsimiles of ancient Maya imagery. This, coupled with the fact that they are handmade by a local "Maya" artisan, gives them a certain "authenticity" while providing a tangible reminder of a direct contact with the "Mundo Maya." The artisans themselves recognize that a historical and cultural gulf separates them from the ancient Maya, yet feel a sense of pride in their distant ancestral heritage. While the carvings are made to supplement income, and vary in size, detail, and level of finish, Miguel, Angel, Jesús, and Wilbert make it clear that making these carvings provides them with sense of satisfaction and personal creative expression. Thus, although tourism tends to reinforce visitors' ideas that the most authentic image of Maya culture resides in the pre-Columbian past, the economic incentive it provides also has supported these artisans' efforts to reclaim and re-task such cultural imagery, giving it new meanings that convey only one strand of their more complex contemporary cultural identity, while permitting them to express both the artistic and entrepreneurial aspects of their personal identity.

Although it has been common to classify the types of carvings created by the Puuc artisans as "tourist art," typically considered to be a form of "low art," this exhibition argues that, like all aesthetic artifacts, these carvings emerge from and reveal aspects of the historical, cultural, social, and economic matrix in which they arise. As such, as forms of cultural expression these sculptures warrant recognition and serious art historical investigation, even as they challenge the limitations that have been imposed on them by current Western art historical criteria and categorizations. They are created by talented and knowledgeable individuals who, like other artists, are motivated by complex combinations of a desire for economic gain, social recognition, and personal expression, and they communicate significant messages about how Maya cultural identity is negotiated and expressed visually in a world increasingly affected by forces of globalization.

Notes

1. Issues associated with globalization are discussed at an introductory level in a relatively recent sociology text by Giddens and Duneier 2000: 4–6, 56–57, 65–72, who note that it is an outgrowth of the growth of capitalism, the formation of the nation state, and processes of colonialization and industrialization, but that increasingly from WWII onward it has involved the "development of social and economic relationships worldwide" (p. 539) as the result of the rise of the power of multinational corporations, computer literacy, the internet, and new communications media, immigration and residential mobility, among other factors. See also Kohler and Chaves 2003.

2. Tilly 1995, 1–2, notes that this is a critical component of globalization, writing that "globalization means an increase in the geographic range of locally consequential social interactions." See Giddens and Duneier 2000: 112–113 for a discussion of tourism; immigration is discussed throughout the text.

3. Diamond 1999, Sabloff and Lamberg-Karlovsky 1975, Frank and Gils 1996.

4. Fanon 2005, Wolf 1982, Wallerstein 1974, Braudel 1992a, 1992b, 1992c. Specifically for the Maya world, these processes are discussed by Farriss 1984 and Restall 1997.

5. Stiglitz 2003. Giddens 2003.

6. Baklanoff and Moseley 2008.

7. The grand tour was type of educational, cultural, and social travel engaged in primarily by young European men of upper class background during the late seventeenth through early nineteenth centuries. It involved a fairly standard itinerary that included various points of historical, cultural and artistic interest, as well as providing opportunities for the traveler to mingle and form contacts with other members of aristocratic society. See Fussell 1987.

8. Cohen 1984, 376–77.

9. Cohen 1984 provides a good overview of these issues as of the mid-1980s. A more recent volume devoted to these questions is Smith and Robinson 2006. Discussions of tourist journeys as pilgrimagelike quests for "authentic" experience can be found in MacCannell 1973, 590, 593, and MacCannell 1976.

10. See Cohen 1984 and Nash 1981 (with comments by other scholars)

11. Urry 1995, cited in Robinson and Smith 2006, 1.

12. As Robinson and Smith 2006, 4 put it, ". . . conventional conceptions of what we understand to be 'culture' have largely been dictated by our postenlightenment sensibilities

regarding the romantic, the beautiful, the educational, and also, by extension, the moral. It is not surprising that what is now heralded as 'cultural tourism' broadly follows the patterns of the 'grand tour' of the eighteenth and nineteenth centuries indulged in by the social elite," although they acknowledge that more affordable transportation has made such travel possible to a wider segment of the public. They define this tourist public (from a European perspective) as a "well-educated, largely White, high-spending, middle-class tourist," p. 5). See also Kirshenblatt-Gimblett 1998.

13. This is discussed by Kirshenblatt-Gimblett 1998, 140–45, and summed up in a quotation from the Wellington Region [New Zealand] Tourist Strategy: "Tourist attractions within the industry are events and facilities oriented to experiential opportunities. Most attractions are in themselves outside the scope of the industry . . . including free, inherent, and natural resources" (Kirshenblatt-Gimblett 1988, 3). This attitude and business strategy presumably reflects the fact that "cultural tourists" form only a small component of the world tourist industry. As Robinson and Smith 2006, 5 put it, "the vast majority of tourists could be said to be culture-proof (Craik 1997) in that they are not seeking the exotic, culture or heritage, but relaxation, warm weather, and various forms of hedonistic activity."

14. Heritage tourism forms a major component of the discussion in Smith and Robinson 2006, and is the focus of Kirshenblatt-Gimblett 1998. Useful studies that discuss the effects of heritage tourism in northern Yucatán include Castañeda 1996, Breglia 2006, and Magnoni, Ardren and Hutson 2007.

15. See, for example, Cohodas 1999, 161.

16. Phillips and Steiner 1999a, 4.

17. The list of articles dealing with these topics is too voluminous to include here, but many are referred to in the catalog text or accompanying essays. Graburn (1999) himself presents a brief historiography of how his initial interest in Inuit art provide the seed for gathering scholars together in a 1970 conference that culminated in the publication of *Ethnic and Tourist Arts in the Fourth World*, as well as reviewing some important literature and theoretical approaches to the field that have developed since its publication. Among the most influential anthologies that feature many articles pertinent to the subject of "tourist art" (or the closely related topic of "primitive" and ethnic arts) are *Exhibiting Cultures: The Poetics and Politics of Museum Display*, edited by Ivan Karp and Steven D. Lavine (1991), *Destination Culture: Tourism, Museums, and Heritage*, by Barbara Kirshenblatt-Gimblett (1998), *The Traffic in Culture: Refiguring Art and Anthropology*, edited by George E. Marcus and Fred R. Myers (1995), *Unpacking Culture: Art and Commodity in Colonial and Postcolonial Worlds*, edited by Ruth B. Phillips and Christopher B. Steiner (1999), and *Anthropologies of Art*, edited by Mariët Westermann.

18. Shelly Errington 2005, 220.

19. A discussion of the art/artifact dichotomy appears in Phillips and Steiner 1999a. Another recent discussion of the issue can be found in Pasztory 2005, 7–15. It reflects an evaluation, or in some cases a re-valuation, of the objects' placement in a predominantly "western" disciplinary practice (i.e., art historical versus anthropological) and epistemology based on categorization of different objects, and by extension the cultures and peoples who produced them, as embodying a hierarchical system of objects that emerged in and reinforced assumptions in colonialist and capitalist economies, as has been discussed by various authors, including Appadurai 1986, Bourdieu 1984, Clifford 1988, Karp and Lavine 1991, Marcus and Myers 1995, Price 2002. Ways in which disciplinary approaches (e.g., art historical, anthropological, historical, folkloristic) determine the nature of museum exhibits and interpretations, and thus affect and shape the viewer's understanding are considered in Karp and Lavine 1991. See also Kirshenblatt-Gimblett 1998, and Karp, Kratz, Swaja, and Ybarra-Frausto 2007.

20. Williams 1976, 76.

21. Matthew Arnold 1883, xi.

22. Ideas put forth in Williams' essay "Culture is Ordinary," reprinted Higgins 2001, 10–24. [Originally published in MacKenzie 1958]. See also Williams 1958.

23. Tylor 1873, 1.

24. William Haviland 1991, 280, notes that considered in this sense, culture has a somewhat ideal and normative character, as though it consists of an essential set of mental guidelines that determines the thoughts and actions of individual members of a society.

25. Geertz 1973, 89. See also Turner 1974, Turner and Bruner 1986.

26. Dirks, Eley, and Ortner 1994, 1. Borofsky, Barth, Shweder, Rodseth and Stoltzenberg 2001 provide a good review and consider the difficulties posed by continued use of the culture concept.

27. A classic expression of this conception of social identity as involving a complex social practice in which individuals merge multiple roles and obligations into a self-conception was formulated by Erving Goffman 1959. Another influential version

takes the form of the "social interaction theory" of Anthony Giddens 1991, 54, who observes that "A person's identity is not to be found in behaviour, nor—important though this is—in the reactions of others, but in the capacity to keep a particular narrative going. The individual's biography, if she is to maintain regular interaction with others in the day-to-day world, cannot be wholly fictive. It must continually integrate events which occur in the external world, and sort them into the ongoing 'story' about the self." See also Pierre Bourdieu's discussion of "structures, habits, practices," in Bourdieu 1990, 52–79.

28. Hall and du Gay 1996, 1.

29. Hall and du Gay 1996, 2 observe that the present perspective "accepts that identities are never unified and, in late modern times, increasingly fragmented and fractured; never singular but multiply constructed across different, often intersecting and antagonistic, discourses, practices and positions. They are subject to a radical historicization and are constantly in the process of change and transformation. We need to situate the debates about identity within all those historically specific developments and practices which have disturbed the relatively "settled" character of many populations and cultures, above all in relation to the processes of globalization, which I would argue are coterminous with modernity (Hall, 1996) and the processes of forced and "free" migration which have become a global phenomenon of the so-called "post-colonial" world. Though they seem to invoke an origin in a historical past with which they continue to correspond, actually identities are about questions of using the resources of history, language, and culture in the process of becoming rather than being: not "who we are" or "where we came from," so much as what we might become, how we have been represented and how that bears on how we might represent ourselves.

30. Hall and du Guy 1996, 4.

31. See Fabian 1983. For a thoughtful discussion of how these ideas relate to study of the Maya of Belize undergoing transformations as a result of globalization and concepts of "progress" see Wilk 1991, 3–33. Related to ideas regarding the relative stability of "traditional" cultures is the notion of acculturation. As defined by Redfield, Linton and Herskovits 1936, 149, "Acculturation comprehends those phenomena which result when groups of individual cultures come into continuous first-hand contact, with subsequent changes in the original culture patterns of either or both groups." Noting that cultures that had formerly been more isolated and independent did, of course, change as a result of the expansion of

European and American (i.e., Unites States of America) power, anthropologists of the nineteenth and earlier twentieth century saw acculturation as a process that mainly affected smaller-scale indigenous groups (often those defeated militarily and made part of colonizing projects or territorial expansion) rather than larger, industrialized nation states. Addressing perceptions of the Native American peoples affected by such processes, Cohodas (1999, 146) notes that any changes to "traditional" cultures were seen as evidence of a detrimental "acculturation." He also notes that "These assessments carried negative connotations because of the dichotomous character of the modernization paradigm, which constructed change as a virtue and a sign of progress when associated with dominant Euro-American groups, but as a threatening vice when associated with subordinated groups" (146). Richard Wilk (1991, 3) refers to this set of concepts as the "modernization paradigm," which, as Cohodas (1999, 145) notes, is based on "a polar opposition of the *modern* (characterized by technology, progress, capitalist commerce, industrialization, alienation from nature, materialism) and the *premodern* or *primitive* (characterized by precapitalist forms of production and exchange, adherence to tradition, closeness to nature, spiritualism)." We do not mean to imply that all (or even most) anthropologists today still subscribe to these older notions regarding the changeless nature of non-Western societies, either before or after contact with Euro-American groups during the age of exploration and colonial expansion. However, as various scholars have noted, the older anthropological paradigms are reflected in the practices of heritage tourism, and products associated with it, that emphasize the traditional and "essential" character of the regions and peoples being visited.

32. See discussions in Graburn 1999, 350–53, Steiner 1999, and Cohodas 1999.

33. Graburn 1999, 351.

34. Erik Cohen 1988.

35. Graburn 1999, 350–53. See also Cohodas 1999, Kasfir 1999, Phillips 1999 for cases in which new types or aesthetic innovations were introduced into the arts of California basket makers, the Samburu people of Kenya, and nineteenth century Huron tourist arts, respectively.

36. Cohodas 1999, 161.

37. Lavine and Karp 1991, 1.

38. Lavine and Karp 1991, 1.

39. The two quotations are from Lavine and Karp 1991, 3. See Cameron 1972.

40. Cameron 1972, 197, quoted in Lavine and Karp 1991, 3.

41. Although this represents the first exhibition to provide an extended investigation of the carvings produced by artisans from the Puuc region, we note that a previous exhibition, *Ah Dzib Pisté*, held at the Durand Art Institute at Lake Forest College, Illinois, and organized by Quetzil Castañeda and Lisa Breglia, examined the aesthetic wood carving "tradition" of Pisté, Yucatán from a comparable perspective. See Castañeda 2004a and Castañeda, Fumero, and Breglia 1999.

42. This issue is also addressed in the accompanying essay by Quetzil Castañeda, who notes that the wood carvers of Pisté, Yucatán also consider *artesano* to be a respectful rather than a dismissive term. The term "artisan" did not have negative connotations in antiquity, when makers of paintings, sculptures, ceramics, and various other crafts were all thought of primarily as those who had mastered the design principles and techniques needed to produce specialized artifacts of particular types. The Latin word *"ars,"* the root of our word "art," refers more to this concept than to the notion of a specialized field focused on the creativity of the artist and the particular aesthetic aspect of the artwork. Manual dexterity and mastery of skills and specialized techniques was a common characteristic of various artifacts that demonstrated the *ars* of their maker(s). A good source for this ancient definition in the context of a study of changing conceptions of the role of the artist over time, appears in Wittkower and Wittkower 2006.

43. For general introductions to ancient Maya society and culture see Sharer and Traxler 2005, Coe 2005, and Demarest 2004. For more specialized coverage of the archaeology of the Puuc region see Pollock 1980, Gendrop 1983, and Dunning 1992. The architecture, art, and archaeology of Uxmal and the Puuc region are presented in Foncerrada de Molina 1965, Kowalski 1987, and Kowalski and Dunning, 1999, 274–297.

44. A diagnostic type of pottery known as "slateware" and other ceramic types that constitute the Puuc Region's Cehpech ceramic complex began to be manufactured between AD 700 to 750 and continued in use until about AD 1000. Hieroglyphic dates, many of which were recorded using a regional "Tun-Ahau" system of dating, tie the late Puuc architecture of Uxmal, Kabah, Labná as well as related "Chichén-Maya" architecture of Chichén Itzá, to the late ninth and early tenth centuries (early Cycle 10 in the Maya Long Count calendar).

45. For the identification of "Lord Chaak" see Kowalski 1987. General discussion of Uxmal's role in the consolidation of a Puuc regional state is found in Dunning and Kowalski 1994, 63–95. For discussion of the iconography of the House of

the Governor see Kowalski 1987, Kowalski and Dunning 1999, Kowalski 2003a. On Chan Chaak K'ak'nal Ajaw see Schele and Mathews 1998, chap. 7.

46. For discussions and interpretations of the architectural sculpture and iconography of Puuc buildings see Foncerrada de Molina 1965, Gendrop 1983, Kowalski 1987, and Kowalski 1994, 93–120.

47. For general overviews of Chichén Itzá see Sharer and Traxler 2005 and Coe 2005. An introduction to the site and survey of artifacts dredged from its sacred cenote appear in Coggins and Shane IV 1984. An early comprehensive study of Chichén Itzá is provided by Tozzer 1957. A recent reconsideration of the site's culture history and its relationship with Tula and other Mesoamerican cities and regions is found in Kowalski and Kristan-Graham 2007.

48. For a survey of northern Maya archaeology of the late Postclassic period, from Mayapan to the time of the conquest, see Sharer and Traxler 2005 and Coe 2005. Milbrath and Peraza Lope 2003 provide a recent discussion of archaeology at Mayapan. For the re-evaluation of the Postclassic see Sabloff and Rathje 1975, 72–82. See Andrews 1993, 35–69 for a review article on the subject, and Masson 2001 for broad discussion of Postclassic archaeology from the perspective of a small rural site.

49. Important sources of information for this section have been overviews provided by Jones 2000, as well as by Moseley and Delpar 2008. Works that cover broad time spans within this period and provide excellent bibliographical sources include Farriss 1984, Joseph 1986, and Moseley and Terry 1980.

50. Although the preconquest name of Mérida is sometimes referred to as Tiho, this derives from the phrase "Ti' Jo'", a prepositional phrase meaning "to Jo'" or "at Jo" (Jo being the Maya city on the site of today's Mérida). Ti' Jo' was used so frequently when talking about the town that the proper place name designation became confused. See UADY's online Maya-Spanish dictionary, http://www.mayas.uady.mx/diccionario/index.html.

51. Landa, who later became the third Bishop of Yucatán, probably wrote his famous manuscript *Relacion de las Cosas de Yucatán*, in which he provides a lengthy account of the native historical traditions, religious beliefs, customs, and daily life of the Yucatec Maya, to explain and justify this harsh treatment to the Council of the Indies in Spain; See Tozzer 1941.

52. For general discussion of the *encomienda* and *repartimiento* systems, as well as other aspects of colonial period

life, political organization, and cultural practices, see Carmack, Gasco, and Gossen, 1996, chap. 5, Jones 2000, 365–74, and Moseley and Delpar, 2008, 21–22.

53. See Bricker 1981, 73 and James Lockhart 1969, 411–29.

54. The transition from *encomienda* to *hacienda* is considered in Farriss 1984, Millet Cámara, 1984, 11–37, and Rugeley 1996.

55. For the history of the Caste War and its impact, see Reed 1964, Lapointe 1983, and Dumond 1997.

56. Moseley and Delpar 2008, 26–31, Turner, 1914, Cline 1948, 30–51, and Wells 1985.

57. Baklanoff 2008, 2–7.

58. Baklanoff 2008, 7–8.

59. Jones 2000, 379.

60. Baklanoff 2008, 2–13. Processes and events affecting the Maya of Yucatán from the post-Caste War period to the mid-twentieth century are considered in Cline 1948. See also Fallaw 2001.

61. See the New 7 Wonders of the World website at http://www.new7wonders.com/classic/en/n7w/results/ (accessed 1 December 2008).

62. Many inhabitants of Santa Elena still refer to the village by its ancient Maya name, which means something like "burning houses," a reference to a great fire prior to the conquest.

63. The mummies, which appear to be children, are believed to be those of German immigrants who settled in Santa Elena in the nineteenth century rather than the remains of ancient Maya individuals.

64. This information is based on Mary Katherine Scott's personal interviews with various individuals in Santa Elena in June and July of 2008, but for the sake of the security of their relatives currently in San Francisco, will remain nameless.

65. This statement is based on a conversation Mary Katherine Scott had with Don Hernán in March of 2007 at his home in Santa Elena.

66. See Hervik 2003, xx. At the time of publication of this text in 2003, however, population of Oxkutzcab was estimated at 16,000 people. More recent estimates, including a 2005 census, placed the population of the city proper at 21,341 people.

67. Hervik 2003, xx, 9–13.

68. Hervik 2003, xx. During his early research at Uxmal and other Puuc region sites, Jeff Kowalski and his wife, Mary, were guided by Mario Magaña and Pedro Gongora of Oxkutzcab, INAH caretakers for a host of smaller Puuc sites located in the fertile *Witz'ob* zone south of the town. After hours of cutting trails or clearing buildings for photos, they took breaks by enjoying fresh sweet oranges that Mario or Pedro skillfully peeled in only a single strip of rind.

69. Hervik 2003, xx.

70. Jesús Delgado Kú, personal interview, 18 July 2006. Hervik 2003, 11.

71. Hervik 2003, 11.

72. See for instance, *Lo Cotidiano y lo Ritual en las Artesanías Yucatecas*. Cuadernos de Cultura Yucateca no. 2. (Mérida, Yucatán: CULTUR Servicios, Talleres Gráficos del Sudeste, 1993).

73. Virginia Miller, personal communication, January 2007; Raúl Cervera Molina, personal interview, 6 July 2006. Sr. Cervera is the owner of Tienda Anji, in Mérida, Yucatán. Mary Katherine Scott's personal observations while shopping at the *Casa de Artesanías* in Mérida also support this statement.

74. See Morris 1984 and Morris 1987. See also Chibnik 2003, 10, Oettinger 1990, Sayer 1990, and Danly 2002.

75. Chibnik 2003, 7. See also Neal 1990, 29.

76. Hobsbawm and Ranger 1985.

77. Chibnik 2003, 8.

78. *Indigenismo* is a cultural, political and anthropological movement that began as a literary movement in the early part of the twentieth century focusing on the study and valorization of indigenous cultures in Latin America. However, *indigenismo* is not limited to modern indigenous cultures, but rather celebrates the history and cultural achievements of pre-Columbian civilizations as well as postconquest indigenous cultures, as well as their popular arts, customs, and beliefs in general. For a brief discussion and critique of the concept see Carmack, Gasco, and Gossen 1996, 266–69. See also Kowalski's essay in this catalog.

79. Castañeda 2004, 26. See also Castañeda's essay in this catalog.

80. Castañeda 2004, 27.

81. Tozzer, 1941, 159–160. Quoted in Newsome 1998, 125.

82. Tozzer 1941, 160; Newsome 1998, 126.

83. See Pollock, 1980. For the Kabah lintel see Stephens 1963 [originally published 1843], 250, pl. XXI. The Tikal wooden lintels are described and illustrated in Jones and Satterthwaite 1982. For wooden objects from the sacred cenote at Chichén Itzá, see Coggins and Shane 1984, figs. 24, 26, 40, 109–13, 123–27, 174–77.

84. Jesús Delgado Kú, personal interview, 18 July 2006; Miguel Uc Delgado, personal interview, 16 July 2006

85. Jesús Delgado Kú, personal interview, 18 July 2006.

86. Jesús Delgado Kú, personal interview, 18 July 2006.

87. Jesús Delgado Kú, personal interview, 18 July 2006. Quote translated from the original Spanish by author.

88. Jesús Delgado Kú, personal interview, 18 July 2006.

89. During our conversation, it was unclear whether in this position he is employed directly for INAH or if he is an elected officer for some kind of workers' union that is affiliated with INAH.

90. Miguel Uc Delgado, personal interview, 16 July 2006.

91. Jesús Delgado Kú, personal interview, 16 July 2006.

92. Miguel Uc Delgado, personal interview, 16 July 2006. Quote translated from the original Spanish by author.

93. Jesús Delgado Kú, personal interview, 16 July 2006.

94. Jesús Delgado Kú, personal interview, 16 July 2006.

95. According to the Center for Archaeoastronomy at the University of Maryland, archaeoastronomy is "the study of the astronomical practices, celestial lore, mythologies, religions and world-views of all ancient cultures." See http://www.wam.umd.edu/~tlaloc/archastro/cfaar_as.htm (accessed 18 February 2008). An excellent introduction to archaeoastronomical studies in Mesoamerica is Aveni 1980.

96. See Castaneda's essay in this catalog.

97. See Hervik 2003, 10–11.

98. Angel Ruíz Novelo, personal interview, 18 July 2006.

99. Angel Ruíz Novelo, personal interview, 18 July 2006. Quote translated from the original Spanish by author.

100. See Castañeda's essay in this catalog.

101. Clancy 2001, 129. For general discussion of these issues see Clancy 2001, 128–50, Austin 1994, 4–6, Long 1991, 205–22, Ardren, 2004, 103–13, and Baklanoff 2008, 7–13.

102. Alfonso Escobedo, personal interview, 7 July 2006.

103. For a good introduction and overview of these events, see Joseph 2002). The significance of the Olympic games for projecting an image of Mexico as a stable and prosperous nation, and the Tlatelolco massacre is also reviewed in Michael C. Meyer and William L. Sherman 1991, 665–71.

104. Ramiréz 2008, 69–91. Along with the 1968 Olympics, examines many factors and individuals involved in efforts to promote industry, economic growth, and modernization in Yucatán.

105. Alfonso Escobedo, personal interview, 7 July 2006.

106. Alfonso Escobedo, personal interview, 7 July 2006.

107. Alfonso Escobedo, personal interview, 7 July 2006.

108. Miguel Uc Delgado, personal interview, 16 July 2006. The school also offered classes in technical drawing, carpentry, and electrical work.

109. Alfonso Escobedo, personal interview, 7 July 2006.

110. Alfonso Escobedo, personal interview, 7 July 2006.

111. Miguel Uc Delgado, personal interview, 16 July 2006. It should be understood that the four artisans whose works are the focus of this exhibition are not the only carvers producing such works in the Puuc region. A carver named Carlos Cancino Baaz, who currently lives in Muna, produces *réplica* style panels whose style and subject matter resemble those of the sculptures discussed herein. He displays his work at an entry area to a tourist restaurant housed in a large thatch-roofed palapa just north of the Uxmal site. According to Cancino Baaz he has been carving such pieces for about 36 years, and was largely self-taught. His brother, Wilbert Cancino, began carving about 1968. He also mentioned that his brother-in-law is a carver named Carlos Romero, who formerly worked in the Puuc region, but now has a shop and sells his work in Xcaret in Quintana Roo, Mexico. Wilbert Vázquez recalls that Carlos Cancino Baaz and his brother began carving at about the same time he did, and that all of them worked with and received some training with Antonio Salazar. Furthermore, and as discussed above, Wilbert also plays the part of a third party vendor by representing a number of artisans who live and work in Muna. These artisans, Renán Salazar (the nephew of Antonio Salazar), William "La Hormiga" Martín, and individuals identified in notes only as Freddy, and XXX, create both *réplica* carvings and "invented" imagery inspired by pre-Columbian Maya forms and figures. Wilbert, as a tour guide, then sells these to his tourist clients who desire more "authentic" Maya wood carvings than can be bought in the various tourist gift shops around Mérida and other centers of tourism in Yucatán. Clearly, the local history of the development of the Puuc regional expression of this type of carving is a subject for further investigation.

112. Alfonso Escobedo, personal interview, 7 July 2006.

113. Jesús Delgado Kú, personal interview, 18 July 2006.

114. Jesús Delgado Kú, personal interview, 18 July 2006.

115. Jesús Delgado Kú, personal interview, 18 July 2006.

116. Jesús Delgado Kú, personal interview, 18 July 2006.

117. See Klein 1988, 42–46.

118. Jesús Delgado Kú, personal interview, 18 July 2006. A recent interpretation of Late Classic Maya art and writing by Herring 2005 sees its curvilinear and calligraphic style as a key element in constructing cultural identity in the elite, courtly society of this period.

119. Alfred P. Maudslay originally discovered the lintels at Yaxchilán, but they were removed from the site upon his

request and donated to the British Museum at the end of the nineteenth century. See the British Museum's Website, http://www.thebritishmuseum.ac.uk/compass/ixbin/goto?id=ENC130 (accessed (29 Nov. 2006). See also Tate 1992.

120. See Tate 1992.

121. Jesús Delgado Kú, personal interview, 18 July 2006. This statement is also supported by the fact that all four of the artisans typically had a larger number of wooden reproductions of these lintels in either whole or abbreviated form than they had of other similar carved stela or lintel from elsewhere in the Maya region. The Vision Serpent from Lintel 25 is commonly reproduced, as is a kneeling Lady Xook.

122. Schele and Miller 1986, 187. For these and other monuments at Yaxchilan see also Schele and Freidel 1990, 262–305. This figure's name has also been spelled as Lady "Xoc," as in *The Blood of Kings* catalog, but in current orthography, scholars spell her name as "Xook." See Martin and Grube 2000, 123–26 on Itzamnaaj B'alam III (Shield Jaguar) and Lady K'abal Xook. For an update on the dynastic history of Yaxchilan see Martin and Grube 2008, 116–37.

123. Schele and Miller 1986, 186.

124. Schele and Miller 1986, 187.

125. Tate 1992, 120.

126. Tate 1992, 120.

127. Tate 1992, 150–51; Schele and Freidel 1990: 295, 297; Martin and Grube 2008, 128–30.

128. Tate 1992, 98–99, fig. 38a; Schele and Miller 1986, 226, 234, pl. 86; Martin and Grube 2008, 134–37.

129. Yaxchilan Lintel 17: Tate 1992, 88, 130, 197–99; Schele and Freidel 1990, 285–86; Martin and Grube 2000, 128–29.

130. Yaxchilan Lintel 15. Tate 1992, 35, 88, 130, 197–99; Schele and Miller 1986, 190, 200, pl. 65; Schele and Freidel 1990, 287; Martin and Grube 2008, 131.

131. Miguel Uc Delgado, personal interview, 16 July 2006.

132. Tate 1992, 59, 92–93, 135, 177–78.

133. For general overviews of Palenque's art and inscriptions see Schele and Freidel 1990, chap. 6, and Martin and Grube 2008, 154–75.

134. Schele and Mathews 1998, 95.

135. For further information on Palenque, K'inich Janaab Pakal I, and the Temple of Inscriptions, see for instance, Ruz 1998; Martin and Grube, 2000, 162–67, or the newly published book by Stuart and Stuart 2008.

136. Schele and Miller 1986, 268.

137. Mary E. Miller 1999, 167. Two fine views of K'inich Janaab Pakal I's portrait head appear in Miller and Martin 2004, Pl. 113

138. Schele and Mathews 1998, 116.

139. At one point thought to represent the local *sahal* Chac Zutz' (Great Bat), the principal figure is now identified as Palenque king known as K'inich Ahkal Mo' Nahb III. Freidel, Schele, and Parker 1993, 307, fig. 7:14; Martin and Grube 2008, 172–73.

140. Miller 1999, 110.

141. Schele and Miller 1986, 112. Miller and Martin 2004, 202.

142. Maudslay 1889–1902, vol. IV, pls. 32, 35.

143. Jones and Satterthwaite 1982, 45–46, fig. 30; Houston and Miller 1987, 56–57, fig. 12.

144. See Schele and Mathews 1998, chap. 5, fig. 5.10 for the older Ah-Bolon-Abta Wat'ul-Chatel reading of the ruler's name. For the Aj Bolon Haabtal reading see Martin and Grube 2008, 227; see also Sharer with Traxler 2006, 520–24, fig. 9.5.

145. Stephens 1963, 250, pl. XXI.

146. Foncerrada 1965, figs. 15, 42–45. Emerging from the open serpent maw relates such figures to other images of lineage founders in Maya art, such as the Yaxchilan founding ancestor Yohpat Bahlam (formerly known as Yat Balam) seen on Lintel 25; see Schele and Freidel 1990, 271. However, Martin and Grube 2008, 125, suggest that the figure emerging from the "vision serpent" on Yaxchilan Lintel 25 may be the current king, Itzamnaaj Bahlam III.

147. Sharer with Traxler 2006, 110–12, fig. 3.8.

148. Mary K. Scott's research indicates that Angel had a number of enlarged and isolated glyphs taken from either the month signs for the 260–day ritual and 365–day agricultural calendars, or from other more complex glyphic writings on various monuments.

149. See Thompson 1966, 162–83 and 1960 for his interpretations of the Classic Maya's fascination with cyclical time and their multiple, interpenetrating calendars. For a brief reference to Thompson's emphasis on the priestly and peaceful nature of Classic Maya society and the non-historical nature of Maya writing see Schele and Miller 1986, 23–24; see also Becker 1979.

150. Sharer 1995, 696, fig. 15.19; Freidel, Schele, and Parker 1993, 265–67, fig. 6.9.

151. Coe 1973, 98–99; Coe 1975, 34–39, Vase 4: Vase in Codex Style: Underworld Ritual; Schele and Miller 1986, 287, pls. 117, 117a.

152. Freidel, Schele and Parker 1993, 65, fig. 2.4.

153. Piña Chan 1968, fig. 64.

154. Schele and Miller 1986, 269–71, fig. VII.1; Freidel, Schele, and Parker 1993, 89–94, fig. 2.25.

155. A brief introduction to the pre-conquest Maya codices, known as the Dresden, Madrid, and Paris after the location of the libraries where the original manuscripts are housed, can be found in Sharer and Traxler 2005, 127–29. A black and white reproduction of these manuscripts is Villacorta C. and Villacorta, 1977 [originally published 1930]. A possible fourth manuspript, known as the Grolier Codex, was published by Coe 1973.

156. See Villacorta C. and Villacorta 1977, or another edition, Carlos A. Villacorta and J. Antonio Villacorta C., *The Dresden Codex: Drawings of the Pages and Commentary in Spanish* (Walnut Creek, CA: Aegean Park Press, 1992 [facsimile of 1930 edition]). Because their identities were not always well understood, deities in the codices were described using an alphabetical classification by Schellhas (1904).

157. For a discussion of possible deity association of these mask panels see Kowalski 1987, 187–202. For an earlier identification of the masks as Chaak, as well as God K, see Seler 1917. Spinden 1913 believed this elongated snout was a serpent's or dragon's extended upper lip due to frequent depictions in Maya art. Schele and Mathews 1998, 267–69 suggested that some of these masks, including a number of examples at Uxmal on the Adivino (the Pyramid of the Magician) and those on the buildings in the Nunnery Quadrangle instead represent variants of the old creator god, Itzamnaaj in his avian manifestation as the Principal Bird Deity or Itzam-Ye, instead of Chaak. Finally, more recent scholarship by Taube 2004, 69–98, suggests that these masks actually represent iconographic mountains (*wits*) and thus transform the buildings they adorn into "Flower Mountains," a kind of resplendent solar celestial paradise associated with flowers and beauty. See Coe, 2005, 166.

158. Karl A. Taube, 1983, 171.

159. See Miller and Taube 1993, 146.

160. Taube 1992, 41, 50.

161. Miguel Uc Delgado, personal interview, 16 July 2006; Jesús Delgado Kú, personal interview, 18 July 2006; Angel Ruíz Novelo, personal interview, 18 July 2006.

162. Thompson 1954, 195–96. See Thompson 1970.

163. Taube 1992, 31.

164. Thompson 1954, 195.

165. Taube 1992, 101. Traci Ardren 2006, 32 has argued that this goddess has mistakenly been identified as Ixchel and has been conflated with aspects of the Moon Goddess Ixik Kab, when she is in fact more closely related to that of Chac Chel or "Red Rainbow" (Goddess O), the female aged deity, who is associated with weaving, water, divination, curing, and destruction. However, given the Puuc artisans' identification of this figure as Ixchel in their wood carvings, she will be referred to as such in this catalog.

166. Taube 1992, 101.

167. Taube 1992, 101.

168. Sharer with Traxler 2006: 742; Taube 1992, 11–17; Miller and Taube 1993, 74, 146, 177–78.

169. Jesús Delgado Kú, personal interview, 19 December 2007.

170. Miller and Taube 1993, 80.

171. See Miller 1982, 89.

172. Miller 1982, 89.

173. Miller 1982, 89.

174. Taube 1992, 41.

175. Taube 1992, 41.

176. Wilbert Vázquez, personal interview, 20 December 2007.

177. Taube 1992, 81, 85.

178. Taube 1992, 81, 88.

179. Miller and Taube 1993, 102. For more detail discussion of the importance of the jaguar in Mesoamerica, as well as elsewhere in the ancient Americas, see Benson 1972, and Saunders 1998.

180. See Taube 1992. See also Miller and Taube 1993, 102.

181. See the chapter on the Bicephalic Jaguar Throne in Kowalski 1987, 229–42. See also Silverstein 1998, and Miller and Taube 1993, 102. See Coe 1999a, 175 77, pl. 117.

182. Tozzer 1957, XI, 129–35; XII, fig. 432.

183. For more discussion on the chacmool, see Miller 1985, and Desmond 2001, 168–69.

184. Miller 1985, and Desmond 2001.

185. On the use of the circular plates held by Chacmools as possible supports for fire-drilling ritual see Coggins 1987, 427–84.

186. Tozzer 1957, XI, 123–27; XII, figs. 314–20; Diehl 1983, 61. color plate VII. On the relationship between Tula and Chichén Itzá see Coe and Koontz 2002, 173, and Kristan-Graham and Kowalski, 2007.

187. Tozzer 1957, XI, 109; XII, fig. 184. On the Great Ballcourt at Chichén Itzá and for an image of the balustrade trees, see Schele and Mathews 1998, chap. 6, fig. 6.47.

188. Coggins and Shane 1984, 50, fig. 25. On the Chichén Itzá-Tula relationship see Kristan-Graham and Kowalski 2007, and other chapters in the volume in which this essay appears.

189. See Thompson 1966, fig. 16, and pp. 162–69 for his discussion of the Maya "Philosophy of Time."

190. The Feathered Serpent (known as Quetzalcoatl among the late Postclassic Aztec peoples, and as K'uk'ulkan among the Maya of northern Yucatán) is one of the most complex and long-lived images of and metaphors for multiple aspects of the principle of divine creativity in ancient Mesoamerica. Those interested in exploring the nature and impact of this god on Mesoamerican religion and history might begin by consulting Nicholson 2001 (for a brief introduction) and Carrasco 1982 (for a more lengthy study).

191. Carmichael 1970, 17, 36.

192. Commonly cited scholarly references included popular and influential works by Linda Schele and colleagues (e.g., *The Blood of Kings, The Forest of Kings*) and various editions of Michael Coe's *The Maya*. One of the coloring books from which images are borrowed is Wilson G. Turner, *Maya Designs* (Mineola, NY: Dover Publications, 1980). A guidebook used by Miguel Uc Delgado is Javier Covo Torres, *Los Maya (en las rocas)*. (Editorial Dante. S. A. Mérida, Yucatán, Mexico, 1986).

193. Angel Ruíz Novelo, personal interview, 18 July 2006.

194. Adolf Ehrentraut 1996, 17.

195. Alfonso Escobedo, personal interview, 7 July 2006.

196. Miguel Uc Delgado, personal interview, 16 July 2006.

197. According to Miguel Uc Delgado (personal interview, 16 July 2006), the disparity between the carvings of Chichén and the Puuc region is also due in part to the fact that the Chichén artisans are "new carvers," that is, that they really only began producing *artesanías* seriously within the last fifteen years. This statement is intriguing, particularly considering that the Puuc tradition is itself a new tradition, having emerged in the late 1970s to early '80s, around the same time as the first carvers began producing pieces at Pisté near Chichén.

198. In addition to his essay in this volume, see Castañeda, Fumero, and Breglia 1999.

199. See the essays in this volume for further discussion of the issue cultural representation in relation to globalization, heritage sites, and arts produced for sale in tourist contexts.

200. Quetzil Castañeda, personal information, 21 February 2009. He also notes that a number of the recently made *máscaras* "retain a high level of technical sophistication but there are also a flood of *máscaras* with relief headdress that is

not technically superior and also a significant amount of *tabla* being produced by the Yaxuná carvers as their work continues to flood the market all over the peninsula."

201. This assertion is based on observation of a price range between $35–$150 for the *máscaras* of Chichén Itzá or the nearly identical Yaxchilán and Palenque cedar reproductions made by artisans in the Puuc region.

202. Brown 1999, 298, 301.

203. Re Cruz, 2003, 496. Maya farmers (although they typically have their own field that they either legally own or lay claim to) require the assistance of other farmers in their village to perform the initial clearing of their field (the slash and burn method) as well as during the actual harvesting of their crops, a communal effort that is reciprocated.

204. For further discussion on this idea, see Said 1978.

205. Re Cruz 2003, 496. See also Heusinkveld 2008, 133 for another discussion of the economic opportunities provided by tourism, and its attendant jobs in the construction and service sectors, as well as the challenges it poses to preserving aspects of traditional life ways and cultural practices.

206. Farriss 1984, 147.

207. Farriss, 1984, 147.

208. Farriss, 1984, 147.

209. Farriss, 1984, 12, 147.

210. This issue is also addressed in an article by Matthew Restall (2004) (cited by Castañeda 2004b, 39), who notes that "Maya" was not used to describe self-identity by indigenous groups in Yucatán at the time of the conquest and early colonial period, although they recognized that they shared a common "culture" across political boundaries.

211. Fallaw 1997, 574.

212. Fallaw 1997, 575.

213. Fallaw 1997, 577.

214. Fallaw 1997, 577.

215. The Institute was replaced by the National Commission for the Development of Indigenous Peoples (CDI) in 2003.

216. Gabbert 2001, 479.

217. Gabbert 2001, 478–79.

218. LaBrecque 2005, 101.

219. Gabbert 2001, 484.

220. Quetzil Castañeda, personal information 21 February 2009, notes that "the validity of Hervik's analysis of Maya identify does not extend outside of the Puuc region. For example, [regarding] the categories of identity—*catrin* does not exist

in maize region or even further east or north." In a broader discussion, he notes that "once these identity labels enter into academic languages as cross-cultural variable concepts of comparison, we have a tendency to assume that they are unproblematic and can, therefore, be used to anchor both comparative and "non-comparative" analyses. As is well known, terms such as "mestizo," "catrin," "ladino," and "Indian" are not only unstable across the hemisphere but even within different periods of the same region. In contrast, "materialist" notions of race and class seem to provide an identity anchorage for the "culturalist" series of labels, despite the fact that the former are also socio-historically variable." See Castañeda 2004b, for more analysis of this issue from a different perspective in Yucatán.

221. Hervik 2003, 95, 107 argues that while "outsider" Western researchers and scholars still use the term "Maya" to refer to those individuals who are of Maya ancestry (whether or not it is a "pure" bloodline or a "mixed" one), the problem with using such a designation is that it collapses the whole history of Maya culture and civilization under one term, which promotes a faulty understanding of the diversification in both the ancient and modern cultures. He argues that contemporary Mayas, by choosing to refer to themselves as *mestizos*, are expressing their "changing perception[s] of self" within the larger, modern world.

222. The term *"indio"* acquired its derogatory meaning from the original Maya rebels of the Caste War who, instead of forming military and political alliances with the Spanish *criollos*, chose to fight for their autonomy. Once the war was over and the Maya rebels were defeated, *"indio"* was the term that other Maya who had aligned themselves with the victorious Spaniards used to describe the rebels. It thus took on the negative connotations associated with savages, brutality, and low class people. See Gabbert 2001, 472 for more discussion.

223. Hervik 2003: 96.

224. Gabbert 2001, 476.

225. Ehrentraut 1996, 26.

226. Smith 1990, 18. Quoted in Ehrentraut 1996, 26.

227. Hervik and Kahn 2006, 212.

228. In a 2004 article Wolfgang Gabbert (cited by Castañeda 2004b: 39) argues that a more collective sense of "Maya" identity in Yucatán was an outcome of the Caste War, rather than a principal cause of the conflict. He notes that this identity was more forcefully adopted by those, like the Cruzob, who actively resisted government rule, than those in other regions [including the Puuc region].

229. Gabbert 2004, 161.

230. Angel Ruíz Novelo, personal interview, 14 March 2007.

231. Miguel Uc Delgado, personal interview, 14 March 2007.

232. Wilbert Vázquez, personal interview, 15 March 2007.

233. Wilbert Vázquez, personal interview, 15 March 2007.

234. Wilbert Vázquez, personal interview, 15 March 2007.

235. Wilbert Vázquez, personal interview, 15 March 2007.

236. Jesús Delgado Kú, personal interview, 13 March 2007.

237. Jesús Delgado Kú, personal interview, 13 March 2007. See also Gabbert 2001, 476.

238. Watanabe 1995, 35.

239. See Carmack 1992 and Warren 1998.

240. Castañeda 2004, 39.

241. Castañeda 2004, 38.

242. Castañeda 2004, 37.

243. Castañeda 2004, 38.

244. Castañeda 2004b, 38–39, notes that, "If we allow those who are marked as "Maya" less allochronic otherness and more similarity to "us," we might make a useful comparison. The claim by "a Maya" that he is not "indigenous" has a parallel in the way a Texan might absolutely reject the identity of being Chicano/a and at the same time assert that they are indeed Mexican American—which also means neither (hyphenated) Mexican-American nor Mexican. In Arizona and New México, a person an outsider might mistake as a Mexican-American, might quite emphatically inform you that they are neither Mexican-American nor Mexican, and under no circumstances should you ever call them Chicano or Chicana. They are Hispanic, and only occasionally, in delimited circumstances, will they allow themselves to be named Latino. In contrast, yet similarly, how many others in the USA refuse to be Hispanic just because Nixon made it a legal ethnicity in the 1970s? They are Latinos, and their identity is not hyphenated, whether the hyphen is lived (or theorized) as the "minus" of acculturation or as the "plus" of transculturation (see Pérez Firmat 1994)."

245. Watanabe 1995, 35.

246. Watanabe 1995, 35.

247. A number of book-length studies of village life in Yucatán have been published. In many cases, the projects on which they were based were carried out by non-Maya, usually Western scholars. While this is by no means an inclusive listing, some of the most important of these studies include Hervik 2003, Redfield and Villa Rojas 1962), Redfield 1964, Re Cruz

1996, Castañeda 1996, Hanks 1990, and Thompson 1974.

248. Castañeda 2004b, 41.

249. Castañeda 2004b, 37.

250. Castañeda 2000, 41.

251. Ehrentraut 28.

252. See MacCannell 1973 on "staged authenticity" and Kirshenblatt-Gimblett 1998: 57–78 on "performing culture" regarding the importance of such events for the promotion of cultural tourism or, as she calls it, "heritage tourism." Aspects of these issues are discussed at somewhat greater length in the essays by Kowalski and Scott in this volume.

253. Ehrentraut 1996, 28. *La Ruta Maya* was the name given to a multinational coordinated effort to publicize the major restored archaeological sites, colonial architecture, and areas known for their traditional cultural practices in the "Maya World" (*Mundo Maya*) as an organized, but flexible itinerary that would attract tourism and promote regional economic development. Ehrentraut 1996, 16 notes that this policy was "implemented through international treaties and the foundation of an umbrella organization named *Mundo Maya*, the Maya World (Del Carmen Solanes and Vela 1993 and Garrett, 1993)," He observes that the official magazine of the Mundo Maya celebrates these attractions in romanticized terms: "Discover a land where ancient sages once charted the heavens, where the jaguar still reigns supreme, and where Indian weavers still faithfully recreate designs first used centuries ago. This is the Maya World The Maya World offers something for everyone: mystery, tradition, beauty, sun, sand, and sea and just a little adventure." See Solanes C. and Ramírez 1993, 11–19, Garrett 1993, xii–xv, and Comisión Empresarial Mundo Maya 1995, 4.

254. Castañeda 1996, 2004b, Hervik and Kahn 2006, and Castillo Cocom 2005.

255. For more discussion on this topic, see Watanabe 1995; this, of course, represents a general trend in anthropology, demonstrated by works such as those of Fabian 1983, Clifford and Marcus 1986, Marcus and Fischer 1999, and Dirks, Eley, and Ortner 1993. Castañeda 1996 provides an important application of this critical approach in studying the effects of archaeology and tourism on the inhabitants of Pisté, as well as in shaping outsider's perceptions of "Maya culture." Hervik 1999, 166–97, and Hervik 2003.

256. Heritage tourism can be defined as a variant of cultural tourism that focuses on experiences at historical sites and museums, or witnessing "performances" of traditional practices. This concept is discussed further in Kowalski's essay in this volume.

See also Kirshenblatt-Gimblett 1998 for a general consideration of the topic, and Castañeda 1996 and Breglia 2006 for more specific case studies and discussions of heritage, tourism, development, cultural representations, and the production of knowledge and control of access to archaeological sites in northern Yucatán.

257. See Clifford 1988.

258. Castañeda 2004b, 37.

259. These categories are used here as a convenient heuristic device to characterize more popular paradigms that correlate with the historical and intellectual formation of Maya archaeology. The categories are based loosely on, but are modified somewhat, from those that appear in more comprehensive discussion in chapter four of Castañeda 1996. Yaeger and Borgstede 2004 also provide a helpful overview of the historical development of Maya archaeology, with special emphasis on its relationship to broader historical, political, and economic contexts from which it emerged and in which it was practiced at various stages. Following earlier observations by Willey and Sabloff (1993), Trigger (1989), and Patterson (1995b, 1999), they identify four such broad stages: "the Colonial and Antiquarian Period, from the Spanish conquest until the formalization of archaeology as an academic discipline; the Institutional Period, during which archaeology in the United States became embedded in larger academic institutions; the Scientific Period, corresponding to the dominance of the New Archaeology; and the Postcrisis Period, which emerged out of the crisis in American archaeology marked by postprocessual critiques of the 1980s and 1990s."

The study of ancient Maya society has undergone dramatic changes during the past fifty years. New information has been provided by archaeological projects and synthetic works on Maya cultural evolution and customs, and on indigenous modes of thought and expression. The latter has been assisted by important breakthroughs in translating Maya hieroglyphic writing and by careful studies of Maya art and iconography. For some reviews of new findings, approaches, interpretations, and theoretical perspectives in Maya archaeology see Fash 1999, Golden and Borgstede 2004, and Sharer with Traxler 2006. We have benefited from archaeological discoveries and interpretations and use them in our discussion of the subject matter of the Puuc carvings (and Kowalski has endeavored to contribute to them during his career). Yet we recognize that they are also embedded in, and help to create, larger discourses about the nature of "Maya Civilization," that become condensed to create

"representations" of Maya identity that are partial, incomplete, anachronistic and ethnocentric. See Pyburn 2004.

260. These paradigms are discussed at greater length by Castañeda 1996, 131–51.

261. Culbert 2004, 313. This emphasis on warfare and captive taking also conforms to the recent definition of Classic Maya society as a "timocracy," in which a "sharp sense of personal value ('pride'), especially among men, played a marked role in face-to-face interaction." See Houston, Stuart, and Taube 2006, 202.

262. Castañeda 1996, 128–29 notes that "Archaeologists read and write Maya culture in their practices of excavation and restoration, thereby inventing the spatial text of artifact-exhibits and the place of the museum as a strategic order of things. The tour guides, for their part, read the archaeological texts, both books and the archaeological zone, and write their texts, that is, invent Maya culture, in the practice of the Tour, which is a form of writing constituted by three factors (space, time, and word). The guide conjugates, within the regimen of the tourist timings, the explanatory word and textual space in order to create another text, which is literally a script *of* and *for* Maya culture. The tourist also reads and writes Maya culture, over the shoulder of the guides, as it were. The tourist, already familiarized with, if not steeped in, the signs of Maya culture via the publicity campaigns and propaganda associated with the tour packages as well as travel and leisure literature, has a horizon of reading erected by the multinational promoters of tourism in Mexico. The tourist reads the guidebooks and 'reads' the explanatory tour of the tour guide, all in order to *understand* Maya culture as represented by this life-size simulacrum."

263. Magnoni, Ardren, and Hutson 2007, 365.

264. Magnoni, Ardren, and Hutson 2007, 365–66.

265. As Castañeda (1996, 129) notes, "*Artesanos* and *vendedores* read over the shoulder of the tourist, reading the tour guide, who is, in turn, reading the archaeologist reading Maya culture. In this way, they get answers to the questions, What is Ancient Maya Culture? How do you sell it? What of it is bought by tourists? The artisans then provide their answer in the multiple forms of handicrafts by which the tourist can sign—sign in signature and signal—the text of Maya culture that they invent."

266. Watanabe 1995, 33.

267. Hervik 1999, 171.

268. Graburn 1976, 19.

269. Steiner 1994, 1995. See the earlier discussion in this chapter and notes 32–36 for other works concerned with the issue of how to define the "authenticity" of arts produced for tourists or other cultural outsiders.

270. Graburn 1976, 6.

271. Phillips and Steiner, "Art, Authenticity, and the Baggage of Cultural Encounter," in Phillips and Steiner 1999, 6.

272. Podro 1982, xxi.

273. Jarozombek 1994, 29, 31. Wölfflin believed one must experience the form of an object in an intensely felt way. This interaction with the object has been termed "aesthetic experientialism' and is rooted both in Wölfflin's writings and Enlightenment theory. Wölfflin's writings, which weren't popularized until the early to mid-twentieth century, have been called "one of the great accomplishments of twentieth-century modernism" since it made artworks more accessible to the average viewer by downplaying allegorical content, and thus promoting more of a populist approach to understanding works of art.

274. Jarozombek 1994, 29, 31. It is this kind of thinking that brought about a second wave of formalism under Wölfflin that focused on the intuitive, aesthetic experience after training oneself to identify the "good" from the "bad" in art by building a knowledge of style based on comparisons of many works of art. Phillips and Steiner 1999, 6, observe that this "art for art's sake" formalist-expressive definition of "fine art" "was further supported in the 1930s by the Idealist aesthetics of Collingwood and has remained relatively undisturbed since then in mainstream art history." The twentieth-century art critic, Clement Greenberg, would continue both Wölfflin's subjective experience of art as well as his judgment of "good" and "bad" through style analysis, although Greenberg also abandoned the populist approach and returned the study of art to the realm of the elite, as Winckelmann and Hegel had done before him.

275. See Greenberg 1939. Greenberg's discussion is based on the idea that different categories of art exist because of the disparate audiences to which they speak. For instance, avant-garde art and poetry, or the "advanced" high arts that Greenberg refers to as "genuine" culture, are supported and promoted by their audience, the educated economic elite. Folk art and culture, or the "low" arts, on the other hand, were associated with the illiterate and rural poor of the countryside, whether the more vernacular traditions of Europe or those of smaller towns in the United States. However, with the emergence of the industrial age and with the mass migration of the population from the country to the city, a new bourgeois middle class emerged that could not only read, but that also demanded higher standards of quality

and leisure in their social and domestic lives. Such cultural activities, like art collecting, poetry reading, and so on had previously been a privilege associated with the upper classes, but with literacy becoming the standard rather than the exception, class distinctions began to blur. It is with the rise of this bourgeois group that a category related to the "low" arts, namely "kitsch" and the mass production of popular culture, began to take shape. In this context, kitsch refers more specifically to artworks or aesthetic objects that represent inferior, debased, or overly romantic and sentimental versions of existing art styles or of particularly well-known examples of high art. It represents the antithesis of the experientially dense, aesthetically superior, and emotionally and morally "authentic" creations of high culture.

276. Pop artists wanted to send a message to their viewers about everything that had gone wrong with the art world since the 1950s. In particular, they aimed to address the contradiction between the excessive market value of current avant-garde art and the "purity" and "expressive" quality that such art supposedly embodied. See Lichtenstein et al. 1963 and 1964, 102–15, 109. Robert Indiana stated, "Pop is reenlistment in the world. It is shuck the Bomb. It is the American Dream, optimistic, generous and naïve…"

277. Though Alloway is often credited with introducing the term "Pop art" by way of his 1958 article, the term was actually coined by John McHale, a fellow Pop artist, during one of his ongoing conversations with Alloway in 1954. Gary Comenas, "Interview with John McHale (Jr.): The Son of the Father of 'Pop'" (2006). http://www.warholstars.org/articles/johnmchale/johnmchale.html (accessed 24 Nov. 2006).

278. Mary Katherine Scott's essay (this volume) discusses the definitions and the categorization of art in further detail. Good discussions of these issues, however, can be found in a number of important texts, for instance Gell 1998, McEvilley 1992, and Kubler 1962. Esther Pasztory's recent book, *Thinking with Things: Toward a New Vision of Art* (2005) challenges traditional approaches to the study of art and holds that the European concept of fine arts unduly restricts understanding of the production and uses of aesthetic objects in broader historical and global contexts. She stresses that the common characteristic of such artifacts is not their stand-alone presence as objects of aesthetic delectation, but their role in communicating culturally encoded meanings. Pasztory argues that all aesthetic objects that embody such meanings are valid subjects of investigation and interpretation, and it is this broader, more inclusive approach that informs the methodological and curatorial approach of this exhibition.

279. Dean 2006, 27.

280. James Clifford's summary of Susan Vogel's idea, in Clifford 1988, 203.

281. Clifford 1988, 215.

282. Clifford 1988, 225.

283. Clifford 1988, 203, 224.

284. Bourdieu 1984, Becker 1982.

285. "Histories of the Tribal and the Modern," in Clifford 1988, 189–214.

286. Steiner 1995. Similar issues are raised in Janet Berlo's essay in the discussion of the proper "framing" of recently made southwest silverwork in the "authentic" setting under the portal of the Palace of the Governors in Santa Fe, New Mexico.

287. *Magiciens de la terre: Centre Georges Pompidou, Musee national d'art moderne, La Villette, la Grande Halle* (Paris: Editions du Centre Pompidou, 1989). For further discussion see Scott's essay in this volume. As Dean 2006 points out, while this emphasizes such objects as part of the universal creative expression of humanity, it downplays and diminishes the need to provide a fuller understanding of the work's function(s) and significance for members of the culture that created it. Graburn 1999, 348, notes that the exhibition continued to follow parameters that dictated the non-western artists "create only those arts (and crafts) that cater to the image desired by the mainstream art market. . . . the breakthrough exhibition *Magiciens de la Terre* in Paris (Centre Georges Pompidou 1989), which exhibited the works of First, Third, and Fourth World artists side by side, revealed by this very juxtaposition that the 'ethnic' artists were expected to create something stereotypically traditional, yet the metropolitan (white) artists were allowed to draw their images from anywhere and to appropriate motifs or materials from nature or from cultural alterity without limitation."

288. Bhabha 2003, 73.

289. Smith 1992 [1989], 38.

290. Rubinstein 1989, 63. Granted, this "fully matured cultural tradition," (i.e., modernism) is now seen simply as historically and culturally contingent and a limited concept of art and aesthetics.

291. Decter 1989, 58.

292. Wahl 1989, 64.

293. Kubler 1962, 86, 88–89.

294. Crouch and Lübbren 2003, 2. For a good introduction to Visual Culture Studies, see Howells 2003, and Sturken and Cartwright 2000.

295. Freedman 2003, 1.

296. Freedman 2003, 2.

297. Freedman 2003, 1.

298. Harris 2001, 7.

299. The influential art history methodology survey by Kleinbauer 1971, 68 referred to contextualist approaches to the study of art that focus on its relationship broader historical events and processes, or social, economic, and cultural forces as "extrinsic" approaches. There is a voluminous scholarly literature associated with the New Art History. Along with Harris 2001, some important overviews include Rees and Borzello 1986, Pointon 1994 (first edition 1980). Two foundational feminist studies are Parker and Pollock 1982, and Broude and Garrard 1982. See also the collection of articles in the special themes sections "The Object of Art History," *Art Bulletin* 76, No. 3 (1994) and "Rethinking the Canon: A Range of Critical Perspectives," *Art Bulletin* 78, No. 2, 1996). The short book by John Berger, *Ways of Seeing* (Harmondsworth, Penguin, 1972) and an accompanying BBC television series by the same name played an important role in examined the social contexts and ideological messages of "fine arts" traditions, while pointing out their relationship to more contemporary popular media and advertising imagery, and had an impact on the development and popular awareness of both the New Art History as well as visual culture studies.

300. Crouch and Lübbren 2003, 3.

301. Crouch and Lübbren 2003, 3.

302. Lipman, "Backward and Downward with the Arts," *Commentary* (May 1990), in Bolton 1992, 217. In *An American Dialogue*, a report on artistic touring and exhibitions written and organized by members of the NEA, the Rockefeller Foundation and the Pew Charitable Trusts.

303. Danto 1996. It would probably be fair to say that Danto's own focus remains primarily on western art and he recognizes that the high end "art world" still values art that is new, ironic, polemical, and conscious of its own place in the hierarchy, however socially constructed rather than historically inevitable that hierarchy may be.

304. Bolton 1992, 24.

305. Westfall 1989, 64.

1.8— *(above)* The wooden lintel from the west palace group at Kabah, Yucatán. Engraving after Frederick Catherwood, in John L. Stephens, Incidents of Travel in Yucatán, Vol. 1 (after Stephens 1843, Vol. 1, Pl. XXI)

1.15— *(right)* Lintel 25 from Yaxchilan, Chiapas, Mexico, showing Lady K'abal Xook kneeling as a founding royal ancestor appears from the maw of a "vision serpent" emanating from smoke curling upward from burnt bark paper strips on which blood has been collected as an offering (after Maudslay 1889–1902, vol. II, pl. 87. Image reproduced from the facsimile edition of Biologia Centrali-Americana by Alfred Percival Maudslay. Published by Milpatron Publishing Corp., Stamford, CT 06902. Further reproduction prohibited.

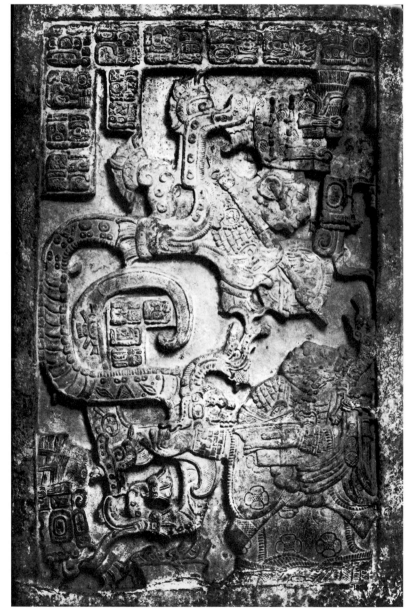

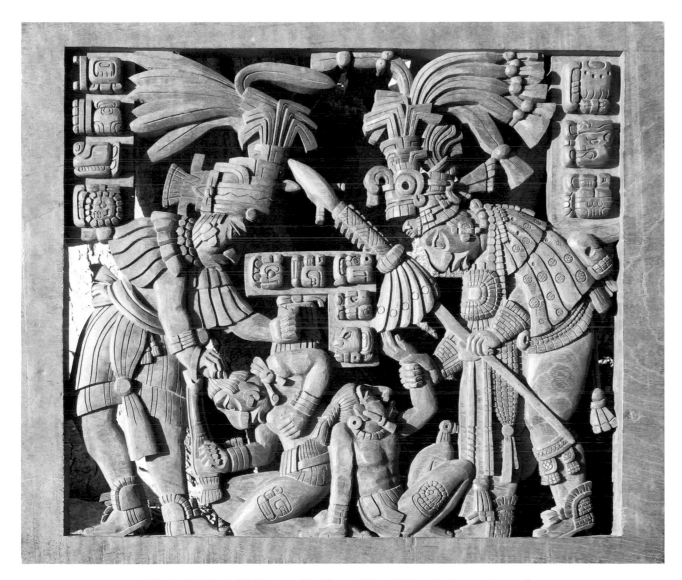

1.16—Jesús Delgado Kú, The ruler "Bird Jaguar IV" and his Sahal taking captives, cedar,
H-W, 18 x 21 inches (45 x 53 cm), based on Lintel 8 from Yaxchilan, Chiapas.

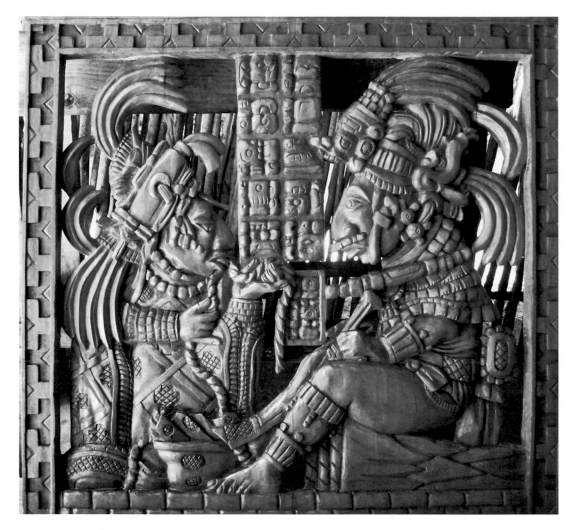

1.18—Angel Ruíz Novelo, The ruler Bird Jaguar IV (Yaxun Bahlam) and Lady Mut Bahlam, a Lady Ajaw of Hix Witz, based on Yaxchilan Lintel 17. cedar, H-W, 17 x 17 inches (43 x 43 cm).

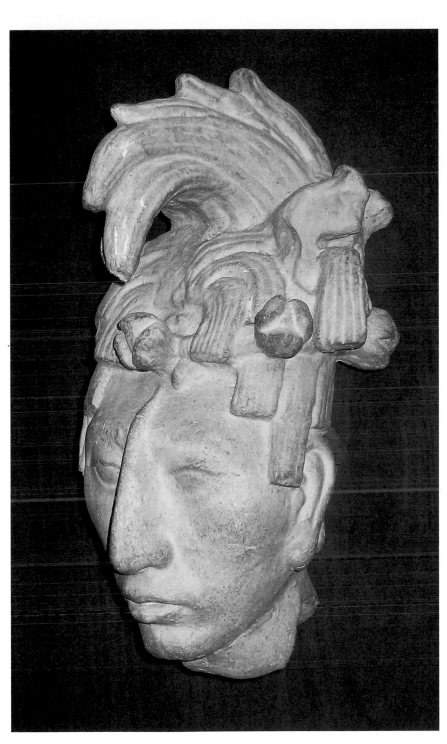

1.19—Jesús Delgado Kú, three-dimensional version of the 'vision serpent' on from Lintel 15 of Yaxchilan, Chiapas, cedar, H-W, 15 3/4 x 7 1/2 inches (40 x 19 cm).

1.24— The stucco portrait of K'inich Janaab Pakal II of Palenque, facsimile plaster sculpture in the dining room of the Hacienda Uxmal hotel.

1.26— Jesús Delgado Kú, three-dimensional portrait head of the ruler K'inich Janaab Pakal II, H-W, 12 x 6 3/4 inches (30 x 17 cm), based on the stucco portrait head from Palenque, Chiapas.

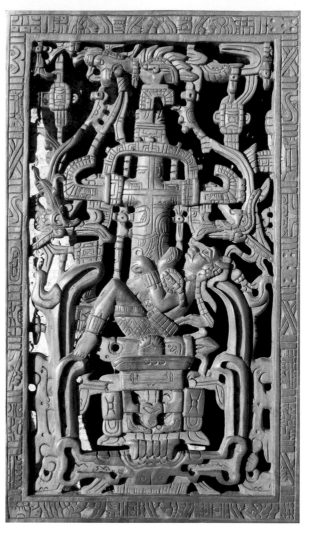

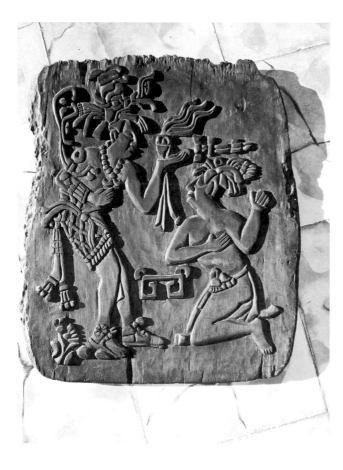

1.28— *(upper left)* Wilbert Vázquez, The ruler K'inich Ahkal Mo' Naab III, cedar, H-W, 12 3/4 x 9 1/2 inches (32 x 24 cm), based on the Tablet of the Slaves from Palenque, Chiapas.

1.23— *(above)* Jesús Delgado Kú, The ruler K'inich Janaab Pakal II entering the underworld, cedar, H-W, 27 1/2 x 16 1/2 inches (70 x 42 cm) based on the sarcophagus lid from Palenque, Chiapas.

1.32— *(left)* Wilbert Vázquez, Standing ruler and kneeling figure, cedar, H-W, 21 x 18 inches (54.5 x 47 cm), based on Pier C of the western corridor of the Palace at Palenque, Chiapas.

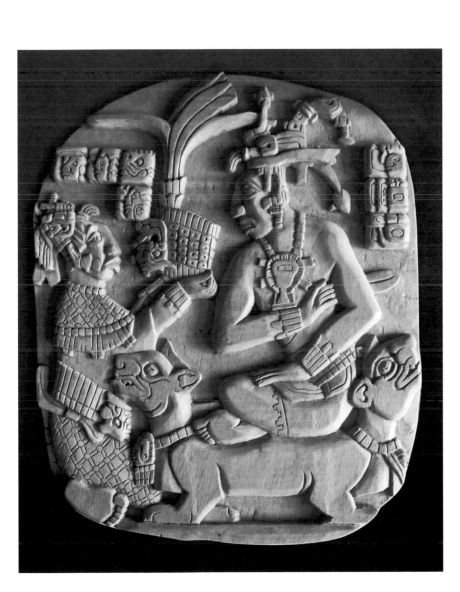

1.30— *(above)* The Oval Relief Tablet from House E of the Palace at Palenque, Chiapas, showing Lady Sak K'uk' bestowing a tall, mosaic-covered "drum major" headdress on K'inich Janaab' Pakal II at the time of his accession to power (after Maudslay 1889–1902, vol. IV, pl. 44. Image reproduced from the facsimile edition of Biologia Centrali-Americana by Alfred Percival Maudslay. Published by Milpatron Publishing Corp., Stamford, CT 06902. Further reproduction prohibited.

1.31— *(left)* Miguel Uc Delgado, the ruler K'inich Janaab Pakal II and his mother, Lady Sak K'uk', cedar, H-W, 13 x 13 inches (34 x 34 cm), based on the Oval Relief Tablet from House E of the Palace, Palenque, Chiapas.

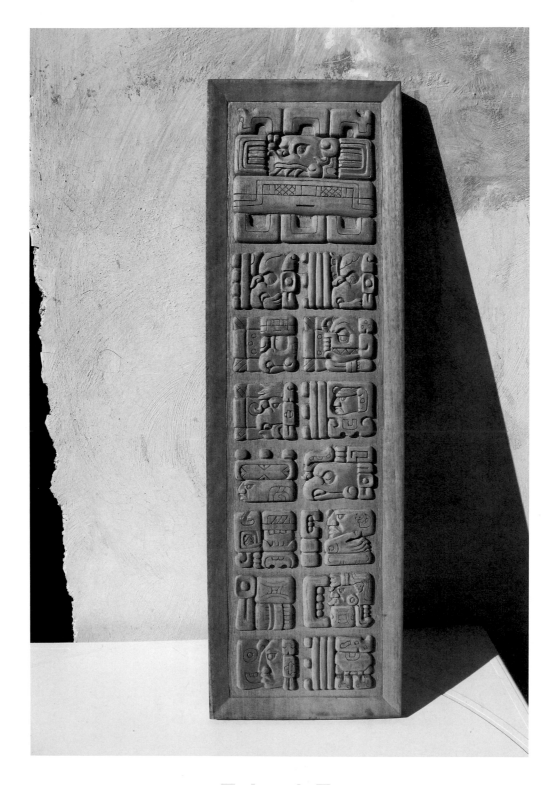

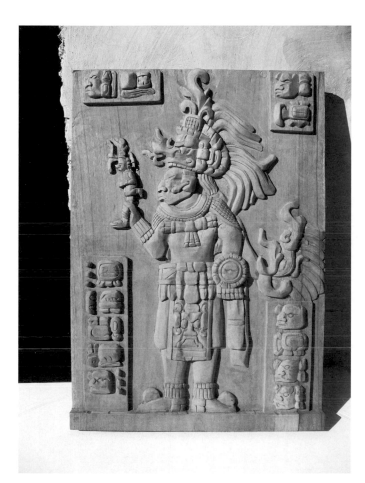

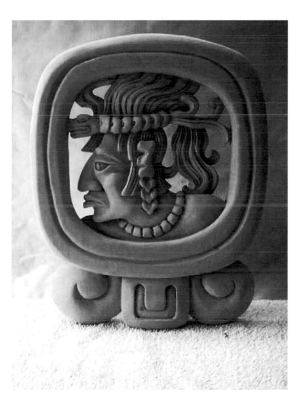

1.35— *(above)* Miguel Uc Delgado, Maya Ruler with K'awiil scepter, cedar, H-W, 24 x 17 inches (70 x 43 cm), a composite based on various stelae monuments.

1.37— *(left)* Miguel Uc Delgado, Initial Series Date, cedar, H-W, 28 x 8 1/2 inches (71 x 21.5 cm), based on the inscription on Stela F of Quirigua, Guatemala.

1.38— *(right)* Angel Ruíz Novelo, Personified Ajaw day sign (Maya lord within cartouche), cedar, H-W, 14 x 11 inches (35.5 x 28 cm).

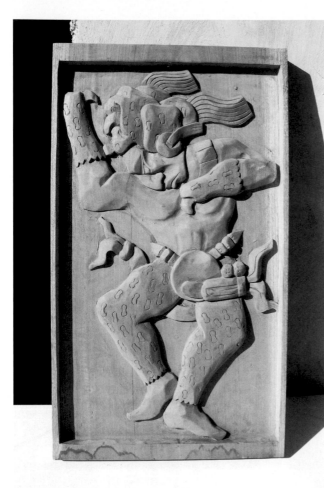

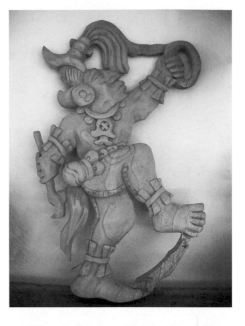

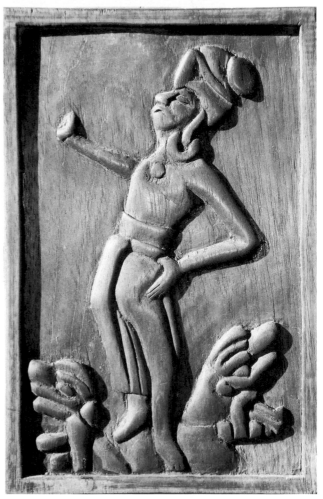

1.39— *(above)* Miguel Uc Delgado, Figure dancing as his Jaguar Alter-Ego, cedar, H-W, 23 1/2 x 13 inches (58.5 x 34 cm), based on a polychrome cylinder vase from Altar de Sacrificios, Guatemala.

1.40— *(above, right)* Angel Ruíz Novelo, Dancing figure of Chak-Xib-Chaak holding an axe, cedar, H-W, 19 x 13 inches (48 x 33 cm), based on a 'codex-style' vase from southern Campeche, Mexico.

1.41— *(right)* Wilbert Vázquez, Standing figure known as the "Presentador," cedar, H-W, 12 x 8 3/4 inches (32.5 x 19.5 cm), based on a ceramic figurine from the island of Jaina, Campeche.

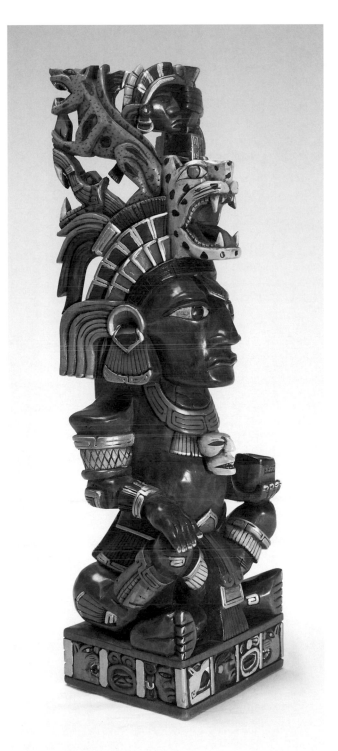

2.3— *(far left)* Gloria de K'uk'ulkan, Cedar with a dark red-brown acabado, H-W-D, 70 x 28 x 1.6 cm Wilbert Serrano Mex, 1999.

2.5— *(middle)* Yum Dzak, Dios de Medicina, in mascarón form, with a Xipe Totec headdress, H-W-D, 40 x 17 x 9 cm. Alfonzo Cetz Címe, 1999.

2.7— *(left)* Yum Dzak, Dios de Medicina, with yellow jaguar headdress, K'uk'ulkan, jaguar, and priest offering incense, chakah wood with painted acabado, 43 cm high on a base 12 x 14 cm. Abelino Cemé Mex, 1999.

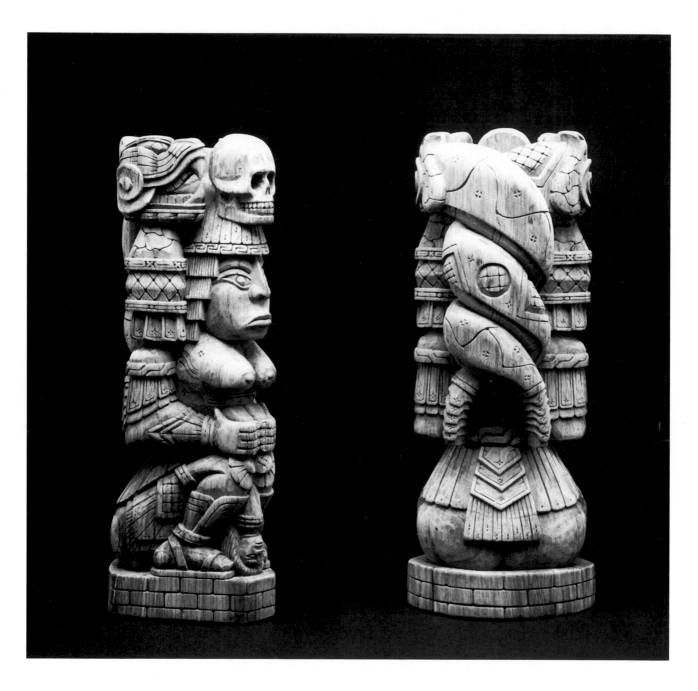

2.8—Ix Chel, Goddess of Childbirth, Weaving, and Medicine, Unpainted cedar with no acabado, H-W-D, 22 x 9 cm x 8 cm. Ramon Quijano Balam, 1999.

1.54— *(above)* Miguel Uc Delgado, Calendar Wheel with Kneeling Figure, cedar, Diameter 22 1/2 inches (57 cm), based on a well-known diagram in the book *The Rise and Fall of Maya Civilization* by J. E. S. Thompson

1.53— *(left)* Wilbert Vázquez, Tree with Birds and Butterflies, cedar, H-W, 21 3/4 x 7 Inches (55 x 18 cm), based on the relief sculptures on the ramps flanking the stairway of the North Temple of the Great Ballcourt, Chichén Itzá, Yucatán..

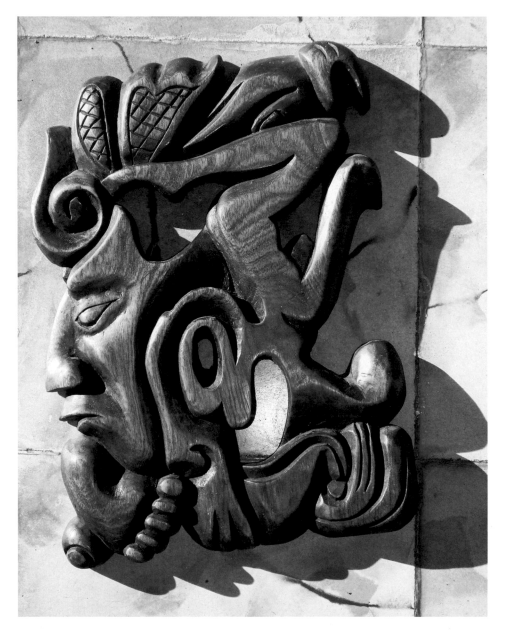

1.55—Wilbert Vázquez, Abstract Maya Profile, cedar, H-W, 14 x 10 inches (35.5 x 25.5 cm), this carving is based loosely on depictions of the Maize God in various media, with other allusions to fertility incorporated in the design.

OTHER CARVINGS

IN THE EXHIBITION

Jeff Karl Kowalski and

Quetzil Castañeda

▸ This chapter provides a listing and discussion of other carvings that are displayed in the exhibition, including those by Puuc artisans that are not illustrated in the catalog, as well as those by carvers from Pisté, Yucatán.

Carvings from the Puuc Region

As mentioned in the previous chapter, the woodcarvings from the Puuc region display a set of common subjects and source imagery, while reflecting the ways that Miguel Uc Delgado, Jesús Marcos Delgado Kú, Angel Ruíz Novelo, and Wilbert Vázquez individually reinterpret these subjects based on artistic influences and through their signature carving styles. The favorite subjects among the Puuc artisans are highly detailed depictions of rulers and dynastic scenes seen on Classic Maya stone monuments from southern sites such as Yaxchilan, Palenque, Bonampak, Tikal, or Copan.

Many of these are described in and appear as illustrations for the previous section. Related examples included below are Miguel Uc Delgado's depiction of a standing warrior and kneeling captive from a carved jamb found at the site of Kabah, Yucatán, and Wilbert Vázquez's sculpture that combines imagery from a stone lintel at Kuna-Lacanha, Chiapas, with a "sky band" frame like that seen on the Palenque sarcophagus lid.

Depictions of deities from the Dresden codex and scenes from Classic Maya polychrome ceramics are also favored motifs. Angel Ruíz Novelo has used the elaborate scene from the frequently illustrated codex-style ceramic vessel, sometimes referred to as the "Resurrection Plate," as the subject for the circular format of a tondo carving. Other motifs include a variant of a Classic period full-figure date glyph, and an inventive variant of the "calendar wheel," as well as several images extracted from the iconography of Chichén Itzá (including two versions of a "Toltec" warrior emerging from a cloud serpent, and the "jaguar-serpent-bird" seen on many carved pillars at that site).

As previously mentioned, in an effort to cater to buyer preferences for more organic figural subjects, Puuc artisans are less likely to use the more geometric sculptural motifs of Puuc architectural façades as subject matter. Jesús Delgado Kú's sculpture of "La Reina de Uxmal" (Queen of Uxmal) below is a Puuc motif that is popular because of its portrait-like depiction of a human head in a serpent mouth, recalling the scene on Yaxchilan Lintel 25 (see Figure 1.15). However, Delgado Kú has also combined a geometric, long-snouted mask of the Yucatec rain god Chaak with a frontal deity head derived from ceramic incensarios (incense burners) of the type found at Palenque, Chiapas to create a hybrid image recalling the creative mix of motifs found in the Pisté carvings discussed by Quetzil Castañeda and illustrated in the list of Pisté carvings that follows.

The Puuc artisans also engage in personal explorations of themes and forms, some of which are based on reinterpretations of ancient Maya subjects, as well as on individual interests and creative experimentation with content and formal design. Personal interpretations below include Angel Ruíz Novelo's panel depicting the alluring yet deadly X'tabay, and a carving of a "Freudian" head. Jesús Delgado Kú created an images of a baby held in the palm of a hand, and Miguel Uc Delgado fashioned a carved panel portraying a romantic couple embracing in front of the arch at Labná, Yucatán. A larger carved panel with a related composition graces a wall of Miguel and Estela's restaurant in Santa Elena. Both recall the "serious kitsch" of the Archer figure by the Pisté artist José León Tuz Kituc discussed below (Figure 2.5).

The following Puuc region carvings, listed by individual artisan, appear in the exhibition but are not illustrated in the catalog.

JESÚS MARCOS DELGADO KÚ

Palenque incensario/Chaak mask hybrid, cedar, H-W-D, 31 1/2 x 18 x 10 inches (80 x 45 x 25 cm.). This three-dimensional work illustrates the use of multiple sources to create an inventive metaphor for Maya civilization.

La Reina of Uxmal, cedar, H-W-D, 13 x 9 x 5 inches (33 x 23 x 12 cm.). This carving is based on the stone sculpture known as "The Queen" (La Reina) of Uxmal. The stone sculpture, which originally was found above the central doorway of the Lower West Temple of the Pyramid of the Magician, may represent a founding ancestor.

Baby in the palm of hand (Jesús' creation image), H-W-D, 13 x 9 x 5 inches (33 x 23 x 13 cm.).

MIGUEL UC DELGADO

Two-Headed Feathered Serpent, cedar, H-W, 7 1/2 x 13 inches (19 x 33 cm.). This distinctive image is based on a small wood sculpture encrusted with turquoise mosaic from central Mexico.

Seated Figure in Calendar Wheel, cedar, Diameter 13 inches (32.5 cm.). This carving is based on the calendar wheel sculptures that illustrate the intermeshing of the 260-day divinatory cycle and 365-day solar-agricultural calendar, but is simplified to give greater prominence to the central Maya lord.

Warrior and Captive, cedar, H-W, 23 1/2 x 13 inches (60 x 33 cm.). This subject, depicting the triumph of an armed ruler or war leader over a submissive prisoner, is common in Maya art. It is adapted from a sculptured stone door jamb from the site of Kabah, Yucatán.

Romantic pair (Princess Nikte-Ja and her lover (Chak-Xib-Chaak of Chichén Itzá?) embrace in front of Labná arch), cedar, H-W, 31 x 27 1/2 inches (79 x 70 cm.).

ANGEL RUÍZ NOVELO

Ix Tab (X'Tabay), temptress of hunters in the forest, cedar, H-W, 28 x 17 inches (71 x 43 cm.), based on a Yucatan folk tale.

Warrior emerging from the jaws of a Cloud Serpent (Mixcoatl), cedar, H-W, 21 x 11 inches (53 x 28 cm.), based on an image from a golden disk (pectoral) dredged from the Sacred Cenote (sacrificial well) at Chichén Itzá.

The Maize God rising from the earth, accompanied by his sons the Hero Twins, cedar, Diameter 16 inches (40.5 cm.), based on a "codex-style" Late Classic ceramic vessel.

Man's head with a "woman on his mind" (Freudian illustration), cedar, H-W, 10 x 6 inches (25.4 x 15 cm.).

WILBERT VÁZQUEZ

Jaguar-Bird-Serpent Figure, Aguacate, H-W, 8 x 23 inches (20 x 58.5 cm), based on images from

architectural sculpture at Chichén Itzá and possibly representing Venus as morning star.

Warrior Figure and Cloud Serpent, cedar, H-W, 18 x 10 inches (46 x 25 cm.), based on an image from one of the golden disks (pectorals) dredged from the sacred cenote (sacrificial well) at Chichén Itzá.

Full Figure Glyph of a Kneeling Deity, cedar, H-W, 11 x 9 inches (28 x 23 cm.).

Seated Figure with two-headed serpent Ceremonial Bar, partly enclosed by "skyband" frame, cedar, H-W, 17 x 25 1/4 inches (43 x 64 cm.), based on images from Kuna-Lacanha Lintel 1 and the Sarcophagus Lid from Palenque.

Carvings from Pisté, Yucatán

The town of Pisté, Yucatán, three kilometers distance from to the archaeological zone of Chichén Itzá, is the center of a flourishing and highly diversified practice of wood carving that has developed since the mid-1970s. As discussed in Quetzil Castañeda's chapter in this catalog and in other publications, Pisté artisans are sensitive to the consumer preferences of the tourists who visit Chichén and have created a variety of styles and forms over the course of the last thirty years. The majority of wood carvings are produced quickly in cottage based mass-production. However, a number of Pisté carvers have created more ambitious and aesthetically developed works, initially as an expression of their own creativity and skill. Increasingly, due to the flooding of the market with lower quality souvenir carvings and tourist preference for less expensive handicrafts, these artists create works of art mostly by commission from collectors. Such pieces demonstrate a combination of inventiveness of form and mimetic carving of life forms that convey a sense of energy and life-like presence. We have included several of the various types of more detailed, imaginative, and highly finished examples of such carvings by Pisté artisans/artists in this exhibition.

In the El Arquero (The Archer), a work of art created by José León Tuz Kituc in 1999, the central figure playfully derives from Mexican calendar art (circa 1950s), which in turn is a kitsch copying of late Colonial period romanticist painting of Aztec mythological or historical figures. Here the archer represents Cuauhtemoc, the Aztec Hero King, while the Maya Princess is derived from the cartoon cover of an issue of the Mexican novela, a raunchy–romantic popular literature distributed in cheap newsprint books. They are supported on a stylized double-headed serpent bar, representing Maya divine kingship, that is carried on the backs of two crouching slave-captives or cargadors. —**2.1** *col.*

José León Tuz Kituc also created the Capture Scene, based on Yaxchilan Lintel 8 (see also in Chapter 1 the earlier discussion associated with Figure 1.16). The thickness of the carving and representational style dates this piece to the same period as the Archer. The deep relief combined with the smoothness of the human form is characteristic of his aesthetic style of carving. In contrast to other Pisté artists, José León prefers a less "baroque" aesthetic in terms of details. —**2.2**

Carved by an unknown artist, Bird Jaguar IV Bloodletting is a *réplica* style sculpture based on Lintel 2 from La Pasadita, Chiapas, and depicting the well-known eighth century Yaxchilan king conducting personal bloodletting sacrifice in the company of the local ruler (*sajal*). This piece, not illustrated in the catalog, was sold by Gabriel Uc from Pisté and expresses the *tabla réplica* style of carving that a number of Pisté artisans began to develop in the 1990s.

The sculpture Gloria de K'uk'ulkan, by Wilbert Serrano Mex (1999), is steeped in pre-Columbian iconography but is a unique narrative created by the author. This piece illustrates his Tajín-style sensibility or aesthetic, which is evident in the form, mass, and shape of the human figure in miniature, in the narrative composition, and in the movement given to the feathered serpents. The main figure holds K'uk'ulkan (the feathered serpent), whose flowing body creates narrative frames. Kneeling in front is a woman offering

a bowl of incense. Above, two figures face each other; on the right, a priest sits on an altar while the Young Corn God emerges from his headdress. On the left, the protagonist sits on the head-glyph of a deity, to receive the offering of a Vision Serpent, while a feathered serpent emerges from his headdress. —**2.3**

The *mascarón* is inspired by the figure of Lady Sak K'uk from the Oval Palace Tablet of Palenque (see Figures 1.30 and 1.32). However, here she is shown offering a miniaturized figure, perhaps Pakal, to Time itself, while a feathered serpent flies above. To the right and left of Lady Sak K'uk's feet are a pair of glyphs that mark the zero or "new era" calendar date of the Maya Long Count, "4 Ahau" and "8 Cumku." Below the glyphs, the artist has written the corresponding dates in Roman numbers and alphabet. This figural group rests atop the head of a Chaak (Rain God) mask typical of the Yucatán Maya region, especially at Chichén and Puuc sites. This unique artwork combines distinct Maya cultural icons from three regions in a hybrid that relies on elements from the *máscara*, *mascarón*, and *ídolo* forms. —**2.4** *col.*

The carving by Alfonso Cetz Címe depicts Yum Dzak, Dios de Medicina (1999), in *mascarón*, with a Xipe Totec headdress in which two yellow-spotted jaguars form a base with a slave-cargador for the Corn God protected by K'uk'ulkan (left top) and a priest offering (right top). The central Xipe Totec image derives from the lid of a ceramic bowl from Burial 10 at Tikal (Tzakol culture period), and is painted in the Teotihuacan style of Central México. The use of bright yellows, multiple reds, and distinct blues makes the red-based painted *acabado* stand out against the more characteristic Pisté *acabado* based in deep reds and browns. This piece therefore evokes a "Mexican" multicolored folkloric aesthetic, which is already signaled by the Teotihuacan style Xipe Totec. —**2.5**

The Balam Ahau, Jade Mask of Jaguar King, is by José Mitch and represents an artistic innovation that this artist initiated in 2002. The smooth face is carved in geometric or other designs and painted before the application of the *chapopote acabado*. This creates a jade mosaic effect that evokes the jade masks found in Maya tombs. The headdress consists of a double-headed feathered serpent bar with glyph signs taken from niche carvings on the Venus Platform, Chichén Itzá. Emerging from the serpent bar is a yellow jaguar head, on top of which is seated a Maya man, to whose right are three figures kneeling in a row and to whose left is a Maya priest in *Chacmool* position with K'uk'ulkan (feathered serpent) flying above the scene of sacrifice. The artist's use of the jade-mosaic technique and the figural headdress was so thoroughly imitated and mass-produced that it transformed the Pisté art scene and the aesthetics of masks beginning of this decade. —**2.6** *col.*

The *ídolo* type carving by Abelino Cemé Mex and portrays Yum Dzak, Dios de Medicina, with yellow jaguar headdress, K'uk'ulkan, jaguar, and priest offering incense. This piece illustrates the classic Pisté *acabado* and painting style and the artistic innovations that occurred in the ídolo form during the late 1990s. This is expressed both in the cross-legged seated pose of the main figure and in the figural style headdress with miniaturized jaguars, serpents, and humans. —**2.7**

The figure of Ixchel is a classic example of Ramón Quijano's intricate detailed carving in small statuary. While Ixchel is often referred to as the goddess of weaving, medicine, and childbirth, Pisté artists interpret the main meaning and significance of Ixchel as the goddess of life (childbirth) and death, which is represented below by the emerging child and above by a headdress composed of death-skull held in the jaws of a two feathered serpents whose bodies intertwine behind the head in a visual metaphor for the typical Maya hairdressing style of the Maya, which is known by the name of a serpent. The intricacy of Ramon's art is evident in the attention to and proliferation of detail in body tattooing, feathering, facial and body features (e.g., eyes, toes, hair), and clothing (e.g., straps on the sandals). —**2.8**

The Pisté carvings discussed in this section form part of Quetzil Castañeda's personal collection.

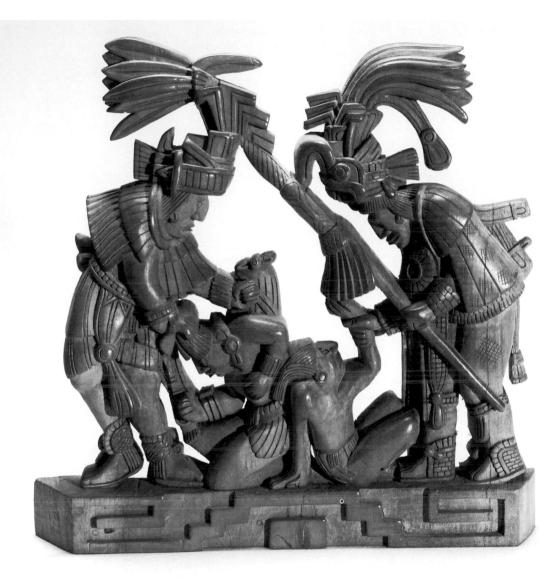

2.2—Capture Scene based on Yaxchilan Lintel 8, Unpainted cedar tabla, H-W-D, 37 x 38 x 5 cm, José León Tuz Kituc, circa mid to late 1990s.

Jeff Karl Kowalski and Quetzil Castañeda

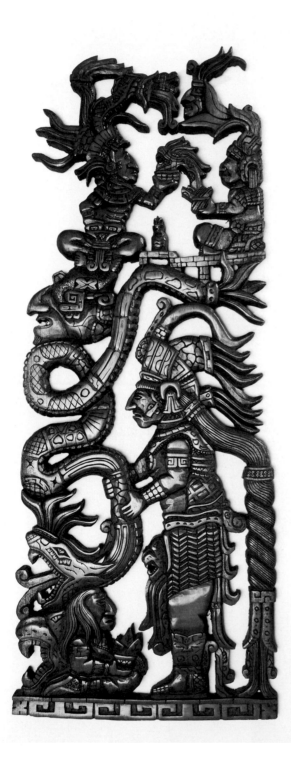

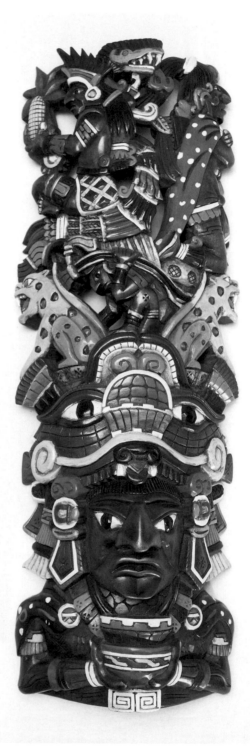

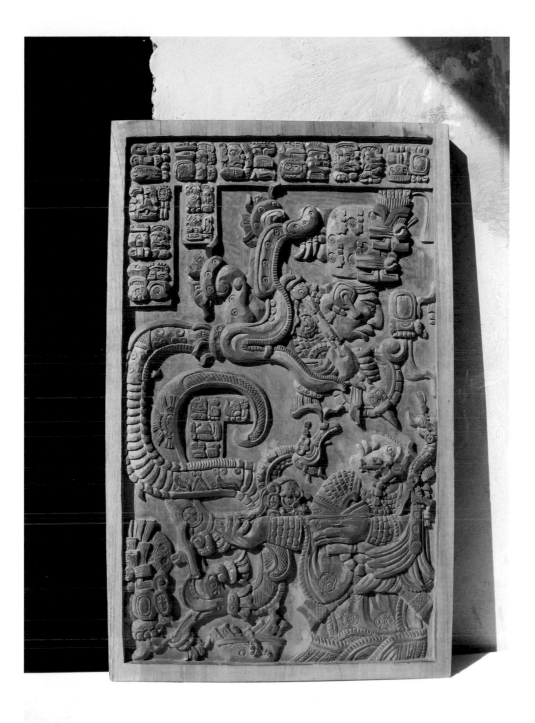

1.1—Angel Ruíz Novelo, Lady K'abal Xook with a 'vision serpent' and royal ancestor, cedar, H-W, 27 x 17 inches (69 x 43 cm), based on Lintel 25 from Yaxchilan, Chiapas.

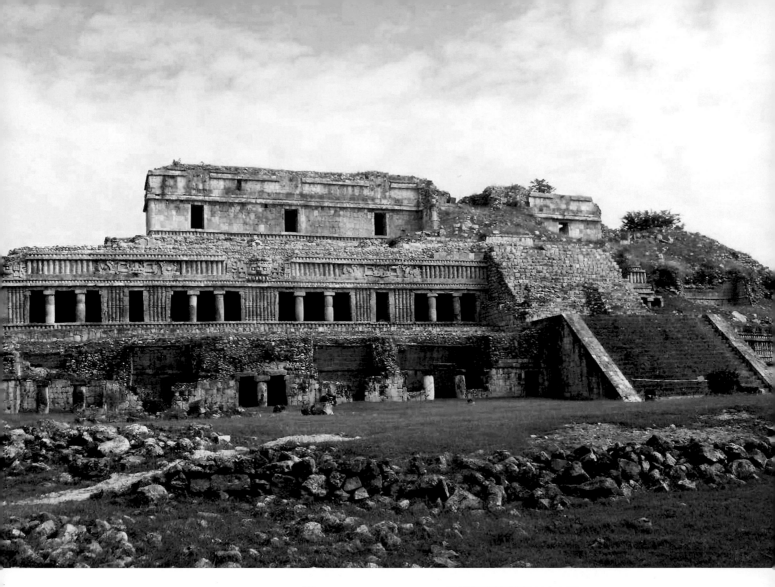

1.2—The Main Palace at Sayil, Yucatán.

1.4— *(right)* The central plaza in heart of the old section of Mérida, Yucatán. The broad, well manicured plaza is a center for local citizens on Sunday, and has booths around the periphery operated by vendors selling a variety of goods to tourists. In the background is the Cathedral of Mérida. This large colonial structure, whose construction began in 1561, rose above the remains of the ancient Maya capital city of 'Jo. This was the seat of the Bishops of Yucatán, including the infamous Diego de Landa, responsible both for the ruthless suppression of Maya religious beliefs as well as the record of Maya history and customs in the *Relación de las Cosas de Yucatán*.

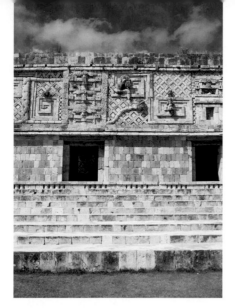

1.3— *(left)* The West Structure of the Nunnery Quadrangle at Uxmal, Yucatán, with the image of the feathered serpent winding across its facade.

1.5— *(below)* Hacienda Yaxcopoil, located south of Mérida, is a good example of the type of large estate that produced henequen during the nineteenth to early twentieth century.

1.10— *(above)* Miguel Uc Delgado, shown in the shop attached to the restaurant owned by Miguel and his wife, Estela. He holds a personalized sculpture depicting the frontal head of a Maya lord.

1.7— *(above, right)* The central "20 de Noviembre" market in the town of Oxkutzcab, Yucatán.

1.12— *(below, right)* Angel Ruíz Novelo in the work area at his home in Oxkutzcab, Yucatán. He is displaying the partly-finished circular carving, based on the "Resurrection Plate," that is one of the pieces included in this exhibition.

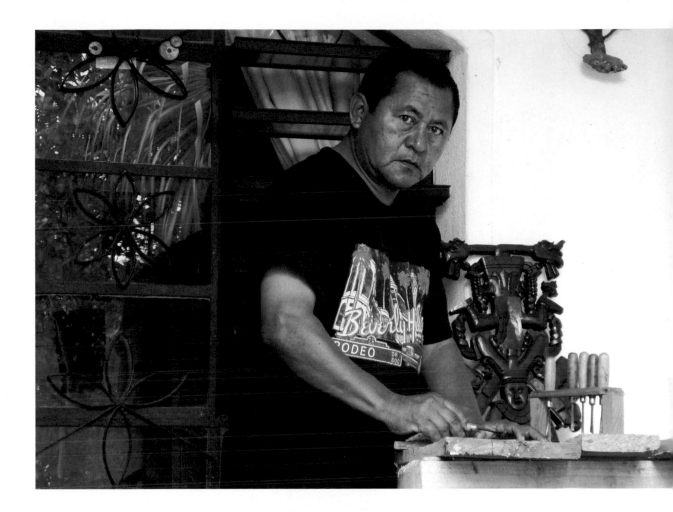

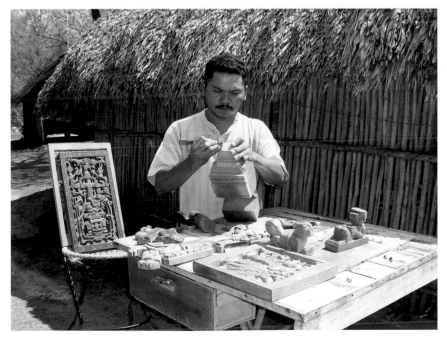

1.9— *(left)* Jesús Marcos Delgado Kú, in the early stages of creating a carving. Some of his tools and other pieces are seen on a table where he works next to the thatch roof palapa where he displays his sculptures at the archaeological site of Kabah, Yucatán.

1.11— *(above)* Wilbert Vázquez, also known by his nickname, Shibata, shown at the work area at the rear of his home in Muna, Yucatán.

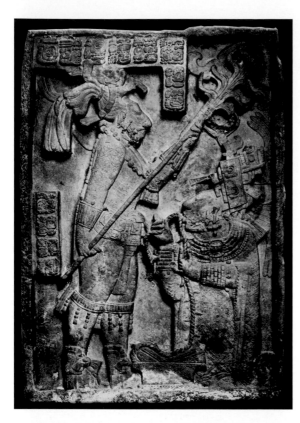

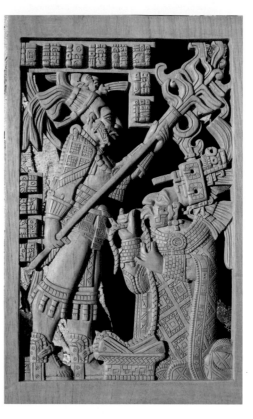

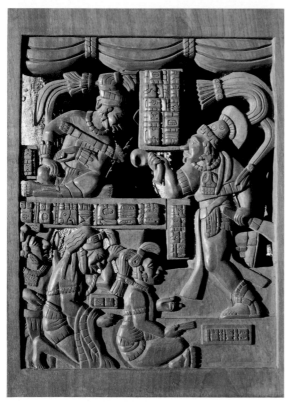

1.14— *(above)* Jesús Delgado Kú, The ruler "Shield Jaguar" (Itzamnaaj Bahlam III) and Lady K'abal Xook performing a bloodletting ritual, cedar, H-W, 24 x 16 (60 x 40 cm), based on Lintel 24 from Yaxchilan, Chiapas.

1.13— *(above, left)* Lintel 24 from Yaxchilan, Chiapas, Mexico. A scene showing the local king Itzamnaaj Bahlam III (Shield Jaguar) holding a torch while his principal wife, Lady K'abal Xook (Lady Xoc) performs a bloodletting ritual of ancestral veneration (after Maudslay 1889–1902, vol. II, pl. 86. Image reproduced from the facsimile edition of Biologia Centrali-Americana by Alfred Percival Maudslay. Published by Milpatron Publishing Corp., Stamford, CT 06902. Further reproduction prohibited.

1.17— *(left)* Jesús Delgado Kú, the ruler "Itzamnaaj Bahlam IV" (Chel Te) and a *Sahal* overseeing a presentation of captives, cedar, H-W, 24 3/4 x 17 3/4 inches (60 x 45 cm). from the Kimbell Panel, thought to be from the site of Laxtunich located near Yaxchilan, Chiapas

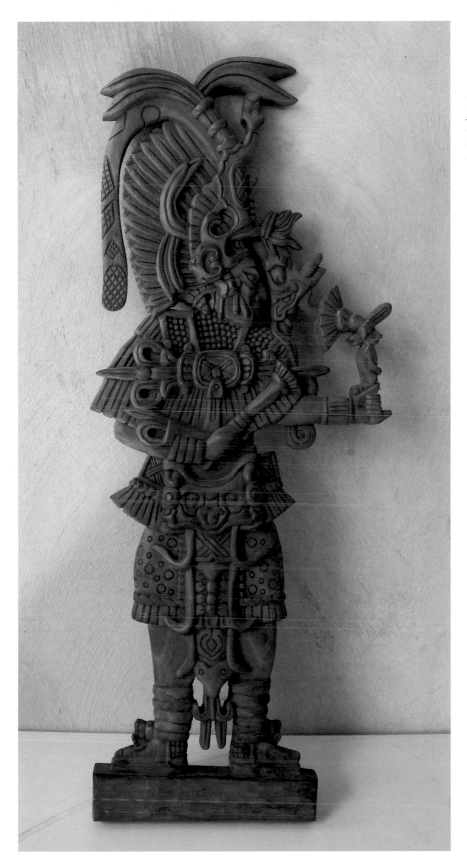

1.20—Wilbert Vázquez, The ruler "Bird Jaguar IV" holding a Manikin Scepter, cedar, H-W, 20 x 8 inches (52 x 21 cm), based on Stela 11 from Yaxchilan, Chiapas.

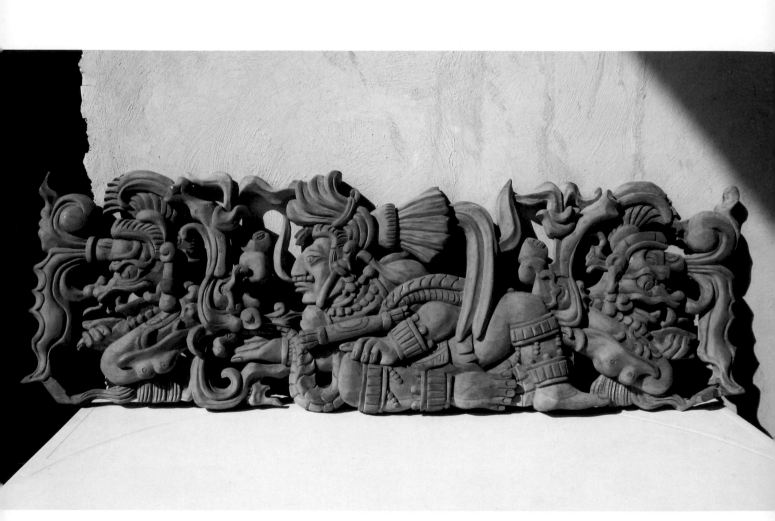

1.21—Angel Ruíz Novelo, Seated ruler ("Bird Jaguar IV") holding a two-headed serpent 'ceremonial bar', cedar H-W, 11 x 34 inches (28 x 86 cm), based on Lintel 39 from Yaxchilan, Chiapas.

1.25—*(right)* Miguel Uc Delgado, three-dimensional portrait head of the ruler K'inich Janaab Pakal II, cedar, H-W-D, 10 x 3 x 5 inches (25 x 8 x 13 cm), based on the stucco portrait head from Palenque, Chiapas.

1.27— *(below)* Angel Ruíz Novelo, low-relief portrait head of the ruler K'inich Janaab Pakal II, cedar, H-W, 10 x 7 inches (25 x 17 cm), based on the stucco portrait head from Palenque, Chiapas.

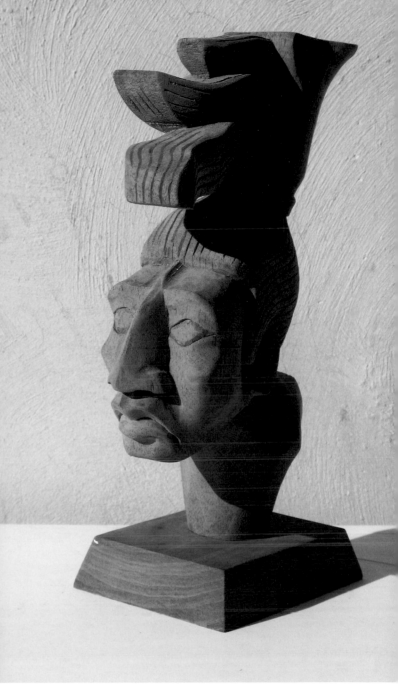

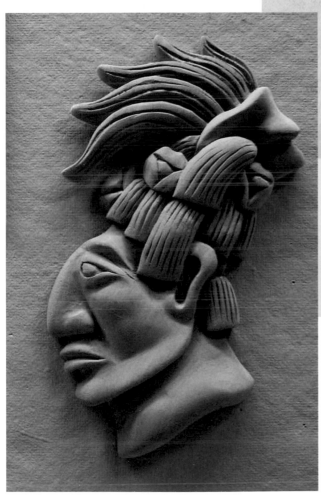

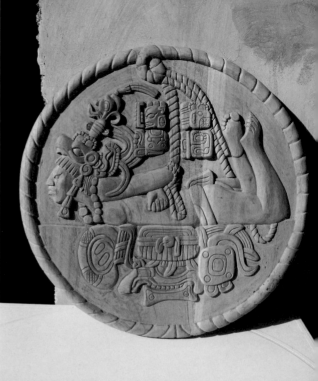

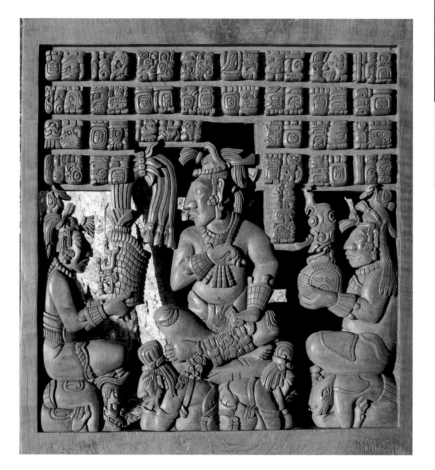

1.29—*(left)* Jesús Delgado Kú, The ruler K'inich Ahkal Mo' Nahb II and his parents, cedar, H-W, 19 3/4 x 17 3/4 inches (50 x 45 cm), based on the sculptured panel known as the Tablet of the Slaves from Palenque, Chiapas.

1.33—*(above)* Miguel Uc Delgado, Bound Captive on personified place name, Cedar, Diameter 22 1/2 inches (57 cm), based on Altar 8 from Tikal, Guatemala.

1.34—*(right)* Wilbert Vázquez, The ruler Aj Bolon Haabtal (formerly known as Ah-Bolon) holding a ceremonial bar, Cedar, H-W, 19 1/4 X 10 inches. (49 x 27 cm.), based on Stela 10 from Seibal, Guatemala.

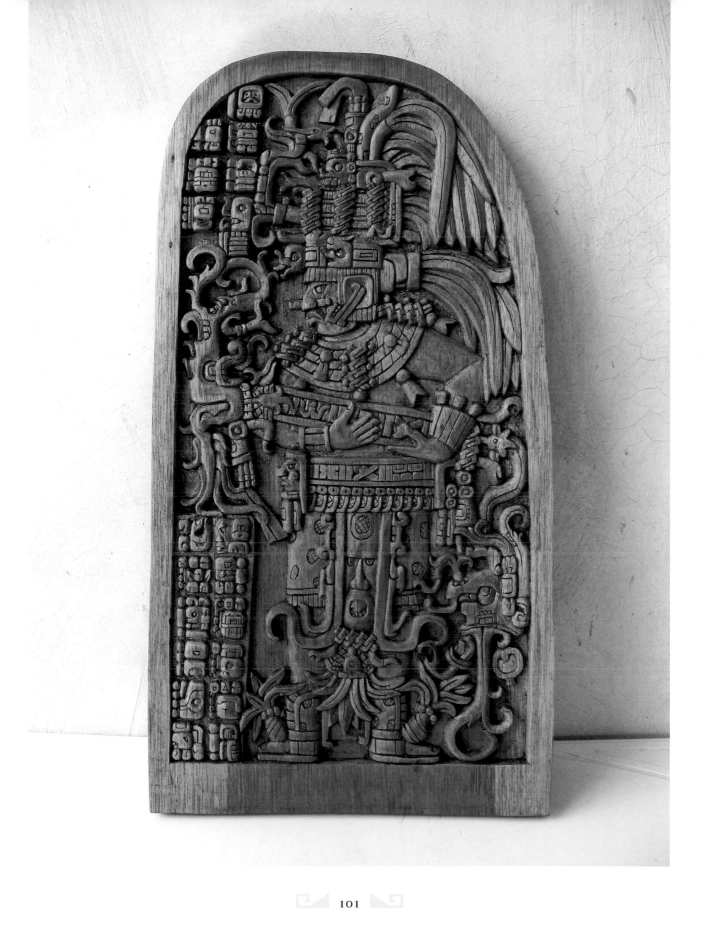

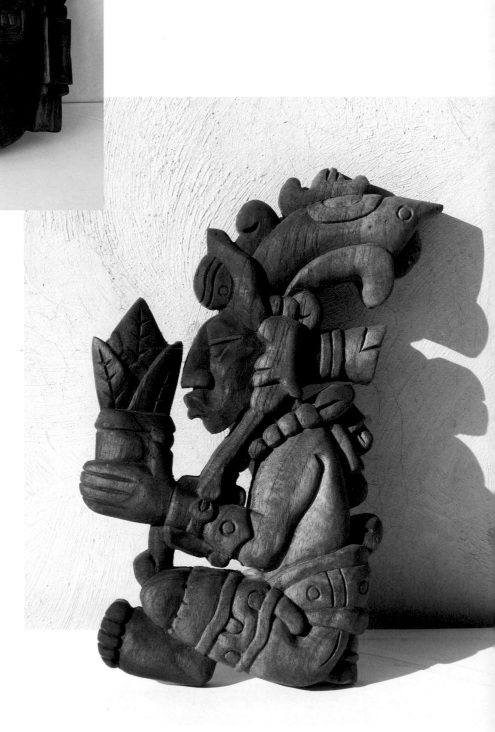

1.36—Wilbert Vázquez, Maya Mask, cedar, H-W, 18 x 16 inches (43 x 40 cm), a composite based on various ancient Maya images.

1.45—Miguel Uc Delgado, Yum Kaax, the Maize God or Lord of the Forest Field, cedar, H-W, 12 x 7 inches (30.5 x 18 cm), based on a depiction of the deity in the Dresden Codex.

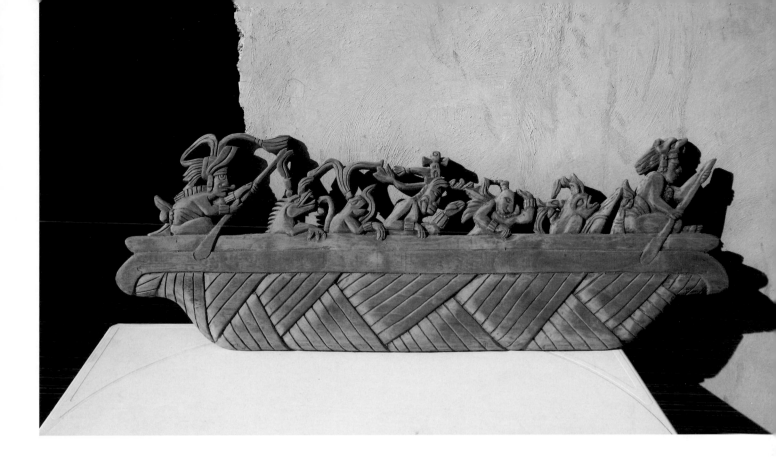

1.42—Miguel Uc Delgado, Canoe carrying the Maize God to the Underworld, cedar, H-W, 12 x 35 inches (30.5 x 89 cm), based on a carved bone from Burial 116 at Tikal, Guatemala.

1.49 Wilbert Vázquez, the "Diving God," cedar, H-W, 19 x 11 inches (48.25 x 29.25 cm), based on depictions of this motif in the architectural sculpture of Tulum, Quintana Roo.

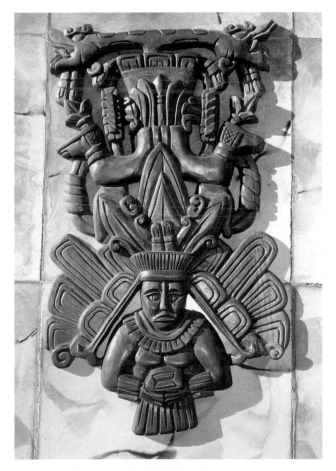

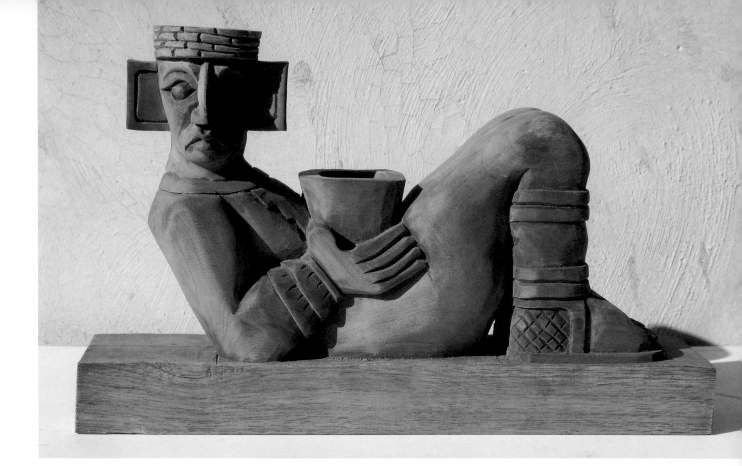

1.52— *(above)* Miguel Uc Delgado, Chacmool Figure, cedar, H-W, 8 x12 1/2 inches (20 x 32 cm), based on similar types of stone sculptures found at Chichén Itzá.

2.1— *(right)* El Arquero (The Archer), Cedar *tabla* in a light orange-brown acabado, H-W-D, 67 x 38 x 5.5 cm, José León Tuz Kituc, 1999.

2.4— *(far right)* Hybrid work depicting Lady Sac K'uk, the Feathered Serpent, and a Chaak Mask, chakah wood in a burgundy red brown acabado, H-W-D, 65 x 21 x 10 cm at deepest point, with additional 7 cm for nose. Jorge Enrique Pool Cauich, 1999.

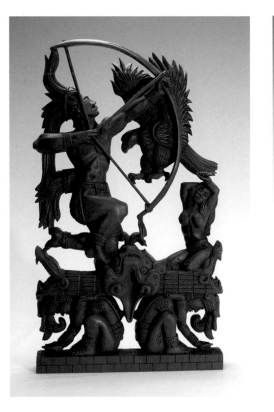

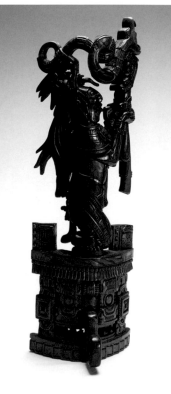

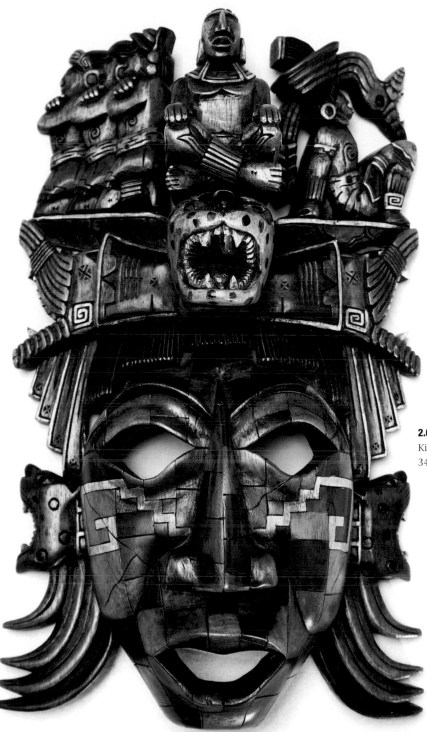

2.6—Balam Ahau, Jade Mask of Jaguar King, Cedar in painted acabado, H-W-D, 34 x 21 x 13 cm. José Mitch, 2003.

3.4— *(top, right)* Engraved walrus
tusk with Jewish New Year greeting,
Angokwazhuk (Inupiat Eskimo, 1870–
1918), Nome, Alaska, 1910. Walrus tusk
with gold inlay. 10 x 1 inches. The Jewish
Museum, New York/Art Resource, NY.

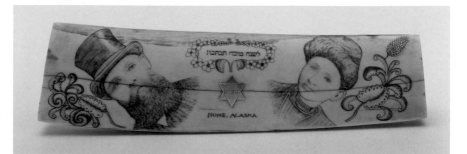

3.6— *(middle, right)* Beaded whisk broom
holder, 1930, and picture frame, 1986.
Unidentified Tuscarora artists, Niagara
Falls, Collection of Janet C. Berlo.

3.7— *(below)* "Pueblo Craftsmen, Palace
of the Governors," Pablita Velarde (Santa
Clara Pueblo, 1918–2006). Watercolor
on paper, 1941, from the collection of
Gilcrease Museum, Tulsa, Oklahoma,
#0227.505.

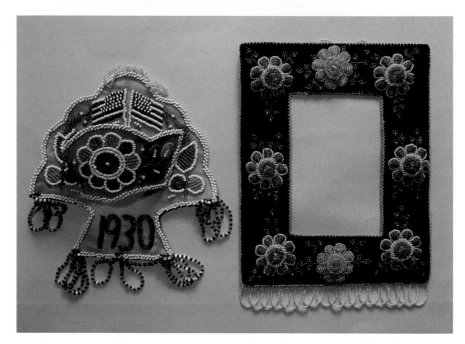

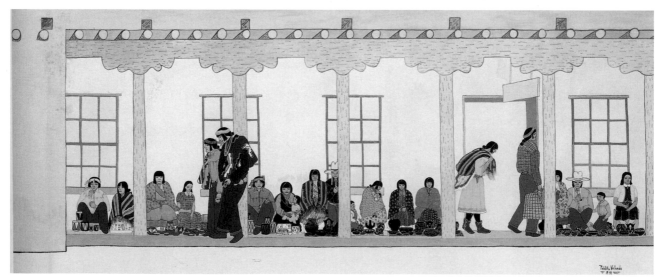

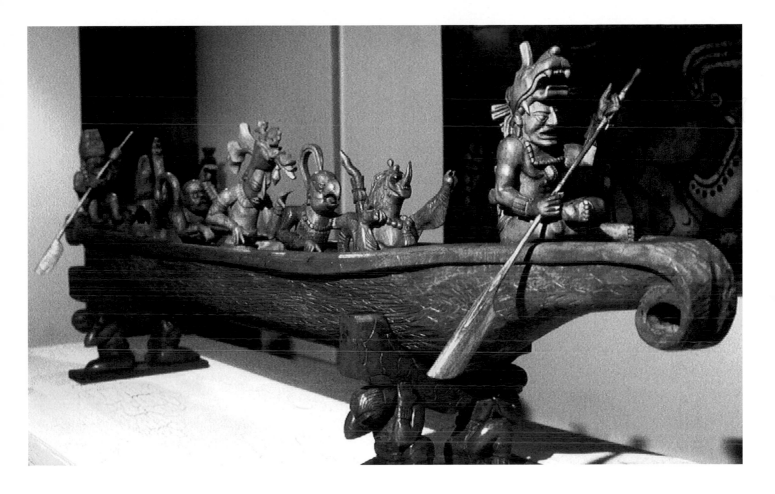

5.1—The Tikal Death Canoe. Commissioned for the 1999 exhibit, "Modern Maya Art in Ancient Traditions" held in the Durand Art Institute, this sculpture depicts the death voyage of the Tikal King now known as Jasaw Chan K'awiil (earlier called "Double Comb" or Ah Kakaw) to Xibalba or the Underworld, conducted by the "Paddler Twin" gods and accompanied by various animal guardians who hold their wrist to forehead in a gesture of death. The canoe is 2 meters long, 28 cm wide, and 16 c. deep. The seated figures are 12 cm x 14 cm at base with variable height up to 34 cm high for the king, including the seat. Created by José-León Tuz Kituc, Jorge Enrique Pool Cauich, Gilberto Yam Tun, Wilbert Serrano Mex, 1999. Collection of Quetzil Castañeda.

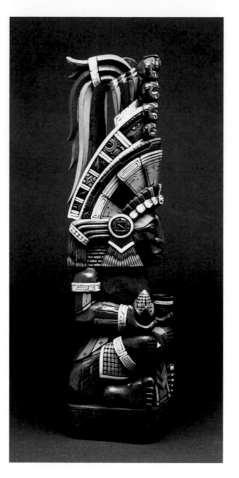

4.4—Anoh Acou, "Gentleman's Suit" (1990). Courtesy of the Museum for African Art, New York, New York.

5.3—Sacerdote Maya. This Maya Priest displays delicate details and vibrant painting that complements the carving. Multiple cut patterns create textural interest, while the precise carving of the face, toes, and fingers contrasts with the absence of any attempt to give accurate shape to the major body masses. Realistic details appear on the feathered serpent: the white underbelly scales, the dorsal patterns of rattlesnakes, and the feathering curling at corners of the mouth. The combined generalization and attention to "accuracy" is typical of Pisté representational realism. It is where artists are distinguished from Pisté artisans. Pìich wood in painted *acabado*, 33 cm high and 8 cm x 7 cm at base. Ramón Quijano Balam, 1999. Collection of Quetzil Castañeda.

5.4—Jaguar-Feathered Serpent Throne. This Feathered Serpent-Jaguar Throne exemplifies the perfectly executed realism and *acabado* that predominated the 1990s. Chakah wood with painted *acabado*, 34 cm long x 9.5 cm wide x 17 high. Artist unknown, 2003. Collection of Quetzil Castañeda.

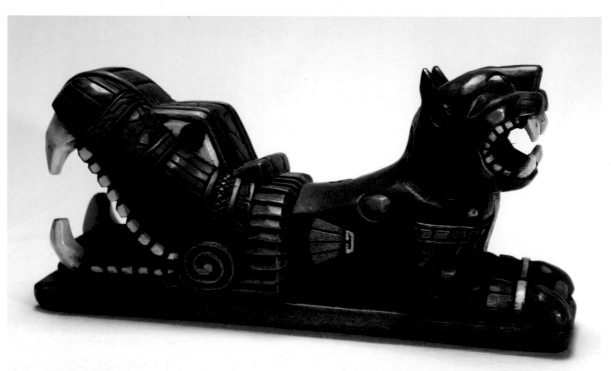

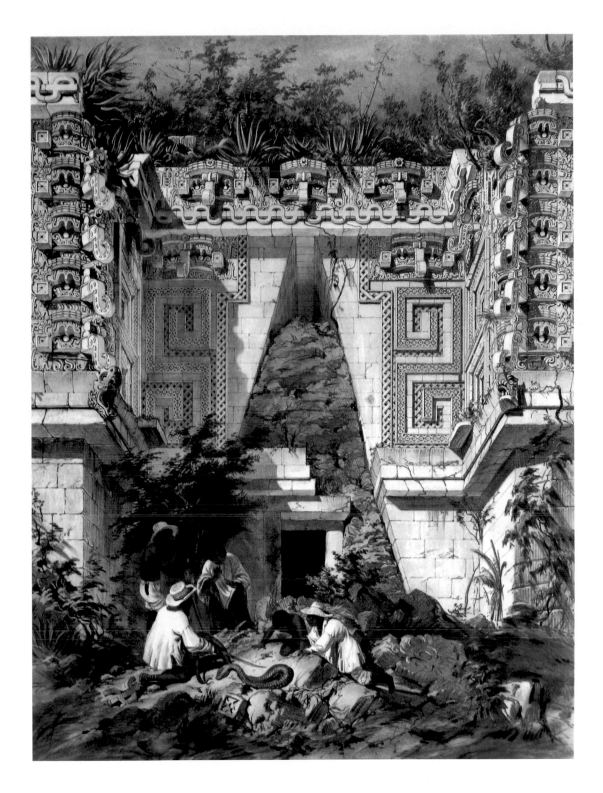

6.2—The Archway of the House of the Governor at Uxmal (after Catherwood 1844, Pl. 10).

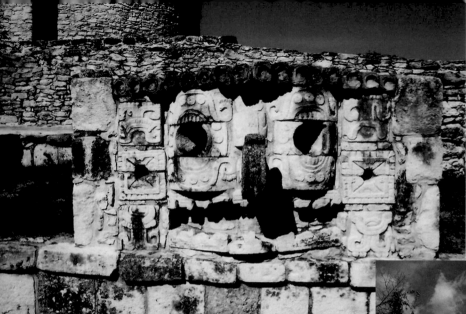

6.1—Long-snouted stone mosaic masks, probably representing the Yucatec rain deity Chaak, on the basal platform of the Hall of the Chaak Masks (Str. Q151) at Mayapan, Yucatán, Mexico. The reuse of such masks, probably from the site of Kabah, may reflect the Xiu family's claims to have been former governors of Uxmal and the Puuc region.

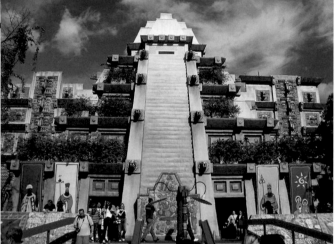

6.5—The entrance to the Mexico Pavilion at the Walt Disney Corporation's EPCOT Center in Orlando, Florida. The entrance features an "Aztec" pyramid temple that is a pastiche of various Mesoamerican structures, in front of which is a "Maya" stela (combining elements of Yaxchilan Lintel 43 and the Tablet of the Cross at Palenque). The upper facades of the pavilion itself are adorned with long-snouted Chaak masks and lattice panels like those seen at Uxmal and other Puuc sites, and trapezoidal arrangements of serpent bars based on those from the East Structure of the Nunnery at Uxmal. Photo courtesy of Benjamin D. Esham for the Wikimedia Commons: image license "Creative Commons Attribution–ShareAlike 3.0 U.S."

7.4—Gift shop in Santa Elena. Entered from a sunny courtyard off the main road from Uxmal to Kabah, the walls of Miguel Uc Delgado's gift shop display a variety of carvings based on Classic Maya sculpture and Postclassic codices. The shop is adjacent to the Uc Delgado home.

NATIVE AMERICAN ARTISTIC CREATIVITY AND COMMODITY CULTURE

Janet Catherine Berlo

▸ Is it intrinsic to the human personality to crave objects made by our cultural "others"? In the Bronze Age Mediterranean, the Minoans valued Egyptian scarabs they got in trade. Seventh-century Anglo-Saxons at Sutton Hoo in England prized objects from Coptic Egypt and Byzantium. Albrecht Durer, upon seeing in Brussels a display of Aztec objects brought back from the New World in 1520, remarked, "All the days of my life I have seen nothing that has gladdened my heart so much as these things for I saw amongst them wonderful works of art, and I marveled at the subtle *ingenia* of men in foreign lands."[1] In the late nineteenth century, Charles Longfellow and other avant-garde Americans and Europeans decorated their homes with Japanese fans and prints, souvenirs from their travels abroad, during an era when citizens of Edo, too, eagerly sought images of and objects by Europeans and Americans.[2]

Such examples indicate that globalization in art and commerce is virtually as old as culture itself.

Contemporary critics have a tendency to treat it as a new phenomenon, yet as one distinguished historian observed, "If we knew the sixteenth century better … we would no longer discuss globalization as though it were a new, recent situation."[3] The term "globalization" is most often associated today with the inexorable economic encroachment of Coca-Cola, McDonalds, or Nike across the world. In anthropology and cultural studies, globalization refers also to the "movement of information, symbols, capital and commodities in global and transnational spaces."[4] An analysis of culture and art based on theories of globalization argues that paying attention merely to local processes and identities provides only partial understanding. Instead, we must chart a world "full of movement and mixture, contact and linkages, and persistent cultural interaction and exchange," to quote Jonathan Inda and Renato Rosaldo.[5] This is as true of the study of Native American art history as it is of arts made elsewhere within the last 500 years.

Most importantly, a global analysis shifts the conversation away from simple-minded polarities like center/periphery to "a multi-dimensional global space with unbounded, often discontinuous and interpenetrating subspaces."[6] The most productive way to understand the visual cultures of Native North America of the last 500 years is to understand them in conversation with other peoples and other artistic traditions. In the nineteenth century, Tlingit carvers made masks with Chinese coins as eyes for use in potlatch ceremonies, and Wishram women wore headgear sporting Czechoslovakian beads and Chinese coins.[7] But some arts were made principally for sale, and my examples focus on these because the widespread commerce in objects of material culture changed Native societies in multiple, complex ways. Often, the sale of art allowed Native peoples some measure of autonomy, despite the crushing forces of missionization and forced acculturation, and it continues to do so today. In their essays, Scott and Castañeda note this for the Yucatán as well.

Aboriginal Americans and their goods and artifacts have been in motion and in contact for several millennia, circulating raw materials, valued art objects, and ideologies—a practice that accelerated after contact with European interlopers. Many twentieth-century collectors, curators, and scholars, however, strove to reify Native cultures. They sought the pristine and the authentic, despite the fact that the Pueblos were overrun by Spaniards in the sixteenth century, the Tlingit in the North Pacific had been evangelized by Russian Orthodox missionaries early in the nineteenth century, and the cultures of the Great Plains had been energized and transformed by the adoption of the horse and the gun long before white encroachment in the West in the mid-nineteenth century. The visual culture of North America has long been hybrid, mixed, and inventive, catering to new markets and boldly using new materials. Yet since outsiders began collecting Native-made objects there has been a tension between the search for the authentic and the ubiquity of the hybrid. And of course, given enough time and distance, the hybrid or the souvenir in its new setting in the parlor, the auction house, or the museum can transform into the authentic and the traditional in the eyes of its new proprietors.[8]

While some Europeans and Americans in the eighteenth century sought to acquire objects that affirmed their travels and their contacts with Native peoples, the collecting frenzy for Native American objects reached its peak from 1880 to 1930. This era saw perhaps the greatest flowering of so-called "tourist arts"—objects made principally for sale to outsiders.[9] By the end of the nineteenth century, as Jonathan Batkin has written, "curio dealers and Native American craftspeople had collaborated to invent and market objects that had no purpose but to satiate a nearly irrational desire to own Indian artifacts."[10] An examination of just a few select examples suggests the multiple ways in which goods were made for new markets. What did Native people get in return? This varied with each situation and sometimes with each exchange. It is important to recognize this so that we do not reduce numerous historical situations to one stereotypical encounter.

Plains Indian Drawings

As pencils and small notebooks passed into the hands of Plains Indian men in the last third of the nineteenth century, these artists miniaturized the large-scale narrative scenes they had painted on tipis, hide robes, and shirts. Many men in Lakota, Kiowa, Cheyenne, and Arapaho communities made drawings on paper that depicted their exploits as warriors. These served as *aides memoires* to their bravery in battle, but they also circulated outside Native communities. Their makers sold them to traders and military men eager to go home with memorabilia of their service in the West. In other cases, such drawings were taken by whites from bodies on battlefields and in massacres.[11] Many drawings were made for sale by the infamous inmates of a prison in St. Augustine, Florida, between 1875–78. The Cheyenne and Kiowa prisoners at Fort Marion and their art have been much written about.[12] In part, surely this is because there are not many instances in the annals of tourist art where tourists visited a prison specifically to buy artworks from the prisoners. But also it reflects our interest in this art as a visual history of these men's experiences at a time before many Natives on the Plains were writing their own histories. —**3.1**

Coastal Florida in general—and St. Augustine in particular—were opening up as tourist destinations in the 1870s, and many northerners wintering there were eager to see the Indian prisoners they had read about in newspapers, during the decade when General Custer and Indian battles were much on the minds of Americans. In their interactions with these prisoners, who had remarkable freedom to interact with outsiders, many bought small drawing

books filled with scenes of Plains life or the men's remarkable journey cross-country from Oklahoma Territory to St. Augustine.

A Cheyenne man named Chief Killer drew a vivid scene of combat in which three mounted warriors bear down upon six retreating Pawnee who stride across the bottom of the page. The Pawnee enemies wear the distinctive cuffed moccasins of their nation and are scantily clad. The horsemen on the right carry lances, and one wears a finely beaded war shirt with eagle feathers and locks of hair attached to the arms.

As I have argued elsewhere, to make such art for sale does not obviate its meaning and purpose to the makers.[13] Young male warriors far from their families made these works as a way of remembering their former lives and chronicling the remarkable changes in their current ones. Moreover, by making such drawings, they earned money to spend as they chose, either on themselves or to send home to Indian Territory. Unlike most of the "ledger drawings" made on the Great Plains, the drawings made at Fort Marion were not inscribed in discarded ledgers, but in fresh new drawing books bought specifically for that purpose. These books were sold for $1 apiece, mostly to tourists.

No works are known by Chief Killer after he and the other prisoners were set free in 1878; he returned to the Cheyenne reservation where he worked as a butcher, policeman, and teamster. In this instance, the making and sale of artwork was situational, and perhaps expedient: as a captive, this was one of the ways he could make money, and he came from a culture in which men routinely drew their experiences. We know the names and histories of most of the Fort Marion ledger artists. In the other Native American examples that follow, I have chosen several works by known makers, though many tourist arts are, by their nature, anonymous to their buyers, most of whom are looking for something that exemplifies a cultural type, rather than an individual vision. In some cases they get both.

Haida Argillite

For more than five decades starting in 1785, Northwest Coast Indians including the Tlingit and the Haida traded sea otter pelts to British and American ship captains in exchange for metal, guns, and other exotic goods. Ships leaving Boston Harbor sailed around South America, up to the Pacific Northwest, across to Hawaii, and then on to Canton in China, where they exchanged the furs for tea and fine porcelains, often realizing enormous profits for their efforts. In some years at the beginning of the nineteenth century, one sea otter pelt would earn its Native owner six yards of cloth, or sturdy wool blankets, or a collection of kettles, knives, combs, buttons, and beads.[14] Much of this new material found its way into Northwest coast art. And of course, much Northwest Coast art found its way into non-Native hands.

From their home in the Queen Charlotte Islands, the Haida navigated huge canoes up and down the coast of what is today British Columbia, and were undoubtedly fascinated by the New England whaling ships that plied those waters in the 1830s and '40s. For an audience of these and later maritime traders, Haida carvers made small-scale objects from a soft shale called argillite. Through the decades of the nineteenth century, imagery in argillite charts the changes in Haida society wrought by trade, epidemic, and missionization. The first argillite objects sold to whalers in the 1830s were pipes depicting animals familiar from Haida large-scale wood carving. They were quickly followed by non-Native themes: sailors and ships and round plates with abstract floral motifs worked out with a compass, perhaps inspired by floral patterns on newly purchased china plates.[15] —**3.2**

The smallpox epidemic of 1862 ravaged the population: some 8,000 Haida at the beginning of the nineteenth century were reduced to a mere 800 by the end of it. It was surely a deliberate return to Native themes when, after 1870, argillite objects began to feature elaborate scenarios from Haida myth.

Whereas the previous generation had been attempting to make sense of all that was foreign, artists at the end of the nineteenth century were trying to salvage meaning from within their own fragmented culture. Even though argillite was made for outsiders, the act of making it was an act of remembering and reconstituting the old stories before they were forgotten.

The platter in figure 3.2 depicts such a story, though its import is not entirely clear. At one end of the long oval platter, a bear crouches with a rope around its neck. Directly below, a devilfish (octopus) with a humanlike upper face clutches a whale in its beak. At the bottom, a giant dogfish (shark) holds a fish in its mouth. On the right side a beaver and a man peer from behind these central animals, while on the left, it is a bear and a shaman, the shaman identified by his long loose hair, nose pin, and rattle. In Haida belief, the devilfish is the supernatural protector of the shaman, and only the shaman can control such a powerful marine creature. Around the rim, the characteristic formline designs of Northwest Coast art—ovoids and stacked u-shapes—reveal semiabstract eyes, profile faces, fins, and claws.

Best known for the bold elegance of their monumental wood-carving, nineteenth-century Haida artists used their characteristic artistic conventions in the making of these miniature objects for sale. Specialists recognize individual hands in argillite carving, though the maker of this platter remains unknown.[16] Many argillite carvings are today recognized as masterpieces of the Haida carver's art, though a number of early museums spurned them as "inauthentic."[17]

Though non-functional in an instrumental sense—this platter with its high-relief carving could not hold food, nor could most of the pipes be smoked—such carvings were highly functional in an ideological sense: they perpetuated artistic and cultural practices during an era when Haida culture was under great stress. Moreover, they promulgated Haida art to the world. This platter was bought by a Navy Admiral who sailed to the Queen Charlottes at the end of the nineteenth century.[18]

Objects labeled as curio, souvenir, or tourist arts have often been scorned in favor of those deemed more "authentic" by outsiders whose romantic view of Indians caused them to value far more highly the objects that Native people made for themselves, especially those of alleged ceremonial use. Yet objects made for sale encompass a vast range of creativity, from the most hastily made to the finest craftsmanship. Indeed, as Castañeda's essay notes, different venues cater to different classes of tourists.

People all across North America watch the PBS hit series Antiques Roadshow with excitement to see the popular commodities of yesteryear (from the nineteenth-century Shaker blanket chest or Indian basket to the mid-twentieth-century Mickey Mouse lunchbox) elevated by time and scarcity into the costly fine art or collectible of today. Perusal of any auction catalog of Native American art from recent years demonstrates that the same process has occurred with items that, a generation or two ago, would have been dismissed as mere souvenirs. In other instances, the curio trade sometimes developed subcategories of rarity and excellence that led to exceedingly high prices even a century ago, as discussed below in relation to California baskets.

Of course in the twenty-first century, notions of collectibles and their transits of commerce have expanded exponentially. The finest mid-nineteenth century argillite pieces have recently achieved prices at auction as high as $100,000.[19] Mold-made reproductions of argillite in museums can cost hundreds of dollars—more than some original contemporary Haida argillite carvings! The Canadian Museum of Civilization (Canada's equivalent to the Smithsonian), which owns a considerable collection of argillite, offers in its "cyberboutique" items ranging from $11.99 to a high of $649.[20]

Tourist Arts of Alaska

Marketing the 'curios' of indigenous America was big business in the late nineteenth and early twentieth centuries. The vast trade in Alaskan Native artifacts

provides a good example. The Alaska Commercial Company, a huge mercantile establishment concerned principally with the fur trade and the supplying of goods to Alaska territory, was founded within a year of Alaska's purchase from the Russians. Between 1869 and 1900, it bought enormous quantities of hand-made goods from Native artisans. In some instances, the makers brought objects for sale to the trading posts; in other cases objects were purchased or commissioned, including miniature kayaks, paddles, sleds, figural carvings, and novelty items. Anthropologist Molly Lee points out that by 1899 ACC's inventory "included birchbark baskets, model boats, beaded moccasins, wall pockets, gold-dust pouches, bone letter openers, horn spoons, and toy snowshoes."[21] Some of these items grew logically out of the indigenous arts of Alaskan Native peoples, while others—such as wall pockets and bone letter openers—were minted solely for the curio trade, as they were in other regions.

In Seattle, a prime touristic destination at the beginning of the twentieth century was Ye Old Curiosity Shop, run by J. E. Standley. Crowded with basketry, jewelry, natural history specimens, ivory carvings and other curios, this emporium sold to anthropologists, serious collectors, and casual tourists alike. As Kate Duncan has demonstrated, pieces from here ended up in the Horniman Museum in London, and George Heye's collection in New York (now the National Museum of the American Indian).[22] Some of these were replicas carved by Native entrepreneurs from drawings in Franz Boas' *The Social Organization and the Secret Societies of the Kwakiutl Indians* (1897) a mere ten years after this pioneering anthropologist published his important treatise on Kwakiutl culture.[23] Other items for sale were ivory carvings made by Inupiaq and Yup'ik men. Some carvers found individual buyers or sold to middlemen at local venues (Point Barrow and Nome for example), while other carvers traveled south to Juneau and Seattle to ply their trade with larger numbers of tourists. —3.3

Although Alaskan Eskimo artists had been carving ivory for more than two thousand years, the last years of the nineteenth and the first years of the twentieth century opened up new markets for the Native ivory carver. Impressive gold strikes in the 1890s in several parts of Alaska brought thousands of hopeful prospectors to the north. Gold was discovered on Cape Nome in 1899, and the next two years witnessed a stampede to the tiny hamlet of Nome; 20,000 hopeful people left ports on the West coast and headed there in 1900 alone. It quickly became a boomtown of prospectors, speculators, grocers, and businessmen, as well as a trading center for local Inupiaq Eskimos.

An Inupiaq man named Angokwazhuk (c. 1870–1918) arrived in 1900, too. While working on a whaling ship, he had observed the art of scrimshaw. The whalers' technique of incising scenes on whale teeth and walrus ivory and darkening the incisions with graphite or ink merged with his own native heritage of ivory carving. In Nome, Angokwazhuk sold many incised cribbage boards and other walrus ivory items and was widely recognized as the finest and most meticulous carver. He could incise pictures with near photographic precision, copying photos or advertising images, producing portraits of President Woodrow Wilson, local businessmen, tourists, and even himself. In the engraved walrus tusk in figure 3.4, Angokwazhuk has drawn a lifelike portrait of an orthodox Jewish couple. A Hebrew inscription reads "May you be inscribed for a good year 5671." A commission for the Jewish New Year in 1910, the tusk contains a gold nugget in the shape of a Star of David, and the inscription "Nome, Alaska." This unusual tourist item (perhaps a gift from one of Nome's Jewish merchants for his parents back in Seattle or New York) stands as testimony to the complex transcultural web that Native artists participated in at the beginning of the twentieth century.[24] —**3.4** *col.*

California Basketry

In 1904, an article in the Arts and Crafts movement journal *The Craftsman* observed: "The woman whose every need or whim is satisfied by a product

of elaborate machinery set in motion the world over to do her bidding cannot conceive of the condition of the first Indian woman who, to meet the needs of her family, invented basketry and pottery."[25] For adherents of Arts and Crafts philosophies, and for its women in particular, baskets made by Native women were not only objects that combined hand-made beauty and utility, but objects weighted with cultural meanings often quite different from the meanings ascribed by their makers. The purchasers of such objects were nostalgic for a lost past; they combined a-historical, romantic notions about Indians with an ignorance about the real lives of contemporary Natives. The discussions of basketry in both the popular press and the specialized literature during the era from 1890–1920 focused on the authenticity and antimodernity of these objects and their makers. Yet the women who wove for what came to be called "the basketry craze" were very practical about their audience, providing wares for different price ranges, sizes, and tastes.

Elizabeth Hickox was a mixed-race woman of the lower Klamath River area of Northern California, where Yurok, Karuk, and Hupa weavers lived, worked, and intermarried, not only with each other but with non-Natives.[26] Although her mother was Wiyot, Hickox grew up in Karuk territory and married a mixed-race businessman, so they had access to products like cars and radios, which were out of the reach of many northern California Natives at the time.[27] Regarded as the finest weaver in her region, Hickox used the highest quality materials, fashioned the most complex designs, and wove astonishingly small and tight stitches. She specialized in globular baskets with lids, the excellence of which were diminished by the trivial nickname "trinket baskets." For many years she wove on an exclusive contract to Grace Nicholson, who purchased more than ninety baskets from her. —**3.5**

Nicholson transformed the first floor of her spacious home in Pasadena, California, into a gallery with Navajo textiles, western baskets, and other Native objects adorning every surface. For most of the first quarter of the twentieth century, she sold American Indian artifacts to wealthy collectors, including other women who eagerly sought Native women's artwork to adorn their own domestic interiors, many of which conformed to the Arts and Crafts aesthetic. While Nicholson and others like her promoted the most expensive baskets as the work of individual named craftswomen, other aspects of individuality were lost in this aesthetic discourse which focused instead on the "authentic," the "pre-modern," and the "vanishing."

In many cases, basketry was the best source of income for Native women, at a time when the only other paid work was such as domestic servants to ranchers. Yet Elizabeth Hickox, married to a mine-owner who employed other Natives to work for him, was not dependent on the steady income she made under contract to Grace Nicholson. In fact, her descendants recall that she used her earnings to travel to San Francisco and to purchase stylish clothes—just as a middle-class Euro-American woman who made Arts and Crafts pottery might have done. Though Arts and Crafts consumers sought an edifying tale of authenticity, what they got was, in some cases, an exchange among elites—wealthy white women and prosperous Native ones.

Much of the Arts and Crafts literature suggested that Native basketry had been "contaminated" by consumerism. In fact, the basketry trade helped ensure the survival of these traditions at a time when most other cultural forces were fragmenting Indian lives and cultural practices. Moreover, the basketry trade afforded the finest craftswomen an opportunity to advance their most original and ingenious designs. Having a patron who bought everything she made for a market of wealthy collectors allowed Hickox to continue to make unique baskets with more than 800 stitches per square inch at a time when nothing in the local culture in which she lived rewarded such painstaking artistry. It is also important to acknowledge the strategies by which Native people negotiated

complex cultural situations as active participants, not simply hapless victims, as too many historical narratives have portrayed them.

Iroquois Beadwork

The beaded objects in figure 3.6 represent a continuation into the twentieth century of strategies for artistic and cultural survival practiced by Iroquois women since the early nineteenth century. On the left, a whisk broom holder beaded with American flags, floral motifs, and the date 1930 was almost surely made by Tuscarora beadworkers selling at Niagara Falls. The black velvet picture frame on the right, with colorful rosettes beaded in high relief, dates from 1986, and was purchased at Niagara Falls by myself.[28] As both a tourist destination and an international boundary, Niagara Falls was a site where many Native people have sold beadwork and other souvenir arts, especially in the century from 1850 to 1950. —**3.6** col.

Some white women attempted to make baskets as part of the Arts and Crafts fad for Native women's crafts, but this did not nearly equal the earlier craze for making Iroquois-style beadwork promulgated by *Godey's Lady's Book* and other women's magazines in the 1850s and '60s. The domestic "whimsies" made by Victorian women drew inspiration from, as well as influenced, Iroquois beadwork styles; acculturation was a two-way street. Native beadworkers sought to capitalize on this interest in their work, making a host of practical and decorative items ranging from broom and thimble holders to pin cushions and picture frames. Ruth Phillips has convincingly demonstrated that through these arts, Caucasian and Native women found a meeting point across barriers of race and class.[29] Yet for white women, such handiwork was a passing fad, while for Iroquois beadworkers, this was a way successfully to negotiate modernity on their own terms, using their art to support their families.

In the 1990s, a curatorial team composed of Native scholars and artists as well as Anglo scholars and curators from both Canada and the U.S. created a remarkable exhibit of Iroquois women's creativity, *Across Borders: Beadwork in Iroquois Life*, opened in 1999 at Montreal's McCord Museum, and traveled to several other venues during the next three years.[30] Due in part to this exhibition (which was many years in the planning and involved much consultation with beadworkers themselves) such work has experienced a renaissance in the last fifteen year, with resultant higher prices for its makers. Today, museum exhibits and their widespread publicity often affect the prices set for Native arts everywhere from eBay to the reservation. Native artists everywhere use exhibition catalogs of historical arts as sources of inspiration for their own work.

Tourist Arts of the Southwest

Writing to the proprietor of the Hubbell Trading Post in 1905, a representative of the Fred Harvey Company remarked, "A silversmith is quite the attraction and, as I wrote to you, I would like to have one."[31] He needed a silversmith not only to demonstrate the making of Indian jewelry but also to lend an air of authenticity and to promote sales at the "Indian Department," the new emporium at the Alvarado Hotel in Albuquerque. Like Niagara Falls in the mid-nineteenth century, the desert Southwest was a Mecca for tourists beginning in the 1880s when the Santa Fe Railroad built its service through New Mexico and Arizona.[32] By the mid-1920s, tourists began arriving in private automobiles as well as trains, and the mystique of the Southwest that remains to this day was complete. Much has been written about tourism, commodified culture, and primitivism in the American Southwest.[33] Albuquerque and Santa Fe were the key nodes (and Santa Fe remains) on this regional tourist circuit. Baskets, pottery, weavings, and jewelry made by Navajo, Pueblo, and other Southwestern dwellers have long been sold at trading posts, railway stops, national parks, and metropolitan shops. Moreover, Native people have

long marketed their wares themselves, at roadside stands, within communities, and, most famously, under the *portales* of the Palace of the Governors in Santa Fe. —**3.7** *col.*

Many a tourist has taken photos of the scene in fig. 3.7 that seems to define the picturesque: Indigenous people sitting on the ground, their wares neatly laid out on blankets in front of them, are framed by the posts and carved wooden beams of what seems to be an ancient building. (Of course, this building, which defines the "Santa Fe style," dates from 1913—the same year as modernism's famed Armory Show in New York City, and its style was a deliberate marketing decision on the part of the city fathers, who for nearly a century have successfully legislated a faux period style for the city center.)[34] In this watercolor, Tewa artist Pablita Velarde may seem simply to *record* the touristic vision of Santa Fe, but I believe she complicates it as well.

When Velarde painted this in 1941, she was also working as a telephone operator at the Bureau of Indian Affairs in Albuquerque. She had been earning money as a painter since the age of 15, while still a student at the Santa Fe Indian School, as part of Dorothy Dunn's famous Studio School art program. She worked as an artist in a WPA program at Bandelier National Monument, an archaeological site near her home Pueblo of Santa Clara. Like those artists pictured in her painting, Velarde, too, had offered her work for sale to tourists under these same *portales*.[35]

In the Southwest—and indeed in much of North America, women's arts made for sale generally follow the gender practices of their cultures, so that, while women may be innovative in the *kinds* of weaving, beadwork, or baskets they make, most women have continued to work in the mediums common to women. Velarde was only the second Pueblo woman to achieve recognition as a painter in the early twentieth-century Southwest, following in the footsteps of Tonita Peña. In 1939, Velarde painted one of the murals for the entryway façade of the newly opened flagship store of Maisel's Indian Trading Post, in Albu-

querque. (Her painting depicted the female potters of Santa Clara Pueblo.) Inside Maisel's, the innovative tourist draw was the glass floor that allowed visitors to watch Indian craftsmen hand-finishing silver jewelry in the basement. But what tourists didn't see was the vast factory employing some 85–100 smiths, some of them working at giant 110 ton presses. Jonathan Batkin has written about the sophisticated mechanized processes underpinning Native-made jewelry at Maisel's:

> No cast silver ingots or hand-drawn wire were used in the shop. Maisel's purchased commercially produced silver, both coin and sterling, and in the form of sheets and wire, from Handy and Harman in Los Angeles. Among the shop's machinery were at least two rolling mills, one of which was a triple-geared, hand-operated mill, and the other an electric mill. Workers used these to reduce the thickness of sheet silver and to roll out sheets from melted scraps and filings collected in the shop. All machinery was kept concealed from public view, and all of it was operated by Indian workmen.[36]

Buyers of Southwest Indian jewelry in the 1940s surely never pictured the "Indian workshop" where their items were "hand-crafted" as looking like any other factory's machine room.[37] Of course, concealing the reality of modern production techniques helped to keep the mythic veneer of "ancient craftsmanship" and "authenticity" intact.

Conclusion

Throughout the history of inter-relations between Indigenous artist and non-Native buyer, the social practices involved in the production and marketing of such works have been complex and multivalent. Tradition *and* innovation, collective values *and* individual vision, economic *and* ideological values are all played out in the arena of tourist arts. Making the choice to fashion a basket, as Elizabeth Hickox did,

or to carve a walrus tusk, as Angokwazhuk did, or to work as a jeweler, a potter, a beadworker, or a weaver, as so many Native people have done over the last two centuries, is a way of accepting modernity on one's own terms. It provides a personal autonomy not found in work as a domestic servant, factory worker, or farmer—or any other occupation thrust upon Native people by outsiders. As Ruth Phillips has observed, through the making of souvenir arts, "Native people modernized their economies and lifestyles while they ensured the continuation of important visual artistic concepts."[38]

No matter how modest or how ambitious, Native American tourist arts have always reflected the cosmopolitanism of native culture. For, of course, the makers of objects for sale must have a shrewd understanding of their markets, as the other essays in this catalog demonstrate. Moreover, like artists everywhere, Native artists are energized and inspired by new mediums and materials. While my examples in this brief essay have been very selective, Native American commodity art production elucidates the complex and sophisticated relationship that Native artists have always had with global culture. The negotiating of multiple realms in the making of art and the presentation of culture has been an inescapable aspect of Native-white interaction since first European contact, and one that we are increasingly coming to appreciate. Being Cheyenne, Tuscarora, or Haida is not a circumscribed, essentialized identity, but one that has long been cosmopolitan, labile, and appropriative.

Today, even the most avant-garde Contemporary artists draw inspiration from the souvenir art production of their immediate relatives and their ancestors. All of the art forms I have mentioned in this brief essay endure and are being taken in new directions in the twenty-first century. Tuscarora artist, curator, and scholar Jolene Rickard, for example, is descended from a long line of beadworkers. Her own art practice includes photography and installation as a way to tell and comment upon indigenous histories. She has phrased the relationship of contemporary artist to historical craftworker most succinctly. About the work of her female ancestors, whose images she incorporates into her photography, she writes: "with these beads my grandmothers made souvenirs to sell and served our beliefs as well. This strategy must be acknowledged as part of the beadwork. . . . My work is another bead on the cloth."[39]

Notes

I am grateful to Jeff Kowalski, whom I have known since we were in the same cohort of graduate students in History of Art at Yale in the 1970s, for affording me the opportunity to write for this catalog. I would like to acknowledge the help of several valued colleagues, including Jonathan Batkin, Kate Duncan, Ruth Phillips, Norman Vorano and Robin Wright. Students Jack Caughran (at Harvard in 2002), and Victoria Pass and George Roland (at the University of Rochester in 2008) provided key research and bibliographic assistance.

1. Holt 1957, 339.

2. See Guth 2004 and Meech-Pekarik 1986.

3. Gruzinski 2004, 4.

4. See Kearny 1995, 547. For an anthropological study of Coca-Cola and its movement across contemporary cultures, see Foster 2008.

5. Inda and Rosaldo 2002, 2.

6. Kearney 1999, 549.

7. For the Tlingit example, see Miller, Berlo, Wolf, and Roberts 2008, fig. 7.25. For the Wishram example, and for a discussion of global impact on the Plains, see Berlo 2007, 97–147.

8. Jonathan King 1986, 65–92 was perhaps the first to clearly critique the outmoded yardstick of "traditional" for Native American art. In the same volume, Marvin Cohodas 1986, 203–20 demonstrated the way in which canny impresarios could create "tradition" out of whole cloth, while at the same time both supporting and obscuring the innovative and entrepreneurial spirit of the artists.

9. After the first wave of attention brought to bear on the topic of "tourist art" by Nelson Graburn in his edited volume *Ethnic and Tourist Arts: Cultural Expressions from the Fourth World* (1976), a number of scholars turned their attention to this intercultural art form; the work of Ruth Phillips has been particularly ground-breaking in its mix of exemplary archival and

theoretical work. See, for example, Phillips 1989, 52–63, 78–79; 1991, 19–28; 1994, 98–125; 1999, 33–50; as well as Phillips and Idiens 1994, 21–33. In addition to works cited elsewhere in this essay, some other important recent works on the circulation of Native objects in the marketplace include Jonaitis and Glass, *The Totem Pole: An Intercultural Biography*, forthcoming in 2009; Pearlstone 2001; and Hutchinson, *The Indian Craze*, forthcoming. Noteworthy for the rarity of a Native participant writing about family involvement in tourist art is Ettawageshik 1999, 20–29.

10. Batkin 2008, vii.

11. For a survey of this genre, see Berlo 1996.

12. Two recent publications and their bibliographies ably cover this topic: Earenfight 2007, and Szabo 2007.

13. Berlo 1990, 133–41. For similar acts of self-affirmation in the making of so-called "tourist arts," see also Phillips and Steiner 1999.

14. Gibson 1992, 30, 185. See also Holm 1989.

15. Sheehan 1983 and 2008; Macnair and Hoover 2002; Wright 1979, 1982, and 2001.

16. Robin Wright, personal communication, 14 Oct. 2008.

17. J.W. Powell, who collected for the Smithsonian, boasted in 1893 of his Northwest Coast purchases that he "never spent a dollar" on pieces made solely for sale to the white man. Douglas Cole, *Captured Heritage: The Scramble for Northwest Coast Artifacts* (Seattle: University of Washington Press, 1985), 292. As Cole and others have pointed out, for the most part private individuals rather than museums amassed the largest collections of argillite.

18. See Nunley and Berlo 1991, 29.

19. The price record of $175,000 is an argillite sea captain figure that Donald Ellis Gallery sold to the Art Gallery of Ontario in 2008 (personal communication, 4 Dec. 2008, Donald Ellis, Donald Ellis Gallery Ltd., Dundas, Ontario).

20. The Canadian Museum of Civilization offers items ranging from a keychain emblem at $11.99 to $649.99 for a replica of a carved storage box by John Robson (c. 1851–1924). The piece most like the work under discussion here is an oval platter depicting a sculpin, offered at $329.99. These items, as the museum website proudly proclaims, are "reproduction pieces molded from casts of original argillite Haida carvings from the Canadian Museum of Civilization's collections." http://store02.prostores.com/servlet/cyberboutique/the-From-our-Permanent-Collections-scln--scln--cln-Argillite-reproductions/Categories. Made in Canada, they are manufactured of a resin

material of the same approximate weight as argillite, and a portion of the proceeds is turned over to the Haida community (personal communication, 4 Dec. 2008, Norman Vorano, curator, Canadian Museum of Civilization).

21. Graburn, Lee, and Rousselot 1996, 35–36. See object numbers 574–608, 621–634, 638–645, 1715–1721, 1725–1918 and 2147–2190 in this catalog. By 1900, more than 2300 such objects in ACC's own collection had been transferred to the Anthropology Museum at Berkeley from the Alaska Commercial Company's overcrowded offices in San Francisco. Only in the past two decades have scholars come to appreciate just how often canonical museum collections of Native art were actually formed from the commercial enterprises of the late nineteenth and early twentieth centuries. This is but one example.

22. Duncan 2000, 12, 45–46.

23. Franz Boas 1897, 311–737. See Duncan 2000, 13. It is notable that Boas himself eschewed collecting objects for the American Museum of Natural History in New York that he felt were 'tainted' by commercialism. Nelson Graburn notes, "Boas's acquisitions, guided by the ideology of "science" and limited by questions of origin and diffusion, were an attempt to represent aspects of an imagined past constructed out of late-nineteenth century anthropological theory, which, incidentally, misrepresented the realities of the Native lives already well-enmeshed in the world system." Graburn et al. 1996, 13. See also Jonaitis 1988.

24. See Ray 1989. Angokwazhuk sometimes signed his work with the nickname "Happy Jack" given by the white inhabitants of Nome because of his disposition.

25. Constance Goddard DuBois 1904. See also Herzog 1996, 69–91.

26. Unlike some cultural products that can immediately be characterized as Lakota, Tlingit, Haida, or Zuni, the early twentieth-century baskets of northern California were often the products of mixed-race women who lived in multiethnic (though predominantly Native) communities. Their work often assimilated the styles of different groups. Thus Hickox's baskets have a geographic designation "Lower Klamath River" rather than a tribal one.

27. All biographical data on Hickox comes from Cohodas 1997, an exemplary study of the intricacies of intercultural commerce in the visual arts.

28. I purchased this from a Tuscarora vender at "The Turtle Building," the now-defunct Native American Center for the Living Arts in Niagara Falls which opened in 1981 and closed

just a dozen years later. While artists of most of the Iroquois Six Nations have made beadwork, the preponderance is made by Tuscarora whose reservation is near Niagara Falls, New York, and by Mohawk at Kahnawake Reserve, south of Montreal, Quebec.

29. See Chapter 6, "Genre, Gender, and Home Craft: Victoriana and Aboriginal Art," in Phillips 1998, 197–261.

30. Its multidisciplinary curatorial team included Kate Koperski, Kanatakta, Moira McCaffrey, Trudy Nicks, Sandra Olsen, Ruth Phillips, and Jolene Rickard.

31. Weigle and Babcock 1996, 168.

32. The rail line to the Grand Canyon was completed in 1901, and the touristic complex built there encompassed a luxury hotel, a faux Hopi pueblo, and numerous opportunities to watch Native craftspeople at work and to buy their wares. See Berke 2002.

33. A full listing is beyond the scope of this essay, but some classics include Brody 1971; Rodee 1981; Babcock, Monthan and Monthan 1986; and Parezo 1983. To set all of this into a framework of understanding of the Anglo preoccupation with these things, see Dilworth 1998.

34. See Wilson 1997.

35. On Veldarde, see Ruch 2001, and Nelson 1971. In the WPA program at Bandelier she completed some seventy paintings between 1937 and 1943. Some of these are visible at http://www.nps.gov/history/museum/exhibits/band/artwork.html. On Dorothy Dunn's Studio School, see Bernstein and Rushing 1995. A recent ethnography of the artists who sell their wares at the Palace of the Governors is Hoerig 2003.

36. Batkin 2008, 131. See pp. 129–47 for a fuller history of Maisel's. Batkin page vi illustrates one of these 110 ton presses.

37. Some forty years later, buyers of Inuit prints—a multimillion dollar industry that originates in tiny communities in the Canadian arctic—are equally unlikely to picture their prized limited-edition serigraph being meticulously registered and colored by a modern woman in jeans and a stretchy nylon flowered blouse. In 1991, I watched master printmaker Susie Malgokak do just that while her small daughter squirmed on her back and rock music blared. Until the Canadian fine art world zealously took up the drawings of Annie Pootoogook of Cape Dorset (b. 1969) as the latest postcolonial artist in 2005, drawings featuring commonplace items of twentieth century arctic life—sewing machines, televisions, cameras, and so forth—seldom circulated in non-Inuit culture. See Berlo 1999, 178–93. Fig 11.2 depicts Susie Malgokak at work.

38. Phillips 1999, 198.

39. Rickard 1992, 105–11. See also Rickard's work in McMaster 1998.

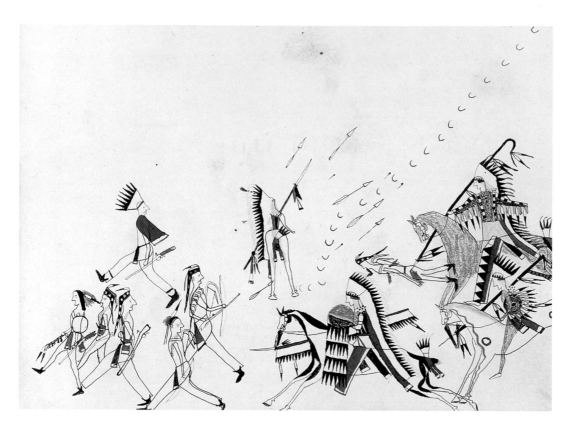

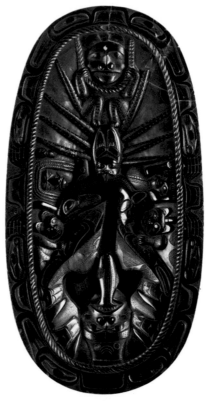

3.1—Drawing, "Sioux Attacking a Pawnee Village," Attributed to Chief Killer (Cheyenne, 1849–1922), Fort Marion, Fl, 1875–76, pencil, ink, crayon, and watercolor on paper, 8 x11 inches. Thaw Collection, Fenimore Art Museum, Cooperstown, New York, T0083.

3.2—Platter depicting mythic scene, unknown Haida artist, circa 1880. Queen Charlotte Islands, British Columbia, Canada. Argillite. Length: 72 cm. St. Louis Art Museum, Gift of Morton D. May 1982.

3.3—Interior of Ye Old Curiosity Shop, Seattle, ca. 1912, with proprietor J. E. Standley at right. Photo courtesy of Kate Duncan.

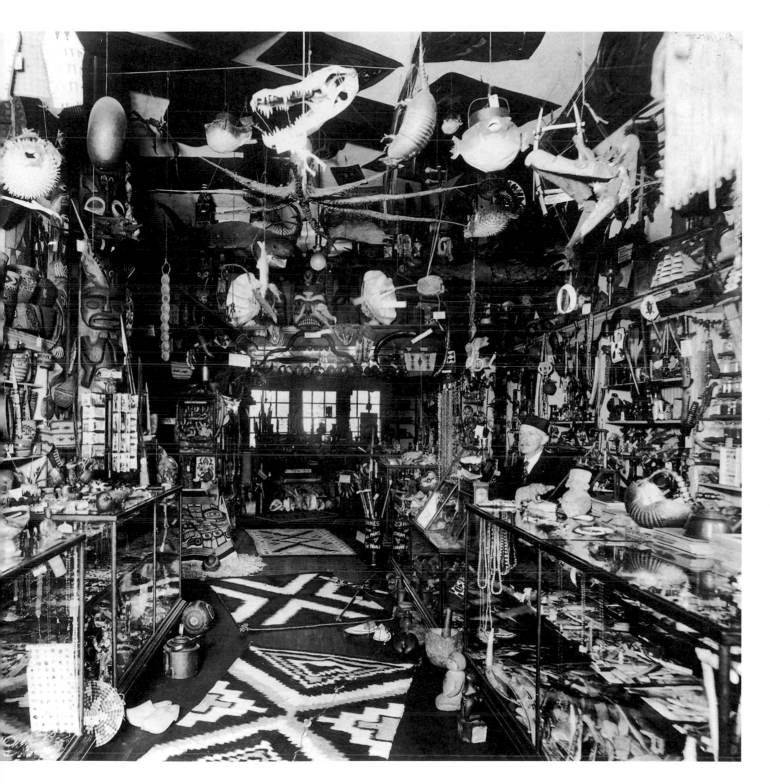

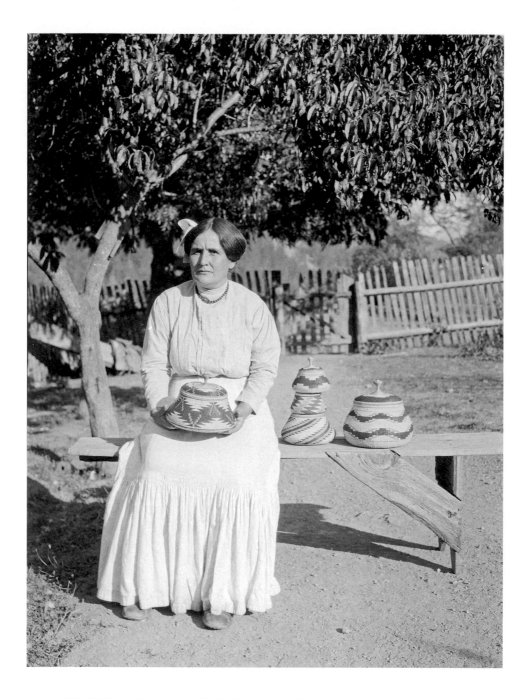

3.5—California basketmaker Elizabeth Hickox and her baskets, c. 1913. Photo by Grace Nicholson. This item is reproduced by permission of The Huntington Library, San Marino, California.

4

THE IMAGE OF AFRICA

AND ITS RELATIONSHIP

TO COMMERCE

Christopher B. Steiner

▸ The invention or construction of the image of Africa has been critical to the history of transnational commerce and exchange between the West and the African continent. At times the image has been negative—inspiring disdain and fear for Africa and its inhabitants. And at times the image has been positive—an idyllic (if not stereotypical) view of a noble, primitive and romantic continent. In this essay I will compare two very different images of Africa from two distinct moments in the history of trade between the West and Africa. The primary connection between these two case studies is the fact that they have both occupied significant chapters in my own research and publications. While there is no obvious historic or chronological relationship between these two examples of transcultural commerce (other than their co-existence in my curriculum vitae), I believe that their comparison is highly instructive and should shed new light on the impact of image making and the cultural construction of Otherness on the history of commerce between Africa and the West.

In the first half of this essay I will examine the trade in factory-manufactured textiles between Europe (specifically France and Britain) and West and Central Africa in the late nineteenth century. In considering these early examples of trans-Atlantic exchange I will argue that the racism and colonial-inspired arrogance that dominated Europe's view of Africa and Africans in this time period was suspended momentarily in the name of capitalist expansion, market formation, and international commerce.

In the second half of the essay I will examine the more recent trade in African tourist craft and art in the mid to late twentieth century. Here too the image of Africa has played a critical role in the construction of a marketable, transcultural product and its trade. But whereas the success of the colonial cloth market was dependent on replacing a racist fantasy of Africa with a more sober vision of African consumers as real men and women with sophisticated tastes and desires, the contemporary tourist and collectable art trade in Africa has rekindled the fantasy of a mysterious, dark continent—thereby suspending the more enlightened vision of modern-day Africans as discriminating consumers of industrial goods that emerged quite uncharacteristically in the Victorian era.

Factory-Cloth Trade and the Suspension of Colonial Racism

European textiles have been traded in West Africa since at least the fifteenth century. In 1469, for example, Bendetto Dei, an agent of the Portinari firm in Florence, is said to have reached Timbuktu where he sought to exchange Lombardian cloth for the gold of the Sudan.[1] During the seventeenth century, companies such as the Royal African Company, the Dutch West Indian Company, and the Compagnie du Sénégal served to formalize textile commerce between Europe and Africa. This same period also marks the first trade war between Indian producers of brightly colored, lightweight cotton prints and British manufacturers of coarse linen cloth in dull and

subdued colors. During this trade struggle—in which the African textile consumer favored the lighter and more colorful Indian prints—Manchester textile producers took special interest in better understanding African taste and satisfying the aesthetic and practical demands of their West African clientele. It was a period in which Manchester printers were able to conquer the West African textile market by producing cloth of special colors and patterns suited specifically to West African needs and desires.[2]

In the second half of the nineteenth century textile manufacturers in England (Manchester) and France (Rouen) identified the African consumer as a likely source of significant revenue for their factory-made printed cotton cloth. Because of the colonial export economy in much of French and British West Africa, men and women had access for the first time to currency that could be used not only for paying their new colonial-imposed taxes but also for purchasing imported, industrial products such as European-made factory cloth. —**4.1**

European producers at this time assumed that any European-made cloth would be perceived by African consumers as superior to the rough, handspun cotton fabrics produced by indigenous weavers. And while the initial response from Africans to imported factory-made cloth was indeed largely positive, it was not always accepted without conditions. African women tended to perceive European factory cloth as generally more supple than indigenous cotton textiles; it was less expensive than local cloth; and the fastness of the European dyes held up better under repeated laundering. However, much to the surprise of European manufacturers, there were many regions of Africa that rejected imported cloth primarily on aesthetic grounds. Although the European-made cloths were of higher quality and more durable and versatile, they did not always fit the consumers' criteria of fashion, color, or style. This rejection of factory-made cloth perplexed the French manufacturers who, throughout the colonial period from the late nineteenth to early twentieth centuries, were

unable (or unwilling) to modify their designs and patterns to suit African taste. If it was good enough for the French of the *métropole*, they believed, then it should be good enough for the "new" French citizens of the colonies.[3]

Two French observers of the colonial cloth market noted in 1954 the failure of the French manufacturers to successfully exploit their own colonial cloth market:

> Fashion in Africa, just as in Europe, has its whims and its imperatives; and to this we regret that French manufacturers have not learned to sufficiently ameliorate the design of their fabrics destined for the African marketplace, nor even to discover and exploit the natives' tastes. For, it is not sufficient to merely depict some hippopotami or elephants, nor simply to draw Eiffel Towers on a piece of fabric for it to become the grand vogue. If a textile succeeds it is usually not because of its overall theme but rather due to a well researched detail in the design.[4]

In marked contrast to the French, the British manufacturers of Manchester cloth were more flexible in developing original patterns and designs intended specifically for the African colonial markets. Having had experience competing for difficult textile markets in India, the British were more familiar with the need for good market analysis that took into account local taste and aesthetic preferences. As one writer noted at the height of European colonial domination in West Africa, "And all these materials [i.e., cloths for export to Africa] are the product of the imagination of Manchester designers who are steeped in the traditions and tastes of far away native populations with whom they may never have had actual personal contact. The indictment of insularity, so often leveled at British designers, can never be better refuted than by examining a collection of such Manchester designed and produced goods."[5] And writing from a historical perspective author Ruth Nielsen observed in the 1970s that, "Manchester merchants varied their

cloth in color and pattern to cater to the different regions in the West African countries, each having its own fashions and tastes, and thereby giving rise to a special West African market for the Manchester cotton industry."[6]

The formation of the textile trade between Europe and West and Central Africa is instructive in identifying the role of "image making" in successful commerce. The colonial agenda of both France and Britain was justified and pushed forward in the popular press by the construction and dissemination of racist and degrading images of Africans as war-mongering, childlike subjects in need of reform and European administration. In the atmosphere of this negative climate, however, the commercial agenda of the industrial textile merchants had to reposition its potential clientele as knowledgeable and sophisticated patrons of commercial cloth who were unwilling to accept goods that did not meet their aesthetic vision and cultural criteria. This was indeed a dramatic shift in attitude from the barbarous, half-naked savage that dominated the literature and imperialist rhetoric of the period. But whereas the success of the textile trade rewarded those who were able to suspend negative stereotypes in favor of a more positive image of Africa and Africans, the cloth market was but a small, isolated pocket of intellectual "enlightenment" in the midst of a more brutal imperialist agenda.

The Invention of Africa and the Marketing of African Art

While the textile trade dominated the colonial economy in the latter nineteenth and early twentieth centuries, the trade in African art originated largely in the mid to late twentieth century as a byproduct of the appropriation of African art and design in the modern Primitivist art movement in Europe. Drawing inspiration from African forms and motifs, European artists such as Picasso, Vlaminck, and Derain not only incorporated the so-called "primitive" into their new art style, but they also began collecting African objects brought back from the colonies by European administrators and merchants.[7] These informal trade routes laid the groundwork for the African art market and tourist trade that burgeoned in the mid twentieth century.

And whereas the textile trade navigated from Europe to Africa, the art trade (by definition) circulates in the opposite direction—from Africa to Europe and America. Yet despite the differences in historic framework and geographic trajectories, both forms of transcultural trade are characterized by their emphasis on either constructing or disrupting an image of the Other and more precisely are dependent for their economic success on the formation of an image of the perceived consumer.

Just as many of the Manchester textile merchants had never met their clients in sub-Saharan Africa—but had rather to piece together an image of their tastes and desires from scraps of information and disparate forms of collected knowledge—so too most sub-Saharan African artists producing for the tourist market have never met the ultimate collectors of their craft. They too rely on second- and third-hand information about the motives, tastes, and desires of those who seek to collect their products. While the Manchester merchants learned quickly that stereotypes of Africa and Africans would not lead to commercial success, the artisans and traders in the tourist market have learned, quite to the contrary, that what sells best are indeed stereotypical views of Africa and its people.

In the Kulebele region of Korhogo, northern Côte d'Ivoire artists have been creating objects for the export tourist trade since at least the 1950s.[8] Although the region is steeped in the iconic sculptural forms of the Senufo people for whom the Kulebele carve, the artists have also learned not to limit themselves to the art of a single region but instead to cater to foreign demand for a wide range of "traditional" masks and sculptures. Thus, in addition to creating the classic Senufo *kpelié* masks or hornbill statues, the Kulebele also carve masks in the style of the Dan people of

Western Côte d'Ivoire, sculptures based on Dogon figures, and Baule-type statues representing colonial officers or Africans in Western attire. The point is, in a manner comparable to the carvers of Pisté, Yucatán mentioned in Quetzil Castañeda's essay, the Kulebele respond continually to shifting interests and desires in the international art market and tourist industry—whatever sells they will produce.

Travelers to Africa have always arrived with preconceived notions of what they would find. Today's tourists are no exception. They arrive steeped in the stereotypical imagery presented to them in guidebooks, movies and the popular imagination. Their quest in collecting art and curiosities is often to simply confirm what they already think they know. As Kenneth Little states quite succinctly, "Tourists come to Africa with a perspective in mind and they try to find scenes that resemble these prior images that evoke recognition and an easy sense of familiarity."[9] For the art trade this means that the forms of the objects must either duplicate the well-known images that grace the pages of African art texts and museum exhibitions (a practice broadly comparable to the duplication of ancient Maya images in the Puuc region wood carvings that are the subject of this exhibition), or must represent a menagerie of animals associated with Europe's vision of an untamed African wilderness. Walking into one of the tourist marketplaces in the Côte d'Ivoire's commercial capital of Abidjan, tourists and collectors are greeted by row upon row of carvings that duplicate the most well-known examples of masks and statues. Also available are carved animals in ivory and wood—bookends in the form of elephants, letter openers crowned with the head of a gazelle, and salad servers in the form of giraffes. This is not the reality of Côte d'Ivoire, where authentic masks and statues are sacred and rare and where the wilderness has been pushed back by industrialization and urban expansion. It is the phantasm of the canon and an illusory natural world that seeks to be discovered by tourists and collectors alike. And thereby the ingenuity and inventiveness of the African artist and his creative mind is stifled by the consumer's preference for the recycled visual lexicon of recombinant mythology. —**4.2** *and* **4.3**

So how does all this relate to the image-making process and its connection to economic marketability and commercial success? The European textile trade might be seen as an anomalous case where the reduction of Africa to stereotypical trope was an impediment to commercial viability. The contemporary tourist trade reverses this "positive" trend by re-valuing the cultural capital of the stereotype—subverting the modern reality of Africa that emerged ever so briefly in the commercial realm of the colonial cloth market. What sells in the African art marketplace is not reality but myth.

Just as it was instructive to look at the failure of the French to capture the textile markets in colonial Africa due to their unwillingness to understand the demands of their clientele, it is also instructive to look at a "failed" case of African tourist art production (an instance of an *art manqué*) to better understand the motivation and desires of Western tourists and collectors in Africa. In the late 1980s, Ivoirian artist Anoh Acou (a.k.a. Koffi Kouakou) began creating and marketing carved wooden objects in the form of urban, industrial objects—including carved wooden dress shoes, baseball hats, pressed suits on hangers, radios, telephones, and even a laptop computer. While Anoh Acou believed this was an inventive way of distinguishing himself from the run-of-the-mill artisans producing replicas of canonical-style masks and sculptures, his efforts were not well rewarded by the marketplace. At his roadside stand in the beach resort of Grand Bassam (near Abidjan), Anoh's whimsical carved creations were left largely unsold. "Anoh's dilemma," explains Bennetta Jules-Rosette, "is caused by the types of artistic themes that attract tourists. Images of an idyllic Africa 'that never was' are exotic souvenirs. As a result of deliberately ignoring popular trends and stereotypes by focusing on modern images, artists like Anoh are at risk."[10] —**4.4** *col.*

Anoh Acou's dilemma underscores the logic of

stereotype and repetition that dominates most of the African tourist art market.[11] It is not through ignorance or insularity that most artists producing for the export market repeat in their work the same imagery again and again. Rather it is a market driven truism that what sells to tourists is the familiar, the known and the ideal. Thus, in sharp contrast to Fourneau and Kravetz's warning to French textiles exporters in the 1950s (cited above) that it was "not sufficient to merely depict some hippopotami or elephants, nor simply to draw Eiffel Towers on a piece of fabric for it to become the grand vogue," for the producers of African tourist art it often *is sufficient* to depict some bush animals or iconic tropes for it to become the grand vogue.

Conclusion

It has long been acknowledged in the literature on African tourist art that the most lucrative path to success for artists and merchants is to produce and promote images of Africa that are stereotypical, simplistic, and naïve. The reasons for the success of such imagery can be traced to the earliest moments of transcultural contact between Africa and the West during which the inventory of false images and tropes was first generated. It has been assumed that the trade in material culture between Africa and the West throughout the colonial and indeed postcolonial period has been buttressed and defined by these stereotypical ideals and images.

Yet, when we examine the trade in European cloth intended for African consumption we note with surprise the sensitivity and nuance in European perceptions of African taste and desire. It is thus ironic that at the end of the colonial period the advent of the tourist art trade brought about a reversal of the image-making process that existed in a pocket of enlightened attitude found in the factory-made cloth market. For in order to sell their crafts, African artists and artisans had to subvert the image of themselves as modern consumers living in the industrial age, and instead re-imagine themselves as members of a "timeless" culture

untouched by Western production and expansion. The fact that they had been consumers of European goods and ideas for many generations was hidden in favor of the invented ideal of a pristine, untouched continent which Europeans sought to reclaim in their collection of African material culture and crafts.

The paradoxes set up in the binary opposition of these two historic modes of transcultural exchange are referenced and explored in the sculptural creations of Yinka Shonibare, a contemporary artist of Nigerian origin who lives and works in London.[12] Shonibare's sculptures consist of life-size fiberglass mannequins covered in West African factory cloth— i.e., the type of fabric associated with African fashion since the early importation of such cloth from Europe in the late nineteenth century. Using this archetype of African identity, Shonibare contrasts the African qualities of these bright, vibrant patterns with European imagery drawn both from the Victorian era and the contemporary (sometimes futuristic) world.[13] For example, one of his sculptures, *Vacation* (2000), shows a nuclear family walking in spacesuits made of African factory cloth. Here, science fiction imagery co-exists in the plane of the fictional Primitivist trope, suggesting a disruption of the conceptual markers between Dominant and Other that normally separate these two geo-political spheres.

The majority of Shonibare's work plays with the legacy of European colonialism in Africa by combining in unpredictable ways African factory cloth with figures and scenes drawn from Victorian painting and literature. Again, it is the implicit irony of combining these two contradictory aesthetics that Shonibare seeks to mine and explore in his work. In his sculpture entitled *Mr. and Mrs. Andrews Without Their Heads* (1998), he captures the paradox of ethnic authenticity and colonialist practices. Based on Thomas Gainsborough's painting, *Mr. and Mrs. Robert Andrews* (c. 1748–50), the sculpture depicts a couple of elite landowners of eighteenth-century England attired not in period dress but in West African factory cloth. "I have dressed the Andrewses in

costumes made of African fabrics," Shonibare said in an interview regarding the sculpture. "The origins of the fabrics are important because this kind of cloth is not indigenous to Africa at all . . . but were industrially manufactured in Holland and England and then sold to the West African market."[14] In this regard, Shonibare's work draws explicit attention to the fact that African culture is hybrid. "People like the idea of pure culture," he notes in the same interview. "A lot of my work challenges these mythologies and stereotypes to highlight the fact that all culture is essentially hybrid, and that the notion of purity is null and void."[15]

What Shonibare seeks to reclaim in his eclectic and thought-provoking creations is a balanced African perspective on history and commerce that acknowledges and indeed celebrates the commercial and aesthetic connections between Africa and the rest of the world. Unlike his artistic brethren in the tourist trade—who produce in the shadows of the world system a limited set of visually redundant craft objects that replicate European and American stereotypes of Africa and its people—Shonibare challenges preconceived notions by producing a complex and nuanced vision of a transcultural African aesthetic.

Having emerged in a period of intense racism driven by imperialist expansion, factory-cloth in Africa is a testament to the capacity of European merchants to understand and respond to African consumers as sophisticated agents of change who have built a unique cultural identity out of elements drawn both from tradition and modernity. The contemporary traffic in tourist art and crafts has, in many respects, squelched this independence of mind and reverted to the propagation of stereotypes and images drawn from a less enlightened era. By examining the history of textile commerce between Europe and Africa within the framework of the contemporary art and tourist trade it is possible to identify alternative forms of image-making and new ways of conceiving of the place of modernity and industrialization in the history of Africa and the world.

Notes

1. Hodder 1980, 204.
2. Nielsen 1979.
3. Steiner 1985.
4. Fourneau and Kravetz 1954, 16.
5. Fraser 1948, 103.
6. Nielsen 1974, 25.
7. An early and ample study of the impact of African, and other non-Western, aesthetic objects on the development of European modernism is Goldwater 1967. For a more recent survey see Rhodes 1994. Other discussions of the ethical and classificatory issues raised by the collection and artistic appropriation of "primitive art," and their relationship to power relationships and colonialist attitudes are considered in Price 2002 and Clifford 1988.
8. Richter 1980.
9. Little 1990, 157.
10. Jules-Rosette 1990, 29.
11. Steiner 1999.
12. My thanks to Jeff Kowalski for pointing out to me the connection between Shonibare's art and the juxtaposition of the art market and cloth trade as presented in this essay.
13. See Kent and Hobbs 2008 and Hynes and Picton 2001 for a discussion of the issues addressed in Shonibare's work, and illustrations or references to the pieces mentioned in this essay.
14. Shonibare 2002, 82.
15. Shonibare 2002, 82–83.

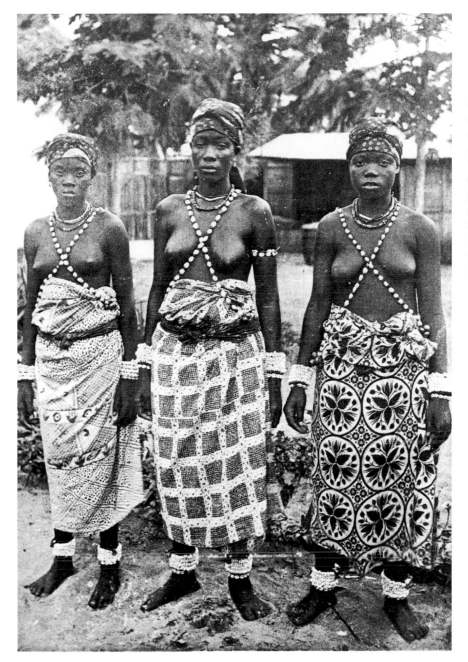

4.1—Women in Togo (ca. 1920). Typical of many photographs of its time, this image portrays these women in a stiff, stereotypical and objectifying manner. They are wearing three types of available cloth: indigenous hand-stamped patterns; imported European cloth in a machine-stamped motif inspired by indigenous fabrics; machine-printed European cloth with European floral pattern (after Lethbridge 1921, Facing page 70).

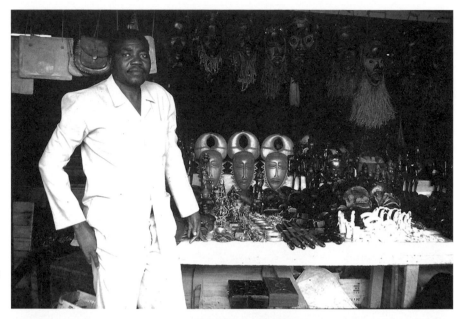

4.2—*(right)* African tourist art stall, Abidjan, Côte d'Ivoire (1987).

4.3—*(below)* Bronze castings, carved ivory and wood souvenirs, Abidjan, Côte d'Ivoire (1987).

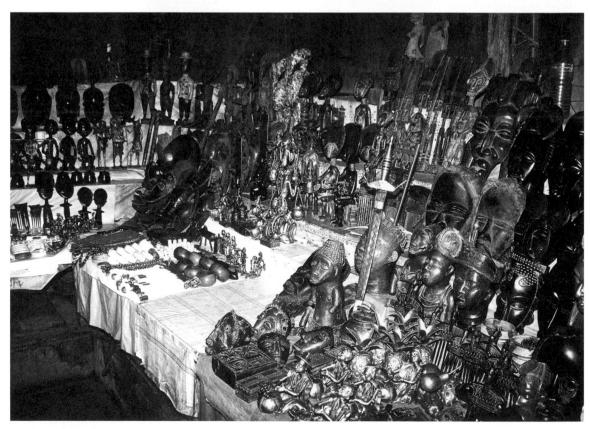

5

AESTHETICS AND AMBIVALENCE OF MAYA MODERNITY

The Ethnography of Maya Art

Quetzil Castañeda

▶ The expression of pre-Columbian Maya themes and images in contemporary Maya wood carving is an art that was invented in the mid-1970s at Chichén Itzá.[1] This tradition of art and handicrafts did not develop out of any prior tradition; it has no direct social connection to, nor historical continuity with, any previous tradition of Maya art. It was created "out of whole cloth" by a resident of Pisté and an employee of the Mexican National Institute of Anthropology and History (INAH) who worked as a park warden (custodio, guardián) at the archaeological and tourist site of Chichén Itzá.[2] In the absence of a regional handicraft tradition of carving statuary in the style and image of pre-Columbian art, he began carving wood and stone for sale as souvenirs to tourists. Nearly forty years later the artwork has been recognized locally as arte pisteño or Pisté Maya art and has developed a surprising breadth of forms, figures, styles, and aesthetics. Arte pisteño, or the artwork of Pisté, has been the original

stimulus and source for the development of derivative wood-carving styles in other communities, such as Yaxuna, Popolá, and Ebtun. The Pisté art has also played an influential role in the emergence and continued expression of the Puuc artwork.[3]

Historically speaking, Chablé's carvings are the origin or ur-source of Piste community's different styles of wood and stone carving, batik, and synthetic molding reproductions that has come to proliferate in the northern Yucatán peninsula. There are other styles of wood handicrafts and art that are informed and inspired by pre-Columbian Maya artwork, but, because of their derivation from and secondary relationship to the art of Pisté artisans and artists, they should be considered as subsets of arte pisteño, whether as community-based styles or as aesthetic variations. The two major derivative styles are the artwork of Puuc-based artists working primarily in the réplica style and the handicraft of Yaxuna artisans who primarily produce tablas and máscaras. As well, there are other Maya wood-carving traditions, such as discussed by Scott,[4] that have entirely different content matter if not also mode of production. The wood carving of the Coba-Tulum corridor is one such distinct and independent Maya handicraft tradition which coheres around a folk or folkloric aesthetic.[5] In this chapter, I provide a historical and ethnographic context to Pisté art by addressing questions of tradition and identity. This leads me to pose the problem of "categories," to which I return in the conclusion after sketching the aesthetic and stylistic development of Pisté Maya art.

The Work of Tradition in the Age of Identity

The crafts made by contemporary representatives of the distinct Maya, Zapotec, and Nahuatl groups preserve techniques and art traditions over a thousand years old... *Continuity in social traditions is ensured in craft production.* The intrinsic value of crafts to the sophisticated traveler or catalogue consumer is precisely the human labor embodied in the product and what it tells about a whole way of life....*The traditions*

of the society that produces the craftspeople inhere in the form and function of the objects.[6]

Many villages in Yucatán have some industry like hammock or hat making, the manufacture of pottery, baskets, candles, or chocolate mixers, *but Piste [sic] has none of these…. During my observations in the village … No one carves stone or wood.*[7]

In the mid-1970s, Vicente Chablé began to carve soapstone and species of soft woods, *piich* (guanacaste) and *chakah* (gumbo limbo), into representations of pre-Columbian Maya gods. Previously, without evidence to the contrary of Steggerda's view (above) that no tradition of wood or stone handicraft production existed, except for what any peasant knows about whittling sticks for building fences, houses, and animal pens. Further, there is no evidence that any craft production that involved copying, reproducing, or imitating pre-Columbian Maya material culture existed after the Indigenous conversion to Christianity in the sixteenth century and the forced abandonment and transformations of ritual, destruction of idols, and torture to death for idolatry under Spanish colonialism. Contra the claims of scholars, such as June Nash, who assert thousands of years of cultural continuity of Maya artisanry based on household production, there is no folk "system of objects" whose production has maintained and maintains a Maya folk aesthetics across the last 200 years, much less 500 or 1,000. In Pisté, as is the case throughout the Yucatán, no tradition of aesthetic production based on pre-Columbian cultural forms or content have survived either colonialism or the nineteenth century Caste War that transformed the social, ethnic, political, and cultural landscapes of Yucatán.[8]

With no tradition to follow or build on, Chablé was inspired by ancient Maya art forms with which he was familiar as a resident of Pisté and as an INAH *custodio* of the archaeological site of Chichén Itzá. While one of his sources was the statuary of Chichén, a second source was the painted reproductions of the seated gods depicted in pre-Columbian codices, such as the Dresden or Madrid, that were painted as murals and decorations on Pisté restaurants in the 1970s. Chablé understood that the tourists who visited Chichén (which in those days numbered less than a hundred thousand a year compared to over a million a year by the end of the twentieth century) were interested in taking home some type of handicraft souvenir to remember their adventures in Yucatán and Chichén specifically. Thus, he began to devote his free time to carving and selling figures. Knowing that he had cornered the market on a growth industry, he sought to keep the knowledge of his tools and techniques hidden. Eventually, so goes the story told me by Silverio Koyok and his brother-in-law, Mitch Ucan, some boys discovered the secret cave in the forest surrounding the pyramids of Chichén where Vicente had cached his merchandise. Using the goods as leverage, Silverio, Mitch, and their siblings learned to carve from Chablé. From these men the techniques spread to others in Pisté.

In this inauspicious manner, Vicente Chablé created a handicraft tradition entirely for consumption by tourists where none had previously existed.[9] The modification of previously existing artisanry and the invention of completely new "traditional" handicrafts is documented throughout the world as an expected dynamic of local, Indigenous, and community engagement with tourism.[10] In this case, this artwork, invented by Chablé and developed by the Ucans, Koyoks, Balams, Tuns, and an increasing number of others, was a unique creation. There was no precedent or parallel in Pisté or elsewhere in Yucatán. Nor is there similar wood carving in other areas of the greater Maya world, such as the Guatemalan highlands where masks for the Dance of the Conquest is a centuries-old tradition. There may certainly have been (and now are) other "traditional" wood-carving traditions in other parts of Yucatán, e.g., in Ticul and Coba, but they are still not this tradition, which was designated "Pisté Maya art" or *arte maya pisteño* by the community in 1999.[11] The artwork was based only

on Chablé's loose imitative style of pre-Columbian figures and images which resulted in "rudimentary" or "archaic"-looking forms that is called by Pisté artists and artisans today by the concept, using the Spanish word, *rústico* ("rustic").[12] Using one part artistic creativity and one part entrepreneurship, Chablé put his rudimentary carving skills to work in developing a product that compelled consumption by tourists and, in turn, inspired creative innovation by competitors.[13]

This was indeed an invented tradition in the sense that Hobsbawm and Ranger elaborated in 1985. For decades the Pisté community itself disparaged the art form as *engaño* (Sp., "deceit," "fraud") and *chen tus* (Maya, "just lies"), that is, as a false representation, lie, and hoax, since the art is not pre-Columbian and it has nothing to do with the living contemporary culture and society of the Maya: contra Nash, there is neither continuity of culture nor meaningful function with regard to this artform/handicraft. This is the case even if Maya Protestants from the nearby community of Xocempich have never engaged in wood carving precisely because they view it as having a real meaning, that is, the meaning idolatry. This view, however, is fairly preposterous to the several hundred Pisté artisans—Catholics, Evangelical Presbyterian, Jehovah's Witnesses, Mormons, and Pentecostals—who carve wood. In other words, the carvings have no relationship to any contemporary ritual, religious beliefs, or spiritual worlds that have emerged before or after Spanish colonization and conversion to Christianity in the sixteenth century. If indeed, it is true, as Nash suggests, that the value of handicrafts is in terms of "what it tells about a whole way of life" then the life these carvings speak about is that of the tourists who consume this artisanry. Indeed, the artwork is less "auto-ethnography" of contemporary Maya culture, than ethnography of the Western romantiticized visions of Maya culture and México.

The artwork had and has no meaning for its producers other than that which is derived from the personal satisfaction of being engaged with aesthetic

production and the economic value of gaining an income. It has no functional use except as a product to sell to anyone who would buy it, that is, tourists. The production of the artwork is not motivated by ethnic, social, or cultural identification: unlike traditional dress, food or corn farming, there is no expression that "we" as "Maya" make our wood carvings this way, not that way, nor motivation that "I as Maya" carve wood because it is "my cultural way of life" and I therefore carve it in such-and-such a manner. The producers are not wood-carving artisans because they are Maya; they are Maya who choose to make a living carving wood, in some cases after decades of having been engaged in other kinds of economic activities that have ranged from agricultural work, masonry, waiting tables, hotel service, making and selling food, to just about any other wage labor and small time entrepreneurial activities. Further, the produced objects do not reflect on the maker an identity of "being" "Maya," of indigenous ethnicity, of social belonging as "Maya," or community identity as Pisteño any more-or-less than the economic occupations of tour guide, taxi driver, mason, or grocery store owner. Further, because the wood carvers recognize that they live in the present in contrast to the ("ancient") Maya that lived centuries ago, they are not producing, only reflecting, "Maya culture" (which is implicitly defined throughout Yucatec and Mexican society as "pre-Columbian Maya"). Thus, they identify the objects that they produce as cultural things that belong to contemporary (not ancient) Yucatec Maya culture as handicrafts and works of art, not as pre-Columbian Maya artifacts and archaeological patrimony. The real issue therefore is not how "they" identify with it, but how do "we" outsiders ascribe to it an identity of iconic and symbolic Mayaness.

I belabor this point because the anthropology of non-Western art, especially in contexts of tourism, has come to be dominated by the fetish of identity. In other words, the analysis of artistic production in terms of how locals construct their cultural identity

has become a mandated requisite for scholars working on this topic.[14] However, the construction of (cultural) identity, in this case and I would hypothesize in many more cases, is an ideological issue of and for the analyst, as well as for the collector: It is not an issue for the producers. In fact the insistence on identitarian analyses of tourist arts and non-Western arts is a continuation of what Greenblatt called the viewer-response of (ethnographic) "resonance" versus (aesthetic) "wonder." It thereby maintains the art-culture "system" of high/low art described by Clifford (see Scott and Kowalski, and Scott, this volume) despite the insistence, on the part of some anthropologists and art critics/historians, that the Eurocentric categories of art have been overcome or debunked.[15]

To be perfectly clear, producing artwork does create an identity, but it's that of artisan or artist (whichever the case may be for a given producer). This means that the producers recognize themselves as an artisan (as is the case with the Puuc artisans) or more rarely as an artist. All producers are recognized as artisans by the community, that is as someone who devotes their time and energy to this and not to some other economic activity, say waiting tables or writing articles about Maya culture for academic journals, such as the case with one Maya that I know from this community.[16] In Rome, the waiters and cooks do not identify themselves as Italian because they serve or cook pizza, nor would they feel less Italian if they were to work in a Chinese restaurant and cook or serve General Cho's Chicken instead of carpaccio. In truth, for some artisans, mass producing wood carvings or its derivative forms is not much different than waiting tables for a dollar or producing "handmade Indian Jewelry" in a basement factory hidden from Santa Fe tourists as discussed by Berlo in this volume. There are, of course, economic occupations and activities that are deeply associated with cultural identities and thus reflect back to the agent a cultural identity. For example, traditional agriculture, bee-keeping, dancing Yucatec-style for tourists,

cooking Yucatec cuisine at home or in a restaurant, and even working as an archaeologist or park guard at an archaeological site for the INAH are pervaded by sentiments of Maya identity; in contrast are jobs such as that of a taxi driver, an occupation that is suffused with a Western-modernity sensibility and can provide drivers a modern versus traditional identity.

There are others, however, who do have deep feelings of personal self-worth related to carving. They pride themselves in their unique skills, are committed to further development of their abilities, aestheticize designs, and, in short, identify *as artist*. However, these sentiments are typically not expressed by the label "artist" except in delimited contexts since there is no formally identified Art market in Pisté and Chichén, only artisanry markets. The manifest expression of an artist-identification is, therefore, subtle and resides materially in the quality of their work and the recognition by Pisté artisans and artists of the qualitative difference in their work and their abilities to produce technically more difficult pieces that are made with greater quantity and quality of decorative cuts. There is, of course, more to the artist—for example, style, creativity, innovation, range of forms, control of design and composition, mastery of hard woods—than just intricacy and depth of relief and carving, but this is a primary criterion. Although these elements are used by artisans to distinguish among themselves, the idea of self-identification as "artist" emerges in the historical interaction with anthropology. Specifically, the ethnographic action research project that I directed in 1998 and 1999, which used focus group workshops with wood carvers, sought to encourage and enable artisans to conceptualize both their subject position as artists and their aesthetic production as art.[17]

Again, their self-identity as "Maya" is not necessarily created or furthered *by being an artist* or by *producing Maya art*: they are already comfortable being Maya or *mayeros* (speakers of the Maya language) in a community where "being Maya" is neither a social or a psychological struggle and "self-identifying as

Maya" does not depend upon an exterior manifestation that fits the anthropological fetishization of indigenous identity.[18]

On the face of it, therefore, this art, consumed as if it were a traditional handicraft by tourists, does not fit with the categorical conception of traditional handicrafts as expressed by June Nash (quote above)—which may lead some readers and has definitely led a significant number of archaeologists, Mérida intellectuals, and state cultural arts promoters over the years to sympathize with the local assessment of this as *engaño*. The idea of fraud or hoax is often ascribed by these social agents because of the tourism context of production and because they feel that the "Maya" culture of the producers is "false" and "corrupted" for being modern and, therefore, that the producers themselves are *unworthy cultureless or de-cultured, inauthentic, non-Maya Maya*.[19]

The first generation of artisans were primarily corn farmers and *ejidatarios* (i.e., federally recognized recipients of federal land grants held by communities). They were males ranging from adolescent teens to fifty plus years old. This was a group of men that enjoyed quite a bit of personal freedom in their lives, although within the constraints of few wage labor opportunities and little to no formal education. They took quick advantage of the opportunity to work for quick and easy cash during the tourist high seasons. Often they consumed their profits in Chac Pool brand aguardiente and gained a bad reputation in the community for their public intoxication, frequent fighting, and bad behavior. They were called *chac mooleros* in honor of one of the figures that they carved, i.e., the Chac Mool; a sculptural type depicting a man sitting on his buttocks with knees bent up, head turned to the side, and hands holding a plate or bowl over the stomach or chest (see Miguel Uc Delgado's Chac Mool in Figure 1.52 of the catalog).[20] Significantly, this famous statue, considered a kind of Mayan Hermes because the priests locate offerings in the plate, say a fresh heart, as sacrifice to the gods, is known by the misnomer given to the statue by an

archaeologist in the nineteenth century. When excavating a platform Augustus Le Plongeon discovered a red (*chak*) painted "paw" (*mool*) and thus bequeathed this phrase in Maya as the enduring and provocative name of this statue. Thus, the first generation of carvers were nicknamed *chac mooleros* perhaps, however, not as legend would have it, i.e., because they carved this figure so frequently. Instead, I suspect that the local nickname derives from recognition of the carvers' manipulation of tourist desires for souvenirs based on the disconnection between the Western visions of the Maya, on the one hand, and a lack of knowledge about the living reality of contemporary Maya, on the other hand.

To a great extent the lack of local and regional acceptance of the artwork as a traditional handicraft and of the producers as artisans stems from a complicated political process extending over twenty-five years. Pisté artisans and venders were systematically targeted by different state and federal agencies for having illegally invaded the archaeological zone of Chichén Itzá to sell directly to tourists.[21] A stigma of being unruly, de-cultured Maya has been historically expressed by the identity label that was ascribed to the producers of the artisanry, *chac mooleros*, from the origin of the art form in the mid-1970s through to the mid-1980s.[22] Driven by the tourism market of Chichén, the artisans and artists of Pisté have always shrugged off this disparagement, although in truth this denigration continues to work against them in terms of social status and against the market value of their artwork: the art and anthropology world of Yucatecan society continues to use subtle mechanisms of disparagement, delegitimization, and exclusion.

Nonetheless, through piecemeal governmental programs, including handicraft competitions and exhibits over the course of thirty years, the Pisté art tradition has slowly and grudgingly become validated and legitimated as a handicraft of Yucatán by state agencies such as Culturas Populares, the State Directive of Artisanry, the INAH, and also by locals.[23] For example, at the height of the invasion

of Chichén Itzá in 1985–87, the state director of the Yucatán office of the INAH at the time, Alfredo Barrera Rubio, pointed out to Pisté artisans that the concept of *chac moolero* was denigrating and that they should be proud to call themselves *artesanos* ("artisans"),[24] a label which operates as a highly significant sociopolitical concept in Mexico, regardless of any consideration of what this means in terms of cultural identities, aesthetics, and "art." While this sociopolitical history is too intricate to elaborate in this chapter, I note that the local acceptance of the handicraft production as art derives primarily from the ethnographic fieldwork processes and curatorial programs that I directed from 1996 to 1999 in the context of the Field School in Experimental Ethnography. These projects included art exhibitions in Pisté and in the USA at the Durand Art Institute, Lake Forest, Illinois.[25] Not only did the general community of Pisté begin to recognize the aesthetic quality of the artwork as art, but it also encouraged a number of Pisté artists to participate in state handicraft competitions and in handicraft expos in México City.[26] Further, it was this intervention of anthropological projects and agents into the then existing art-writing circuit that assigns value in this tourism art-world of Yucatán that facilitated shifting self-concepts from artisan to artist.[27] —**5.1** *col.*

The political contexts of invasions is also inseparable from the aesthetic development of the tradition. On the one hand, a de facto governmental policy of black-listing Pisté is evident in the near complete absence of any marketing support, subsidies, and inducements programs that the government gives to rural communities to develop their artwork. Pisté is not "poor," Indian, or peasant *enough* to be a community "in need." It has thus been avoided by the diverse state and federal agencies that are devoted to the task of what Garcia Canclini has called "hybridization" or *reconversión*, that is, a process of government subsidization of popular, folk, and Indigenous handicrafts with the aim of producing a symbolic "traditional México" that can be marketed for tourism and that can generate a nationalist culture of modernity. On the other hand, the uneven periods of boom sales to tourists, especially during invasions inside the zone (1983–1987, 1993–1997, 2005–present) created such a demand on production that producers turned to mass production of pieces which have significantly lower artistic/aesthetic investment. The mass tourism market, with its preference for cheap, exotic (i.e., foreign, non-local) souvenirs, favors high volume production of lower quality and punishes the production of high-end artwork with higher aesthetic quality and thus (economic, cultural, aesthetic) value. The great works of Pisté Maya art are only occasionally made by artists and are generally based on special requests from collectors or their own need for creative-artistic expression; the majority of their time is devoted to the primary economic activity of handicrafts of greater or lesser art-value. These artists work at home and wait for a collector, anthropologist, or hotel owner from Playa del Carmen to arrive unannounced asking for this or that major piece of artwork to decorate a hotel, restaurant, or home. The mass market thus stimulates a dynamic contradiction between conservativism, or the tendency to reproduce the same with standard to diminishing quality, and artistic creativity, or the drive to create new figures, forms, and designs that no one else produces. Mechanical reproduction kicks in and motivates a large sector of artisans to mimetically copy "best-sellers" through silicon molding and faux-stone sculptures. As Walter Benjamin noted, the aura of art based in tradition withers by mechanical reproduction only to be re-formulated and re-established through the politics of capitalist markets.[28] Applied to the present situation, this suggests that the artwork of Pisté is simultaneously handicraft and art. But how is this duplicity, ambiguity, and ambivalence comprehended by anthropological theory and art history critique?

On the surface, this "indigenous art" holds no surprises as an invented tradition created in response to Western consumerism that is driven by rhetoric

and visions of Otherness. Current logic asserts that this too could be art in theory, so long as it fits the magic box of James Clifford's art-culture system and signals authenticity through the Maya identity of both object and producer.[29] But, these carvers are not "crafting" or "weaving" their Maya identity (as assert the titles of so many ethnographies of tourist art), since neither artisan nor artist play a strong game of identity. Meanwhile they continue to carve products that are carefully produced in response to market demands and consumer desires for souvenir-symbols of Maya culture and Mexico, whether this be mass-produced low end pieces or high end aesthetically detailed artwork. Rather than "craft (their) identity," they use practical and ethnographic understanding of consumer tastes as an inspiration to their own aesthetic and artistic creativity: It is this combination that drives the ongoing innovation and development of the art.

What, then, is and/or can be the status and, by implication, the value of this artwork? Before I address this question, I first describe Pisté Maya art[30] in terms of the historical emergence of its aesthetic styles and forms. In conclusion I return to this question of prospective value by turning to the gap between the theoretical idea that anything could be art and the practical reality that not just anything can circulate as art.

The Aesthetic Development of Pisté Maya Art

Pisté Maya art is an invented tradition with an astonishing breadth, sophistication, resilience, and creativity. This cultural invention of a "traditional" handicraft has flourished, matured, expanded, and even stimulated the development of secondary industries of mimetic reproductions. In this section I provide an overview of this historical development by tracing the aesthetic qualities and styles of the different forms that comprise this tradition.

The wood carvings or statuary in general are referred to as *figuras*, or figures, and initially also

ídolos, or idols. Initially, the artwork was first made from tree trunks of varying size from two species of soft wood, the *pìich* and *chakah*. The first generation developed four primary figures: the Dios de Maiz or Corn God,[31] the Ixchel Goddess of Birth and Death,[32] the Young Corn God, and the Chac Mool;[33] other figures were much rarer, such as feathered serpents[34] stylized as the Maya ball game bat or serpent columns modeled on a common architectural feature at Chichén. The Dios de Maiz and the Ixchel are essentially the same figure with key substitutions in design and gender-based symbols.[35] Whereas the former squats with an oversized cornstalk held by both hands between his knees, the latter squats with hands on knees and the cornstalk becomes the head of baby emerging below. The former has a headdress of corn tassels carved onto the top end of the wood; the latter has a headdress of a skull held by two facing serpents heads. Given that the figures were front carved only, the bodies of these serpents were not portrayed until the 1990s when the backside began to be carved.[36] The Young Corn God is based on the famous bust from Palenque in which the ruler Pakal uses a headdress made of young corn tassels tied and tossed forward above of the face. —5.2

In addition to these basic forms that predominated production, there were less commonly carved figures that were discontinued, no doubt due to lack of sales. One such figure is the Jaguar Throne, which is based on a stone sculpture in the interior temple of an earlier building underneath the Pyramid of K'uk'ulkan. These *ídolo* figures were also carved in soapstone, *jaboncillo*, until the early 1980s. By 1985, when I first began fieldwork in Pisté, I had not actually seen a "stone carving" and I had assumed that the local lore that Vicente Chablé used to carve stone was fictional history. In August 1999, however, his sons showed me three stone carved figures—a Jaguar Throne, an Ixchel, and a Dios de Maiz—that their father had carved.[37] According to local artisan history, the exhaustion of the local source of soft stone led the artisans to create their own "stone." Using a mixture

of ground limestone powder, cal, and cement, they would create blocks of stone that were then carved or scraped into diverse shapes. Paint powder is added to the mixture for variations in color, but the predominant color ranged from purple, mauve, and slate, to dark grey; black outlining of the cut strokes were often added to increase perspective and depth. Initially the stone carvings replicated the forms and figures that artisans were already carving in wood.

The incorporation of the new material actually triggered a creative expansion of the repertoire of artisans in the 1980s, whom I have previously designated in my writings as the second generation. Perhaps in recognition of the aesthetic limits of this faux-stone, or what I have called *piedra pisteña*, Pisté stone, the artisans began to creatively play with forms, designs, and motifs. Different kinds of serpents, especially the ubiquitous serpent column (found in the Ball Court, Temple of Warriors, and Pyramid of K'uk'ulkan) and a double-headed serpent were added to the series. The Serpent Column was later hybridized with the Chac Mool such that a serpent head replaced the feet of the man. Small stone Pyramids, Maya heads with or without a headdress, ashtrays, and other pre-Columbian-like figurines were also developed.[38]

The 1980s proliferation of forms also extended to carvings in wood. On the one hand, the wood carvers, who were virtually all adult males were inspired by the creativity of the stone carvers who tended to be boys from eight to sixteen years old. They began to copy the Serpent-Chac Mool and Double Headed Serpent, while also adding the Serpent Bate; *bate* refers to the carved club-like stone playing sticks used in the Mesoamerican Ball Game. Variations of the core *ídolo* form were also developed by the end of the 1980s, such as the seated and kneeling Maya with different kinds of headdresses, for example the Maya Guerrero (an empty handed seated or kneeling figure with a warrior's jaguar helmet). These artistic shifts in *ídolo* were just a prelude, however, for creative expansion of forms in the 1990s.

The design and motif elements consist of niche cuts and, with increasing presence, detailed cuts (e.g. quincunx, frets, wavy line, diamonds, hatching). These cuts are delicately arranged in single or multiple lines, sets of niches, circles, and star patterns to represent body tattooing. The general quality of the carving remained rather simple; by the third generation this carving aesthetic with little design intricacy or detail (as well marked by poor mastery of forms, balance, and expressions of humans and animals) became known as "rustic" or *rústico*. In addition, a polite way of speaking about another artisan whose carving was *rústico* was to say that the artisan was "just learning how to carve." Enhancing this rudimentary style was the fact that, in this generation of artwork, the wood carvings remained in their natural color, unpainted. In the case of *pìich* carvings, the color is a rich buttery yellow or bright white, while *chakah* pieces have dark yellow and reddish orange tone and striations.[39] Unfortunately, especially with *pìich,* the color and weight did not signal, to my mind at least, either a hard or old wood, nor therefore a highly valued wood.[40]

Beginning in 1991 I began to talk with Gilberto Yam about the artwork and ways of further developing the art. Giliberto, as well as many other Pisté artisans, was interested in using me as an informant on the consumer tastes of the tourists in order to create a product to meet demand. I repeatedly suggested that the wood should be treated, painted, or varnished in some way. There were two reasons for this suggestion. First, the dominant wood that was used at the time, especially the *pìich,* has a bright buttery white color and is very light wood; I viewed these qualities as antithetical to normative cultural expectations of most tourists that assume expensive woods to be naturally darker in color and heavy in weight. Second, freshly carved bright colored wood did not communicate any historical depth to the pieces, which in fact were often still wet from having been so freshly cut.[41] Thus, having in mind the Guatemalan Maya masks and Christian figures that have pock marks and missing chunks of wood for

having been eaten by termites, I suggested the need to "antiquate" the wood.[42] I recounted the scene from *Art In and Out of Africa*,[43] also described and analyzed in Chris Steiner's work, in which African middlemen smeared almond or other food mixtures on fresh wood carvings so that chickens and turkeys would peck at and chew up the wood for a few days. Neither this method nor the idea of antiquing ever took hold among Maya artists in either Pisté or the Puuc region (though it has I believe among Highland Guatemalan Mayans) no doubt because of artistic pride of creating something beautiful. My artist friends would only laugh at the clever deceitfulness of the Africans and the ignorant naiveté of Americans. They expressed a moral sentiment that this staging of authenticity and antiques was wrong. Thus, instead, Gilberto Yam began two years of experimentation with different kinds of paints, varnishes, and techniques of creating an *acabado*, or "finishing." His final determination was initially at least a secret combination of *chapopote* or tar used for paving streets and synthetic paint.[44] In trying to imitate his finishing, artisans created a number of different *acabados* with different types of water and oil based paint. However, the technique that Giliberto developed is the more predominant *acabado* used today.[45]

The invention of this *acabado* marks the emergence of the third generation of artwork by 1993. There is in addition a general and widespread maturation of the technical skills and aesthetic vision of the artisans. With more than a decade of carving experience, the adolescent and young boys that came of age in their twenties and thirties began an artistic revolution. The Jaguar head was created by one artist who used a plastic key chain as his source for what became an iconic best-selling souvenir. Using the *ídolo* as a model, new figures were created from the basic Ixchel-Corn God form or the iconography and motifs of these figures were expanded and further developed: the God of Medicine, the Dios de la Suerte, Maya Sacerdote, Maya Guerrero, and other derivatives, were created by having the figure sit cross-legged, instead of kneeling or

squatting, and holding their hands palm up or down and/or holding in offering any number of different things: balls of incense, bowls, plates, spears, heads, corn cobs, and skulls. In addition, the headdress also became a space for new creative expression on the *ídolo* figures. Faces or full bodies of serpents, jaguars, and then other humans began to be carved emerging out of the headdress in a manner that inspired the further development of the *máscara* and the *tabla* forms as discussed below (see Figures 2.5, 2.7).

Aesthetically, the rendition of the body, that is, the shaping of muscles and cheeks, the curves and expression of the eyes, nose, and mouth became exquisite and vivid. While the musculature retained a style of realism and not a mimetic realistic depiction, the figures came alive. The details of the face in combination with the new painting created an engaging aesthetic in which the faces, especially the eyes and mouth, communicate a unique feeling of presence. As always, the signature mark of the artist that composed the piece is found in the aesthetic rendition of the mouth, nose, and eyes, in terms of shape, line, and curve. The artisans are especially attuned to portrayals of facial features as being both Maya and believable/realistic. They use this as one aesthetic criteria by which to evaluate a work and the skills of the artisan.

With these new figures the *ídolo* tended to shift from frontally carved or partly three-dimensional to fully in-the-round statuary. The dominant tendency is nonetheless still to create work with frontal emphasis. Bases and detailed carving of the bases also began to be developed, at least in part to my insistence that this was an area that needed to be creatively explored as the *ídolo* moved to full statuary. The Ixchel figure is especially interesting because from early on the back of the piece had some minimal elaboration in those cases that incorporated intertwined bodies on the back of the figure to complete the two serpent heads that sat facing forward on the Ixchel headdress. It is in this figure that the technical and artistic skills truly manifested and differentiated the artist from

the artisan. Ramon Quijano Balam proved himself as a master of aesthetic design, details, expression, and balance in small, intricately carved statuary (see also Figure 2.7). —**5.3** *col.*

The *máscara* form, which originated in the '80s, was also further developed. The *máscara* is carved from a board, *tabla*, or a very slightly curving (nearly flat) section of a trunk. In its original development, the *máscara* could not stand on its own; it could only be hung on a wall and *máscara* curve is too flat to have a viable function as a mask.[46] The masks consist of a Maya face with a headdress consisting of feathers and headband. As the technique of expression in the faces was continually refined, a new form, the *mascarón* developed. As a way to communicate its unique aesthetic form and signature, I have referred to this as the Maya totemic style. A second, third, and even fourth level was added to the *máscara*. Sometimes a second face was added on top of the headdress of the first. Another variation was based on adding a series of other figures in miniature on top of the headdress. These could be pyramids, jaguars, serpents, humans in positions of offering, priests taking sacrifice, and human faces. There are crucial distinctions between the *máscara* and the *mascarón*. The *mascarón,* is carved to stand on a flat surface and with multiple levels of figures in the headdress which characteristically is centered on a second level human face, shown frontal or profile, and in the same scale as the bottom full frontal face. Typically the faces are not exceptionally realistic but more representational. In contrast the *máscara* by definition only has one face, is carved to be hung, and tends to only have one level of headdress, even if this space can become quite complicated in composition. (See Figures 2.4, 2.5, both of which creatively use and break from both the *máscara/mascarón* forms in their distinct headdress carvings.)

The level of bas-relief carving extending from the headdress was always placed at the top level and signaled a creative adaptation of aesthetic techniques. It further lead to the development in the mid-1990s of an entirely new form of carving on the *tabla*. Although I cannot give an exact date, the *tabla* form did not exist in 1995 but appears widespread by 1997 among a handful of the best artisans, that is, those who came to implicitly identify themselves as artists. Due to the increasing exhaustion of the *chakah* and *pìich* trees, cedar wood boards began to be purchased for use by the artists. The boards or *tablas* offered a blank slate for new kinds of aesthetic creation. Initially, the artists trimmed away virtually most of the wood to produce a single standing figure that was a direct copy of famous stela and stucco panels from Palenque, Yaxchilan and Bonampak. Emblematic of this work is the production of the Tomb (sarcophagus lid) of Pakal, other Pakal figures, Yaxchilan Queens, the Vision Serpent, Bird Jaguar, and other iconic figures of Classic Maya art. This mimetic copying of pre-Columbian figures or images is locally known as *réplica*.

These are the Pisté pieces that are closest in approach and appearance to the work of the Puuc artisans featured in this catalog and discussed in Mary Katherine Scott's essay. It is not clear to what extent the idea of *tabla réplica* spread from the Puuc to Pisté, these were separate developments, or whether it had a more diffuse origin, based on, for example, the extensive reproduction of Pakal Sarcophagus Lid on burned leather (a Chiapas, specifically Palenque product).

Pisté artists were not content to copy famous pre-Columbian works of art. Many artists also created their own "invented" narratives and figural designs in the blank space of the *tabla*. These invented pieces whether in *tabla* or *ídolo* are called *inventada* in contrast to *réplica* interpretations of known pre-Columbian pieces. Wilbert Serrano Mex, for example, are posed in distinct acts, i.e., narratively composed into scenes that articulated an overall theme or concept. *Sacrificio a K'uk'ulkan* is an example (see Figure 2.3). Other artists created a symbolic style in which all the figures were organized around the depiction of a singular activity or event. *Sacrificio a K'uk'ulkan* is an example (see Figure 2.3). To my mind, the narra-

tive style, figures, and aesthetic of which Wilbert is representative, resonates greatly with the carvings of Tajín, a lesser-known Classic Veracruz archaeological site in the Mexican Gulf Coast region. This is due to the use of miniaturized figures of humans and serpents typically in acts of sacrifice depiction, priests, minimal use of jaguars and death imagery, and the use of geometric or serpentine borders to frame the entire image or individual narrative scenes. The Tajín aesthetic of created bas-relief contrasts to the lintel style of réplica copy: The former depicts invented figures, the latter is a mimetic copy of well-known pre-Columbian figures almost always derived from the three sites just mentioned above. The former always includes main figures in large cut and secondary scenes with miniatures; the latter includes the main figures in large and add as iconic elements, to a greater or lesser degree, the peripheral images such as hieroglyphs, birds, star signs, and flora. Diagnostic of the Tajín-style is the representational realism of the human body which expresses not an anatomically accurate rendition of the shape and flow of body muscles, but rather a symbol of body mass. This creates a busyness of the figure that contrasts to the uncut, smooth surfaces of human figures in other styles.

By the early to mid-1990s, if not earlier, a number of Pisté artisans began to produce tabla réplicas. Although the exact dating of the emergence and source of inspiration of the Pisté tabla is unclear, it seems likely to have been initiated through familiarity with the tabla bas-relief of the first Puuc artists working in this form. Among Pisté artists, the carving of bas-relief replicas in tabla was restricted to only a few of the more skilled artisans, such as José Leon Tuz Kituk. Among the more commonly produced replicas are bas-relief lintels from Palenque and Yaxchilan, especially the Tomb of Pakal sarcophagus lid, the capture scene from Yaxchilan Lintel 8, and the famous Vision Serpent from Palenque.[47] (See Figure 2.2.)

Another set of artists in Pisté, best represented by Jorge Pool Cauich, took the máscara headdress to a new aesthetic development by placing replicas of bas-relief figures from the repertoire of the Classic period lintel figures. He had a predilection for the Queens of Yaxchilan. The máscara in this catalog shows Lady Sac K'uk from Yaxchilan, posed on top of the famous Chaak Mask, or Rain God, which is iconic of Yucatec Maya Late Classic as seen throughout buildings at Chichén Itzá (see Figure 2.4).

The pioneer of the bas-relief, however, is José León Tus Kituc, who began to carve at the age of twenty and quickly gained fame in the Pisté art scene with his exploration of high relief up to three inches on cedar, a much harder wood than either chakah or píich. Along with his older brother Luis, who was a master of ídolo figures cut in trunks of cedar, they initiated the development of réplica figures in tabla. José León was the artist that challenged all others to match his intricacy of detail and depth of cut in bas-relief. Having mastered the ability to render the mimetic details as well as a vivid, animated expression of replicas, he developed a uniquely personal aesthetic style, which is manifest clearly in The Archer. This hybrid and humorous figure is total and yet quite serious kitsch. The main figure is an Aztec warrior king, or Huey Tlatoani, known as Cuauhtémoc, ready to launch an arrow into the air, inspired by 1950s Mexican calendar art, which in turn is a kitsch reproduction of an earlier Mexican Romanticist Neo-Aztec period of painting. At his feet is a woman rendered from the cover of a cheap, risqué romantic Mexican novella (a type of popular literature produced in "comic" book form). In José León's Archer, the Aztec warrior-king and princess are posed on top of a Classic Maya Period Serpent Scepter Bar that symbolizes divine kingship; this serves as a narrative border under which sit two Maya slaves hunched over as they carry the burden of the carvings above (see catalog Figure 2.1; compare with Figure 2.2 a réplica tabla).

By the end of the 1990s, during the transition into the fourth generation of artwork, mascarónes came into vogue. These figures, carved from trunks, retain a horizontal curve that creates a balance and a base

so that the piece can be placed onto a flat surface instead of being hung on a wall like masks; their size and weight prohibit hanging them on a wall. With the *mascarón*, Pisté artists extended the totemic style with new creative designs in the headdress and faces, which at least initially always had double-stacked faces of the same scale. These tended toward the large and very large, in part due to the use of older *pìich* and *chakah* trees from forest reserves in communities far away from Pisté. Unfortunately, the apogee of the *mascarón* signaled, finally, the exhaustion of a supply source of wood from trees and the definitive turn to cedar and *tabla*, that is, wood boards cut by lumber yards, as the main medium.

Nonetheless, in the fourth generation of artwork, Pisté artists were able to create a wide array of new figures in *ídolo* form that built on and extended the 1980s repertoire of serpent figures. At the onset of the new millennium, included among the new forms that were created were the Double Headed Serpent, the Double Entwined Serpent, The Serpent-Jaguar Throne, and the Feathered Serpent. Secondary forms were tried out with the consumers. Other non-Maya figures such as the Sleeping Mexican with Sombrero, initially a ceramic from central México, and the realistic Turtle appeared but do not have widespread production. Their simple designs are more inexpensively produced through silicon molding with Pisté stone. These secondary items however are clearly of the souvenir class of handicrafts: cheap, little time invested in production, no details, and iconic of "México" of *lo tradicional* (the traditional). —**5.4** *col.*

In 2003 a newly renovated *máscara* suddenly appeared on the scene after a period of aesthetic decline. The pioneer in this aesthetic revolution was José Mitch Dzib, a young man with a strong artistic vision that began carving in the 1990s in his late teens. Earlier, he had created the Maya Governor, a painted cedar *ídolo* (1999) that expressed a creative innovation in the *ídolo* form with its break from the core Ixchel-Corn God model; the piece nonetheless manifests a technical difficulty with the hard wood

that the young artist was to overcome in the bas-relief figures and facial details of the new *máscara*. This new *máscara* had three major innovations. First, the face was carved with geometric cuts that would later be painted in multiple colors to give a mosaic effect. The new technique was stunning for the way the *acabado* and geometric cuts transformed the wood into a ceramic tiling or jade piece set that strongly resonates with the famous jade Maya death masks from Palenque or Kalakmul (see Figure 2.6). Second, the headdress began to be carved with miniature figures of humans, jaguars, serpents, and other elements that created a strong image of symbolism and meaning. Third, an increasing number of *máscaras* began to be made with the cedar. These masks tend to remain unpainted, especially when they carry extensive detail work. Nonetheless, there is a high percentage of small and simple masks in cedar, as well as the few *pìich* and *chakah máscaras* that continue to be painted.

In summary of this sketch of the historical development of forms and styles, the general Maya aesthetic, contemporary, and pre-Columbian can be quite "baroque," that is cluttered or busy. Due to the consumer demand for less expensive and portable handicrafts, the market has imposed a reduction of the baroque aesthetic toward simpler, less detailed carving. On the one hand this has reduced the incentive for artistic intricacy, details, and creative expression. The exception to this tendency is the ubiquitous Sarcophagus Lid from the Tomb of Pakal, which as a *réplica* maintains a high level of baroque detail. On the other hand, this market drive has compelled the artists to continue to refine their line, curves, and balance in the portrayal and composition of the human figure. This factor is clearly expressed in the double dynamic of the reduction of serpents and jaguar heads and the expanded use of the miniature human in full form, as well as full-bodied jaguars, as a component of headdresses and bas-relief *tabla*.

The artistic expertise in this regard of the Pisté Maya artist is immediately identifiable. It starkly

contrasts to the proliferation of Yaxuna produced *máscaras* and *tablas* in the Chichén market place. The latter are easily identifiable by the verticality of composition marked by a long curving line, as well as the broad, simple designs, lack of intricate details, flat or matte tones from water-based paints, and earthy colors.

Historically speaking, the exhaustion of the soft woods in the proximity of Pisté forced artisans to search out a more stable source of wood; they began to buy trees from forests held as community property by Yaxuna, which sits on the north point of a large area of uninhabited jungle areas to the south. The Yaxuna peasant farmers realized they would gain more by producing handicrafts instead of being suppliers of raw materials. Thus, they began to supply the Pisté market with thousands and thousands of wood figures of all types that were only half shaped. The Pisté artisan would buy the modified raw product, complete the carving, finish the painting, and retail the item in their venues at Chichén or at other venues along the charter bus corridor—Xcalacoop, Cuncunul, Ebtun, Kaua, Valladolid—Mérida and the coastal destinations—Cancun, Tulum, Cozumel, Playa del Carmen. Today, the Yaxuna artisans supply Pisté venders, who sell at Chichén and a series of other stores in the tourist corridor and directly to other retailers located on the coast. In a majority of cases, especially in the markets from Valladolid to Mérida, the Yaxuna product has almost entirely displaced the Pisté product, and it has a strong presence in Playa del Carmen and Cancun. While the Yaxuna handicraft is not a rudimentary carving that comprises the *rústico* style, it nonetheless manifests a lower quality of design, carving, composition, and expression that merits consideration as its own style. To the untrained eye, it would be mistaken for a Pisté product.

As for the relationship between the Puuc and the Pisté artwork there is still need for much further study of the ethnographic contexts and comparative analysis of the aesthetics. Nonetheless, what is clear, as noted in the chapters by Scott, Kowalski, and Scott

and Kowalski, the Puuc artists do not participate in the full breadth of the Pisté art tradition. In terms of content, the following is offered: Puuc artists focus on *réplica* style pieces in *tabla* and, less frequently, in *ídolo*, particularly pieces such as the Old Ixchel and the Pakal bust. Further, Puuc artists are both not as much interested in snakes and jaguars and very likely to carve individual glyphs, inscribed dates, or the Maya calendar in tabla form. In contrast, the Pisté artisans refrain from carving glyphs in and of themselves (only as part of a larger work) and always focus their compositions on a human face (in the case of statuary and masks) or on human figures engaged in action (tabla bas-relief). Further, the Pisté artists love to carve jaguars or snakes, whether in full figure or just the face (e.g., Jaguar-Serpent Throne above), eschewed by the Puuc artists.

Indigenous Kitsch and Ambivalent Modernities

On a final note, it is important to reiterate that *arte pisteño* is an art and a handicraft. However, this tradition of artwork has never developed a folk aesthetic that might considered as diagnostic or (stereo-) typical of "traditional" or "folk" handicrafts. By this I mean that peoples who engage tourism development in their communities typically begin to create a product marked by realism and naturalism in terms of both content and style. The Coba carvers in Quintana Roo are an example. They carve well-known animals such as deer, jaguars, cats, and other four legged jungle animals, *but not snakes,* which are ubiquitous, especially with aggressive demeanors, in Pisté Maya art. While these are not necessarily all "friendly" animals, they do tend to be (or to produce) "cute" and "fuzzy" (feelings); significantly, they fit within an ideological vision of a happy, harmonious folk world that is one with nature, non-modernity, positive traditional values, and non-capitalist economy. The aesthetic here is "folk primitivist" with smooth, balanced lines and minimalist detail that effect a simple realism or naïve realistic representation. The

Oaxacan *alebrijas* represents an interesting variation of this traditional folk art for its inclusion of "negative" spirit elements (demons, dragons, etc.) and for its extreme playfulness. Figures of and from nature (humans, real animals) are depicted, sometimes in an exaggerated or highly stylized realism other times in a totally fantastic, colorfully quasi-surrealistic mode, with fantasy animals. Nonetheless these fantastic-surreal animals and images of Death ultimately remain non-threatening and "cute" (i.e., happy in tone, non-threatening, not serious-somber)! The tradition of Guatemalan Mayan masks from Chichicastenango and Lake Atitlán are another example of a folk art style that relies on a representational realism (masks depicting Spaniards) alternating with naïve supernaturalism (masks depicting hybrid or spirit animals). These masks may not be entirely "cute," but they have a happy tone that contrasts starkly with the somber, manly, perhaps at times "angry" or aggressive expressions of the Pisté Maya art. This is especially evident in the faces of various figures.

Pisté Maya art virtually completely stays away from the folk style of subject matter, representation, and simplicity. There are very rare cases where an artisan will produce this type of folk art, as noted above, and only as a side activity to the real—we could say with pointed irony, "authentic" artwork of Pisté. Given that Classic Maya civilization, or pre-Columbian Mesoamerica, generally, is the ur-source of artistic inspiration or is being re-interpreted by the artisans and artists, I would call the Pisté Maya art a "civilizational art," that is an art whose aesthetics and primary subject matter derives from "elite," "high" culture: it is not ever completely a "folk," "primitive" or "primitivist," popular, pop, or "traditional" art in terms of tone, aura, substance, style, design, aesthetics, or consumer ideologies. It hybridizes these modalities but in Bhabha's sense,[48] not in the sense of Garcia Canclini.[49] *Arte pisteño* only ambiguously and ambivalently, partially but not fully, through tactical hybridity fits those pre-given art-world categories that correspond to the hierarchy of moder-

nity constructed by Eurocentric museums, collectors, galleries, academies, institutions, and critics.

Instead, Pisté Maya art resonates with the aesthetics of the Balinese, consider a Rangda mask, or of Islam, consider the designs formed out of Arabic writing on Mosques. It would cause too much mental and market friction to call those arts "folk." Certainly not all the elites of major civilizations that have formed a Great Tradition of state society have had preferences for baroque aesthetics; some have enjoyed minimalist or subtle art, and they all have widely divergent arts and axiologies. Yet, the civilizational aesthetics of the Maya, past and contemporary, absolutely tends toward the baroque, the intricate, and the masculine as well as toward symbolism, narrative, and abstract concepts.

With tongue in cheek we might ascribe this contrast to a function of Robert Redfield's folk-urban continuum, but only as a device to point to the substantive issue: the artisans and artists of Pisté have developed a unique art that has stimulated a large knock-off handicraft industry. We might, therefore, ask why and why here? The special circumstances of the development of Chichén Itzá as an archaeological tourism destination are paramount. This has provided nearly forty years of experience of creative expression combined with technical growth in relation to changing media and consumer tastes. Market demands have stimulated exploration of *réplicas*, that is copying of pre-Columbian art, and *inventada* forms, that is the creation of unique aesthetic production. While the dominant consumer preferences among tourists limits the quality of aesthetic production (quantifiable measurable in time invested in a carving and qualitatively measurable in terms of depth and extent of details), there is nonetheless a group of artists that express themselves with unique art when given the appropriate market opportunities with high-end buyers, collectors, and cultural art promoters.

Both *inventada* and *réplica*, one should note, constitute an art that is best comprehended as kitsch. The

Pisté Maya art is kitsch, or if you prefer an "indigenous kitsch." It would not be worthwhile to rehearse here the various and often contradictory conceptions and ideologies of kitsch.[50] However, the reproduction of iconic images (such as a Marilyn Monroe, Hawaiian Hula Dancer, or Pakal) in different media and in a representation that communicates not the artist's inner psychology or vision of the sublime but as a mirror that reflects back the consumer's own ideological and fetishized tastes—in this case the western romantic fantasy and exoticism of the Maya—are certainly aspects of one vision of kitsch.[51] It is this ubiquitous mode of kitsch that intrinsically operates in the gamut of indigenous and popular inventions of artwork that are tailored to the tourist-consumer tastes and desires for "the souvenir" of *their* experience. This kitsch principle is another reason why the invented folk, traditional, and indigenous arts are *modern arts*, participating in and producing an "alternative" modernity, to use terms of a now old debate. I would prefer to call this an "ambivalent modernity" for its ambiguous categorical standing in established art worlds, multiple economic and aesthetic values, and ambivalent symbolic-meaningful function for consumers.[52] It is the marked, visible difference of these ambivalent modernities constituted by indigenous kitsch that conditions and enables the continual erasure of any adjectival qualifiers to (Western, globalized) Modernity. The Pisté artist provides consumers with an ethnography of their own marvelous desires "for" The Maya, or The Traditional México, The Other, embodied in a product that is conditioned by the anthropological knowledge machine. Pisté Maya art is an objectified ethnography of our Western romance with the Maya.[53] In the exchange, the mystery of that romance is erased to leave the consumer as a modern subject owning a smoking, yet modern, mirror.[54] This is indigenous kitsch at work—and it is a fully modern, contemporary art.

One might ask, as did one anthropologist colleague who specializes in art and tourism, why discuss this issue of the transcultural hybridity of the Maya art?

Have we not already learned that "art" is a Western label that is artificial and has no validity cross-culturally? Have we not learned that anything can be "art"? Perhaps "we" academics have learned this, yet not everything in fact circulates as art, sometimes for reasons that have nothing to do with aesthetics.[55] In fact, when Maya artists from Pisté sought to get their artwork into diverse kinds of art galleries in Chicago in 1999, they confronted the fact of these categorical ambivalences. Their work was refused by galleries and museum stores that specialize in Mexican handicrafts, "ethnographic art," colonial era collectibles, or contemporary Latin American art precisely because it does not fit into a proper category. Thus, while academics theorize the aesthetic relativity of art, others control the assignation of commercial, cultural, and aesthetic value of all that circulates in art worlds. In this context, the politics of "art-writing" is a very important consideration: how one writes about art does matter.

In this chapter, I have sought to minimize the anthropological questions that would situate the Pisté artwork in an ethnographic frame. Thus, for example, I have pointed the reader to other publications that deal with the ethnographic, social, political, and cultural histories in which the artisans and artists are embedded. I am also not keen on elaborating how this art "crafts" Maya identity. This is not significant here primarily because the Pisté artisans and artists are not carving their identities as ethnic persons via this artwork. Thus, the insistence in the anthropology of art to theorize and analyze crafts peoples' identity via their aesthetic production is clearly a mis-direction, not always a relevant issue. Instead, I have sought to focus on the artwork per se in a way that may strike some readers as something of a throwback to an "outdated" style of art criticism. My objective is simple: I seek to enact an art writing, or art commentary, that contributes to re-evaluation and re-assignation of the economic and cultural values of this artwork. In turn this exhibition and the catalog also contribute in a major way to bringing

this artwork out of the tourism market of folkloric handicrafts and into other circuits of exhibition and valorization.

As a final note it is worth remembering that Benjamin defined the aura of the work of art in terms of the unique time-space coordinates of ruins. Perhaps he was thinking of archaeological vestiges of Europe, perhaps the Roman Forum or the Parthenon, but we may use his idea to think about the heritage of Maya ruins. There is no doubt that the aura of archaeological ruins is exponentially expanded as "art"—whether specifically a culture's intangible or material heritage, Civilization, World Heritage, or a Wonder of the World—by the proliferation of images, icons, and handicrafts that in one metonymic or another metaphoric way signal the original—or, rather the consumer's experience of the original. It is this kitsch function that makes folk and traditional arts resolutely modern, regardless how much we erase and refuse this reality. But, what does it mean when one class of such "reproductions" is itself the subject of mimetic copying, replication, and imitation? This proliferation points to the originality and creativity of a new work of art. Out of these general conditions, out of their heritage of archaeological ruins, the Pisté Maya artists have created an intangible, modern heritage in the mode of a unique art that has only begun its dynamic growth and escalation into the modern world of contemporary art.

Notes

The present essay is based on over twenty years of collaborative research with Pisté Maya artists and with participants in the Field School in Experimental Ethnography (1997–1999). I thank Wilberth Serrano Mex, José León Tuz Kituc, Jorge Pool Cauich, Ramon Quijano Balam, José Mich Dzib, Antonio Pech Canton, Pablo Tun Bolio, Juan and Sixto Mex Mex, Juan Gutíerrez, Alfonso Cetz Ceme, Gilberto Yam Tun, Lisa Breglia, Joy Logan, Juan Castillo Cocom, Abdel Hernández, Cynthia Robin, Reynaldo Mis, Rebeca Pat, Chris Reed, Yoli and Pepe Pat, Fernando Armstrong Fumero, Steve Mintz, Lawrence Hogue, Shawn Webb, Tim Wallace, Mark Leone, Geoff White, Jeff Himpele, Patricia Fortuny de Loret de Mola, Leticia Becerril, Maggie Hug, Martha Lofte, Jay Indik, Ed Cimafonte, Kevin McGuirk, Christine Maher, Kim Benson, Saul Martínez, Laurie Kovacovic, Laura Bunt, Gisela Fosada, Edith Flores, Ana Wandless, Hutan Hejazi-Martínez, James Todd, Carlos Aranda, Paula Girshick, Mary Katherine Scott, David Nugent. A special appreciation and thanks to Miriam M Mendez Castañeda whose paintings and sculptures as well as collections of Mayan kitsch figurines from Guatemala no doubt nurtured my fascination for the art and art-world of Pisté.

1. It is necessary to clarify that Maya is the proper name of one of the thirty or so indigenous groups that comprise the sociocultural and linguistic family of Mayan peoples. There is only one group that has self-identified (although with nuances and complications) as Maya (without the "n") for over a hundred years (at least). This group originates in the Yucatán Peninsula, where the majority of Maya continue to live. They speak a language that linguists call Yucatec Maya, but Mexicans, Yucatecans, and its native speakers call simply Maya. Out of respect for these Maya, I use the term *Maya* (not Mayan) to refer to them and I use this proper name in both the singular and plural and as an adjectival qualifier.

2. The Spanish terms translate poorly as custodian or guard, but the work is akin to US park wardens and rangers. These are employed by the National Institute of Anthropology and History or INAH.

3. See chapters by Scott and Kowalski, Kowalski, and Scott.

4. This volume, Scott 2008.

5. Note that the Maya wood carving of the Coba-Tulum corridor is an entirely different style. It is a distinct Maya handicraft tradition that is formed by a folk or folkloric aesthetic.

6. Nash 1993, 2, 4, emphasis added.

7. Steggerda 1941, 22, 24–25.

8. See also Scott and Kowalski, this volume; Nash 1993.

9. It is worth noting as a comment on Steggerda above, that Chablé was among a small handful of persons from the town of Oxkutzcab in the Puuc region who have migrated to Pisté since the 1920s. The majority have worked as masons or as wardens for the government archaeology agency.

10. Discussion of this process, and specific examples, can be found in Graburn 1976, 1984; Clifford 1988; Garcia Canclini 1993, 1995; Ben-Amos 1977; Ben-Amos Girshick 2008; Errington 1998; Steiner 1994, 1995; Price 2001; Myers 2003; Mullin 1995, 2001; Chibnik 2003; Little 2004; Wood 2008; Morphy 1995.

11. Castañeda 2004a, 2004b, 2005a, 2005b, www.osea-cite. org/history/ahdzib.php.

12. The rustic style is evident in Castañeda 2005b, 89, fig. 1, 91 fig. 3 and Castañeda 2004a 26, fig. 2 and 27, fig. 3.

13. Compare two of Chablé's figures (dates unknown) in Castañeda 2005b, 89, fig. 1 with an Ixchel by Gilberto Yam (1993) in Castañeda 2004a, 28, fig. 4 and both against the Ixchel *ídolo* in the exhibition catalog.

14. See, for example, Ben-Amos Girshick 2008, Philips and Steiner 1999, Marcus and Myers 1995, Myers 2003, Nash 1993, Little 2004, Wood 2008, Chibnik 2003.

15. Greenblatt 1991, Clifford 1988.

16. See Castillo Cocom 2005, 2007.

17. Castañeda, Fumero Armstrong, Breglia 1999, Castañeda 2004a, 2005a,2005b. See www.osea-cite.org/history and especially www.osea-cite.org/history/ahdzib.php.

18. There are significant differences in the social nature and cultural expressions of identity as Maya, as artisan, as campesino, as Yucateco, as Indígena, and as Mexican across the Yucatán Peninsula. These differences have tended to be obliterated by anthropologists and ethnographers ever since the landmark studies by Robert Redfield in the 1930s. For example, Peter Hervik analyzes the ethnic-social categories of one small community in the Puuc region and generalizes these to all other subregions of the Peninsula, each of which have quite different social, economic, political, cultural, and racial-ethnic histories and social constructions of identity. In point of fact, the central category of Hervik's analysis, *catrin*, is not used in any other region than the Puuc. Contrary to his assertions, Hervik's analysis does not have validity in the rest of the Yucatán peninsula. Just as Robert Redfield's books on Yucatán profoundly shaped the understanding of Maya identity across the academic world, Hervik's book has come to shape and inform the general academic understanding of Maya identity due to the marketing success of this book. Anthropologists and other social scientists who know little about Yucatán may assign this in their courses on Mexico, Latin America, or Indigenous identity, and thereby come to believe that Hervik's model of Maya identity is valid throughout the whole of Yucatán when in fact it is not beyond the villages of this region. There is an extensive ethnographic literature about the complications of identity "as Maya" that are based on many different communities in many other regions of Yucatán. This literature demonstrates that there are dramatically different categories and constructions of identity and sentiments of being Maya. The propagation in second-

ary literature of the "Hervik model of Maya identity" as THE model of Yucatec Maya identity has become alarming indeed. See Castañeda 2004b and especially the chapters by Mathew Restall, Wolfgang Gabbert Ben Fallaw, Paul Eiss, Juan Castillo Cocom, Patricia Fortuny Loret de Mola, and Ueli Hostettler in Castillo Cocom and Castañeda 2004 for counter views.

19. I have extensively elaborated this idea in previous publications, Castañeda 1995, 1996, 1997.

20. Miller 1985, Desmond and Messenger 1988.

21. See Castañeda 1996, 1997, 2003, 2009, and Peraza López, Rejón Patrón, and Piña Loeza 1987.

22. See Castañeda 2004a.

23. The sociopolitical history of the artisans, the handicraft markets, and heritage tourism are large issues not directly pertinent to this discussion of the aesthetic styles of the art. For those who are interested in this aspect please consult my other publications (Castañeda 1995, 1996, 1997, 2000b, 2003, 2004a, 2004b, 2005a,b, 2009).

24. Wilberth Serrano is one artist who is particularly cognizant of the significance of Barrera Rubio's statement in triggering the shift from chac moolero to artisan and my own role in enabling artisan self identification as artists. See Castañeda 2004a, 2005a, 2005b for details.

25. Castañeda, Fumero Armstrong, Breglia 1999, Castañeda 2004a, 2005a, 2005b. See www.osea-cite.org/history and especially www.osea-cite.org/history/ahdzib.php.

26. Alcoholism also greatly diminished in the community in general and specifically among artisans. This is due to the crackdown of civil authorities on public intoxication and drinking over the last 20 years, but also to widespread recognition that income from tourism is in fact hard earned, that it can evaporate instantly. The artisans, especially those who commercialize nonlocal handicrafts, now comprise a visible majority of the middle and upper economic classes of the community. Perhaps it is the fate of the vocation of the artist to remain poor, but the majority of those I consider artists have not gotten onto the economic escalator that is represented by the Chichén market. They tend to retain a class standing that is referred to in regional terms as *humilde*, "humble."

27. On art-writing and related concepts of art-world/s and art-culture system, see Carrier 1987, Danto 1964, Becker 1982, and Marcus and Myers 1995, Clifford 1988. On the design of the ethnographic research projects as a mode of art-writing, see Castañeda 2004a, 2005a, 2005b.

28. Castañeda 2005b. The dominant reading of Benjamin's

famous slogan that the aura of art (or authenticity) "withers away" is that it completely disappears or erodes . Yet, such a reading is too easy and contrary to obvious empirical reality as a number of critics have noted. The maintenance of the value of the "original" is quite dependent upon the materiality and technologies of the initial production. Thus, although Benjamin uses the idea of identical reprints of a photograph having destroyed the aura of the original, he failed to account for the materiality of the negative. Even in digital photography, the initial file image, with its specific technological qualities, has a unique status even if it can be multiplied in identical reproductions. Further, Benjamin later in his text explains in less aphoristic and more analytical terms that the basis of the aura changes from (non-modern, non-capitalist) "tradition" to (modern) "politics." I suggest that Benjamin is using this latter word to reference the politics of capitalist economy, its relations of production, marketing and consumption (see also Castañeda 2000a). Aura of art is contestable negotiation dependent upon the forces that are struggling to define aesthetics, value, and consumption.

29. There is an ever expanding anthropological literature on tourist and ethnic arts, their politics, production, marketing, distribution, curation, values and glass ceilings, relationships to imagining nations, ethnic/indigenous identity formation, and art-world. As well anthropologists have conducted participatory, action, and applied research with communities of properly qualified traditional artisans and artists throughout the world. For a sampling of work I suggest: Graburn (1976, 1984), Clifford (1988, 1997), Mullin (1995, 2001), Marcus and Myers (1995), Errington (1998), Myers (2003), Little (2004), Wood (2008), Chibnik (2003), Price (2001), Steiner (1994, 1999).

30. I include the batik painting of cloth and t-shirts within the greater concept of Pisté Maya art (see example Castañeda 2004a 35, fig. 5, 36, fig. 6). It was first introduced to a Pisté wood carver who produced it in his house in Pisté and sold to a retailer located in Playa del Carmen. Early in the 1980s Juan Gutierrez, from Puebla, México, moved to Pisté and further developed the art. As a gifted painter, he has devoted himself to the production of batik for the tourism markets of the region. Other locals picked up the art in a part time manner, but not with a long lasting dedication. Rather, the art of silk-screening t-shirts has been the primary Pisté alternative to wood and stone carving. Nonetheless, the art of Maya batik was developed in Pisté and alongside the art of carving. However, given the focus of the exhibition and this book, I do not comment further on any aspect of this art.

31. Examples of the Dios de Maiz (Corn God) from 1989 are the fourth, sixth, eighth, and eleventh statues from the left in fig. 2, page 26 in Castañeda 2004a.

32. See Castañeda 2004a, 28, fig. 4 and third statue from the right Castañeda 2004a, 26, fig. 2.

33. There are three traditional Chac Mool figures carved in stone (see discussion below) from 1985 in Castañeda 2004a, 27 fig. 3. The other Chac Mools in this illustration are creative hybrids called *inventados*. See the Chac Mool figure carved in *chakah* (from 1989) sitting atop the fourth statue (a Corn God) from the left Castañeda 2004a, 26, fig. 2.

34. See the feather serpent in the middle of Castañeda 2004a, 26, fig. 2 and on the left hand corner of the table in Castañeda 2005a, 91, fig. 2.

35. Compare Chable's Ixchel and Dios de Maiz in Castañeda for 2005a, 89, fig. 1.

36. Examples of the Young Corn God from 1989 are the fifth and seventh statues from the left in fig. 2, page 26 in Castañeda 2004a. From the same year is the Corn God on the far right of the table in fig. 3 Castaneda 2005a 91. The tassels of corn rise up and illustrate the two colors, reddish brown and dirty yellow, of the *chakah* wood. Also in this illustration is a Young Corn God in profile cared in *máscara* form, third statue from left Castaneda 2005a, 91, fig. 3. A more realistic versus representational carving that dates to 1999 is seen in Castañeda 2005a, 98, fig. 8.

37. See Castañeda 2005a, 89, fig. 1.

38. See examples in Castañeda 2004a, 26, fig. 2, 27, fig. 3.

39. See unpainted figures from late 1980s in Castañeda 2005a, 91, fig. 3, 2004a, 26, fig. 2.

40. It was interesting to watch tourists pick up a big piece of carved *pìich* only to discover that it weighed significantly less than anticipated. Age, hardness, color, smell, and weight are barometers of the aesthetic, economic, and market values of wood.

41. For examples see Castañeda 2005a, 91, fig. 3 and Castañeda 2004a, 26, fig. 2.

42. Grabun calls this "archaism." However, I prefer the concept of antiquate as the drive to make something look old in the form of either an antique or an antiquity, which reference either a colonial historical period (say sixteenth through nineteenth centuries) or an archaeological time frame, respectively. Thus, antiquate is more appropriate given that the archaeological antiquities i.e., the pre-Columbian antiquities of the Maya are in fact the literal model, inspiration, and meaning-concept of all the artwork.

43. Barbesh and Taylor 1993.

44. See discussion in Castañeda 2004a, 27–29.

45. See Giliberto's original 1993 *acabado* and painting in Castañeda 2004a, 28, fig. 4 and variations including monocolor dark and light tones as well as painted *acacabados* in Castañeda 2004a 37, fig. 7, Castañeda 2005a, 94 fig. 6, 96 fig. 8, and in the Pisté pieces exhibited in this catalog.

46. See the first three statues on the left in Castañeda 2004a, 26, fig. 2 and the three *máscaras* in the forefront leaning against the display table in Castañeda 2005a, 91, fig. 3.

47. See Castañeda 2005a, 94, fig. 6.

48. See Bhabha1994, Young 1994.

49. Garcia Canclini 1993, 1995. See also Coombes 1994, Krasniuaskas 2000, Coombes and Brah 2000, Young 1994.

50. See Scott and Kowalski, this volume.

51. There is no time to delve into a robust review of the contentious debates about the nature kitsch and varieties of theories of kitsch and its relation to modernity. Two key sources that have informed my thinking is Calinescu (1987) and Toulmin (1992).

52. Danto 1964; Becker 1982; Bourdieu 1993; Dubin 2001; Clifford 1988; Greenblatt 1991; Greenberg, Ferguson, and Nairne 1999.

53. See Kowalski, Steiner, Berlo, this volume.

54. "Smoking mirror" references the magic reflective stone that is used by ritual specialists, gods, magicians, and especially the Mexican trickster figure of Tezcatlipoca. There is evidence of smoking mirror representations in the Maya world as well.

55. For a sampling of these issues see Geismar (2001), George (1999), Price (2001), Marquis (1991), Rushing (1995), Steiner (1996, 1999), Marcus and Myers (1995), Myers (2003), Chibnik (2003), Phillips and Steiner (1999), Welsch (2004).

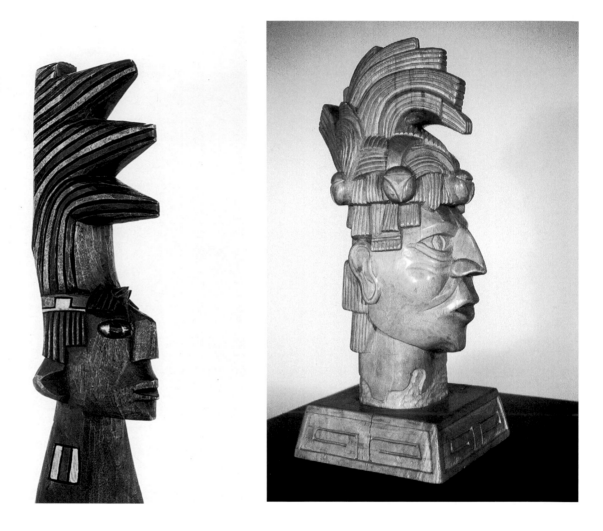

5.2—Pakal as Young God Corn. Two interpretations of Lord Pakal from Palenque as the Young Corn God by the same artist, Gilberto Yam Tun. The figure on the left illustrates the newly invented acabado that Gilberto developed in the early 1990s and the rudimentary/rústico style of the 1980s. The figure on the right was commissioned for the 1999 exhibit in the Durand Art Institute and illustrates Gilberto's growing mastery as a carver. Cedar with a yellowish flesh tone *acabado*. Collection of Quetzil Castañeda.

6

"THRICE BUILT"

Uxmal and Constructions

of Maya Identity

Jeff Karl Kowalski

▸ Uxmal, located in the Puuc hills region of the state of Yucatán, Mexico, was a powerful pre-conquest capital city, a largely abandoned ruin during the colonial period, and today is a UNESCO world heritage site and major tourist attraction. One possible translation of *Uxmal* is "thrice built," perhaps referring to the fact that its principal pyramid temple, the Adivino, was rebuilt several times, or perhaps based on evidence for several different occupations.[1] Taking this name as a broader metaphor, this essay will discuss how conceptions of Uxmal and its role in the shaping of Maya identity have changed from pre-Columbian times to the present. Such identity has been constructed and contested from the time of the site's foundation and has been affected by its connections with broader world systems. However, with the growth of tourism in Yucatán, Uxmal has become a particularly potent "cultural commodity" that attracts thousands of visitors each year who are drawn to the

widely promoted site as special destination where they can directly experience their mythic image of ancient Maya civilization.

The imposing edifices and striking architectural sculpture that draw visitors to Uxmal today originally were created between about AD 750 to 950/1000, when Uxmal and many centers in the Puuc region had a rapid increase in population and an accompanying rise in political, economic, and military power. This time, known as the Terminal Classic period, witnessed the disintegration of centralized political power in many southern Maya city-states (e.g., Tikal, Copan, Palenque), leading to population movements, shifts in trade routes, and the formation of new political states and elite-level alliances in northern Yucatán.[2] Uxmal emerged as the capital of a regional state in the eastern Puuc area during the late ninth through early tenth century, when a local ruler, Chan Chak K'ak'nal Ajaw (or "Lord Chaak"), governed the site. Because Lord Chaak and his predecessors were relative newcomers to the Puuc region, they supported their claims to legitimacy by using traditional Maya symbols of dynastic authority, such as stone stelae depicting them as warriors or engaged in ritual performances. Chan Chak K'ak'nal Ajaw's reign bolstered his claims to power by constructing the monumental House of the Governor, a residential-administrative structure on which he appears above the central doorway, flanked by secondary rulers elsewhere on the upper façade. In front of the House of the Governor was a jaguar throne, a traditional Maya symbol of divinely sanctioned rulership.[3] A similar strategy was used at the Nunnery Quadrangle, a group of four large multiroomed "palace" structures grouped around a central courtyard. The different levels on which the buildings rest, their doorway counts, aspects of their sculptural iconography, and the presence of a prominent central stone column probably representing the sacred world tree (*Yaxcheelcab*) suggest that the building complex was designed to incorporate traditional Maya cosmologi-

cal concepts associated with Maya creation mythology that served as a divine charter for kingship.[4]

Uxmal also was participating in the complex system of political alliances and long distance trade network that took shape in Mesoamerica during the Epiclassic period in central Mexico and the Terminal Classic period in the Maya region. The most obvious evidence for such external connections takes the form of feathered serpent sculptures that adorned the façade of both the West Structure of the Nunnery Quadrangle and the Main Ballcourt (see catalog Figure 1.3). This feathered serpent imagery reflects Uxmal's close ties with the powerful northern Yucatán capital city of Chichén Itzá during the reign of Lord Chaak, who seems to have had a military alliance with Chichén Itzá, whose warriors helped to consolidate Uxmal's hegemony in the eastern Puuc region. Other evidence of this close relationship between Uxmal and Chichén can be seen in the presence of round temples and structures with colonnaded entrances at both sites, and their importation of specialized trade ceramics (e.g., Silho Fine Orangeware, Tohil Plumbate ware). It seems quite probable that Chichén Itzá was the dominant and donor site in this relationship. The Itzá rulers of Chichén controlled an extensive circum-peninsular trade system and forged a special alliance with the rising capital city of Tula, Hidalgo, reflected in the remarkable parallels in building plans, sculptural themes, and iconographic elements found at both sites. Various scholars have discussed the rise of these sites as key administrative centers in a Terminal Classic/Early Postclassic period Mesoamerican "world system" in which regional elites benefited from tribute extracted from regional economies, while bolstering their claims to authority by sharing "symbolic capital" represented by the long distance exchange of precious commodities and the sharing of interregional religious beliefs and cult practices—the latter being particularly evident in the widely shared feathered serpent symbolism and iconography. At some point during the tenth century, however, as the result of Chichén Itzá's growing eco-

nomic and military power, Uxmal's political power and that of many nearby Puuc sites was broken. Monumental building projects ceased and afterwards the site centers were occupied by small groups of squatters living in poorly built unvaulted structures whose low stone foundation walls used elements taken from the deteriorating façades of the earlier monumental edifices.[5]

Long after the Terminal Classic city of Uxmal was abandoned, however, it continued to play a role in supporting claims to political authority. At the Late Postclassic period city of Mayapan, the Xiu family traced its distant ancestry to the ancient city. According to native Maya and Spanish historical sources, the Xiu family journeyed for a number of years from a homeland in the southwestern base of the Yucatán peninsula, and then established itself at, or founded, Uxmal during the reign of a king known as Aj Kuy Tok Tutul Xiu, also known as Hun Uitzil Chaak Tutul Xiu. Various accounts of Mayapan's history describe the Xiu as chafing under what they perceived as the haughty and despotic rule of the Cocom family, who traced their ancestry to the site of Chichén Itzá. Although there is some question about when the Xiu actually entered the Puuc region and "founded" Uxmal, it is clear that their connections with the ancient city supported their claims to elite status, and strengthened their ability to lead a rebellion against the Cocom family at Mayapan around AD 1450.[6]

The Xiu family's claims to have been former governors of Uxmal may have been expressed visually at Mayapan by the distinctive façade decoration of the building known as the Hall of the Chaak Masks (Str. Q151), whose basal platform was adorned with several long-snouted stone mosaic masks, probably representing the Yucatec rain deity Chaak. These masks are virtually identical to those that adorn the earlier Codz Pop structure at Kabah, a site located in the Puuc region near Uxmal. Milbrath and Peraza Lope suggest that the masks were brought to Mayapan from Kabah, perhaps during the Hocaba ceramic phase (c. AD 1200–1300) when such ceramics are

found at both sites. More recently, they have proposed that this "palace" type structure at Mayapan may have been the principal residence of the Xiu lineage, which signaled their association with Uxmal by using masks from a prominent and allied nearby Puuc site.[7]—**6.1** col.

After the time of the Spanish conquest, Uxmal was largely unoccupied, although some inhabitants of the Puuc region visited the site periodically to leave offerings in the now ruined structures, and the site is mentioned on a 1557 land map of the province of Mani that was used to demonstrate the extent of the territory associated with the Xiu family. In general, various Xiu-related native historical sources (e.g., the Chilam Balam Books of Mani and Tzimin, several of the Relaciones de Yucatán) mention the history and nature of their connection with Uxmal as a means to bolster claims by high-ranking members of the family to be "natural lords," a colonial period title for former Maya nobility that provided them with certain rights and privileges. Aside from such references, and a few others such as a brief description of the site by Fray Alonso Ponce in 1588, however, the site was largely forgotten and permitted to languish, its ancient platforms and vaulted buildings gradually deteriorating as it was made pasturage for the local hacienda owned by the Peon family.[8]

The shaping of Uxmal as an exemplary image of "ancient Maya civilization" did not begin until Mexico gained independence from Spain and more-sustained exploration of Uxmal began during the nineteenth century. The early explorers included colorful and eccentric personalities, such as Jean Frederic de Waldeck and Augustus Le Plongeon, whose accounts of Uxmal and other Maya sites feature blends of fact and fancy. The site gained greater recognition following the visits by American lawyer and travel writer John Lloyd Stephens. His accounts, published in 1841 and 1843, complemented by illustrations by the English artist Frederick Catherwood, provided detailed and accurate descriptions of Uxmal (and various other Maya sites such as Copán,

Palenque, and Chichén Itzá). He recognized that the decaying stone structures were the works of the ancestors of the present-day Maya peoples living in the area (although he considered their forebears to be somewhat fabulous culture-bearers known as the "Toltecs"). However, he also contrasted the intellectual and cultural achievement of the ancient Maya civilization, and the grandeur of ancient buildings like the House of the Governor at Uxmal (which he considered fitting to stand alongside of, though not equal to, well-known edifices of the ancient Egyptians, Greeks, or Romans) to the physical and cultural impoverishment of their descendants, the "miserable Indians who now linger about their ruins." R. Tripp Evans notes that this contrast was given visual expression in Catherwood's images, in which the majesty of fallen façades is complemented by the inclusion of Maya guides or workmen, reminding the viewer of the gulf that separated the knowledge and skills of the ancient builders from the subservient position of their descendants.[9]—**6.2** col.

Desiré Charnay, who produced the earliest photographs of structures at Uxmal (including a magnificent panoramic view of the House of the Governor), similarly placed Maya workmen in several photos of Mesoamerican sites. Charnay's photograph of the Iglesia structure at Chichén Itzá, for example, shows a local worker standing in front of the building to give a sense of scale. The image carries an implicit message that the contemporary Maya is primarily a prop, clearly secondary to the striking visual power and iconographic complexity of the ancient edifice. In addition to posing Maya in this way, Charnay also "documented" local Maya individuals by posing them in pseudoscientific paired frontal and profile views.[10]

Stephens' and Charnay's attitudes reflect a common perspective during their time. In North America, particularly in the United States, pre-Columbian civilizations and their aesthetic accomplishments were recognized as part of a broader "hemispherical" heritage that redounded to the credit not only of the nation states in which such civilizations arose,

but also formed part of the comprehensive history of the rise to power of the Americas. Since it was the "manifest destiny" of the United States to be the dominant political, economic, and military entity in the hemisphere, the cultural achievements of any ancient American peoples could be considered part of its broader heritage. As Curtis Hinsley has pointed out, growing awareness of pre-Columbian societies and civilizations represented, and an accompanying desire to record, collect, and display their architecture, art, and artifacts was, a practice that was ideologically implicated in cultural discourses regarding the legitimacy and necessity of European and American (i.e., the United States of America) empires.[11]

This attitude was given material expression in the program of the World's Columbian Exposition held in Chicago in 1893. Speaking of the broader ideological message of this World Fair, Marling notes that:

> For Chicago, capturing the Columbian Fair was an important confirmation of its rebirth from the ashes of the Great Fire of 1871, a proof of its renewed vigor. The victory of a new, western city over the venerable New York also seemed to assert the hegemony of the New World over the Old, of America—the land Columbus found—over foreign nations.[12]

At the exposition, Uxmal and the nearby site of Labná were represented by a number of plaster casts of sculpture and architecture made by Mayanist Edward H. Thompson, an American diplomat, explorer, and archaeologist known for his work at sites in the Puuc region and for his early investigations at Chichén Itzá. The architectural casts were used to construct full-scale sections of the façades of the Nunnery Quadrangle and the House of the Governor from Uxmal that stood in front of the Anthropology Building, within which were photographs and plaster cast monuments from these and other buildings and artifacts from other ancient American civilizations.[13]—**6.3**

The display of such casts, artifacts, and photographs,

which were acquired at great effort and expense by intrepid explorers seeking to properly document the remains of previously unknown civilizations, was related to the fair's focus on industry, science, and progress—positivist themes associated with gaining control of nature and creating a rationally ordered society (i.e., a capitalist one dominated and governed by Euro-American nations). As if to emphasize the broad theme of "conquest," Diana Fane notes that Thompson's casts of the Uxmal buildings:

> reinforced the themes of discovery and salvation by reproducing the jungle growth along with the ruins. Nature and science battled for control of these great edifices. . . . the presence of these architectural reproductions in Chicago proclaimed science the victor. Several nations shared the spoils; the World's Fair celebrated the intellectual conquest of ancient America by France, Great Britain, and the United States.[14]

Uxmal made another appearance at the 1933 "Century of Progress" World's Fair in Chicago. The fair's organizing committee included a section devoted to the theme of "The History of Man in America before the Conquest," and it was decided to house the collections and educational materials in an accurate replica of a native pre-Columbian building. The structure chosen was again the Nunnery Quadrangle at Uxmal. To accomplish this, the director of the Anthropological Section, Dr. Fay Cooper-Cole, commissioned the Middle American Research Institute of Tulane University to organize an expedition to Uxmal led by archaeologist Frans Blom, to produce large-scale photographs, scale drawings, plans, site maps, and other data needed to duplicate the buildings. Ultimately the plan to reproduce the entire quadrangle proved too ambitious, and only a portion of the North Structure of the Nunnery was actually constructed, using plaster casts created by Gerhardt Kramer.[15] Although the exhibit had a scientific and educational purpose, contemporary literature for the fair also reflects a

romanticized view of the Maya, describing the Nunnery structure as follows: —6.4

> The temple is a reproduction of one of the buildings of the Monjas, or Nunnery, at Uxmal, Yucatán—a striking example of the architecture of the Mayas. The Monjas is thought to have been the nunnery of the vestal virgins, who attended the sacred fires in the temples of their gods, and who were put to death if they broke their vow of chastity. The barbaric facade of the temple is decorated with relief carvings of the intertwining bodies of the feathered serpent god Kukulcan. Fantastic, grotesque masks done in the brilliant colors that characterize Mayan architecture, adorn the walls.[16]

As we will see, the exoticized and sexualized aspects of this purple prose, along with the emphasis on the more violent (even somewhat sado-masochistic) aspects of ancient Maya society have been given new life in some of the more sensational representations of pre-conquest Maya life, religious belief, and ritual practice in contemporary promotional materials and popular media (exemplified by the recent film Apocalypto).

Maya architecture in general, and that of Uxmal and the Puuc region in particular, proved to be an inspiration to two United States architects: Frank Lloyd Wright and Robert Stacey-Judd. Wright admired pre-Columbian architecture, which he considered one of many of the great world traditions. An early influence from Uxmal appears in the capitals of the columns supporting an arcaded "screen" in the Winslow house of 1893–1894. As Dmitri Tselos notes, these capitals were based on the tiered arrangements of two-headed serpent bars that adorned the façade of the East Structure of the Nunnery Quadrangle at Uxmal, an architectural group two sections of which, along with other monuments from the site, were reproduced in plaster casts at the 1893 Chicago Columbian Exposition. Elements of design based on the sharply cut geometric patterns of the architecture of Uxmal and other Puuc regions sites (e.g., the Arch at Labna) were also used in a cast frieze of the Bogk house in Milwaukee and on the exterior of the Midway Gardens in Chicago, although such designs also indicate Wright's interest in fusing his own design principles with aspects of European geometric abstraction and cubism.[17]

While Wright's references to pre-Columbian architecture reflect his appreciation for its organic relationship to ancient society, its relationship to nature, and for it being capable of inspiring his own search for an architecture consonant with American Democracy,[18] other aspects of the Puuc architectural style of Uxmal and nearby sites such as Kabah, Sayil, or Labna appealed to and were quoted liberally in the Maya Revival style structures designed by Robert Stacy-Judd. Stacy-Judd was an intriguing personality—an Englishman who sought to create an authentic American architecture based on the model of pre-Columbian antiquity, but who also viewed ancient Maya civilization as a center of esoteric wisdom and spiritual enlightenment. Although his early buildings displayed elements borrowed from ancient Egyptian architecture or that of the Islamic Middle East, he became familiar with Maya architecture through Catherwood's engravings in the Incidents of Travel books. at that point he developed a life-long passion not just for appropriating details from Maya edifices in his own projects but in remaking himself as an explorer, promoter, and interpreter of ancient Maya culture. One of his best-known examples is the Aztec Hotel built in Monrovia, California, in 1925. According to Jesse Lerner, the hotel "embodies the enormous vogue for things Mexican," and represents a turning point in the history of the Maya Revival Style in the United States, distinct from both the more imperial era which it followed and the "Good Neighbor" phase which coincided with the Second World War.[19]

While United States explorers, such as Stephens, and the World's Fairs held in Chicago in 1893 and 1933 sought to appropriate ancient Mesoamerican

cultural achievements (including the monuments of Uxmal) as part of a broader "American" heritage, the nineteenth-century movement for Mexican Independence from Spain featured a glorification of the nation's "Indian" past for more nationalistic purposes. As Donald Fowler notes:

> Both Carlos María de Bustamente and José Mariá Morelos sought Mexican independence through a repudiation of the Spanish heritage and the restoration of an idealized Aztec empire (Phelan 1960: 767–768). Such ideas were sidetracked after Mexican independence in 1821. But they re-emerged very strongly in the Revolution of 1910. As part of this re-emergence, the Mexican archaeological past began to be studied systematically, initially through the efforts of Manuel Gamio after 1907. The places associated with an ideology derived from the past again began important. Over the years, Gamio, Alfonso Caso, Ignacio Bernal, and their many distinguished colleagues and co-workers clearly demonstrated the brilliance and achievements of pre-Conquest Mexican civilizations through their work at Teotihuacán, Monte Albán, Tula, Chichén Itzá, and other major sites. Archaeology became an integral part of the emerging and on-going indigenismo movement, a core feature of Mexican nationalism (Keen 1971: 463–508; Lorenzo 1984: 90–91).[20]

Thus, in the early stages of Mexican independence, and during the subsequent heady time of the Mexican Revolution that ultimately resulted in the formation of the PRI, there was a deliberate effort to forge a recognizable "Mexican" identity. The use of references to the pre-Columbian past permitted politicians, whether more conservative and authoritarian or those seeking more radical and sweeping change, to evoke the memory of the achievements of Mexico's ancient civilizations to create an image of a society that was founded on "mestizaje." While the achievements of past civilizations were celebrated, however, they were integrated into a metanarrative

of "progress." Ancient cultures and monuments were valued as part of the national patrimony, but it was understood that they were way stations on a road toward unified nationhood, modernization, and improvement of everyday living conditions coupled with a sense of corporate identity and citizenship as opposed to life in backwater communities based on ethnic identity.[21] The culmination of this nationalist movement was the 1964 inauguration of the Museo Nacional de Antropología, in which the pre-Columbian past in general, and the Mexica-Aztec empire in particular was lionized on the ground floor, while the upper floor featured ethnographic tableaux of life, customs, material culture, and "popular arts" of regional "folk cultures" of Mexico.[22] Guillermo Bonfil Battalla notes that such approaches to archaeological reconstruction and museum interpretation are a reflection of the approach of "Manuel Gamio, a colleague of Frans Boas, who simultaneously exalted the 'positive values' of Indian cultures yet acknowledged the necessity of a homogeneous society to forge a new nation."[23] Speaking of this process, Benjamin Keen observes that it provided more psychological esteem than material benefits for the average Mexican:

> To be sure, the revolution gave a large impetus to the cult of ancient Mexico, and the postrevolutionary regimes have created an imposing array of museums, schools, and research centers for its study. But I should note that today, as in the days of Don Porfirio, the cult of ancient Mexico has more pragmatic uses, serving to improve the image of a corrupt, authoritarian Mexican government and to cover up the intolerable conditions, the "internal colonialism," of Mexico's living Indians.[24]

Much of the work at major sites carried out by the Mexican government, first by the Dirección de Antropología and later by INAH (Instituto Nacional de Antropología e Historia), during the first half of the twentieth century was an expression of this viewpoint, and it helps explain why the government

continues to maintain official title to archaeological sites, as well as to any newly discovered ancient pre-Columbian artifacts, as part of the "patrimonio cultural." Since the Second World War, however, archaeological work in Mexico generally has served several overlapping ends. On one level, many of the projects carried out under the auspices of INAH have involved purposeful and government-supported efforts to use archaeological research to engender a sense of a shared history and Mexican national identity. Since the time of Revolution of 1910, official government policy has encouraged archaeologists to "increase knowledge and public awareness of the pre-Hispanic civilizations of that country" to "promote national unity by glorifying Mexico's past and honouring the achievements" of its indigenous peoples, who constitute a large percentage of its population.[25] Such efforts result in developing heritage sites that, through reproduction in various media, ranging from academic to popular, create a distinctive image of Mexican culture. It is also intended to assert Mexico's cultural distinctiveness to the rest of the world. Beyond this, however, an important part of this policy is the development of major archaeological sites as open-air museums for the entertainment of Mexicans and tourists alike.[26]

The growth of tourism has had a powerful impact on the fortunes of Uxmal and on the lives of people who live in the vicinity of it and other Puuc region sites. Uxmal is the third most commonly visited archaeological site in the northern Yucatán region, following Tulum and Chichén Itzá, both of which benefit from their greater proximity and more direct access to the throngs of tourist who visit the East Coast resorts at Cancun, Playa del Carmen, and Akumal. Of course, tourism at Uxmal and in the Puuc region forms part of a broader worldwide phenomenon that has expanded tremendously since the Second World War. This is particularly true in Mexico, which has witnessed a dramatic increase in tourist visitors and revenues. Prior to the 1970s, tourism tended to be localized, focused on "border"

transactions or travel to Mexico City and Acapulco, and most governmental and private-sector development policy focused on fostering industrialization rather than tourist services.[27] Tourism increased dramatically from 1970 to 2000, however, so that it currently is the third largest industry in Mexico, a major focus for foreign investment, and the second largest employer after agriculture. México has a top-down "statist" approach to planning and managing tourism resources, which are seen as important sources of local development. In Yucatán the importance of tourism began to accelerate during the 1960s, the time when the state tourism agency FONATUR was created. The lure of revenue and development led the Mexican government to pursue tourist projects with little consultation with local populations, and in some cases over strong local opposition.[28] According to Clancy:

> "The predominant form of tourism found in Mexico today is export-oriented, large-scale, mass-based, and centered around beaches. Evidence shows that this brand of tourism has been significantly affected by state action. Polity makers began to emphasize tourism by planning and creating five new tourist resorts in the 1970s after a three-year study by the Banco de México to identify the possibilities for expanding Mexican exports" (see New York Times 1972; Hiernauz 1989: 111–112).[29]

One of these new tourist facilities was the Cancun beach resort, recreation and entertainment complex, located on the eastern coast of the Yucatán peninsula. By 1989 Cancun had surpassed both Acapulco and Mexico City and its surrounding Federal District as the most popular tourist destination in Mexico.[30]

Cancun and the other resort and recreation areas along the "Maya Riviera" certainly account for the lion's share of the tourist revenue generated in the northern Yucatán peninsula. However, the Mexican government also supports archaeological projects at sites deemed to have enough aesthetic appeal and

cultural significance that they can serve as additional draws for visitors. Although INAH supports scientific archaeological research at both such major centers, as well as lesser known and less frequently visited sites, it is generally recognized that larger, better-funded projects concentrate on those which have a greater potential to attract tourists and provide economic benefits beyond pure research. José Luis Lorenzo has commented on this policy, although bemoaning it, writing that:

> It is understandable that most of the interest and funding should be concentrated upon archaeological remains that are more easily restored and which best exemplify the cultural glories of the past. Added to this is the consideration that, although work in such zones is more expensive, it is easier for the archaeologist to obtain more spectacular results. These are frequently picked up by the press and bring him considerable fame with little effort on his part. Not many engage in the other, non-monumental, archaeology and they should at least be accorded the recognition they deserve of being much more scientifically rigorous in their work.[31]

In the interest of furthering this mix of scientific and practical goals, various government-sponsored archaeological projects have been carried out at Uxmal. The majority of such projects have been directed by Mexican archaeologists. Those completed from 1917 to the 1940s by Juan Martínez Hernández, Eduardo Noguera, Eduardo Martínez Cantón, Manuel Cirerol Sansores, and José Erosa Peniche implemented state efforts to preserve major monuments associated with the national heritage, but they pre-date the major tourist era. Others carried out from the late 1940s to the present by José Garcia Payón, Alberto Ruz Lhuillier, Jorge Acosta, César Sáenz, Amalia Cardós, Barbara Konieczna, Pablo Mayer Guala, Alfredo Barrera Rubio, and José Huchim Herrera occurred during a time of increasing tourism in the Puuc region. Such studies have included mapping of the site, studies

of its hydrology, and recording and interpreting its architecture, ceramic and artifacts, and, to a greater or lesser extent, they also include sections that use data collected to interpret Uxmal's role in pre-Hispanic culture history and the processes involved in its rise and fall. However, much of the money and effort was directed toward carefully restoring, and to some extent, reconstructing the larger and more impressive stone masonry structures that are located inside of the central civic-ceremonial zone within relatively easy walking distance for visitors. This is understandable, since Uxmal is second most heavily visited tourist site in Yucatán state, having had some 186,566 visitors in 1992, and growing to 215,405 visitors in 2008, surpassed only by Chichén Itzá, which saw 605,236 and 1,454,661 visitors in the same years.[32] As tourism has increased in northern Yucatán, changes have occurred in the touristic infrastructure that supports (and is supported by) Uxmal and other Puuc region archaeological sites. These have included periodic enlargements of the site entrance, with the addition of more tourist shops and support services, the adding of a "light-and-sound" show, and the building of newer restaurants and hotels of both large "luxury" and smaller 'backpacker' varieties.[33]

There are, of course, different types of tourists who visit Mexico. The large majority are "sun-sand-and-sea" aficionados who are attracted to largely self-enclosed enclaves such as Acapulco, Manzanillo, Mazatlan, Puerto Escondido, or the Cancun "Maya Riviera" corridor. However, a significant number of visitors are "cultural tourists" who have an interest in visiting sites with historical connections to Mexico's colonial and/or pre-Columbian past. In addition, large numbers of Mexicans appreciative of their historical heritage also visit such sites as part of what has been termed "turismo social."[34]

Because of its relative proximity to the East Coast tourist site of Cancun, the site of Chichén Itzá is one of the most heavily visited archaeological sites in Mexico. Busloads of tourists are transported daily to the archaeological site and typically are given a

rather hasty two- to three-hour walking tour of the site's major architectural monuments, accompanied by rather romanticized presentations on the ancient Maya and their penchant for esoteric ritual and gory sacrifice. Signs at the site itself identify the major structures, but these have frustratingly brief texts. Uxmal, farther away from Cancun, has fewer casual "sun and sea" visitors on an annual basis, although the grandeur of its buildings attracts many tourists who are motivated by an interest in history or a desire to experience different cultural traditions. Uxmal's visitors are typically drawn by the allure of the past and by the promise of being able to experience the grandeur of ancient Maya civilization embodied by the remains of one of its premier architectural expressions. Promotional materials for tours to the Puuc region emphasize this character, stressing the images of the Maya past, or the more "traditional" aspects of the Maya present. For example, an online brochure for a tour of the "Hidden Cities of the Yucatán" organized by the *Far Horizons* agency notes that "The Yucatan peninsula has been the home of the Maya for at least 4,000 years. Breathtaking sculpture and mural-covered pyramids stand witness to the magnificent civilization, which formerly existed there. Today, thatch-covered houses and hand-embroidered costumes of villagers are vivid reminders that the Maya are still very much alive."[35] Having been a tour lecturer for several educational trips of the Maya region (including some for *Far Horizons*), my perception is that such tours draw a fair number who have a serious avocational interest in the ancient Maya, along with others who have a general interest in experiencing various cultures of different parts of the world. In some cases, their knowledge of the Maya has been either shaped as a result of reading a few survey books (e.g., Michael Coe's *The Maya*, or Robert Sharer's *The Ancient Maya*) or somewhat more specialized though still "popular" studies, or based on knowledge of a few major exhibitions.[36] For even more visitors, particularly at Chichén Itzá, Tulum, or other sites seen by the beach club aficionados, their

perceptions of ancient Maya society and culture may have been based on shorter, more synthetic, and more popularized interpretations and images found in journals such as *Archaeology* or the *National Geographic*, television programs seen on PBS or the History Channel, or simply on one of many short local guidebooks or information provided by local guides.

As noted in chapter 1, limited and anachronistic views and representations of the Maya presented by more popular media inculcate ideas regarding both the "timeless" and "mysterious" aspects of ancient Maya society and culture, while generally glossing over the significant changes Maya peoples have experienced and adaptations they have made as the result of historical events and social forces that have affected them from the time of the Spanish conquest to the present. Peter Hervik, focusing particularly on the portrayal of the ancient Maya in the *National Geographic*, notes that the majority of its articles celebrate the "glorious past" of the Maya (though also stressing its sacrificial rituals), while downplaying the more gritty and economically challenging realities of their present-day lives. When present-day Maya are discussed and pictured, it is often in romanticized or exoticized contexts that stress ways in which practices such as the use of traditional foods, field rituals, or shamanistic practices represent continuities with their pre-Columbian past.[37] Traci Ardren has commented on the ways in which tourist-oriented advertisements in the popular archaeology magazines *Arqueología Mexicana* (published in Mexico) and *Archaeology* (published in the United States) further such anachronistic and exoticized stereotypes. Related observations have also been made by scholars such as John Watanabe, who notes that even as such stereotypical conceptions have been used to brand the Maya as backward by those who would continue to dominate and exploit them, they also are celebrated by spokespersons for pan-Mayanist political and artistic movements.[38]

Such problems are not simply the result of the fact that more accurate or "truthful" accounts of ancient

Maya society are bowdlerized and oversimplified by staff writers for more popular media, but reflect complex processes of knowledge production. In many cases, the popular journals feature articles written by, or completed in consultation with various academic experts.[39] Conversely, specialists may write books that have serious scholarly value, but that nevertheless inadvertently contribute to creating stereotypes that eventually filter into the popular imagination.[40]

This demonstrates a professional dilemma commented on by Philip Kohl, who notes that archaeologists are becoming increasingly aware of the political and economic implications of their work, and realize that the ways that they interpret the past play a role in creating "stories" about places, peoples, and cultures that shape outsider's perceptions. In an age of greater global economic integration and broader opportunities for travel and tourism, such perceptions help shape visitors' notions and contribute to the knowledge base they bring with them to encounters with what had formerly been considered remote areas and exotic others. He notes that as archaeologists become more critical of their own relationship to the marketing of the past, and strive to recognize how their academic interpretations are modified and simplified through the filter of more popular journals and entertainment media, they have begun to recognize, and to respond to the fact that they are implicated in a system producing cultural knowledge and a machinery of marketing that turns both past and present cultures into saleable commodities. In doing so, reified and oversimplified conceptions of such cultures are often assimilated by nonspecialists.[41]

As a "heritage site" Uxmal functions as a type of outdoor museum (a variant of a "Museum of Maya Culture" to use the title of Quetzil Castañeda's book on the impact of archaeology and tourism at Chichén Itzá). We typically think of a museum as a space enclosed in, and defined by, a specialized building whose imposing or impressive architectural treatment gives museum-goers a visual cue that the objects they

will see or the experiences they will have inside differ qualitatively from those outside.[42] But similar values have also been attached to places that do not fit within this conventional definition—special places such as famous battlefields, historical and architecturally significant buildings, and archaeological sites. Like museums, reconstructed archaeological sites are not simply passive records of past meanings, but have become active agents in the creation of meanings for the visitors who flock to them, for those who see them in popular media or touristic advertisements, or for those who use them as backdrops for political or cultural events. Often referred to as heritage sites, such cultural resources continue to generate meanings and/or have economic value in our own time and therefore are actively preserved and "managed" by contemporary humans.[43]

As we have noted, Uxmal, like other pre-Columbian remains, is valued as a physical embodiment of Mexico's cultural heritage and national identity. More recently, in 1996, it was officially designated as a UNESCO World heritage site. Barbara Kirshenblatt-Gimblett has observed that "heritage is a new mode of cultural production in the present that has recourse to the past," and goes on to say that such heritage sites function as a kind of "time machine" that aims at transporting "tourists from a now that signifies hereness to a then that signifies thereness."[44] In Kirshenblatt-Gimblett's words, heritage "not only gives buildings, precincts, and ways of life that are no longer viable for one reason or another a second life as exhibits of themselves; it also produces something new."[45] However, such experience is not that of the original builders and inhabitants, but remains vicarious. It permits visitors to imagine ancient Maya society and culture heritage, based on whatever pre-existing conceptions they have assimilated from previous information and images gleaned from either scholarly or popular media. Tourism and heritage are thus deeply intermeshed and function as "collaborative industries, heritage converting locations into destinations and tourism making them economically

viable as exhibits of themselves. Locations become museums of themselves within a tourism economy Once sites, buildings, objects, technologies, or ways of life can no longer sustain themselves as they once did, they 'survive'—they are made economically viable—as representations of themselves."[46]

The notion that archaeological sites become representations of themselves evokes Roland Barthes' discussion of the mythologizing character of cultural representations (also discussed in relation to the imagery of the Puuc carvings in Mary K. Scott's essay), Baudrillard's discussion of simulacra, as well as recalling Walter Benjamin's ideas regarding the ways in which the flood of reproductions of famous monuments or artworks made available in the mass media diminish their "aura" by making them accessible to ordinary viewers.[47] Yet, ironically, tourist visitors to Uxmal come seeking the unique experience of standing before the "original" structures (even though they have been extensively reconstructed), even as the frisson of excitement created by being in their presence owes much to having seen them previously in survey books, popular magazines, or television specials.

The notion Uxmal, as a vestige of ancient Maya society, has the "aura" of the original is linked to Barbara Kirshenblatt-Gimblett's observation that to attract tourists, sites must be recognized as a destination with a difference.[48] She also asserts that the "The Key to Heritage Productions is their Virtuality," and observes that although tourists seek out experiences in the presence of tangible objects, sites, or performances, these phenomena speak of the "the intangible, absent, inaccessible, fragmentary, and dislocated"[49] (i.e., the gulf of time and cultural understanding separating the visitor from the lives, thoughts, and feelings of the ancient Maya in the case of Uxmal). The sites are brought to life through the imaginative experience of the visitor, whose understandings and perceptions have been "imagineered" (apologies to Walt Disney Corporation) by a complex nexus of information provided by sources ranging from education, mass culture, tourist promotional materials, on-site didactics, lecturers and guides, and so forth. Relating these ideas to this exhibition, the physical presence of the monumental buildings at Uxmal and the Puuc sites, coupled with the imagined presence of the past, becomes tangible in the striking visions of ancient Maya imagery displayed in the wood carvings displayed and sold by the artisans at the site entrances or in nearby towns. Although the sale of the artworks is enhanced by their proximity to the impressive façades of Puuc buildings, they also provide memory images of the Maya (internalized as the ancient Maya) that many tourists have assimilated and absorbed. In this sense, although the carvings themselves are actual contemporary objects, their imagery helps to "people" the site in a virtual sense, and contributes to the visitors' experience that they have entered a zone of cultural difference, created by the interplay of the real and the imaginary, or "a collaborative hallucination in an equivocal relationship with actualities."[50]

In a related way, the growing influx of tourists has affected changing attitudes toward the management of archaeological sites, a process which Silberman terms a transformation from "patriotic shrines to theme parks," also noting that, "What is certain . . . is that economic considerations can open the way to an era in which archaeological resources are selectively exploited, not for scientific or ideological reasons, but according to someone's idea of what sells."[51] This is certainly reflected by the fact that the control of the sites, which was formerly primarily under the control of INAH, has now been merged with that of both national government tourist agencies such as SECTUR, as well as local tourist agencies such as CULTUR (see note 30). Perhaps the most overt "theme park" aspect of Uxmal is the evening light-and-sound show. One can find regular "light-and-sound" presentations in Spanish and English at both Chichén Itzá and Uxmal. The ticket price is fairly steep (currently 9 dollars), certainly costly enough to dissuade local Maya inhabitants of Muna or Santa

Elena Nohcacab, the towns nearest to Uxmal, from attending. The light-and-sound shows blend smatterings of archaeological knowledge with overly dramatized plots based on condensed versions of native histories of Yucatán, accompanied by multicolored light displays and carefully coordinated music played on native wind and percussion instruments to create the impression of authenticity and the "time travel" aspect mentioned previously. Such presentations give the sites a more postmodern quality, creating a simulacrum of ancient experience based on a pastiche of archaeology, ethnohistory, and striking visual effects. For some tourists this experience may well evoke a momentary sense of awe and a feeling that a union with the site has been achieved.[52]

If the boundary between reality and "hyperreality" thins at Uxmal, where the reconstructed remains of the Nunnery Quadrangle house the audience for a light-and-sound show, it dissolves further at the Walt Disney Corporation's EPCOT center in Orlando, Florida. One of the latest manifestations of the earlier attitudes embodied in the two Chicago world fairs mentioned above, EPCOT is an actual "theme park" where Uxmal is an important source of imagery for the façade of the Mexico Pavilion. The entrance to the pavilion, called an Aztec Pyramid in various online descriptions, actually features a mélange of elements based on several Mesoamerican cultural traditions and sites. The pyramidal base features outward sloping or "flaring" cornices and countersunk panels reminiscent of the Pyramid of the Niches at El Tajín. Projecting from the broad ramps flanking the stairways, however, are large polychrome serpent heads based on those seen at the Old Temple of Quetzalcoatl at Teotihuacan. Surrounding the doorway of the temple are latticework panels like those that appear on many of the major buildings at Uxmal and at other sites in the Puuc region. Direct quotations from architectural sculpture from Uxmal and Kabah are evident on the façade of the pavilion behind the pyramid. These include stacked masks representing the long-snouted Yucatec Maya rain god, Chaak, that

resemble those seen on the masks from the Codz Pop palace at Kabah, as well as the West Structure of the Nunnery Quadrangle at Uxmal (see Figure 1.3). Over the doorways into the pavilion are arrangements of two-headed serpent bars with latticework interiors, based on the principal architectural sculpture motifs seen above the doorways of the East Structure of the Nunnery at Uxmal.[53] Of course, most visitors to EPCOT will not recognize these specific sources, nor realize that they represent a pastiche of buildings and images from throughout Mexico. Yet they serve as an effective, though caricatured and commodified, stereotype of the celebration of the pre-conquest past as the image of Mexican national identity. In this sense the EPCOT experience recalls the creative juxtapositions of various iconic motifs from both ancient Maya and Mexican art seen in the Pisté *máscaras* and *mascarones* discussed by Castañeda in his essay in this volume and elsewhere.[54]—**6.5** *col.*

Uxmal's presence is also evoked in a more surreal and sensational way in the set design for Mel Gibson's recent blockbuster movie, *Apocalypto*. The film centers on the destruction of a small and somewhat idyllic Maya farming village nestled in the jungle by rampaging members of a major Maya city-state capital. The hero of the story, Jaguar Paw (played by an adopted Comanche and Cree actor Rudy Youngblood) is lead back to the city, depicted as a place of decadence and political machination, to be sacrificed. The city itself consists of a mélange of motifs taken from buildings and sculptures drawn from various Classic Maya centers. The façade of the temple where the sacrifice is to take place features elements drawn from the architecture of Uxmal and the Puuc sites, particularly evident in the "roof comb" consisting of a stack of long-snouted Chaak masks crowned by the goggle-eyed image of the Teotihuacan Storm God, Tlaloc. This is based closely on the series of such mask towers that form the crenellated roofline of the North Structure of the Nunnery Quadrangle at Uxmal. Yet, while the temple features northern Maya motifs, the headdress of the principal priest, a

large cylindrical turbanlike form with a frontal Storm God mask, is more clearly based on the sculptures of Copan, Honduras, a site located several hundred miles to the southeast that flourished about 100 to 200 years earlier. Thanks to the occurrence of a solar eclipse, Jaguar Paw escapes and much of the rest of the movie consists of him being pursued by warriors hell bent on catching him, many of whom meet extraordinarily violent ends. Finally, just as Jaguar Paw appears doomed, he leads his wife and family to a Deus Ex Machina ending as they watch Conquistadors and Christian missionaries make landfall on a beach.

At the time of the film's release, various scholarly critiques rightly condemned its simplistic and overly sadistic vision of ancient Maya society. They generally noted that recent scholarship has demonstrated that Maya elite did indeed wage warfare both for personal prestige and material gain, and that there is evidence for the sacrifice of war captives as well as forms of penitential personal bloodletting, but objected that none of the mythic, cosmological or ritualistic bases for such practices are explained for the viewer. Instead, the ceremonies simply seem like a caricature of a barbarian society entirely centered on bloodlust—one that deserved to be conquered by Spain (the implication of the film's ending).[55]

If *Apocalypto* exaggerates new evidence for violent aspects of ancient Maya culture, earlier notions of a pacifistic Maya society governed by priests with an interest in the calendar, astronomy, and esoteric spiritual knowledge still inspire some visitors to Uxmal who arrive in search of various types of personal renewal. Some are counter-cultural backpackers, who visit Uxmal and other Maya sites in order to create a connection with a sense of spiritual wholeness that seems missing in their own lives (perhaps fitting MacCannell's notion of tourism as a form of secular pilgrimage more than most).

Such voyages of spiritual discovery and self-actualization can also take the form of more commercialized vision quests. From the time of the conquest to the present, some have seen the ancient Maya as having fantastic origins and fabulous intellectual and spiritual powers. Such ideas were reinterpreted and repopularized in the 1980s in the book *The Maya Factor* by José Argüelles. Chichén Itzá has been the focal point for such beliefs: exemplified in the past by the fantastic ideas about the site found in the writings of explorers such as Augustus and Alice Le Plongeon, and demonstrated more recently by the gathering of New Agers to witness the "serpent of light" phenomenon at the Castillo pyramid at Chichén Itzá.[56] However, as chronicled in the website for *Children of Light: Center of Empowerment and Personal Healing*, Uxmal also formed one of the destinations of several New Age voyagers who participated on the "Journey to the Mayan Temples of Mexico" with tour guide Eric Solis, and spiritual guide Hunbatz Men.[57] After an initial ritual to create the group resonance necessary to move collectively into the Age of Aquarius, trip participants visited Tulum, Kohunlich, Palenque, Uxmal, Chichén Itzá, and Ek Balam. On 18 October 2005, the group reached Uxmal in time to participate in a special ritual, identified as the "Worldwide Meditation: Grounding the Light of the World Soul." The next day the group worked with Hunbatz Men to connect with the sacred energies of the Pyramid of the Magician, which he told them was a space honoring feminine energy. Thereafter, the women gathered in the plaza space of the Nunnery Quadrangle to celebrate their feminine/goddess nature. None of this has anything to do with what we believe to have been the specific functions and meanings of these places in preconquest times, but the aura of "mystery" associated with the Maya and the fact that the architectural edifices and spaces were intended to create the sense that Uxmal was an important "world center" and that many sculptures did represent Maya deities provide the ontological setting and psychological prompt for the susceptible seekers of New Age spiritual sustenance.

As another element of their visit, the New Age seekers performed a ritual on site, making a special

spiral labyrinth in the grassy lawn, a performance aimed at joining the energies of the superconscious, conscious, and subconscious minds to create a time of healing and integration. According to the website, when the participants awoke the next morning "there were ten hotel employees running through the spiral with great joy on their faces." Perhaps so. Or maybe what they took for "joy" was a kind of knowing laughter at the antics of the gringo visitors. Much of this essay has focused on what Uxmal has meant to cultural outsiders after the conquest, particularly to more recent tourists, but heritage tourism also has an impact on local people, most of whom are bilingual Spanish-Yucatec Maya speakers who have lived in the vicinity of the site all their lives. While they recognize that it is an important monument and part of the cultural patrimony, for them Uxmal is not a destination, but part of their home territory and a resource from which they derive varying levels of economic benefit working as guardians, groundskeepers, guides, vendors, and parking lot attendants at the site itself, or as waiters, housekeepers, and other staff positions at local hotels, restaurants, and rest stops. By and large, the money they make in a year from such work is somewhat less than the amount the cultural tourists visiting Yucatán are likely to spend for a two-week trip.[58]

In the book, *Monumental Ambivalence: The Politics of Heritage*, Lisa Breglia comments on the contentious relationship between present-day Maya peoples and their archaeological past, posing the question, "Who are the proper heirs to Maya cultural patrimony?" She points out that, on an official level, sites such as Chichen Itza and Uxmal, which have been declared official UNESCO world heritage sites, form part of the common inheritance of all humanity. However, in real world terms, "Heritage is a set of values, meanings, and practices differently constituted at local, regional, national, and international levels by social actors and institutions. Distinct regional, local, and even site-specific understandings of Maya cultural heritage exist in tandem and in tension with

both the Mexican nationalist discourse on cultural heritage and UNESCO's criteria of universal cultural value."[59] Her studies reveal that local Maya experience the sites of Chichén Itzá and Chunchucmil differently than foreign visitors, but even Maya perceptions vary depending on the level of the site's touristic development and their own relationship(s) with it. Until recently, inhabitants of Chunchucmil thought of the local ruined structures primarily as part of their ejido farm fields and associated it with the natural landscape.[60] In contrast, Breglia notes that "almost everyone living in the vicinity of Chichén Itzá recognizes its archaeological importance, its significance as a 'heritage site,' and understands its economic importance to the region." but its meanings are contested, and the economic benefits brought by visitors are not shared equally.[61] This contestation involves competition over who controls production of knowledge about the site and physical access to it, as has been discussed by Castañeda in his essay in this catalog and elsewhere.[62] Based on their own testimony, it would be fair to say that because of their involvement with the Puuc archaeological sites, either as guardians or an on-site guide (in the case of Miguel Uc Delgado, Angel Ruíz Novelo , and Jesús Marcos Delgado Kú) or as a tour guide (in the case of Wilbert Vázquez), they have a greater personal awareness and appreciation of the Puuc sites and ancient Maya heritage that is reflected in their carvings. They have been better able to benefit economically from Puuc sites than some other local people, but not as much as the tour agencies and hotel chains that promote these sites as cultural destinations and provide the infrastructure needed to profit from them.

Which of the different versions of Uxmal discussed above is most authentic or represents the "real Uxmal"? As stated at the beginning of this essay, the notion that Uxmal was "thrice built," may refer literally to several preconquest occupations or re-buildings of the site, but it also may be taken figuratively to refer to the idea that conceptions and uses of the site have shifted over time and have conveyed

different messages to different audiences. Throughout, it has represented different visions of identity. It was constructed as cosmic center that chartered local kings and then was recognized as an ancestral home by the Xiu. In the nineteenth to early twentieth centuries it became a pan-American center of "Toltec" culture, an indigenist symbol of Mexican cultural identity, and a captured image of an ancient past at World's Fairs. More recently it has become a World Heritage site and a prominent tourist attraction, as well as a destination for seekers of new age wisdom, and a source of popular and exoticized images of Maya culture at the EPCOT center or in Hollywood adventure movies. Uxmal, along with the "Ancient Maya Civilization" in which it emerged and which it continues to represent, has served as a palimpsest—an overwritten slate that has provided many different people with a "usable past" capable of expressing and supporting dramatically different worldviews, ideological conceptions, and political and economic agendas. As the title of the 1985 volume, "Who Owns the Past?" suggests,[63] although monumental edifices at sites such as Uxmal are generally recognized as part of the national cultural patrimony of Mexico, as well as the broader inheritance of humanity, insofar as Uxmal has gained widespread recognition as a representation of Maya civilization, it has also become a cultural commodity that provides the lure for tourist visitors. This makes Uxmal a contested resource, both as a source of symbolic capital and actual income.

Notes

1. For the archaeology of the Puuc region see Pollock 1980, Gendrop 1983, and Dunning 1992. The architecture, art, and archaeology of Uxmal are presented in Foncerrada 1965, Kowalski 1987, and Kowalski and Dunning 1999. Another interpretation of the site's name could be that is derived from the word "*ux*," which means to harvest or pluck the fruit from a bush, and "*mal*," which refers to the number of times a certain work is repeated: in other words "Uxmal" could refer to a region where there is an abundant harvest. See Barrera Rubio, 1985: 17.

2. Many aspects of Terminal Classic period culture history and social processes are discussed in Sabloff and Andrews 1986 and Demarest et al. 2004.

3. For the identification of Lord Chaak see Kowalski 1987, chap. 5. General discussion of Uxmal's role in the consolidation of a Puuc regional state is found in Dunning and Kowalski 1994. For discussion of the iconography of the House of the Governor see Kowalski 1987, Kowalski and Dunning 1999, Kowalski 2003a. On Chan Chaak K'ak'nal Ajaw see Schele and Mathews 1998, chap. 7.

4. Kowalski 1994, Kowalski 2003a.

5. On feathered serpent imagery and the round temple at Uxmal, see Kowalski et al 1998. A discussion of the Terminal Classic feathered serpent cult is found in Ringle et al. 1998. Aspects of Yucatán's role in the broader Terminal Classic to Early Postclassic Mesoamerican "World System," is discussed by Kepecs et al. 1998, Smith and Berdan 2004, and Kowalski and Kristan-Graham 2007. The breakdown of centralized political power at Uxmal and in the Puuc region is discussed in Reindel 1998 and Kowalski 2003b.

6. These events are discussed in Roys 1962 and Kowalski 1987, chap. 4. A recent reconsideration of the dating of the Xiu "foundation" of Uxmal appears in Schele and Mathews 1998, chap. 7.

7. For a discussion of these issues see Milbrath and Peraza Lope 2003: 11, and Milbrath and Peraza Lope n.d.

8. For a discussion of historical sources on Uxmal, the Xiu, and the province of Mani during the colonial period see Kowalski 1987, chap. 4. The concept of "natural lords" and the survival and adaptation of Maya elites and their role in government during the colonial period is covered by Roys 1943, chap. 15, and Farriss 1984, chap. 8.

9. Early accounts of Uxmal are summarized in Saville 1921, and Kowalski 1987, chap. 2. Overviews of early explorations of the Maya area, including those of Waldeck, Le Plongeon, and many others can be found in Wauchope 1962, 1965, Brunhouse 1973, and Baudez et al. 1992. For the accounts of Stephens and illustrations of Catherwood, see Stephens 1841, Stephens 1963 [1843], and Catherwood 1844. The quote is from Stephens 1841, II: 429–30. The contributions of these and other early explorers are placed in general histories of the archaeology of Mexico and the Americas in Bernal 1980 and Willey and Sabloff 1980. A recent historical and cultural critique of these early archaeological accounts and their role in creating images of the Maya and antiquity that validated nationalistic ideologies is found in Evans 2004.

10. See Davis 1981 and Reis n.d. [2005]. Such treatment

of local people as accoutrements to images, to provide scale or snippets of "local color," or posed to provide "scientific" records, were common in much early photography of ancient civilizations or exotic cultures (see Banta and Hinsley 1986). Peter D. Osborne 2000. 30, notes that in early photographs of Egyptian monuments "contemporary Egyptians appeared among the ruins as nameless guides or porters, or as figures establishing the scale of the monuments. They attended on the thing that diminished them."

11. Hinsley 1993, 118, notes that the exploration of archaeological sites and collecting of artifacts, while pursued for scientific purposes on one level, often took place in the context of efforts to extend United States or European political influence and economic interests in Mexico and Central America, noting that although it is easy to dismiss early explorers such as Charnay and LePlongeon as cranks and egotists, or more scrupulous ones such as Stephens and Catherwood, W.H. Holmes, or Sylvanus G. Morley as having cultural-scientific interests, their explorations took place "according to cultural instructions of long duration" that "guided the transfer of Pre-Columbian artifacts as aesthetic objects, as scientific data, and as symbolic capital into the public museums and private galleries of metropolitan North America and Europe."

12. Marling 1992, 16. For general discussions of the historical background of and ideological messages implicit in the various World Fairs held in the United States during the nineteenth and earlier twentieth century see Rydell et al. 2000.

13. Hubert Howe Bancroft 1894, 626 describes these as follows: "As reproductions of the famous sculptures of Central America, the French minister of public instruction has furnished imposing casts, covered with strange figures and hieroglyphic, from moulds taken by Désiré Charnay. Other contributions are from the Berlin museum, the government of Honduras, and the Peabody Museum of American archaeology. For those who care not for these strange weird forms and faces, there is a gallery of forty large photographs, representing the exhibits of Great Britain and the achievements of one of her explorers [Alfred Percival Maudslay], whose views were taken from the ancient structures of Guatemala, Honduras, Chiapas, and Yucatán."

For a biographical sketch of E. H. Thompson see Coggins and Shane 1984, 23–26. Thompson's contribution to the 1893 Chicago Worlds Fair is considered by Reis n.d. [2005] and Fane 1993, 161–62 For another general description of the Mexican exhibit see Flinn 1893, 56–57. For a view of the Uxmal buildings see Shepp and Shepp 1893, 321.

14. Fane 1993, 162.

15. Hinderliter 1971, 240–41. A general consideration of the 1933 fair is found in Rydell 1993 and Ganz 2008. Its architecture is discussed in Ganz 2007.

16. See Century of Progress, Chicago World's Fair, UIC Website.

17. For general consideration of Wright's admiration of pre-Columbian buildings, see Tselos 1969, 58, Wright 1957, 111, Heatherington 1986, 33. Tselos 1969, 58–60 discusses individual references in Wright's architectural projects.

18. Tselos 1969, 72. See also Braun 1993, chap 4.

19. Stacey-Judd's unique interpretations of Maya culture and Maya revival architecture are discussed by Lerner 2000 and Gebhard and Peres 1993. The historical-cultural background of Stacy-Judd's work and the "vogue for all things Mexican" is chronicled by Delpar 1992.

20. Fowler 1987, 233–34. From the 1980s onward, several important studies have discussed the relationship between archaeology and politics, particularly with regard to archaeology's role in providing explanations and interpretations of the past that have supported imperialistic, colonial, and/or nationalistic goals (Baram and Rowan 2004, 3). For some examples of such studies see Trigger 1984, Gathercole and Lowenthal 1990, Kohl and Fawcett 1995, Patterson 1995.

21. Yaeger and Borgstede 2004, 266, and Vargas A. 1995, 57–58.

22. Florescano 1993, Errington 1993, 231–41.

23. Bonfil Batalla 1996, 116, quoted in Ardren 2002, 380.

24. Keen 1994, 487. See also Trigger 1984, 359.

25. Trigger 1984, 359.

26. Lorenzo 1981, Bernal 1980, 160–89.

27. Clancy 2001, 129.

28. For general discussion of these issues see Austin 1994, Clancy 1999, 2001, Ardren 2004, Van den Berghe 1994, Long 1991.

29. Clancy 2001, 132.

30. SECTUR 1992. See Castañeda 1996, 72–74, 81–82 for a discussion of the development of Cancun and its impact on the economy and tourism in northern Yucatán, particularly at Chichén Itzá.

31. Lorenzo 1984, 97.

32. Source, Internet Website: https://paginah.inah.gob.mx/modules.php?name=Estadisticas&file=searchestadisticas&op=Ecalculo_estadisticas_ano. Attendance figures and website information provided by Alfredo Barrera Rubio (15 March

2008), archaeologist and former director of CRY-INAH in Merida. Other figures reported in Barrera Rubio (n.d.).

33. Baklanoff 2008, 9. Barrera Rubio (personal communication 15 March 2008) notes that that Light and Sound show at Uxmal was implemented in 1975, and continues to be operated by the Government of the State of Yucatán, and by the state institutions including the Secretaria de Turismo and CULTUR. INAH gave the authorization and made new arrangements for the physical housing of equipment for this show in 2009. According to Barrera Rubio, because the lights are still located in the interior spaces of the major archaeological monuments of Uxmal, they continue to conflict with the cultural preservation of the monuments. The general movement toward greater control and development of archaeological sites by sites by the Government of the State of Yucatán and its agency, CULTUR (Patronato de las Unidades de Servicio Culturales y Turísticos del Estado de Yucatán), and the declining support for INAH is discussed in Barrera Rubio 2002.

In the early 1970s, when I began my work at Uxmal, there were only two major upscale hotels (the Hacienda Uxmal and the Hotel Misíon Uxmal) located at the site, which was then entered through informal gate near the North Group. Although Uxmal and Kabah could be reached by the blacktop highway connecting Merida with Campeche, an off-road vehicle was required to visit the sites of Sayil, Xlabpak, and Labna.

By the later 1970s a Club Med hotel was constructed just west of Uxmal, whose official entrance was moved to an area west of the Pyramid of the Magician. The visitor climbed a gentle stairway that led to a small ticket office (on the north) and a *tienda* selling sodas and snacks (on the south). In the late 1970s a small "downscale" hotel and restaurant, the Rancho Uxmal, was constructed a few kilometers north of the site on the road to Muna, as well as a large palapa-style restaurant and gift shop at the Uxmal Parador Turistico.

By the late 1980s a new entrance and parking area was built west of the stairway leading into the site. Still in use today, this entrance complex consists of a series of small stores (a bookstore, shops selling mixes of clothing, crafts and "arte popular," as well as inexpensive keepsakes, an ice cream shop, as well as a small restaurant/café) surrounding a small courtyard. Adjoining a modest auditorium is a small museum that houses several of the best-preserved monuments and artifacts from the site. Sitting opposite the ticket kiosk are members of the sindicato (union) of official guides, greeting visitors and soliciting work. Outside of the entrada courtyard complex are a few small struc-

tures at which vendors sell refreshments, T-shirts, and other inexpensive keepsakes.

Other changes occurred during the 1990s, the most notable being the construction of another major hotel, the Lodge at Uxmal, and the associated bar and restaurant beneath a giant *palapa* or open-air thatch-roofed structure. (The Lodge at Uxmal is owned by Mayaland Resorts, the same company that owns and manages the Hacienda Uxmal and the Mayaland, Hacienda Chichén, and Lodge at Chichén Itzá.) In addition to the more upscale hotels and restaurants located near the site, there has also been gradual growth of less luxurious tourist facilities as well. Following construction of the Rancho Uxmal in the 1970s, from the 1980s to the present several other restaurants have opened along the stretch of road leading north from the site, while small hotels with clean rooms and restaurants have also opened in the nearby town of Santa Elena Nohcacab (one of them, the Hotel Chacmool, is owned by Miguel Uc Delgado, whose work forms part of this exhibition).

34. Van den Berghe 1994, 73–74.

35. On-line site and promotional brochure for Far Horizons Archaeological and Cultural Trips, Inc. (http://www.farhorizons.com/mexico/Maya-Cities-of-Yucatán.htm).

36. Scholarly popular books include Schele and Freidel 1990, Freidel, Schele and Parker 1993, Schele and Mathews 1998. Influential exhibitions include Schele and Miller 1986 and Schmidt et al. 1998.

37. Hervik 2003, chap. 3. In a recent *National Geographic* feature article "The Maya, Glory and Ruin" a section on the Maya collapse includes a two-page photographic layout of a stucco frieze at Toniná, Chiapas with the following caption: "Forces of Darkness: In a terrifying expression of royal power, a stucco mural at Toniná, in Mexico, shows a skeleton . . . grabbing the hair of a severed head with the portraitlike profile of a real person. At left, a mythical rodent carries another head in a ritual bundle. These spirits, called *wayob*, served Maya kings as their alter egos, which they could invoke to curse their enemies. The feather-covered scaffold . . . bears the head of a human sacrifice" (Gugliotta 2007, 102–3). Although not about the ancient Maya per se, the lead in and title of a recent *National Geographic* article on the Pyramid of the Moon at Teotihuacan read "Unearthing the bones of human and animal sacrifices, archaeologists probe the mysteries of Mexico's Pyramid of Death" (Williams 2006, 144).

38. Ardren 2004, Watanabe 1995, 34–40.

39. In the interest of full disclosure, it should be noted that

I have served as such a consultant on, or have been quoted in several such volumes, including *The Magnificent Maya*, part of the Lost Civilizations series published by Time-Life Books (1993, 2, 143), National Geographic's *Lost Kingdoms of the Maya* by Gene S. Stuart and George E. Stuart (1993, 133), and a recent (August 2008) National Geographic special issue entitled *Mysteries of the Maya*. In addition, I have been a lecturer on several educational culture tours of the Maya area for commercial agencies such as Far Horizons, as well as institutional tours organized by Smithsonian Associates, National Geographic Society, Washington and Lee University, and Northern Illinois University.

40. For discussions of how various anthropological studies and more popular accounts of Maya society have promoted an essentialist vision of Maya ethnicity see Fischer 1999, Hervik 1998, or Watanabe 1995: 34–35. Without intending to imply that it is more implicated than various other scholarly books that have also achieved wide readership, an influential book such as *Maya Cosmos: 3000 Years on the Shaman's Path*, by David Freidel, Linda Schele, and Joy Parker, epitomizes this process. A compendious and serious study, this book contains a great deal of valuable information regarding the role of mythology and ritual in legitimizing Maya kings, and thereby maintaining ancient Maya society. It also emphasizes and interprets the astronomical knowledge of the ancient Maya in light of their creation mythology, and examines the view that Maya kings supported claims to authority through shamanistic performance. Although these interpretations are subject to scholarly debate (see Klein et al. 2002), the authors support them with copious evidence and careful argument. However, as summaries of the interpretations of such subject matter filter into popular awareness, they, combined with a tendency found in many such studies to focus only on aspects of contemporary Maya life that represent "survivals" of pre-Columbian beliefs and practices, lend themselves to an "essentialist" view of Maya identity and supports some who continue to focus on the mysterious and esoteric aspects of ancient Maya culture.

41. Kohl 2004, 295.

42. Duncan 1995, Zeller 1989.

43. Lipe 1984, I.

44. Kirshenblatt-Gimblett 1995, 369, 370. For fuller discussion see Kirshenblatt-Gimblett 1998.

45. Kirshenblatt-Gimblett 1995, 370.

46. Kirshenblatt-Gimblett 1995, 371. The emphasis on touristic development has, to a greater or lesser degree, affected the approach to preserving, consolidating, or reconstructing the structures at Maya archaeological sites such as Uxmal. In some cases, the approach has been fairly conservative, involving preservation and consolidation of standing sections of buildings, and selective replacement of façade stones and sculptural elements when this can be done with a high degree of confidence of their original position through documentation of their locations in fallen debris (a process referred to as *anastilosis*). In some other cases, the drive to create a more complete vision of the site has led to what some might see as highly selective and/or over-reconstruction. An example of this would be the excavation and reconstruction of the north stairway and upper façade of the Great Pyramid at Uxmal by César Sáenz 1972, as well as, though perhaps to a lesser extent, recent reconstructions of the northern, western, and southern structures of the House of the Birds quadrangle west of the Pyramid of the Magician. The complete, and somewhat conjectural, reconstruction of this side of the Great Pyramid was dictated primarily by the need to have it visible as a focal point in the site's light-and-sound show, which accounts for why the remaining four sides of the structure were left completely untouched (see Molina Montes 1982, 136). Ehrentraut 1996, 19 provides a discussion of the issues and professional debates associated with architectural preservation and reconstruction in general, and in the Maya area in particular, and their relationship to "authenticity." He notes that "Subsequent to excavation, further site intervention runs the gamut from preservation to restoration to reconstruction, and all three approaches are readily applied not only within the same site but even to the same structure. A touristically highly developed major site will thus display a central group of select elite structures partially preserved, partially restored and partially reconstructed. Complementing this core there may be several satellite monuments treated with a similar combination of methods and connected to the core and each other by pathways. The site's other structures remain rubble mounds covered with tangled grasses and shrubbery or a mantle of vegetation so dense that their very presence is completely obscured." Ehrentraut (1996, 22) also notes that the landscaping of sites may be based on perceived needs of tourists, rather than an interest in fidelity to an original conception of urban space. This was the case at Uxmal, where large numbers of trees were planted in the central area surrounding the Main ball court. Although they provide a parklike atmosphere and shade from the sun, they almost surely do not reflect the original intentions of the ancient builders.

In a sense, for a visitor with a moderate amount of previous

knowledge of ancient Maya archaeology and culture history, this provides a sense of time travel on multiple levels, with crumbling and overgrown ruins recalling both the antiquity and "collapse" of Maya civilization, as well as the heroic age of early exploration, and with more fully restored and reconstructed major structures providing a sense of having a direct encounter with ancient Maya experience.

47. Barthes 1972, Baudrillard 1995, Benjamin 1969 [1936]. Ehrentraut 1996, 23 discusses this aspect of Maya sites, whose investigation is dictated by a combination of the professional objectives and conceptual issues of concern to professional archaeologists, coupled with the need to organize the excavation and reconstruction of sites to create "professionally legitimized sights for international tourism." In his words, this interaction "produces an elitist image of Maya architecture that is highly unrepresentative of the lives actually led by the vast majority of the population. In turn, its debatable architectural authenticity burdens the image with a considerable measure of what, in Ruskinesque echoes, Eco 1986 has defined as "hyperreality" and Baudrillard 1983, 12 has decried as "simulacra" or simulations of antiquity, "a resurrection of the figurative when the object and substance have disappeared."

48. Kirshenblatt-Gimblett 1998, 152.

49. Kirshenblatt-Gimblett, 1998, 166, 152.

50. Kirshenblatt-Gimblett, 1998, 166.

51. Silberman 1995, 258. Such attractions add extra "difference" to the site. As Kirshenblatt-Gimblett 1998, 152 asserts, "It is not in the interest of remote destinations that one arrives in a place indistinguishable from the place one left or from any of a thousand other destinations competing for market share."

52. The introduction of the light-and-sound shows at Uxmal and Chichén Itzá is reminiscent of the use of Omnimax large-screen theater presentations at many science and natural history museums. What these public presentations lack in scientific rigor and historical accuracy, they make up for in striking visual and audio effects, leaving viewers satisfied that they have gotten a good entertainment value and an edifying educational experience.

The spectacular, but historically thin, light-and-sound shows stand in contrast to the relative paucity of informative signage available to tourists elsewhere at these sites. Cleere (1984, 129) notes that, "Modern techniques of communication have been developed and widely applied through advertising, yet all too little use has been made of such developments in the presentation of ancient monuments and sites." Efforts are under way to improve the signage at various Mexican archaeological sites, and Uxmal now has a few with somewhat longer texts in English, Spanish, and Yucatec Maya. New site museums, such as one recently inaugurated at the site of Dzibilchaltun in northern Yucatán, are enhancing visitors' experiences of the site, although little information is provided about individual monuments or artifacts. Ardren (2002) notes that although providing some employment and economic benefits to the people of the region where they are located, archaeological sites are often not visited by local Maya, who have not been the main audience either for the scholarly literature aimed at other professionals, or the generalist accounts of ancient Maya society pitched at both foreign and Mexican tourists. As a result, indigenous experience and perceptions of such places are often ignored, a situation that she and colleagues are attempting to redress through collaborative planning of a regional archaeological museum at the site of Chunchucmil, Yucatán. The continuing challenge remains to strike a balance between keeping visitors intellectually and emotionally engaged by conveying accurate information in a stimulating manner, neither boring them with archaeological pedantry nor simply entertaining them with historical fiction, while also making the sites more relevant to local Maya inhabitants.

53. Aspects of the development of EPCOT and its relationship to transnationalism, visions of a utopian future, and history can be found in Smoodin 1994, 118–28.

54. Castañeda, Fumero, and Breglia 1999.

55. Anthropologist Traci Ardren (2006) critiques the film's ending, which seems to imply that: "The end is near and the savior has come. Gibson's efforts at authenticity of location and language might, for some viewers, mask his blatantly colonial message that the Maya needed saving because they were rotten at the core." Ardren concludes her review and critique of the film by observing that: "there is something very different about portraying a group of people, who are now recovering from 500 years of colonization, as violent and brutal. These are people who are living with the very real effects of persistent racism that at its heart sees them as less than human. To think that a movie about the 1,000 ways a Maya can kill a Maya—when only 10 years ago Maya people were systematically being exterminated in Guatemala just for being Maya—is in any way okay, entertaining, or helpful is the epitome of a Western fantasy of supremacy that I find sad and ultimately pornographic. It is surely no surprise that 'Apocalypto' has very little to do with Maya culture and instead is Gibson's comment on the excesses

he perceives in modern Western society. I just wish he had been honest enough to say this. Instead he has created a beautiful and disturbing portrait that satisfies his need for comment but does violence to one of the most impressive of Native American cultures."

Critiques of *Apocalypto* by Ardren and various other scholars are sincere and convincing. They rightly point out the obsessive fixation on violence in the film. Nevertheless, we should remain aware of the extent to which Gibson's emphasis on the violent and sanguinary aspects of ancient Maya society may represent an exaggerated and highly selective extension of the image presented in various popular books, exhibitions, or journal articles on the Maya and other Mesoamerican cultures. As its name implies, the popular exhibition *The Blood of Kings*, and the exhibition catalog written by Linda Schele and Mary E. Miller (1986) played an important role in shifting the public perception that ancient Maya lived in peaceful ceremonial centers governed by calendar priests who were not interested in recording personal history (an earlier image promoted in his popular publications by J. E. S. Thompson 1954; see Becker 1979), to an image of Maya society governed by powerful rulers who boasted in hieroglyphic texts of their personal accomplishments or ritual performances, many of which involved violent encounters in battle or in the ball court, or sacrificial bloodletting rituals (see Klein 1988 for a contemporary critique of the exhibition catalog). This new "vision" of the Maya, building on earlier discoveries and epigraphic discoveries (e.g., Ruppert, Thompson, and Proskouriakoff 1955, Proskouriakoff 1960, Coe 1999b) was embodied by the image of the Yaxchilan royal woman, Lady Xoc (as she was then known) performing personal bloodletting. This observation is not intended to diminish the important and path-breaking new information presented in *The Blood of Kings* catalog, much of which I have benefited from in my own work. Far from it. It is precisely because of the significant contribution it made to Maya studies generally, and particularly to increasing public awareness of the ancient Maya, that it is also worthwhile noting ways in which some of the interpretations discussed in this catalog and other books and articles published since, have selectively filtered into and affected broader public perceptions of Maya society.

56. Arguëlles 1987. For the serpent of light phenomenon see Aveni 1980, 285–86. Castañeda 1996, chap. 6 provides an incisive discussion of interests and motives of the various groups who gather to witness the phenomenon.

57. The description of this amazing voyage to Uxmal is found at the website Children of Light: center of empowerment & spiritual healing (http://www.childrenoflight.com/mayan). A more complete discussion of the mix of entrepreneurial savvy and new age spirituality found in Hunbatz Men's tours of the Maya world appears in Castañeda 1996, 186, 188–90, 192–96.

58. The cost for the 2009 fifteen-day "Hidden Cities of the Yucatán" tour package mentioned above is $8,495.00 per person (double occupancy) including most, but not all incidental costs (it does not include the traveler's airfare from home airport to Houston airport). The per capita income of Yucatán inhabitants who voted for the PRI or PRD party candidate in the 2000 Mexican presidential election was about 6,500 to 7,500 dollars per year, while that of those who voted for the PAN candidate was about 12,500 dollars a year (based on graphs in Jeronimo Cortina and Andrew Gelman. 2006. Income and vote choice in the 2006 Mexican Presidential election abstract). (http://www.stat.columbia.edu/~gelman/research/unpublished/bgy3.pdf).

59. Breglia 2006, 208.

60. Breglia 2006, 61.

61. Breglia 2006, 63.

62. Castañeda 1996, 198, refers to Chichén Itzá as "a battleground of discourses. It is a field structured by encompassing social, cultural, political, and economic histories that have settled upon this place, reconstructing it to be a representation of Maya culture and civilization." Yet, he notes that this modernist project of constructing an integrated and holistic account of the ancient society is impossible (even more so that it was for the divine lords of Uxmal and other Maya city states) given the different political and cultural interests it represents and varied needs it fills so that "At the same time that it is being constructed, it is being contested and disputed. . . ."

63. McBryde 1985.

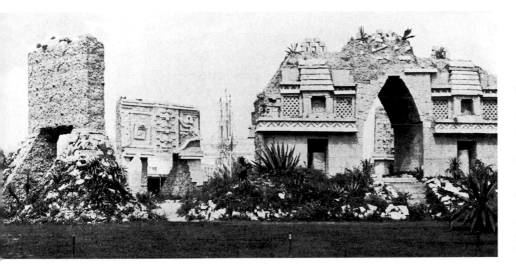

6.3—View of reproductions of structures from Uxmal and Labna at the 1893 World's Columbian Exposition in Chicago (after Bancroft 1893, vol. 4, 633). Courtesy of Northern Illinois University Founders Memorial Library.

6.4—View of the Mexican Pavilion at the 1933 Century of Progress World's Fair in Chicago. COP-17-0002-00038-002, Century of Progress Records, 1927–1952, University of Illinois at Chicago Library.

7

REPRESENTING THE MAYA

When Is It Appropriate to Call "Appropriations" Art?

Mary Katherine Scott

▸ European, Anglo North American, and Mexican explorers to southern Mexico and Guatemala in the first half of the nineteenth century were responsible for some of the first descriptions and imagery of the "lost" and "mysterious" Maya civilization to reach a Western audience since colonial times. A romantic vision of ancient Maya culture was promulgated by a number of these explorers, including John Lloyd Stephens, who romanticized ancient Maya sites such as Copán, Palenque, Chichén Itzá, and Uxmal as the vestiges of a once magnificent civilization. In the twentieth century the lost Maya civilization became the basis of a generic Western understanding of the Maya as "mysterious." In the first section of this chapter, I introduce scholars who are not steeped in Mayanist scholarship to the changing perceptions of the Maya. In so doing, my goal is to cut through this discourse, and to break the frame that these tropes create, in order to better grasp the artistic and aesthetic content of the contemporary Puuc art presented in this exhibition. In the second half of this essay, I return to the long-standing debate

in art history circles regarding the content and criteria of "high" and "low" art with which Mayanist scholars may not be familiar. I relate this art historical discussion to the debates about anthropological categorization of ethnic and tourist arts. My objective in this section is carve out of these polemics an art criticism framework, which is informed by my ethnographic research with the Maya artisans from the Puuc region, and that can be appropriately used to discuss Puuc art. By structuring my chapter in this manner I seek to promote a dialogue between the art-focused scholarship, including art history and the anthropology of art and tourism, and the Maya-focused disciplines of anthropology.

Historical Framing of the "Mystery" of the Maya

Many elite aspects of the pre-Columbian Maya culture were destroyed during earlier sociopolitical transformations that began roughly toward the end of the Late Classic period (c. 800–900 CE). Scholars have called this socio-cultural decline, rightly or wrongly, the "Maya collapse." Archaeologists have held various interpretations of this phenomenon (or event), with regards to the manner in which Maya societies and cultural practices have survived during the Postclassic period (c. 900–1542/1697 CE). These too, however, underwent even more radical transformations during the colonial period when Maya peoples and cultures were deliberately suppressed during the Spanish conquest in the sixteenth century (see in the main catalog text the brief review of these processes as they affected northern Yucatán).[1] One could argue that many aspects of pre-Columbian Maya culture were indeed "lost." For example, the ability of the various Maya groups throughout Mexico and Central America to read and write their native hieroglyphic texts was repressed and then disappeared once the Latinization of their native languages was in place. However, a number of core elements of many other cultural traditions, such as certain agricultural and baptismal rituals, seem to have persevered, although

with significant transformations, from the sixteenth century and into present day.[2] Studies by scholars such as Nancy Farriss have discussed the ways in which the efforts to retain pre-Columbian and contact period beliefs and practices through a dynamic of adapting them to new postconquest realities represent a "collective enterprise of survival."[3] This refers to a process by which Yucatec Maya people strove to maintain a social cohesion and cultural identity wherever accommodation, adaptation, and syncretism permitted. This struggle for identity operates within the context of Maya societies whose residents lost their political, economic, and cultural autonomy, including the freedom to practice many aspects of their religious beliefs. This drive to survive through adaptation is conceptually related to Edward Fischer's idea of a "cultural logic" in which Maya culture is perceived "as a historically continuous construction that adapts to changing circumstances while remaining true to a perceived essence of Mayaness."[4] John Watanabe contends, however, that to romanticize the modern Maya as a direct continuation of their pre-Columbian ancestors, or to focus primarily on those cultural practices that represent "survivals" of pre-conquest ways of life, is to discount everything that has occurred in between the sixteenth century and the present, which includes the Spanish conquest, colonial oppression, and modernization. To neglect understanding these historical transformations of Maya peoples and cultures, and their differing responses, results in a highly distorted picture of Maya reality.[5]

Mayanist scholarship of the twentieth century relied extensively on the notion of cultural continuity. This notion means that, despite ongoing adaptation and transformation of Maya society, there was always some essential core that survived intact across 500 or even 2,000 to 3,000 years. More recent scholarship has argued against this kind of "essentialist" understanding of a unified Maya identity that carries over from ancient times.[6] Scholars such as Castañeda (2004), Hervik and Kahn (2006), and Castillo Cocom

and Castañeda (2004) argue instead that the identity politics that exist in Guatemala or even Chiapas do not exist in Yucatán because the "history of conquest, colonization, independence, and incorporation into a larger nation-state" is significantly different for the Maya—that is, Yucatec Maya peoples—than from the analogous histories of Mayan peoples to the south in Chiapas, Guatemala, Belize, and Honduras.[7]

Despite both the extensive critique of cultural continuity and the real life historical adaptability of the modern Maya, attitudes and oversimplified notions associated with the "Mysterious Maya" cliché (mentioned briefly in our main text), have persevered. With the birth of Maya studies at the end of the nineteenth century, the dominant paradigm among early Western scholars was that Maya civilization was "lost" in the sense that the jungles of southern Mexico and Guatemala had concealed the ancient cities so completely that they were in fact "lost" until nineteenth-century explorers like Stephens "discovered" them again.[8] This paradigm shifted slightly with the field of Maya studies in the twentieth century, in that Mayanist scholars conceded that the ancient Maya cities were not really lost in the archaeological sense: the indigenous locals have always known where the ancient mounds are located! Thus, archaeologists have often "discovered" a new site only because locals decided to take the archaeologists to the location where antiquities looters had already been plundering for years.[9] Local knowledge of sites however did not qualify as "knowledge," however, because the archaeologist would not be able "discover" anything if it had not been "lost." Further, because of the rupture in elite culture that occurred at the time of the abandonment of the Classic period cities, and from the deliberate suppression of traditional Maya beliefs as the result of the conquest, the Maya locals were deemed too ignorant to "understand the scientific importance of these cities"[10] and so were unable to contribute any usable knowledge to scholarly discourses. Thus, as Castañeda notes, the archaeological remains were "lost yet known, and precisely because

of this ironic condition, these artifacts of human agency become mysterious."[11]

These notions and tropes of an essential and essentially mysterious Maya have been absorbed by nonacademic audiences and form a store of knowledge and misrepresentation that is used by tourism industries from Cancun and Mérida to Guatemala and Belize. One of the chief indications of encroaching aspects of the effects of globalization in Yucatán is the success of the tourism industry, which promotes major archaeological sites as important Maya cultural markers and thus as principal destinations for "cultural tourists" (see essay by Kowalski, this volume). Tourist brochures and guidebooks also market these archaeological sites as having a general "Mexican" ambience that might appeal to the average beach-leisure tourist, while more general marketing and promotional materials often draw attention to the "exotic," "mysterious," or "savage" aspects of ancient Maya culture in an effort to attract those seeking an authentic "encounter" with the indigenous "other."[12]

These popular but misconstrued ideas have their roots in a long history of Western conceptualization of the Maya. Mayanist anthropologists are responsible for both producing and critiquing the tropes, symbols, and metaphors associated with this ancient culture.[13] However, unlike the stereotypes that proliferate in the tourism markets and the U.S. media, this critique does not reach a broad audience. Even scholars from the related fields of art history may not be familiar with the way Maya have been perceived since the sixteenth century, the various theories and tropes that have governed Maya studies since the nineteenth century, and how these ideas are promoted in a modern context within the tourism industry in Yucatán.

The "mystery" of the Maya emerged as early as the middle of the sixteenth century in Valladolid, Spain, when early colonizers debated the humanity and/or savagery of the Maya by defining the criteria for true "civilization" (e.g., sedentary life and agri-

culture, religion, overarching government lead by a political elite, urban cities, etc.).[14] Scholars in the first half of the twentieth century further developed these criteria and concluded that the Maya represented an anomaly in pre-Columbian Mesoamerica: they were composed of individually governed city-states, practiced a swidden agriculture that required farmers to relocate their fields every few seasons, and they had a hieroglyphic language that in the early twentieth century was believed to be pictographic (rather than phonetic) and merely communicated religious, astronomical, and calendrical phenomena and events.[15] Thus, ancient Maya society presented a contradiction, a "noncivilized civilization."[16] For example, even though the Aztecs fulfilled a number of the criteria necessary for true civilization, their obsession with warfare, human sacrifice, and cannibalism caused Western scholars to view them as savages, the antithesis of civilization.[17] The Maya, on the other hand, were thought to be stargazing priests, artists, and philosophers, and so any existence of warfare or human sacrifice was dismissed as being introduced by ancient central Mexican colonizers, namely the Aztecs.[18]

It wasn't until the second half of the twentieth century that advancements in hieroglyphic decipherment shed new light on the Maya, after centuries of eluding Western understanding and further adding to the illusion of the "mysterious Maya."[19] Not only was it discovered that the ancient Mayan hieroglyphs communicated much more than calendrics; these writings recorded history, royal accessions, noble births, genealogies, and even accounts of sacred warfare and sacrifice. Furthermore, the written language turned out to not just be logographic in nature, but also phonetic, another marker of high (i.e., Western style) civilization. However, the "mysterious Maya" cliché has persevered in both academic circles and in the popular media, and Castañeda has posited another reason for why this might be: that Maya peoples were and are "survivors," having overcome tremendous obstacles over the centuries (e.g., resource

depletion during the Classic period, colonization by the Spanish, modernization and globalization, etc.), which is an appealing cultural narrative, particularly for nonspecialists (i.e., tourists).[20]

Tourism and Authenticity in Yucatán

The enterprise known as La Ruta Maya under its Mundo Maya aegis (essentially, dozens of preserved and reconstructed Maya archaeological sites from Mexico to Guatemala that are marketed as tourist attractions with a specific angle toward attracting North American and Western European visitors) is highly proficient at promoting the notion of the "Mysterious Maya" and the "relationship between archaeological past and ethnographic present."[21] Interestingly, the promoters of this connection between ancient and modern Maya quite often are locals who self-identify as Mayas rather than cultural "outsiders." This shows an understanding among the Maya of Yucatán that the tourism sector is a profitable industry that is potentially more financially rewarding than other career paths available to the average person living in a rural area, even if it means promoting certain ideas about themselves and their culture that are anachronistic, inaccurate, romanticized, or completely falsified in order to appeal to Western tourists' preconceptions of what Maya culture should look like. Such preconceptions are largely influenced by the image that popular publication and media sources such as *National Geographic*, Discovery and History television channels, and even the active minds of Hollywood (e.g., Mel Gibson's *Apocalypto*, or Carter Smith's *The Ruins*) deliver to their readers and viewers, which can be more focused on entertainment value than presenting a more nuanced, detailed, and accurate account based on known historical facts. That isn't to say that the articles in *National Geographic* or the programs on the History Channel should be thought of as contributing only inaccurate accounts of Maya culture and civilization. These and other media sources do often (even largely)

consult with well-established if not leading academic experts to ensure that the article or documentary is historically accurate according to the existing body of scholarly knowledge. However, this is done only to the extent that such knowledge doesn't interfere with or contradict the main theme that the producers or editors are using to capture their audiences (i.e., the entertaining aspect). What tends to happen is that such publications and programs will instead leave information out rather than directly opposing or fictionalizing known facts, but omitting data can be just as problematic and misleading as misconstruing it given the right angle of presentation. Indeed, for all its sensationalism, even the massively bloody and heart-stopping action film *Apocalypto* was created in consultation with the well-respected archaeologist Richard D. Hansen, a Mayanist scholar who specializes in archaeological sites in the Mirador Basin of Guatemala's Petén region, to ensure some level of historical and culture accuracy. The difference with *Apocalypto* is that, instead of trying to function as a reasonably reliable record of Maya culture and history, the film focused on the more bloody aspects of ancient Maya culture, particularly warfare and human sacrifice, to create a dramatic fictional conflict that would successfully be able to attract audiences with or without any background knowledge of the Maya.

Regardless of one's perception of how popular media sources influence public opinion and understanding of ancient and contemporary Maya culture, it is difficult to deny that they have also increased the visibility and recognition of certain ancient Maya monuments over others, and that, as what have been termed "cultural representations,"[22] these have become symbolic of ancient Maya civilization for the average person with a basic knowledge of Maya culture. Blockbuster exhibitions have also had a hand in publicizing certain Classic Maya monuments, such as the well-known Yaxchilán lintels depicting scenes of personal bloodletting rituals, to audiences beyond the academic community of Mayanists. Some of what we might consider to be the best-known monuments

today is arguably due to the great attention they were given as an important facet of elite Maya culture in the scholarly catalog for the exhibition of Maya art known as *The Blood of Kings*.[23] This exhibition captured a great deal of public attention, with aspects of its findings reviewed and discussed in major newspapers and magazines, and filtering into broader public consciousness in a somewhat more synthesized form in journals such as *National Geographic* and *Archaeology*. Mark Miller Graham in a review of the exhibition catalog described the "great interest and wide publicity"[24] that both *The Blood of Kings* exhibition and a companion exhibition the previous year, *Maya: Treasures of an Ancient Civilization*, occasioned. Indeed, these exhibitions were reviewed extensively across the United States in some of the most widely read and well-respected magazines, journals and newspapers including *Smithsonian Magazine*, *Archaeology*, *Time Magazine*,[25] and *The New York Times*.[26]

In addition to the widespread attention the show received, *The Blood of Kings* catalog featured an image of one of the eighth-century Yaxchilán lintels on its cover, and a number of the lintels were given full-page color reproductions within the catalog itself, more than any other group of monuments from any site in the Maya region. The Yaxchilán lintels have since been reproduced in myriad printed materials and other media, disseminating these images further. Correspondingly, Jesús Delgado Kú observes that for Western tourists what counts as "Maya" art is what they have already seen in museums and popular media sources, so these objects will therefore interest them more than other Maya visual objects with which they are not familiar.[27] It follows that the popularity of the Yaxchilán lintels may be due, at least in part, to the current location of a number of the best-known examples at the British Museum, particularly the lintel series from both Structures 21 and 23,[28] although many more people have been able to see them in print and electronic reproductions. Several of these lintels were illustrated in the volumes on Maya archaeology published by the late nineteenth century English explorer Alfred P. Maudslay[29] who arranged for their transportation to England (see Figures 1.14 and 1.15 in this catalog). Having such a scholarly pedigree and being located at such a world-renowned institution, where tens of thousands of foreign and national visitors flock each year, certainly increases the lintels' visibility and by extension, their popularity.[30] This idea complements Jesús' belief that the allure of these lintels can be partly attributed to the fact that they show scenes of sacrifice with female protagonists instead of the more typical representations of males.[31] Furthermore, viewers might also appreciate the more naturalistic rendering of the figures that can be understood in Western terms of proportion.[32] Carolyn Tate suggests that the high relief of the figures increases the clarity of their forms, which is unusual in Maya art, since elements of royal costume (which can be abundant) are generally carved in the same level of relief as the figures, making it difficult to distinguish the extraneous from the more important.[33] In the Yaxchilán lintels, costume elements are carved in a lower, more delicate relief, though Tate notes that the aspects that are shown are represented with perfect accuracy.[34] She suggests that the delicate rendering of faces and hands in these lintels, as well as the figures' complex body positions, relate them to a more European aesthetic, and compares them with the painting style of Raphael.[35] Furthermore, Yaxchilán lintel 16, for instance, shows that Maya sculptors even understood aspects of perspective long before contact with the Spanish, as is evident in the foreshortened legs of Bird Jaguar's captive in the original monument.

Local Maya promoters (e.g., artisans, vendors, tour guides, etc.) working within the tourism industry are aware of both the misconceptions that tourists associate with the reality of contemporary Maya people as well as those images that have become paradigmatic of Maya culture in general. So, part of the way that they frame and present their culture to outsiders looking for "authenticity" in their experience is in the imagery they use to attract viewers, which ultimately

reinforces tourists' notions of "authentic" Maya culture. Such is also the case with the Puuc artisans featured in this exhibition whose work reflects these assumptions, but also represents a deliberate catering to them that is demonstrated by the motifs and subjects that they reproduce most frequently for sale to their audience composed mainly of tourist buyers. For instance, Jesús confirmed that another one of the reasons the replicas of the Yaxchilán lintels are some of the most popular carvings among tourist buyers is because they represent scenes of blood sacrifice.[36] The bloodletting ritual as a defining characteristic of an older Maya belief system is a theme that is particularly appealing to Western audiences, since it is not practiced in the West, so overemphasizing it exoticizes ancient Maya culture for modern observers, and thus perpetuates the notion of the "Mysterious Maya" discussed earlier.[37]

This idea relates to Quetzil Castañeda's discussions (this volume) regarding the fact that the carvings produced by artisans at Pisté are expressions of a kind of fictive "Maya identity" as it is conceived by non-Maya touristic visitors and potential buyers of Maya handicrafts. Yet other than an awareness on the part of the Puuc carvers (made more tangible because of their regular contact with well-known local Puuc ruins and archaeologists, as mentioned in the main text of this catalog) that they are the distant descendants of the "ancient Maya," they have a multilayered identity that includes identification as Maya,[38] artisan, Mexican, Yucatecan, and others, depending on their occupation, religious affiliation, etc. Thus, since they take pleasure in making the carvings, strive to create well-crafted and well-designed pieces, and sell their works on a regular basis, one of their identities is that of "artesano," a term that, as Castañeda discusses in his essay, actually carries a great deal of respect for the carvers working in Yucatán.

Indeed, Miguel Uc Delgado commented on this idea and the fact that being an artisan also reinforces a certain sense of heritage or legacy for the maker. For instance, in one conversation in 2006, Miguel recounted traveling as a boy with his father and grandfather to many sites that had not yet been reconstructed and developed for the tourism industry.[39] This early exposure to the culture of his ancestors instilled in him a pride for his Maya heritage and an appreciation for the Maya aesthetic, which he has carried into his own work. Miguel noted that it was because of this generational legacy that he began to carve, since he had a kind of nostalgia and admiration for what the ancestors of his father and grandfather had created.[40]

For Angel, what is most important is not how he learned to carve, but that he is able to pass on what he knows to the next generation, as Miguel's and Jesús' grandfather did for them. When his son first started carving iguanas and serpents, Angel used to tell him, "You will be the next one," and his son would ask, "Why?" to which Angel would respond, "Because I won't always be here, and there has to be a continuation, which is you."[41]

The pride that Angel feels for his craft and the legacy that the other artisans believe they must uphold may not be conveyed to their audience in obvious ways, but if you sit down and talk with them—not the superficial explanations offered to the passing viewer, but a real conversation—it becomes quite clear how important it is to these men that they continue to carve. The pride they take in their work is manifested in the product, and even for the most discriminating of viewers, the skill and talent of these artisans is hard to ignore. In addition to the numerous local and regional competitions that each artisan has won, most are asked to complete commissions on an annual basis and their work is admired by the archaeologists and other learned individuals who visit the sites.[42] Jesús recalls the time that some Italians were visiting Kabah and they commented on how well he had modeled his figures. They told him that his work should be in galleries or in museum exhibitions, "but we are here," responded Jesús, "this is our way of life."[43] This reality doesn't seem to be disappointing to him or the other artisans; it's just accepted as the

way it is. Therefore, while their wealth and notoriety would likely increase if their work were on display in Mérida or other metropolitan areas, they are content to be motivated by less tangible rewards—pride in one's creations, their legacy as a carver, the fact that they are preserving and reinvigorating aspects of their Maya heritage—that come from working as artisans in the Puuc region.

Even if the Puuc artisans find some motivation to carve in the more abstract and humble incentives mentioned above, they are also obliged to carve for financial reasons, and so use a number of marketing strategies at the archaeological sites where they work. For instance, Miguel Uc Delgado, Angel Ruíz Novelo, and Jesús Delgado Kú, three of the artisans represented in this exhibition, speak to the other workers at the Puuc sites in Maya, which distinguishes them from Spanish-speaking non-Maya co-workers and tour guides. They also enjoy telling enquiring tourists tidbits about the ancient Maya and the rituals and traditions that are still practiced among modern Maya today, such as the agricultural practice of the Ch'a Chaak where *milperos* ask the gods and spirits of the forest for rain to water their crops, or the Maya baptism ritual known as the "Jetz' Meek," whose symbolism is part of a centuries-old base of knowledge.[44]

Another example might be found in the way that Jesús keeps all of his carving materials and tools on display at Kabah, outside the giftshop hut and close to the park's entrance. His small table affords him little room to work, and being outside, he is susceptible to the frequent downpours that occur during the summer months. Yet by permitting the tourist to enter, using MacCannell's terminology, a kind of "back region," the tourist feels as if s/he is "one of them [i.e., the Maya]" or at least "at one with 'them.'"[45] It differs from the type of "back region" discussed by Steiner in his article "The Art of the Trade"[46] or in his book *African Art in Transit*,[47] in which the Senufo carvers of the Cote d'Ivoire will often place their carvings for sale to the tourist market in highly visible areas (e.g., marketplace stalls, roadside stands), but will confine

other carvings and replicas to rooms in houses not open to the public or other "off the beaten path" places. Having the objects in these locations "create[s] the illusion of discovery" for the collector once the object has been "found."[48] The collector may perceive these latter objects as more "authentic," but as Steiner notes, they quite often are identical to those sold on the street.[49] The difference is that "they are *presented* to the buyer as unique and rare items,"[50] and thus create the impression that they are more authentic treasures that the collector has had to struggle to "discover," producing a kind of thrill of the "hunt" in Steiner's terminology.[51] Berlo (this volume) discusses a related case with southwest Indian silver workers and jewelry makers in the 1940s in Albuquerque, New Mexico.[52] In the Indian Trading Post of Maisel's flagship store, a glass floor was installed to show the silver workshop in the basement where shoppers could watch as Indian workers hammered and soldered silver into the beautiful examples of jewelry for sale in the store. She notes how none of the silver wire or sheets of silver-plate were actually made in this workshop, but were rather mass-produced in a large factory off-site, and even the larger presses and machinery that were on-site, were hidden from the public so as not to disrupt the portrayal of traditional jewelry making.[53] Considering these details, Jesús' outdoor workshop is very similar to the latter in that it serves more as a marketing strategy to advertise his own work rather than functioning as a true "back region." Curious tourists can watch him "work" and ask questions about his carvings in an informal manner. It's as if Jesús performs a live demonstration that, like his wood carvings, is available for tourist consumption. Moreover, witnessing a "Maya" creating the carvings by hand in situ certainly adds to the work's authenticity in the viewer's mind. It also makes it clear that these objects are handmade and, in that sense, relates them to one of the attributes both of traditional fine arts and craft traditions. The careful carving and deliberate replication of ancient imagery distinguishes the "invented tradition" of the Puuc carvings from the pastime-turned-profitable

wood-carving industry begun by Manuel Jiménez from Oaxaca in the 1950s of the small, brightly painted whimsical animal sculptures that have no corresponding imagery among the ancient iconography of this region.[54] —**7.1** (p. ii)

Jesús' actual workshop where he carves the majority of his pieces is in his home, as it is with the other artisans in this exhibition. These can be considered truer "back regions," to the extent that they actually exist. When the Puuc carvings are completed and ready for sale to tourists, they are either sold out of the artisan's home (as it is with Wilbert and Miguel), or displayed near the entrance but within the archaeological site where they are employed, as it is in the case of Jesús and Angel. While Wilbert sells directly from his home, Miguel sells his works in the small handicraft shop in the Chacmool Hotel, the business he owns and runs with his wife, Estela, that is attached to the family home in Santa Elena (see catalog Figure 1.10). In each case, the works are imbued with a certain sense of "originality" both for their obvious creation by a local Maya carver as well as their placement either in situ at Puuc archaeological zones, much like the other ancient stone carvings and monuments surrounding them from antiquity, or in a small "traditional" Maya town where the artisan lives. The tourist buyer makes this connection between the object and the place, and as noted with Steiner's discussion of Senufo carvings, the visitor associates greater authenticity with the object for its "hidden" or "private" physical location that the visitor has sought out as a destination and has "discovered" due to his/her personal initiative and prowess. —**7.2**, **7.3** col., and **7.4**

The authenticity and inherent value to the tourist buyer is also due to the physical and formal properties of the carving itself. For instance the fragrant and fine-grained cedar wood from which they are carved, the smooth polishing and slight sheen of the surface finish, the color and weight of the wood, and the careful and meticulous carving of the intricate details in the subject matter manifest to the viewer the carvings' high-quality, hand-crafted aspect, and durability. These carvings do not only *appear* to be handmade, they *are* handmade, which is evident for the tourist buyer upon inspection. Furthermore, the subject matter of the *réplica* carvings is generally engaging versions and reinventions of ancient Maya images that already resonate in the mind of the potential buyer due to the dissemination of imagery in the popular media (discussed above), which speaks to their perceived "traditional" quality as "authentic" Maya objects.

To use Walter Benjamin's discussion of the work of art in the age of mechanical reproduction (or, today, the electronic and mass transmission of information and images in cyberspace), these sites are visited because they possess the "aura" of the original that is particularly sought by the "cultural tourist."[55] These same "cultural tourists" are those who are most familiar with the specific subjects, and to some degree with the content and cultural significance of the images that are the basis for the Puuc *réplica* carvings. Although most of them clearly realize that the carvings are not actual examples of Classic Maya artifacts, they also recognize and appreciate the skill, the mixture of knowledgeable accuracy, and the personal adaptation evident in the carvings. This, along with the fact that it is recognized that these carvings are produced by local artisans enhances their desirability as a memento of their time spent in the "Maya World."[56]

These issues of hand-craftedness and quality of the wood carvings can be supported by looking at the specific artistic process of the Puuc artisans, specifically as it relates to cultural outsiders' perceptions of "authenticity" in Maya art. While varying slightly from artisan to artisan, this process roughly adheres to a four-part procedure. First, artisans choose a subject for their carving. Once the figure has been chosen, they enlarge the source image through a scale drawing on a photocopy machine to clarify the details and then sketch the design onto the wood itself. Sometimes, the latter is accomplished

by using carbon paper to transfer the drawing to the wood, though this process reverses the orientation of the original image and that the artisan sometimes chooses to carve in this reversed form. If the subject is drawn directly onto the wood, some of the artisans draw a grid over the source image and then create the same-sized grid on their piece of wood and draw the figure accordingly to ensure that the proportions are identical to the original figure. This method is commonly used when the artisans are trying out new imagery that they have not reproduced before or when they are recreating very complex subjects with numerous figures and hieroglyphs that must be kept in proportion to one another. After working with these artisans and their carvings for some time, it becomes apparent which artisans are more meticulous draftsmen versus those who prefer to create their drawings freehand on every piece of wood by how different each person renders identical subjects. For example, Angel prefers to draw all of his figures without the aid of carbon paper or a grid, which is obvious in that his Pakal profiles are always a little different from one to the next even though he uses the same model (images of the stucco bust of Pakal from antiquity) for each. In contrast, William Martin's God L carvings are completely identical in size and level of detail. The only element that changes in these God L carvings is the color or quality of the stain or varnish on the finished piece, which Wilbert (as the dealer of William Martin's carvings) usually applies.

Second, preliminary carving is done on the larger relief areas or those that will become negative space by carving completely through the wood. Such carving is sometimes carried out with the aid of an electric tool, such as a router, which saves the artisan both time and labor, but is inconsistent with the "hand carved" appearance. Consequently, the artisans never have their electric carving tools on display for the tourist gaze. For his freestanding, three-dimensional sculptures, such as his Pakal heads (see catalog Figure 1.26), Jesús creates these figures using a four-square carving method—that is, he draws the figure as it would appear on each face of a block of wood (from the front, sides, and back) and proceeds to carve it from there, perhaps chipping away larger pieces with electric carving tools.[57] This technique is similar to the way the ancient Egyptians carved their large stone blocks into portraits of their rulers, as it was with the famous 4th Dynasty sculpture *Menkaure and his Queen* (Museum of Fine Arts, Boston, 2548–2530 BCE).

Third, the finer details are carved by hand with traditional wood-carving tools. The amount of time spent on a single piece can range from hours to months, depending on the level of detail involved and the size of the piece itself.[58] Finally, the carving is sanded and polished, usually with standard sandpaper of different grains. The artisan's wife or other female family member sometimes carries out this last step, as is the case with Miguel Uc Delgado and his wife, Estela, who does the final sanding on all of his wood carvings.[59] For Jesús, sanding is a three-part process, and he does not use traditional sandpaper for the task. He uses only natural materials, such as (in order from the coarsest grain to the finest) a leaf from the *k'opte* tree (as it is known in Maya), *henequen* (sisal) root that has been frayed to act like a brush, and individual sisal fibers, which together provide surprisingly effective results.

Electric and traditional wood-carving tools are used to create both large and small pieces of the kind described in the main text of this catalog, but of the ancient Maya monuments already mentioned, the Puuc artisans have a preference for reproducing wooden replicas of Lintels 15, 17, 24, and 25 from Yaxchilán, as well as Pakal's sarcophagus lid and stucco portrait bust from Palenque, due to the originals' intricate surface patterning (in clothing details, for example),[60] the meticulous execution of glyphs, or the careful modeling of the figures. The complexity of the details and formal arrangement in these lintels in particular pose a challenge for the artisan; by mastering the patterning in Lintels 24

and 25 or the complex motifs in Pakal's sarcophagus lid, the artisan has effectively proven his skill and proficiency as a carver. This is not to say that the other stelae and lintels from Yaxchilán as well as monuments from other Late Classic Maya sites are not frequently reproduced (for example, see catalog Figures 1.33 or 1.34), but that these subjects in particular are both favored by the Puuc artisans and also tend to be "bestsellers" for the tourist-consumer as discussed earlier. In all cases the Puuc artisans create wooden replicas of these monuments both in their entirety as well as in partial form. The latter, that is, carving only one element or figure from a larger stone relief panel instead of reproducing the monument as a whole, is especially common as it can be produced more quickly, is more portable and less expensive to purchase for the tourist-buyer than the larger reproduction panels, and it allows the artisan to focus on an area that is especially gratifying to carve (see Figures 1.19 and 1.20 in this catalog). In other words, artisans have a tendency to make what sells, such as the highly detailed and naturalistic representations of rulers from the stelae and lintels at Palenque and Yaxchilán. Since the ruler figures of Pakal from Palenque as well as Shield Jaguar and Bird Jaguar from Yaxchilán generally exhibit correct proportion, curvilinear forms, and naturalistic body position, artisanal replicas of these images can be more easily understood in Western terms.[61] Thus, even though contemporary reproductions of these figures are representations of historical individuals among the ancient Maya, their perceived meaning (on the part of the tourist) as objects of an "authentic" and preserved Maya culture give way to their intended meaning (on the part of the artisan-vendor) as objects of Western delectation.

This idea can be related to Steiner's discussion of the nineteenth century Manchester textile producers (this volume) who made a special effort to satisfy "the aesthetic and practical demands of their West African clientele" rather than to allow residual colonial racism to dictate the types of textiles they produced and exported, as French textile producers of this same period had done.[62] The failure on the part of the latter to capture this West African audience was that they assumed, wrongly, that European-style patterns and fabrics would be seen by locals as superior to their own traditional West African ones. The Manchester producers, conversely, chose to view their buying audience as a sophisticated, modern people with complex tastes and needs and thus adapted their product according to this group's specific preferences.[63] We can easily relate this idea to our discussion of Maya handicrafts. If the Puuc artisans chose to only carve those subjects found specifically at the Puuc sites, which are more geometric and less figural and very much unlike the more curvilinear and figure-based subjects found in the Maya Lowlands, they would be ignoring the tastes and preferences of their principal buying audience, which prefers figural representations that are akin to a more European aesthetic, as discussed previously. Monuments whose pictorial dimension is heavily composed of human subjects rendered in a complex but delicate and organic manner thus becomes the aesthetic that Western viewers associate with an "authentic" representation in Maya handicrafts in general, even though it is entirely constructed by the artisans in order to appeal to the demands of their clientele.

Maya (A)rt or Maya (a)rt, and the Problems Therein

In her influential article "The Originality of the Avant-Garde,"[64] Rosalind Krauss found that in Western culture, we imagine that there is a kind of purity, originality, and authenticity that imbues an artist's work. In some ways, however, originality is in fact a myth, since every image created by an artist is a reflection of something that already exists in some form. The Pop artists deliberately challenged the boundaries of the notion of the artist's commitment to "originality" by directly copying and replicating commercial objects and imagery found in popular

advertising and presenting them as fine art. Their success in the art world contradicted the "high" art dictum held by many critics and scholars who were of the opinion that reproductions or mass-produced objects could not be considered on par with other gallery worthy "high" art objects. Accordingly, though in reference to Minimalism, Krauss suggests that the real problem with the idea of "originality," therefore, is not the artist or medium (in the sense that some media allow for the possibility of repetition and multiples), but the culture that rejects reproductive mediums because of the value it places on the idea of the "original." Krauss points out that this way of thinking owes its narrowness to the conditions set out by art historians and connoisseurs, who have folded the notion of authenticity into one concept: style.[65] But style is inextricably linked with the Kantian notion of taste,[66] which seeks to categorize art from non-art and good from bad based on value judgments that, despite Kant's own assertion that they represent a universal consensus (*sensus communis*), are never truly objective.

Closely related to the value placed on originality is the somewhat inverse concept of "appropriation," particularly as it has been used to describe certain practices in the contemporary art world. In a general commentary on the term, Robert Nelson discusses its active character, as a making of one's own idea, expression or image previously well known in its own right.[67] As opposed to simply considering the resemblance of an ill-defined "influence," an appropriation presumes that the person making close reference to an earlier model does so in a deliberate and motivated manner.[68] A particularly striking case of this practice occurs in the work of Sherrie Levine. During the 1980s she became known as an "appropriator of images,"[69] gaining notoriety (or becoming notorious in some circles) for her practice of re-photographing earlier photographs by practitioners such as Walker Evans and Edward Weston. By making replicas that were virtually indistinguishable from the original, she sought to challenge the nineteenth-century

notion of the creative genius of the artist. She was not simply creating a personal copy to study the methods of a "master," or emulate aspects of their subject matter or style as recognition or honoring of their creative models,[70] but deliberately making reproductions of existing works through the use of an intrinsically reproductive medium (photography). As Richard Shiff points out, Levine's paler images differ slightly from the originals, both because they were shot from reproductions rather than originals, but also to remind viewers that photography often involves multiple reproductions.

Of course, the idea of replicating a work from the past is not new, rather part of the heritage of world art traditions. The ancient Romans duplicated ancient Greek statues using either lost-wax casting techniques (for bronzes), or a "pointing system" (for stone sculptures) that left far less room for inventive or personal handling than is found in the carvings of the Puuc artisans.[71] In addition, they "appropriated" aspects of Greek figural style in their depictions of the emperor to convey a greater sense of masculine beauty, purity, propriety, and good order; to communicate his more superhuman status as imperator; and to serve as "an expression of a moral and ethical imperative in his program to renew state and society."[72] The Romans often used Greek sculptors to execute such work. They did this both as an appreciation of the "ars" (superb craftsmanship) of Greek sculptures, but also, by appropriating they demonstrated their power to own Greek things, having dominated Greece militarily.

In more recent times, artists, such as Andy Warhol, Cindy Sherman, and Jeff Koons, have appropriated images from advertising, mass media, and popular culture, either in order to challenge the dominant aesthetic and critical structures of high modernism and interrogate the ways in which images create fame or "brand appeal" (as in the case of the Pop artists), or to "explore the boundaries of commodification" and implode the "distinction which might have been made between avant-garde and kitsch" in the case of Koons.[73] Such efforts have demonstrated

that deliberate and often straightforward borrowings from, references to, evocations, or even outright duplications of other imagery (either from "fine arts" or "visual culture" sources) can be made a fitting subject for art, as long as the institutions and arbiters of that world acknowledge their efforts as valid and successful.

If we can accept the idea that the replication of aesthetic objects (whether from the highest canons of Western definitions of "Art" or the miscellany of popular culture) is a valid form of artistic enterprise, then the Puuc artisans' reproduction of ancient subject matter should be recognized, perhaps even celebrated, as a valid and vibrant form of cultural expression. It certainly is an example of a type of appropriation that represents an active and purposeful re-use of ancient and well-recognized imagery not as a mere "influence," but as a complex process involving their recognition of a distant "kinship" to the makers of such images and the deployment of the images to create a replica that becomes a sign of its prototype, and the generalized and popular notion of ancient Maya civilization to which it refers.[74]

However, despite the fact that the imagery is based closely on, or "appropriated" from ancient Maya sources, it is important to recognize that the Puuc artisans don't consider their carvings to be merely rote copies. Instead, they feel they actively reinterpret, reinvent, and revitalize the ancient forms through their choice of materials, artistic process and signature carving style. This replication thus promotes a strong identification between the Puuc artisans, who are Yucatec Maya and who work at or frequently interact with various ancient Maya archeological sites, and their ancient Maya cultural heritage. Puuc artisans take great pride in their work,[75] and they seem to convey this to their audience through their fine craftsmanship and careful attention to detail. Nelson Graburn has commented on a comparable commitment to craftsmanship in other tourist arts by noting that not only are artisans proud of their work, but that through their craft they also affirm to their foreign buyers that "We exist; we are different. . . . we have something that is uniquely ours."[76]

Following June Nash, this "new creative synthesis," that is, the modern interpretations of ancient forms that we see among the Puuc artisans for instance, is possible because of foreign interest in civilizations of the past, which translates into thriving art markets as a result of the commoditization of art and culture.[77] While having some adverse impact, this commoditization should not be viewed only negatively. A generation ago and without the economic revenue that tourism provides their communities, individuals in Yucatán would not have had the option to work as artists because of the need for manual labor (in the form of farming and construction work) to sustain communities. Denise Fay Brown, however, believes that the commoditization of a culture for a specific consumer market "will have devastating impacts on the indigenous peoples and cultures of the region."[78] She argues that tourism guidebooks and promotional materials fail to educate tourists of cultural differences and meanings present in contemporary Maya communities and instead promote the idea of the Maya as "exotic," and their culture as "mysterious."[79]

But the question remains, are these Puuc wood carvings (and ethnic and tourist arts in general) "Art" with a capital "A"? Do they necessarily need to be categorized as "Art" in order to function as aesthetic objects that appeal to their intended audience, communicate culturally significant messages about the culture that produced them, and have a specific value and meaning therein? Are the non-Western individuals who make them artists? Would another term/designation/category be more appropriate in describing these objects?

A brief return to the *Magiciens de la Terre* exhibition, referred to in the first chapter of this catalog, may help to analyze some of these issues. Critics were indeed faced with these and many other questions with the opening of the exhibition at the Pompidou Centre in Paris in 1989. The goals of the exhibition, in the words of Thomas McEvilley, a contributor to

the exhibition's catalog, were "to find a postcolonial-ist way to exhibit the works of first- and third-world artists together, a way that would involve no projections about hierarchy, or about mainstream and periphery."[80] By exhibiting the work of fifty non-Western artists alongside the work of fifty Western artists without any accompanying text beyond labels with artist, date, and title information, the curators strived to present the works "without any fixed ideological framework around them."[81]

Magiciens received mostly negative commentary following its opening, though the main problem that critics found with the exhibition was its curation.[82] McEvilley notes that the curators largely selected the non-Western artists based on their cultural background rather than whether these artists were representative of their country's contemporary art scene.[83] Much of the work displayed the kinds of primitive clichés associated with the third world, which were further emphasized by the show's title, "Magicians of the Earth." McEvilley believes that the title implies "a romantic tilt toward the idea of the 'native artist' as not only a magician . . . but also as somehow close to the earth."[84] Additionally, given the fact that most of the traditional craftlike, earthy and ritualistic pieces on display were by non-Western artists, the curators also seemed to insinuate that these artists were pre-rational and uncivilized, even if this implication was unintentional.[85]

Along these lines, the curators hesitated to use the word "artist" when referring to the non-Western participants, which may have contributed to further separation between them and the Western artists in the show, a dilemma that I have also had to address in my own work and research.[86] Their hesitation was in response to "the ongoing anthropological debate about whether so-called 'primitive' peoples have the ideology (essentially, in our terms, Kantian) that makes objects 'art' in our sense of the word."[87] This way of thinking is in step with many art historians who study aspects of non-Western visual culture, like Carolyn Dean, a scholar of pre-Columbian art at

University of California at Santa Cruz. Dean rejects the application of the term "art" to describe objects that are created or manipulated in societies where an equivalent term does not exist.[88] By labeling ancient Inca *huacas* or Aztec featherwork as art, Dean asserts that "we risk re-creating societies in the image of the modern West, or rather, in the image of the modern West but just different enough to render them lesser or insufficient, or more primitive," which ultimately reinforces colonialist attitudes.[89] She finds scholars to be at fault in this respect since they will refer to an ancient object as "art" to emphasize to their students the object's quality and value so that they may begin to understand it based on their knowledge of things considered "art" among Western objects.[90] This approach, however, detracts from any inherent value the object embodied within the culture that produced it, which may be altogether different from the ways in which this same object is valued within a Western aesthetic construct.

But if scholars are aware that calling an ancient non-Western aesthetic object "art" is problematic, why are they displayed in art museums as "high" art while finely made contemporary reproductions of these ancient objects are relegated to categories of "low" or "non" art? And why are some ancient monuments, like the Yaxchilán lintels, regarded as "masterpieces"[91] when there was no concept of "art," at least in the Western sense of the term, among the ancient Maya? Perhaps offering a partial answer to these complex questions, Alfred Gell, author of the influential book *Art and Agency* (1998), argued that institutions (e.g., museums, universities, religious centers of worship, etc.) are what determine the artistic output of a culture and the way that culture regards it. While these institutions may also play a significant role in contextualizing the production and exchange of aesthetic objects in non-Western societies as well, the objects themselves may serve specific purposes that are not based on aesthetics or "art for art's sake" in the sense that they may act rather as objects of religious ritual or political

propaganda against oppressive governments, for example. Thus, Gell did not believe that scholars (referring specifically to anthropologists) could refer to aesthetic objects created outside of the Western world as "art" since they are not made with the same intention as art produced in the West, namely as the visual representation of the artist's self-expression.[92] Thus the makers of aesthetic objects (from either the Western or non-Western world) create works that are appropriate to the needs of the institutions that govern the society in question. We can also assume that the appropriate terminology to describe these objects adequately emerges from within the respective culture, and may or may not be equivalent to Western scholars' definition of these same kinds of culturally significant objects. By conceding that Western categorization of art vs. artifact and "high" vs. "low" art may not be the only (or even the best) way to classify objects produced either within or outside Western societies, we have made an important, if small, step forward in the reconsideration of the field of art history and criticism as we know it. The limitations, prejudices, and opportunities for future revision in the discipline certainly exist, especially with regards to ethnic and tourist arts. The latter will only continue to challenge the limitations that have been imposed on them by current Western art historical criteria and categorization.

Notes

I would like to express my deepest gratitude to Jeff Kowalski and Quetzil Castañeda for reading early versions of this paper. Castañeda was particularly helpful in providing comments and selected readings that contributed to the section on the historical framing of the Maya. Kowalski provided some ideas on cultural representation, as well as contributing some references and a discussion on issues related to the concept of appropriation in contemporary art, and in the ancient world, that have been integrated into the section on the problems with Maya art/Art. They provided invaluable feedback and suggestions for revision that have greatly improved the overall clarity and organization of the piece, as well as strengthening the central argument. I would also like to thank Janet Berlo and George Lau for their support and suggestions for further reading, as well as Traci Ardren for identifying key areas in need of revision early on.

1. Watanabe 1995, 33. See also Evans 2004 and Farriss 1984. It should be noted, however, that although Stephens drew attention to the gulf that divided the architectural splendor and cultural achievements of the ancient Maya from the cultural level of the Maya groups he encountered living in Yucatán in the nineteenth century, he nevertheless identified Maya-speaking inhabitants of the region as the descendants of those who built the ancient sites. In this he differed from other colonial historians or early explorers who considered the ancient civilization to have been built by the ancient Romans, Carthaginians, Egyptians, or even inhabitants of legendary places such as the lost continent of Atlantis or Lemuria (Mu). See also Bernal 1983 and Wauchope 1974.

2. See for instance, Redfield and Villa Rojas 1962, Redfield 1964, Jones 1977.

3. Farriss 1984.

4. Fischer 1999, 488.

5. Watanabe 1995, 34.

6. See for instance, Hervik and Kahn 2006, Castañeda 2004, in Castañeda and Fallaw 2004.

7. Castañeda 2004, 38.

8. Castañeda 1996, 133–35.

9. Quetzil Castañeda, personal communication, 25 February 2009.

10. Castañeda 1996, 133.

11. Castañeda 1996, 134.

12. As the essay in this volume by Jeff Kowalski notes, Traci Ardren 2004, 103–13 discusses ways in which advertisements in popular archaeology magazines in Mexico (*Arqueología Mexicana*) and the United States (*Archaeology*) aimed at tourists communicate and reinforce such exoticized views of Maya society and culture.

13. See for example, Castañeda 1996, Hervik, 2003, Hervik and Kahn 2006, LaBrecque 2005.

14. Castañeda 1996, 138.

15. Castañeda 1996, 140–41.

16. Castañeda 1996, 140.

17 Castañeda 1996, 137.

18. Castañeda 1996, 140

19. Castañeda 1996, 143.

20. Castañeda 1996, 144.

21. Ehrentraut 1996, 26.

22. In this context I am defining "cultural representation" as it is used in visual culture and cultural studies, that is, referring to discussions of how the complex processes of acquiring, assimilating, negotiating, and even rejecting the beliefs, practices, and experiences of people who see themselves as having some type of shared history and sense of a shared group identity (i.e., those who have common cultural identity) are "represented" or mediated to those outside of the group (although it can also refer to how members of a group "represent" themselves). This can be by means of more full, accurate, and complete accounts of the complexity and lived experience of members of that "culture," as in the case of a good ethnography (or sociology) based on participant observation coupled with use of historical records of various types, as well as on direct testimony from cultural insiders, or it can be more partial, simplified, distorted or deliberately biased, in which case the "representation" of the culture in question becomes closer to what Barthes describes as a "mythology" or Baudrillard describes as a simulation or simulacrum. Other definitions of "representation" can be found in Marita Sturken and Lisa Cartwright, *Practices of Looking: An Introduction to Visual Culture* (Oxford and New York: Oxford University Press, 2001), 365. An anthology that includes discussions of these issues from various perspectives is Stuart Hall, ed., *Representation: Cultural Representations and Signifying Practices* (London: Sage Publications and Open University, 1999).

23. See Schele and Miller 1986. See also Cecelia Klein (1988):,42–46.

24. Graham 1986, 95.

25. See Blake 1985.

26. See Gluek 1985; Kakutani 1986; Wardwell 1986.

27. Jesús Marcos Delgado Kú, personal interview, 18 July 2006.

28. The British Museum's collection currently houses Yaxchilán lintels 15, 16, 17, 24, 25, 35, and 41. Not all of the museum's holdings are discussed here. Lintel 26 is in the collection of the National Museum of Anthropology and History in Mexico City.

29. Maudslay 1974.

30. Jesús Marcos Delgado Kú, personal interview, 18 July 2006.

31. Jesús Marcos Delgado Kú, personal interview, 18 July 2006.

32. See Klein 1988, 42–46.

33. Tate 1992, 42.

34. Tate 1992, 42.

35. Tate 1992, 44.

36. Jesús Marcos Delgado Kú, personal interview, 18 July 2006.

37. Jesús Marcos Delgado Kú, personal interview, 18 July 2006.

38. For a more in-depth discussion on Maya identity in Yucatán and the complexities involved in one's "Mayanness," refer to chapter 1 of this catalog. See also Hervick and Kahn 2006.

39. Miguel Uc Delgado, personal interview, 16 July 2006.

40. Miguel Uc Delgado, personal interview, 16 July 2006.

41. Angel Ruíz Novelo, personal interview, 18 July 2006. Quote translated from the original Spanish by author.

42. Both Jesús and Miguel could name numerous academics and other scholars who have purchased their carvings over the years for their faithful yet inventive interpretation of ancient Maya imagery.

43. Jesús Marcos Delgado Kú, personal interview, 18 July 2006. Quote translated from the original Spanish by author.

44. Jesús Marcos Delgado Kú, personal interview, 13 March 2007.

45. MacCannell 1999, 94.

46. See Steiner 1995.

47. See Steiner 1994.

48. Steiner 1995, 154–55.

49. Steiner 1995, 155.

50. Steiner 1995, 155.

51. Steiner 1995, 153–54.

52. See Berlo, this volume.

53. . See Berlo, this volume.

54. See Chibnik 2003.

55. See Kowalski, this volume.

56. Some of these inferences come from observations made at the sites and others from conversations with the artisans, during the author's fieldwork in the region from 2006–2008. However, more work needs to be done to gain direct feedback from tourists about their motivations for visiting Puuc sites, and their perceptions of the carvings made by Puuc artisans.

57. Jesús Marcos Delgado Kú, personal interview, 13 March 2007.

58. Miguel Uc Delgado, personal interview, 16 July 2006; Jesús Marcos Delgado Kú, personal interview, 18 July 2006; Angel Ruíz Novelo, personal interview, 18 July 2006.



59. Estela Uc Delgado, personal communication, 15 July 2006, and Miguel Uc Delgado, personal interview, 16 July 2006. This fact is an example of the division of labor according to gender. An in depth discussion of this topic is beyond the scope of this essay.

60. Jesús Marcos Delgado Kú referred to this aspect as "filigrana" or filigree. Personal interview, 18 July 2006.

61. Klein 1988, 44.

62. See Steiner, this volume.

63. See Steiner, this volume.

64. Krauss 1981.

65. Krauss 1981, 55.

66. Kant 1951.

67. Nelson 1996, 117.

68. See discussion in Nelson 1996, 117.

69. See Owens 1982, 148. See also Owens 1992.

70. Discussion in both Nelson 1996, 121, and Shiff 1996, 109–11.

71. Hemingway 2002.

72. Pollini 1995, 262.

73. Wood 1996, 277.

74. In this connection, Nelson (1996, 118) discusses appropriation in connection with the semiotics of Roland Barthes (1972) and his analysis of "myth." Nelson notes that for Barthes "Myth is speech [or what others might more broadly refer to as a text], for what Barthes is exploring is communication rather than an object or idea. He introduces the classic semiotic categories of the signified, the signifier, and their combination, known as the sign. He then extends the concept of the sign by defining myth as a second order of signification. In myth, the first sign, the association of signifier and signified, is transformed into the signifier of a new signified and a component of the second sign. What once was complete and meaningful is taken over by the second system and made to stand for a new notion." In the case of the Puuc wood carvings, the images that the artisans use as source material held original meaning(s) for pre-conquest Maya peoples who made and viewed them, but now, as appropriated images, carry a new meta-meaning that refers to the concept of ancient Maya civilization itself.

75. Shiner 1994, 229. Shiner asserts, "the artisans from small-scale societies who produce this art [i.e., tourist art] have their own aesthetic standards and take pride in their skill and innovation."

76. Graburn 1976, 29.

77. Nash 1993, 18.

78. Brown 1999, 301.

79. Brown 1999, 301.

80. McEvilley 1990.

81. McEvilley 1990, 20.

82. McEvilley 1990, 20.

83. McEvilley 1990, 19.

84. McEvilley 1990, 19. This idea is very much related to the stereotypes of the "primitive" and "primitive" art and artists as reflecting more direct experience with "instinctual" aspects of life, and being motivated more by emotion than by rational thought. A good introduction on these topics can be found in Sally Price, *Primitive Art in Civilized Places*, 2nd ed. (Chicago: University of Chicago Press, 2002).

85. McEvilley 1990, 19.

86. McEvilley 1990, 19.

87. McEvilley 1990, 19.

88. Dean 2006.

89. Dean 2006, 26.

90. Dean 2006, 27. Jeff Kowalski (personal communication, 24 March 2008) rightly points out that most scholars only refer to an object as "art" once they have tried to explain the function and meaning of the object based on whatever ethnohistorical or ethnographic sources of evidence are available. Kowalski says that scholars still use the term "art" to refer to them because these objects have now acquired "quality and value" within a system of objects since outsider-based cultural judgments (specifically Western judgments) have been applied.

91. Schele and Miller 1986, 186.

92. See Gell 1998.

7.2—*(right)* Gift shop at Kabah. The carvings by Jesús Delgado Kú are displayed for sale in the gift shop near the entrance to Kabah. Yaxchilán lintels, Pakal imagery from Palenque, and other subjects vie for the viewer's attention

7.3—*(below)* Angel Ruíz Novelo displays his work in the combined ticket office and gift shop at the entrance to the site of Labna. An array of images taken from classic monuments, manuscripts, and the iconography of Uxmal and Chichén Itzá appear in this view.

Appendix

Prólogo y Síntesis de Capítulo 1

(Traducción Español)

PRÓLOGO

Alfredo Barrera Rubio

▸ Los mayas han sido objeto de estudio y admiración de los estudiosos, particularmente a partir del siglo XIX, cuando los viajeros y exploradores dieron a conocer al mundo académico de la época, las manifestaciones intelectuales y artísticas de esta civilización. Desde entonces, esta cultura ha tenido una amplia difusión, hasta el presente, generándose una corriente importante de visitantes nacionales y extranjeros, que recorren los principales sitios arqueológicos, que han sido explorados, investigados y restaurados.

La intervención arqueológica de los sitios prehispánicos y la promoción turística, han tenido un impacto importante como fuente generadora de divisas. Aunque el beneficio principal de la actividad turística, recae en los grandes inversionistas privados, esta actividad, también repercute sobre las comunidades aledañas a los sitios visitados, que se manifiesta en los servicios y en la actividad económica de las pobladores.

En el estado mexicano de Yucatán, destacan las zonas arqueológicas de Chichén Itzá y Uxmal, como las que más turistas atraen a la entidad. Chichén Itzá, ubicado en el oriente de Yucatán, es una de las zonas arqueológicas más visitadas de México. La protección jurídica de este patrimonio cultural se inició el 5 de diciembre de 1986 cuando se expidió el decreto presidencial que establece "La zona de Monumentos Arqueológicos de Chichén Itzá" y dos años después un nuevo decreto para este sitio estableció con mayor claridad el perímetro del mismo e incluyó no solamente la conservación de los monumentos arqueológicos, sino también de la fauna y la flora del lugar.

Dado el carácter excepcional de los vestigios arqueológicos de Chichén Itzá y considerando el interés creciente de la comunidad internacional en la protección de esta herencia cultural, diversos organismos nacionales, entre ellos el Instituto Nacional de Antropología e Historia, promovieron en 1987 ante la UNESCO que este sitio fuese incluido en la lista del patrimonio mundial. Esta iniciativa fue acogida favorablemente y la ciudad prehispánica de Chichén Itzá quedó inscrita en la lista anterior en diciembre de 1988. De esta manera, sin reemplazar la acción del estado mexicano en la protección de esta zona, se involucró también a la comunidad internacional en un marco de respeto a la soberanía nacional.

No obstante, que Chichén Itzá tiene un reconocimiento internacional, como patrimonio cultural de la humanidad, en tiempos recientes hemos sido testigos de una campaña mediática de la fundación new 7 wonders para designar a el edificio conocido como El Castillo como "maravilla de la humanidad", obteniendo esta designación por votación popular, en julio del 2007. El hecho de que Chichén Itzá quedara ubicado entre las siete maravillas del mundo generó sin duda una campaña promocional sin precedente, que tuvo repercusiones en el incremento al turismo.

En el suroeste del estado de Yucatán, en la región conocida con el término maya yucateco *Puuc*, que significa serranía, se desarrollaron antiguas ciudades mayas, que alcanzaron su esplendor durante el periodo conocido como Clásico Tardío.

Los artesanos mayas prehispánicos alcanzaron un refinamiento extraordinario en la decoración arquitectónica, lo que les facilitó plasmar un simbolismo ideológico y religioso en sus edificaciones.

Uxmal es uno de los sitios más representativos de esta región, ya que en el pasado fue una capital regional y sede de un importante poder económico, político y religioso.

En contraste con la afluencia turística que llega a Chichén Itzá, en esta región sólo Uxmal tiene una buena afluencia turística, siendo la segunda zona

arqueológica más visitada del Estado. Los otros sitios tienen un menor número de visitantes.

Uxmal forma parte de un circuito de sitios arqueológicos conocido como Ruta Puuc, integrado por las zonas de Uxmal, Kabah, Sayil, Xlabpak, Labná y las grutas de Loltún.

Estas zonas arqueológicas, con excepción de Xlabpak y las grutas de Loltún, fueron también promovidas por el INAH, como patrimonio de la humanidad en la UNESCO, las cuales formaron finalmente parte del patrimonio del la humanidad a partir de diciembre de 1996.

El turismo que llega a visitar esta ruta no es por lo común de carácter masivo, sino de carácter cultural, lo cual ha influido en crear las condiciones para el desarrollo de una modalidad artística inspirada en la civilización maya prehispánica.

En esta región es donde se ha generado a lo largo de los años una "escuela" de talla de madera, actividad que difiere de la que se desarrolla en otras regiones de Yucatán, en que no hay una producción masiva. Los protagonistas de esta actividad, no pueden ser calificados simplemente como "artesanos" ya que su labor les ha permitido plasmar en las esculturas de madera elementos creativos y de identidad cultural, que rebasan esa categoría social.

Las personas que se dedican a esta actividad, no viven exclusivamente de esta labor, ya que han tenido o tienen un empleo remunerado como custodios de zonas arqueológicas o bien como guías de turistas.

Las representaciones de la talla en madera son principalmente deidades del panteón maya prehispánico o bien de personajes representados en bajorrelieves, que proceden de elementos escultóricos de otros sitios del área maya, principalmente de la región del Petén. Ocasionalmente encontramos otro tipo de motivos que tienen su origen en una inspiración personal de los autores.

El hecho de que por lo común sólo se elaboren representaciones escultóricas de los mayas prehispánicos, responde a la sobrevaloración turística y cultural de esta antigua civilización y al poco interés en los grupos étnicos mayas contemporáneos, que mantienen una posición social subordinada.

En este catálogo, se da a conocer una gran variedad de las obras de esculturas en madera, producidas por la "escuela" del *Puuc*, lo cual representa el reconocimiento de los estudiosos de la historia del arte, de que estas tienen un gran valor como manifestaciones de la identidad cultural del grupo social que las produce, además de un valor artístico de cierto nivel. Esperamos, que esta obra sirva también como un reconocimiento a los creadores mayas del pasado y del presente.

Capítulo Uno
CREANDO IMÁGENES DE LOS MAYAS
tallados, talladores, contextos y mensajes

Text por Mary Katherine Scott y Jeff Karl Kowalski

Traduccido por Mary Katherine Scott
con Giuliana Borea

▸ "Tallando la Identidad Maya: Escultura Contemporánea en Madera de la Región del Puuc de Yucatán, México" muestra piezas de cuatro artesanos mayas contemporáneos de Yucatán: Miguel Uc Delgado, Jesús Marcos Delgado Kú, Angel Ruíz Novelo, y Wilbert Vázquez. Estos trabajos de excepcional detalle, hechos a mano y de gran atractivo estético, son reproducciones de temas basados en antiguas esculturas, cerámicas y manuscritos mayas (véase por ejemplo figuras 1.1, 1.39, 1.44). Hechos para ser vendidos en los sitios arqueológicos del norte de Yuca-

*Esta traducción representa un síntesis ligeramente condensada del texto de la primera sección de este catálogo. Presenta sus ideas e interpretaciones principales, pero no incluye todas las referencias escolásticos. Mandamos el lector al texto inglés para examinar las referencias, y ver la lista completa de ilustraciones integradas con el texto.

tán, sus principales consumidores son los "turistas culturales" que visitan, en viajes organizados, estos lugares. Los tallados referidos son particularmente una muestra atractiva de las formas de arte que han emergido como resultado de la globalización, cuyo efecto ha producido un gran aumento en el turismo en Yucatán. En este sentido, estos tallados representan una manifestación del "arte turístico", una categoría especializada de expresión visual que ha surgido como un campo importante en la investigación de la historia de arte y la antropología.

El catálogo de la exposición, que incluye un grupo de ensayos de Quetzil Castañeda, Mary Katherine Scott, Jeff Kowalski, Janet Berlo, y Christopher Steiner, explora temas que se ubican en la intersección entre arte, cultura visual, identidades culturales, autenticidad y globalización. Consideramos un rol más amplio de los artistas y de las artes visuales en la sociedad y el estudio de tales formas de arte en el contexto de conceptos cambiantes de arte y estética, con la esperanza de que este estudio fomente investigaciones en el arte turístico en general. Esta investigación es el primer análisis de las obras emblemáticas producidas por estos cuatro artesanos mayas de Yucatán.

En el uso contemporáneo del término, la globalización se refiere a la interacción y la integración crecientes de las economías políticas y prácticas culturales de estados nacionales a través del comercio, la inversión extranjera, el flujo de capital, la migración y el uso de nuevas tecnologías (computación, comunicación electrónica, cultura visual) que han apresurado el intercambio de información y de comercio. Además del movimiento más rápido y extenso del capital, de mercancías y de información, la globalización también ha dado lugar al movimiento de gente ya sea a través de la inmigración o en la forma de turismo.

Como Janet Berlo nota en su ensayo en este volumen tal interacción cultural entre diversas sociedades no es nueva. Los contactos interculturales y la distribución de mercancías y de ideas han sido una fuerza impulsora importante del cambio y de la

innovación desde épocas antiguas, y estos procesos han aumentado desde las expediciones, expansión y colonización europeas dando por resultado procesos complejos y a veces violentos de aculturación, integración y resistencia.

Estas fuerzas se han intensificado dramáticamente durante los últimos años del s. XX y del siglo XXI, produciendo a menudo repercusiones que han afectado profundamente a las economías políticas y a las culturas tanto de los estados naciones con mayor desarrollo socio-económico como a los que cuentan con mayor pobreza y desigualdad. La "tradición" reciente de tallados producidos por los artesanos del Puuc ha emergido en el contexto de globalización de profundas transformaciones económicas, sociales y culturales asociadas con los contactos internacionales en el norte de Yucatán; muchos de los aspectos de estos procesos están considerados en el reciente volumen *Yucatán in an Era of Globalization (Yucatán en la era de globalización:* Baklanoff y Moseley 2008). También los consideramos más adelante en este catálogo.

Relacionado al amplio fenómeno de la globalización se encuentra el incremento de viajes de larga distancia y del turismo internacional. El turismo, por lo menos en su forma de turismo de masa, con frecuencia se considera ser un desarrollo más democrático y moderno, diferente al recorrido aristocrático del mundo antiguo o del "grand tour" del siglo XVIII. Este turismo moderno se asocia con las crecientes oportunidades de viaje para las clases medias en el s. XX, particularmente después de la II Guerra Mundial. Las explicaciones del porqué de tales viajes varían, yendo desde interpretaciones que consideran el turismo como una forma de "ocio moderno" centrado en el entretenimiento, en la búsqueda de placer y recreación, a perspectivas más teóricas que ven el turismo como una versión moderna de un peregrinaje tradicional en el cual la búsqueda de "experiencias auténticas" por los viajeros es comparable a una búsqueda de lo sagrado. Además, muchos estudios antropológicos y sociológicos se han centrado en el carácter del encuentro entre los turistas ("huéspedes")

y la gente local ("anfitriones") en las zonas visitadas, con un énfasis especial en los varios efectos de aculturación en las prácticas culturales locales.

A una subcategoría importante del turismo se le denomina frecuentemente "turismo cultural". Aunque todo el turismo implique una clase de interacción cultural, la definición del turismo cultural sugiere que el viajero haya diseñado por lo menos una porción significativa de su viaje buscando deliberadamente experiencias que den una oportunidad de establecer contacto directo y de experimentar aspectos de la cultura extranjera y/o de lugares de importancia histórica. En muchos casos, esto toma la forma de viajes organizados y puede implicar visitas especiales a "sitios patrimoniales", a lugares de interés histórico, a museos, a espectáculos y exposiciones especiales. Hablando en términos generales, la industria del turismo es neutral hacia diversos aspectos de la "cultura", pero pone énfasis en las oportunidades de viajes a lugares distantes para ofrecer a los visitantes experiencias únicas.

En este sentido, el atractivo de las ruinas encontradas en Uxmal, Kabah, Sayil, y Labná (los principales destinos turísticos de la región del Puuc), provee la experiencia de un encuentro directo con los vestigios de la civilización antigua de los mayas, que el visitante ha viajado para ver. Sin embargo, como sitios patrimoniales, también se convierten en una clase de producto cultural que es económicamente valioso para la industria del turismo, la cual desarrolla una infraestructura adecuada para hospedar, alimentar y entretener a los visitantes de una manera u otra para obtener un beneficio.

Junto al creciente interés en el turismo como fenómeno económico, sociológico, antropológico, y psicológico han aumentado también los estudios de los artefactos estéticos producidos en las zonas de contacto intercultural y de los procesos por los cuales estos son consumidos por los extranjeros. A tales objetos comúnmente se les llama "arte turístico"; aunque ya se ha sugerido que esta denominación sea descartada porque implica diversos tipos de obras

artísticas dentro de una sola categoría, de algún modo despectiva. El desarrollo de estudios académicos de este tipo de obras de arte se remonta generalmente a la antología de Nelson H.H. Graburn de 1976, *Ethnic and Tourist Arts: Cultural Expressions from the Fourth World (Arte Étnico y Turístico: Expresiones Culturales del Cuarto Mundo)*, que Ruth Phillips y Christopher Steiner (1999a: 4) llaman "la primera publicación importante en prestar una seria atención académica a los bienes artísticos de la gente marginada y colonizada y en reconocer su importancia en la producción turística de etnicidad".

En este trabajo pionero, Graburn reunió una selección de agudos ensayos de antropólogos y historiadores de arte cuyos trabajos exploraron estos temas y de cómo se relacionan con formas particulares de arte hechas en diferentes sociedades del mundo. En su introducción propuso un esquema analítico para clasificar tales trabajos de arte (resumido en el texto del catálogo principal) reconociendo que había una gran variedad de estas formas de arte, que van desde los objetos tradicionales producidos para el uso local pero recolectados por los extranjeros a géneros más recientemente desarrollados que utilizan nuevas formas, temas y medios. Graburn también observó que tales productos estéticos eran diseñados con frecuencia para ofrecer formas y/o imágenes que conllevan un mensaje relacionado con la situación cultural y la identidad étnica del artista/hacedor.

Hasta la aparición del libro de Graburn, muchos productos estéticos similares fueron omitidos de la discusión académica ya que fueron vistos como carentes de calidad, no basados en tradiciones locales o producidos sobre todo para propósitos comerciales. Los historiadores de arte no los consideraban "arte" y los antropólogos no consideraban que estos representaban la cultura indígena auténtica. Sin embargo, desde que el libro de Graburn fue publicado una gran cantidad de estudios y artículos, así como de antologías académicas, se han ocupado de este tema. En general, ellos señalan que estos objetos tienen muchas de las características de otros artefactos car-

acterizados como "arte", (por ejemplo, formas intencionalmente determinadas, especializadas y significativas) mientras a la vez sugieren que estos objetos deben ser analizados e interpretados en el contexto de un campo más amplio de producción que refleje su posición en redes complejas de contactos culturales, de intercambio económico y de discursos sociales e institucionales con respecto a la clasificación y asignación del valor a los diversos productos.

Shelley Errington (2005: 220) observa que los tipos de tallados ofrecidos en esta exposición se pueden examinar usando enfoques o "encuadres" alternativos. Uno, un acercamiento artístico histórico más tradicional, es el centrarse en los tallados en sí mismos y enfocar la discusión sobre sus formas y temas individuales. Otro, es acercarse a los tallados como "objetos" o ejemplos de la cultura material que deben "ser explicados y tratados como cualquier otro aparato cuyos significados son proyectados sobre [ellos] y se acumulan en la práctica".

Esencialmente esto describe el carácter dicotómico de los objetos como arte y artefacto. Junto con artefactos estéticos similares que emergieron en situaciones de contacto cultural y transformación, y que fueron producidos para el comercio o la venta a foráneos, los tallados de los artesanos del Puuc entran así en una categoría problemática que toca temas relacionados con nociones de identidad cultural, autenticidad y con la condición de arte en sí misma.

Cultura y la Identidad

El fenómeno del turismo involucra el contacto entre personas de distintos bagajes culturales y levanta preguntas acerca de la identidad cultural. La discusión sobre la identidad cultural requiere que hagamos una breve introducción sobre la definición de cultura, una palabra que según Raymond Williams (1976: 76), un fundador en el campo de los estudios culturales, es "una de las dos o tres palabras más complicadas en el idioma inglés". En el estrecho sentido humanista del siglo XIX, la cultura, de acuerdo a Mat-

thew Arnold (1883: xi), es "un búsqueda de nuestra perfección total, mediante el conocimiento, en todos los asuntos que más nos conciernen, de lo mejor que se ha pensado y dicho al respecto". Como otros de su tiempo, la definición de Arnold suponía que un conjunto particular de modales, opiniones y gustos de las elites (en gran parte de las elites europeas y norteamericanas) proporcionaran el criterio por el cual determinar el valor de todos los logros humanos. En contraste, Williams (2001) afirmaba que la cultura debía ser comprendida y examinada en su totalidad, como un "total estilo de vida", incluyendo la completa gama de significados y expresiones desde aquellos que eran considerados comunes y ampliamente compartidos hasta aquellos que reflejaban un dominio avanzado del saber y las artes.

Durante el siglo XIX el antropólogo Edward Tylor (1873: 1) intentando encontrar una definición de cultura que comprendería las diferentes sociedades humanas escribió, la cultura "es ese todo complejo que incluye el conocimiento, la creencia, el arte, la moral, la ley, las costumbres, y cualesquiera otras capacidades y hábitos adquiridos por el hombre como miembro de una sociedad". Este enfoque enfatizó en la elaboración de listados de las principales creencias de una sociedad, de sus prácticas, y en hacer un registro de artefactos (instrumentos y artes) que conjuntamente constituían la cultura compartida. Más recientemente, el antropólogo Clifford Geertz (1973: 89) ofreció una definición más semiótica de la cultura, describiendo ésta como "una trama de significados históricamente transmitidos, incorporados en símbolos, por medio de los cuales la gente se comunica, perpetúa y desarrolla su conocimiento y sus actitudes hacia la vida". Como otros, Geertz señaló que el uso de símbolos compartidos infundía un sentido de identidad social común y podía motivar acciones cooperativas que facilitaran la supervivencia humana. Más recientemente, el concepto de cultura ha sido cuestionado y criticado desde varios ángulos, a menudo por aquellos que indican que éste es demasiado concreto y a la vez demasiado vago,

así como mencionan que los aspectos culturales son experimentados de forma distinta por los diversos sub-grupos dentro de cualquier sociedad humana. En esta conexión, Dirks, Eley y Ortner (1994: 1) han apuntado que:

> Una de las dimensiones centrales del concepto de cultura ha sido la noción que la cultura es "compartida" por todos los miembros de una sociedad dada. Pero cuando los antropólogos han comenzado a estudiar sociedades más complejas, en las cuales las divisiones de clase, raza y etnia son fundamentalmente constitutivas, se ha vuelto más claro de que si hablamos de cultura como compartida, nos debemos siempre de preguntar ahora, "¿Por quién?," y "¿de qué maneras"? —y "¿Bajo cuáles condiciones"?

En recientes perspectivas, la cultura es vista como construida a partir de una combinación entre la enseñanza formal y el aprendizaje desde las experiencias y es continuada y modificada a la vez por los miembros de una sociedad particular. En este sentido, la identidad cultural se refiere a conjuntos de creencias, de comportamientos y de prácticas habituales que se integran a la imagen de un individuo sobre sí mismo. Esta identidad variará basada en factores como clase, raza, etnia, género, educación y socialización, y será constantemente negociada, desafiada y reafirmada a través de las interacciones con los otros, mientras también será reafirmada individualmente mediante la reinserción a una "biografía" psicológica personal. A fóraneos con solo un conocimiento de paso y con un contacto mínimo con, o con un conocimiento limitado de la historia y la cultura de un grupo particular, nociones de la identidad cultural de este grupo pueden ser reducidas a varios rasgos claves (por ejemplo, creencias particulares, vestimenta, cocina, o nivel de complejidad tecnológica y/o sociopolítica) que representan la cultura de maneras etnocéntricas que son a lo menos limitadas y parciales, y que también pueden presentar nociones estereotipadas acerca de culturas diferentes a las suyas. Porque los

artefactos estéticos (como obras de arte) tienen una apariencia particular, y por lo general son suficientemente pequeños para ser transportados físicamente o ser transmitidos visualmente (en impresión o medios electrónicos), estos han venido a representar a menudo la totalidad de su cultura en una manera icónica.

La discusión sobre la identidad cultural también levanta el tema de la identidad en sí misma. Como Stuart Hall y Paul du Gay (1996: 1) mencionan, los debates acerca de la naturaleza de la identidad nunca han sido más intensos y variados. Como resultado de las críticas posmodernas, muchas disciplinas han aceptado el fin de una idea previa de "identidad unificada, originaria e integral". La firmeza y la estabilidad de la identidad individual son cuestionadas, pero el término queda, aunque solo como referencia abreviada de las complejas intersecciones de influencias que afectan los comportamientos y las auto-concepciones de los individuos. Relacionando esto a las nociones de cultura discutidas anteriormente, una faceta de la identidad individual implica la "identificación" con un grupo más amplio del que una persona se considera ser miembro. Como Hall y du Gay refieren, "En el lenguaje del sentido común, la identificación es construida en lo profundo del reconocimiento de algún origen común o de características compartidas con otra persona o grupo, o con un ideal, y con la muerte natural de la solidaridad y de la lealtad establecidas en este fundamento. En contraste con el 'naturalismo' de esta definición, el enfoque discursivo ve la identificación como una construcción, algo nunca completo—siempre 'en proceso'. . ." (Hall y du Gay 1996: 2). Hall y du Gay (1996: 4) notan que los aspectos simbólicos o semióticos de la cultura juegan un papel poderoso en este constante proceso señalando que las identidades son "constituidas dentro, no fuera de la representación. Ellos se refieren a la invención de la tradición tanto como a la tradición en sí misma, la cual ellos nos insisten en leerla no como una reiteración continua pero como 'el cambio mismo': no el llamado regreso a las raíces

pero un término más próximo a nuestras 'rutas'". Esta observación es especialmente pertinente para los tallados en esta exposición, que son en definitiva una "representación" de la cultura maya, aunque la manera en que son entendidos por los turistas como una referencia concreta a la "auténtica" cultura antigua de los mayas difiere de las nociones más complejas de identidad personal de sus fabricantes.

Identidad Cultural, Autenticidad, y Arte

Relacionada con la discusión acerca de la identidad cultural está la noción de "autenticidad". Los tallados de madera en esta exposición levantan preguntas con respecto al uso de este término, y demuestran la ambigüedad de este concepto. Dentro los parámetros tradicionales de la historia de arte, la autenticidad viene siendo la preocupación de entendidos o curadores quienes están interesados en determinar si una obra de arte es el producto genuino de un artista, de una cultura, o de un período al cual ésta está atribuida. Por otro lado, en el discurso antropológico la autenticidad se ha asociado frecuentemente a cuestiones de etnicidad y se ha utilizado para evaluar el grado en el cual un pueblo, una cultura, o formas de arte se mantienen fieles a interpretaciones arraigadas y comúnmente compartidas acerca de lo que es correcto y apropiado respecto a las creencias y prácticas tradicionales, o a las formas de cultura material. Cuando se trataba con artefactos estéticos de culturas no occidentales, la interpretación común era que estos objetos eran auténticos si es que eran producidos y utilizados localmente, y si provenían de una tradición relativamente continua de producir tales objetos, mientras que los objetos que fueron hechos para el comercio o para la venta a los forasteros, o que representaban formas e imágenes desconocidas anteriormente eran vistos como contaminados e "inauténticos". Sin embargo, Graburn (1999: 351) observó que sus informantes juzgaron las esculturas de esteatita de los Inuits—una forma enteramente nueva—como más auténticas, y las replicas de anti-

guos artefactos de los Algonquinos, vendidos como artesanías de los Cree, como inauténticos, sugiriendo de tal modo que una persona que no es experta puede definir lo inauténtico como "algo mal clasificado, o que pretender ser algo que no es". Mediante esta definición, algunos tipos de reproducciones de máscaras y figuras africanas que son discutidas en los ensayos en este volumen por Christopher Steiner, o la joyería de plata del suroeste producida en serie descrita por Janet Berlo, se podrían considerar como inauténticos. En la medida en que los tallados de madera del Puuc en esta exposición recuerdan y se basan estrechamente en las imágenes de otro periodo y estilo cultural podrían ser etiquetadas como inauténticas o como "falsificaciones" por los criterios de los especialistas (o quizás como "kitsch" según Castañeda en su ensayo en este volumen). Por otra parte, puesto que las minuciosas replicas de la imaginería artística de los mayas precolombinos presentes en estas esculturas de madera no se producen con la intención de persuadir a los espectadores de que son antigüedades, ni los compradores las entienden así, ellos podrían ser considerados como auténticos, en contraste a la definición de lo inauténtico señalada por Graburn. Como Erik Cohen (1988) ha observado, estas valoraciones tienden a ser más precisas dependiendo de la profundidad del conocimiento del espectador sobre la cultura y las formas de arte en cuestión. Sin embargo, este conocimiento no siempre tiene un valor neutro. Los que poseen conocimiento especializado pueden utilizar su "gusto discriminatorio" no sólo para determinar aspectos fácticos de la historia y del autor, pero también para establecer las definiciones de qué cuenta como arte verdadero y qué no cuenta, y qué arte se expone y cual no. Como Marvin Cohodas (1999: 161) ha observado:

> . . . catalogando todos estos trabajos como "arte turístico" [se] hace evidente una circunstancia particular de consumo que no sólo niega la importancia de los distribuidores en construir y autentificar los significados y los valores relacionales sobre los cuales

la valoración del mercado y la clasificación étnica se basan frecuentemente, sino también evoca todas las nociones de lo inauténtico que el término "turista" ha venido a implicar.

Es claro entonces que debemos tener cuidado al usar tales términos como "arte turístico" o en evaluar la autenticidad de los tallados como los que son parte de esta exposición. Producidos sobre todo para la venta a los visitantes extranjeros o de la región del Puuc estos podrían ser considerados como "mero" arte turístico. Asimismo, como ejemplos de tipos de obras de arte que han sido desarrolladas sólo recientemente, podrían ser considerados como "inauténticos" de acuerdo a los criterios de evaluación que se han utilizado hasta hace poco. Sin embargo, preferimos acercarnos a ellos como casos fascinantes de objetos estéticos producidos en un contexto particular de globalización, de contacto cultural, y como reflejo de la mezcla de creatividad personal, de orgullo en el trabajo artístico y de capacidad empresarial de sus fabricantes. Mediante la discusión de los objetos en sí mismos como del contexto histórico más amplio, nos hemos esforzado en examinar la identidad doble de los objetos como arte y artefacto.

Los Ensayos

En los ensayos para este catálogo los colaboradores ofrecen estudios específicos sobre artefactos estéticos en relación a varios de los temas referidos anteriormente, y también introducen sus propias observaciones y perspectivas en estos temas.

En su ensayo "Creatividad Artística del Nativo Americano y la Cultura del Consumo", Janet Berlo examina varios tipos de artefactos estéticos que fueron producidos sobre todo por los nativos Norteamericanos para las colecciones de los foráneos. Ella discute una serie de objetos representativos, incluyendo los dibujos de los Indios del Llano, los tallados en argilita de los Haida, el arte turístico de Alaska (como las replicas en miniatura de objetos funcionales y los

tallados en marfil), la cestería de la tejedora Elizabeth Hickox procedente del Karuk - California, el trabajo con abalorios de los Iroqueses, y el arte turístico del sudoeste americano. Berlo examina temas de mercantilización, comercialización e identidad cultural, resaltando el carácter específico de estos trabajos ya que cada uno surge de una matriz de cambio histórico y de contacto cultural que los afecta pero que también es utilizada conscientemente por los indígenas para crear nuevos tipos de expresiones estéticas dirigidas a nuevas audiencias. A menudo tomando formas híbridas, estas expresiones representan varias combinaciones de antiguas y nuevas técnicas, de materiales y temas. Si bien éstas respondieron a menudo a las expectativas de la gente blanca sobre lo que debían ser las artes y las artesanías de los "indios", la realización de estos objetos también permitieron que sus creadores mantuvieran su identidad étnica y su agencia, así como les abrió la oportunidad de realizar trabajos menos serviles y más creativos. La discusión de Berlo sobre las circunstancias en las cuales la joyería de plata es producida para la venta, por los vendedores que se ubican debajo de los portales del Palacio de los Gobernadores en Santa Fe, aborda finamente el carácter complejo de crear el efecto de "autenticidad". Ella observa que no sólo el edificio del estilo colonial español en sí mismo es un edificio del s. XX, sino que muchas de las obras de plata "hechas a mano" están producidas en un taller parecido a una fábrica que está cuidadosamente escondido de los compradores potenciales. En conclusión, ella observa que "a través de la historia de las interrelaciones entre el artista indígena y el comprador no-indígena, las prácticas sociales implicadas en la producción y la comercialización de tales obras han sido complejas y polivalentes. Tradición e innovación, valores colectivos y visión individual, valores económicos e ideológicos se ponen en juego en la arena del arte turístico". Christopher Steiner, en su ensayo "La Imagen de África y su Relación al Comercio", centra la atención en el intercambio de dos tipos de productos estéticos—el paño europeo producido

comercialmente y las recientes esculturas de madera africanas creadas específicamente para la venta a los foráneos—como ejemplos de dos maneras distintas a través de las cuales las imágenes de África han sido construidas por occidente. Steiner observa que los europeos han tenido tanto actitudes positivas como negativas hacia África, por momentos enfatizando una visión más idílica y romántica (sin embargo estereotipada y degradante) de un continente "primitivo" y virgen, mientras que en otros expresando desdén y miedo enfocándose en los aspectos supuestamente salvajes de la gente y de las culturas africanas. Él sostiene que aunque la conquista europea y el control colonial de África dependieron de una mezcla de ambas actitudes, la realidad económica del comercio de los textiles obligó a los europeos (sobre todo a los británicos y a los franceses) a que evitaran sus opiniones racistas y etnocéntricas para fomentar la extensión capitalista. Los fabricantes, notando que la gente de África tenía gustos particulares y distintos, y que basaban sus preferencias estéticas en criterios previsibles, se vieron forzados a rediseñar sus propios productos para aumentar su atractivo en el mercado. Por otro lado, la más reciente producción de las conocidas máscaras de madera, figuras escultóricas y otros artefactos que a menudo están ilustrados en libros académicos representan la supervivencia de la imagen de África como un continente inmutable y altamente subdesarrollado. Reconocido como "arte primitivo" en las primeras décadas del s. XX, después de su adopción y apropiación por los artistas modernistas, tales obras hablan de una continua "invención de África", que enfatiza la supuesta tosquedad y los aspectos incivilizados o preindustriales de sus culturas "tradicionales". Steiner precisa que muchos turistas, o los compradores en tiendas en el extranjero, tienen una imagen preconcebida del auténtico arte africano que esta basado en los libros de arte y en los catálogos de las exposiciones, y que los empresarios locales—como los talladores Senufos que Steiner (1994) ha documentado en su libro *African Art in Transit (El Arte Africano en Tránsito)* y en otros

estudios—replican su propio arte y el de sus vecinos para satisfacer los deseos de los extranjeros. En sus reflexiones finales, el autor discute las maneras en que el artista contemporáneo Yinka Shonibare—quien frecuentemente utiliza el paño comercial como un símbolo visual de su identidad africana—aborda en sus obras aspectos relacionados a la persistencia de actitudes colonialistas y de estereotipos culturales.

En el ensayo "Estética y Ambivalencia de la Modernidad Maya: La Etnografía del Arte Maya", Quetzil Castañeda repasa el desarrollo de las tradiciones de tallados en piedra y en madera en Pisté, Yucatán, situado junto al sitio arqueológico de Chichén Itzá. Castañeda considera que esta tradición del arte pistéño, primero desarrollada por Vincent Chablé, es el principal punto de origen de las múltiples formas regionales de arte turístico, que varían desde las piezas de gran fidelidad en relación a los obras de los antiguos mayas vistas en el estilo replica de la región Puuc (esto es discutido más adelante en el texto del catálogo y en el ensayo de Mary Katherine Scott) hasta otras artesanías de Yaxuna, un pueblo también cercano a Chichén Itzá. Basados en la combinación de elementos visuales de los antiguos mayas o en otras fuentes mesoamericanas (por ejemplo, los códices, los monumentos de piedra, las imágenes icónicas de Chichén Itzá tales como el Chac Mool o la serpiente emplumada) pero sin una larga herencia local, los tallados de Pisté fueron al principio desacreditados como piezas inauténticas. Puesto que estos recuerdos turísticos se han vuelto más populares, en parte mediante el reconocimiento oficial por el INAH, y también apoyado por las investigaciones y la ayuda promocional dada por el mismo Castañeda, algunos talladores han podido explorar otra identidad, la de un artista-empresario, aunque la expresión de esta identidad es "sutil y reside materialmente en la calidad de su trabajo y en el reconocimiento de los artistas y artesanos de Pisté de esta diferencia cualitativa en su trabajo y en sus capacidades de producir más piezas hermosas". Castañeda también observa que la continua disputa sobre cuándo y dónde los artesanos

(o sus vendedores) pueden vender sus trabajos en Chichén Itzá plantea importantes preguntas sobre quién "posee" y quién se beneficia de la herencia de los sitios arqueológicos.

Las oportunidades para los artesanos de Pisté de demostrar su producción artística está condicionada en gran medida por las fuerzas del mercado. Así, muchas de las piezas son producidas rápidamente con un ojo puesto en atraer la mirada del turista y el otro en asegurar una venta. Sin embargo, muchos artesanos de Pisté han podido crear obras más ambiciosas y estéticamente mejor trabajadas, tanto como resultado de obtener comisiones especiales como de expresar simplemente su habilidad y creatividad personal, que son demostradas por una combinación entre la invención de la forma y un tallado mimético de los modos de vida de la región que expresan energía y realismo. Diferente de otras artes regionales producidas para la venta a los turistas (por ejemplo, en Oaxaca o en las montañas al sur de la región maya) que se esfuerzan por mantener una calidad de "arte popular", los de Pisté (y por extensión los tallados del Puuc mostrados en esta exposición) son más cuidadosamente acabados y demuestran el naturalismo preferido tanto por los mayas precolombinos como por los turistas. Castañeda hace una afirmación importante al señalar que nominar simplemente a un objeto como "arte turístico" no hace justicia en explicar como éste es evaluado y ubicado en un sistema de producción artística, puesto que la venta de objetos estéticos puede ir desde recuerdos baratos hasta trabajos muy elaborados comprados por los turistas en las galerías de los capitales más importantes del mundo. El autor concluye con una discusión sobre los tallados de Pisté (y del Puuc) como kitsch, pero con un reconocimiento de que el kitsch está basado en y refleja la fascinación de los compradores/espectadores de los iconos culturales que han llegado a ser tan familiares como símbolos (en este caso de la civilización maya) que permiten a los turistas llevarse a casa una parte de su propia representación precondicionada de la cultura maya/mexicana.

El ensayo de Jeff Kowalski examina el sitio de Uxmal y su papel en la construcción de la identidad maya desde épocas precolombinas hasta el presente. Hoy en día esta identidad es moleada por las fuerzas del turismo y como resultado de ser reconocida como patrimonio mundial. Sin embargo, la identidad de Uxmal se ha construido y disputado desde su fundación, y se ha formado regularmente en conexión con los sistemas más amplios del mundo. Estas negociaciones y conexiones comienzan con el rápido crecimiento demográfico en la región Puuc en el s. VIII y la creación de nuevas políticas por parte de gobernantes que estuvieron implicados en el comercio regional y de larga distancia. Más adelante, durante el período posclásico y el inicio de la época colonial, los reclamos de la familia Xiu de haber fundado Uxmal reforzó su autoridad política, primero como miembros del gobierno conjunto en Mayapan, y luego como "señores naturales" bajo el dominio español.

Más recientemente, Uxmal, como otros sitios importantes, se ha convertido en un símbolo de la identidad y de la civilización maya. Este proceso comenzó con la centralidad dada a Uxmal y a la región Puuc en famosos relatos de las exploraciones a la región maya (por ejemplo, Incidentes del Viaje en Yucatán por Stephens y Catherwood), e incluye también el uso de Uxmal como modelo para las secciones mayas de las ferias mundiales (la exposición colombina de 1893 en Chicago, la feria mundial de 1933 en St. Louis) y su impacto en la arquitectura de Frank Lloyd Wright y de Roberto Stacy-Judd. El ensayo continua señalando el frecuente énfasis dado a Uxmal y a la región Puuc en los informes sobre la antigua cultura maya, yendo desde su cobertura por la arqueología maya en revistas reconocidas a las referencias de la arquitectura de Uxmal en el parque temático de Disney EPCOT y en la reciente impresionante e hiper-violenta película *Apocalypto*. Desde que Uxmal se ha convertido en un sitio patrimonial y un destino para los diversos tipos de turistas (turistas culturales, mochileros, personas "new age") la infrae-

structura turística de Uxmal se ha ampliado. Los visitantes llegan con diversas experiencias influidas por sus propios objetivos y conocimientos por lo que el significado de Uxmal sigue siendo un recurso cultural disputado y no contenido o definido totalmente por los estudios arqueológicos.

El ensayo de Mary Katherine Scott considera en más detalle la producción entre los artesanos que trabajan en la región Puuc. Ella discute como los artesanos son receptivos a la manera en que su cultura es percibida por los turistas, y como ellos acentúan ciertos aspectos de las representaciones populares de su cultura para ajustarse al ideal del turista. Al visitar una región maya, los turistas esperan encontrar lo "nuevo" o lo "exótico". Conscientes o no, los turistas tienen nociones preconcebidas de los mayas mucho antes de que visiten esta zona, ya que son influenciados por las maneras en que la cultura popular y los medios retratan la cultura antigua y contemporánea de los mayas. Scott describe como las opiniones occidentales acerca de los mayas han cambiado durante los siglos basadas en diversas fuentes académicas o populares, buscando con ello contextualizar el mercado en el que se producen y se venden los tallados de madera de la región Puuc.

De este modo, los gran atención que los artesanos del Puuc ponen en los aspectos de su cultura maya (en cómo es percibida por los foráneos) es utilizada como estrategia de marketing, en la medida en que van reproduciendo en madera y en otros materiales replicas portables de algunas de las más famosas esculturas antiguas en piedra para su venta en el mercado turístico. Como es el caso de otras muchas artesanías en Yucatán, estas reproducciones a menudo son hechas con bastante habilidad y alta calidad, pero su función como "arte turístico" las relega a las categorías de "arte menor" o "no arte", ubicándolas como una clase polémica de objetos dentro del campo de la historia de arte. A pesar que sean una forma de "apropiación", al ser ejemplos de "arte turístico" generalmente son consideradas menos complejas que las apropiaciones de originales en el arte occidental con-

temporáneo o antiguo. El prototipo de la antigüedad, por otro lado, se mira como "arte elevado", lo cual se demuestra en el hecho de que estos "originales" están exhibidos en renombrados museos de arte y de antropología en todo el mundo. Los mayas precolombinos, sin embargo, no habrían concebido estas esculturas cargadas espiritualmente y políticamente como "bellas artes" en el sentido occidental del término, así que su recontextualización hoy en día por académicos de occidente levanta interrogantes con respecto a los sistemas occidentales de estética y a la clasificación del arte en categorías binarias (como arte alto contra arte bajo, bellas artes contra arte popular, original contra reproducción). Considerando las ambigüedades y posibles contradicciones implicadas en tales prácticas de denominación, Scott plantea que resulta más productivo examinar los artefactos estéticos en relación a sus contextos históricos y a complejas esferas de producción.

El Acercamiento de la Exposición

Una exposición en un museo o en una galería es siempre un "terreno disputado", que implica decisiones acerca de cómo elegir, exhibir y discutir los objetos sobre la base de supuestos culturales que varían en el tiempo, lugar y contexto institucional. Lavine y Karp (1991: 1) observan que las exposiciones se convirtieron en el foco de un intenso debate durante el período de los años 80 hacia adelante, dado que "grupos que intentan establecer y mantener su sentido de comunidad y reafirmar sus demandas sociales, políticas y económicas en el mundo más amplio desafían el derecho de las instituciones establecidas de controlar la representación de sus culturas". En este sentido, los curadores de los museos, incluso los que trabajan con buenas intenciones, pueden encontrar las premisas subyacentes de su exposición e interpretaciones acaloradamente discutidas, o incluso sus móviles cuestionados.

Como Lavine y Karp (1991: 3) mencionan, Duncan Cameron "distinguió entre dos posturas distintas

relacionadas a los museos", una postura tradicional que consideraba el "museo como templo", un lugar en donde los estándares del valor y las interpretaciones objetivas son establecidas y mantenidas, contra un modelo más nuevo de museo entendido como foro para la "confrontación, la experimentación y debate" (Cameron 1972: 197). En este nuevo paradigma, el énfasis en el arte occidental, que sirvió una vez como el árbitro para evaluar la calidad y la importancia estéticas, ahora está siendo con frecuencia desafiado por la incorporación de las artes de tradiciones no occidentales y de tipos de arte de otros grupos que tradicionalmente han sido ignorados o sub-representados.

En esta exposición y en la discusión que sigue somos conscientes de estos problemas y nos esforzamos para proporcionar los marcos históricos y teóricos que son necesarios para una comprensión más completa de la importancia de las esculturas talladas de madera presentadas en esta exposición. Comenzamos por proporcionar el contexto histórico y cultural de la región Puuc y del norte de Yucatán, lugar en que los artesanos mayas representados en esta exposición viven y trabajan. Continuamos con una discusión del contexto histórico y social de los artesanos y de sus tallados considerando las formas en que la "tradición" del Puuc se puede ubicar dentro de la más amplia industria artesanal en Yucatán. También abordamos la importancia histórica de los tallados de madera en épocas precolombinas. Luego presentamos información biográfica sobre cada artesano y les proporcionamos una oportunidad para que en sus propias palabras expliquen su trabajo y sus nociones de identidad cultural y artística. Esto es seguido por un resumen de los tallados, del desarrollo histórico de la "tradición" de tallado del Puuc, de las principales fuentes precolombinas que los artesanos utilizan y de cómo estos temas están dirigidos al especializado mercado turístico que los consume. También comparamos la "escuela" Muna-Puuc con la tradición de tallado encontrada en Pisté (discutido detalladamente en el ensayo de Castañeda

en este volumen), para profundizar más en esta idea de cómo los tallados están creados y modificados para atraer las preferencias de los turistas, así como la manera en que incorporan la percepción de los visitantes foráneos de como debe verse la cultura maya en Yucatán. En las dos secciones siguientes, pasamos a discutir cómo las tallas se relacionan con las nociones de la identidad maya en Yucatán, tanto las expresadas por los mayas como las percibidas por los foráneos. Enmarcamos esta discusión dentro de la teoría e investigación antropológica tanto de principios del s. XX como desde las perspectivas actuales.

Nos esforzamos por reconocer que las nociones de identidad cultural transmitidas por las esculturas en esta exposición representan una visión contemporánea pero concreta de la "cultura maya" que se ancla en el pasado precolombino. Sin embargo, incidimos que los fabricantes de tales objetos, mientras que adquieren orgullo en sí mismos como descendientes de esta civilización antigua, reconocen completamente las diferencias entre ellos mismos y sus lejanos antepasados, y crean sus tallados como parte de una "tradición inventada" (comparable a ésa encontrada en las obras producidas en Piste, Yucatán discutidas por Quetzil Castañeda en su ensayo en este volumen) que es pensada para atraer el ojo, para apelar al gusto, y para persuadir a los turistas de comprar sus productos.

Finalmente, ponemos estas discusiones dentro de un marco de interpretaciones cambiantes de la estética y del arte. El arte ahora es con menor frecuencia definido por un grupo de objetos canonizados cuyo valor es universal e inmutable. Más bien está abierto a categorías previamente ignoradas de artefactos y de expresiones cuya importancia reside en la interrelación entre forma y contenido y en los contextos históricos y culturales más amplios de los cuales surgen. El valor de los trabajos de arte es reconocido no como algo inherente, pero como algo determinado por los marcos institucionales dentro de los que circulan y se discuten. Aunque reconocemos que los enfoques que utilizamos y que nuestro propio cono-

cimiento e interpretaciones siguen siendo parciales, nos hemos esforzado por elaborar un estudio que continua siendo autocrítico y abierto a otras interpretaciones, al mismo tiempo que proporcionamos información útil con relación con el contexto(s) y contenido(s) de las tallas de madera creados por Miguel Uc Delgado, Angel Ruíz Novelo, Jesús Marcos Delgado Kú, y Wilbert Vázquez.

Los tallados de madera y los artesanos de la region Puuc—contextos, identidades culturales, y significaciones contestados

El crecimiento del turismo en Yucatán se debe en parte a la construcción de lujosos hoteles en la costa este y a la mejor accesibilidad a los restaurados sitios arqueológicos mayas. Este incremento del turismo ha promovido una fuerte industria artística y artesanal que impacta las economías de muchas comunidades cuyos residentes dependen de la venta de sus productos al turismo como una fuente importante de ingresos. Después de visitar un sitio arqueológico los turistas suelen comprar estas artesanías como recuerdos o souvenirs en el poblado de producción artesanal aledaño al sitio. Las mejores de estas artesanías, como los tallados presentes en esta exposición, denotan una gran maestría en las habilidades técnicas y un dominio de temas complejos que los distinguen de recuerdos producidos en serie y de bajo costo. Los cuatro artesanos de la región Puuc, presentes en esta exposición, Miguel Uc Delgado, Jesús Marcos Delgado Kú, Angel Ruíz Novelo, y Wilbert Vázquez, representan estas cualidades en sus esculturas.

La seria discusión académica sobre el "arte turístico" tiene un desarrollo bastante reciente dentro de la historia del arte. Dado que éste es producido para una audiencia fuera de museos y galerías, el arte turístico no ha sido considerado arte "culto" y con frecuencia está relegado a la categoría de "no-arte". Más allá de si gozan de "calidad" o "autenticidad", el arte turístico comunica mensajes importantes sobre la cambiante identidad cultural de un grupo y muestra como esta identidad es representada en situaciones de contacto con personas de otros bagajes culturales.

Las esculturas de madera seleccionadas para esta exposición transmiten estos tipos de mensajes. Asimismo, éstas muestran agudeza en el tallado y fina habilidad técnica, gran elaboración de las formas y complejos temas a diferencia de otros recuerdos turísticos de producción en masa (figura 1.1). Estos elementos de calidad estética permiten ubicar estos trabajos como ejemplos especializados de artesanías tradicionales e investigarlos junto a otras obras escultóricas que típicamente están consideradas como arte "culto" o "bellas artes".

En esta exposición revisamos las categorías de arte culto y popular "alto" y "bajo" desde una perspectiva contemporánea y por ende tratamos el arte turístico como un tema que merece una investigación histórico-artística más seria. Discutimos como es que los tallados de madera de la región Puuc, y las tradiciones artesanales relacionadas del estado de Yucatán, pueden ser consideradas dentro contexto más amplio de arte popular y arte turístico mexicanos. Además, analizamos como se originó esta "tradición inventada", ejemplificada por las artesanías en esta exposición, y que significados tienen estos objetos tanto para los artesanos que los producen como para los visitantes que las compran.

Sin embargo, antes de continuar con nuestra argumentación, debemos discutir nuestro uso del término "artista" y "artesano". Debe precisarse que los escultores de la región Puuc se refieren a ellos mismos como artesanos y no como artistas. En inglés, el término "artesano" denota un "craftsperson", es decir, la clase de ocupación que está relegada a la categoría de arte "bajo" entre las tradiciones históricas del arte occidental. Sin embargo, las investigaciones de Mary Katherine Scott en la región Puuc y otros estudios sobre la producción artística en culturas fuera del mundo occidental, sugieren que tales categorías occidentales de arte "alto" y "bajo" no se apliquen

tan fácilmente, y que el término "artesano" no lleva necesariamente las mismas connotaciones negativas que tiene entre las tradiciones visuales occidentales. Así, mientras que reconocemos su arte, habilidad y talento en la discusión que sigue nos referiremos a los talladores del Puuc como artesanos, excepto en esos casos donde se hace necesaria una distinción entre el significado del término occidental y el yucateco.

Yucatán del norte y la region Puuc antes de la conquista

Los artesanos del Puuc viven, trabajan y producen sus esculturas en un área que forma parte de una región más amplia de habla maya, la cual ha experimentado transformaciones sociales, políticas y culturales desde tiempos prehispánicos hasta el presente. El término Puuc deriva del nombre maya-yucateco dado a la cadena de colinas que se extiende a lo largo del noroeste de la península de Yucatán. Al sur de la cadena del Puuc se ubican numerosas ciudades antiguas así como pequeñas ruinas mayas. Las ciudades más grandes y más impresionantes del Puuc, tales como Uxmal, Kabah, o Sayil, comenzaron un período de rápido crecimiento hacia finales del s. VIII (figura 1.2). Durante el período Clásico Terminal alrededor del 750 al 1000 D.C. hubo una enorme explosión de creación arquitectónica y artística en el norte de Yucatán dando por resultado construcciones monumentales y sobresalientes fachadas arquitectónicas en las edificaciones del Puuc. Éstas fueron generalmente decoradas con complejos motivos geométricos, como con las máscaras de hocicos largos que representaban al dios de la lluvia, Chaak (figura 1.3). Al final de este periodo, las dos ciudades mayas con mayor poder, Uxmal y Chichén Itzá, se convirtieron en capitales de estados regionales. Hay evidencia de que estas dos ciudades dominantes estaban en contacto y que el gobernante de Uxmal, Chan Chak K'ak'nal Ahaw ("señor Chaak"), pudo haber entablado una alianza política y militar con los gobernantes de ciudades cercanas tales como Kabah y Nohpat, así como con los Itzás, gobernantes de Chichén, quienes ayudaron a Uxmal a consolidar su poder en la región Puuc. El gran tamaño de las ciudades orientales del Puuc, sus edificios monumentales y la elaborada arquitectura de sus fachadas evidencian el poder político que sus gobernantes tuvieron en el pasado, y son hoy una de las principales atracciones para los turistas que visitan la región Puuc.

Yucatán del norte desde la conquista hasta tiempos recientes

Entre las primeras expediciones españolas a Yucatán estuvieron las de Francisco Hernández de Córdoba (1517), Juan de Grijalva (1518) y Hernán Cortes (1519). La conquista y la subsecuente colonización de Yucatán comenzó en 1527, cuando una expedición liderada por Francisco de Montejo El Viejo, invadió la costa oriental de la península de Yucatán. Esta campaña, y otra lanzada en 1531, no fueron suficientes. En 1540 el hijo de Montejo y su sobrino organizaron una nueva expedición para conquistar la península. Quizás ayudado por la desmoralización y el diezmo de la población local, debido a las enfermedades epidémicas, este intento fue más acertado dando por resultado la fundación de Mérida en 1542 y de Campeche, Valladolid y Salamanca de Bacalar (cerca de Chetumal) en 1544 (figura 1.4). En el proceso, Montejo ganó el apoyo del señor de Tutul Xiu de Mani, quien se convirtió al catolicismo y proporcionó apoyo militar. Con la ayuda de Xiu, los españoles pudieron derrotar las fuerzas de los mayas del oriente, dando por resultado el control español de los territorios al noroeste y norte-central de la península, incluyendo la zona del Puuc que formó parte de la provincia de Mani.

La conquista implicó la subordinación física y la transformación espiritual de la sociedad y de las creencias mayas. En las áreas subyugadas por los españoles se concedieron encomiendas a los conquistadores, lo cual implicaba el derecho de recoger tributo de las comunidades nativas situadas en los

territorios bajo control del terrateniente. Vinculado a la encomienda estaba el sistema de repartimiento, bajo el cual se obligada a los mayas locales a proporcionar mano de obra para los proyectos públicos y para la actividad agrícola, supuestamente a cambio de paga. Sin embargo los funcionarios españoles y los encomenderos abusaron del sistema utilizando a los trabajadores para aumentar sus propias riquezas.

Quizás el incidente más conocido por convertir a la gente local al catolicismo y por suprimir las creencias religiosas tradicionales ocurrió en Mani en 1562, donde el fraile franciscano, Diego de Landa, patrocinó un auto de fe para eliminar las idolatrías, incluyendo la humillación pública de los mayas locales acusados de herejía (la persistencia en seguir las prácticas religiosas indígenas) y el quemando de códices mayas.

Debido a la reducción de los ingresos y a la disminución poblacional en el noroeste de Yucatán en el s. XVII, el sistema de encomienda fue substituido gradualmente por las estancias (ranchos de ganado) poseídos por los criollos acaudalados (descendientes de españoles). Éstas se transformaron gradualmente en haciendas, grandes fincas trabajadas por los mayas locales, dedicadas especialmente al cultivo del maíz y a la ganadería para el consumo local. Después de que la independencia mexicana fuera declarada en 1821, se establecieron fincas más grandes en áreas productivas de la península central cuya cosecha principal fue la caña de azúcar. Estas haciendas expropiaron la tierra "vacante", que había sido la milpa comunal (campos de maíz) de los mayas locales, quienes a su vez se convirtieron en peones (criados endeudados) sin posibilidad de practicar su tradicional agricultura de roza-y-quema. La destrucción de maneras de vida tradicionales, junto con la de las diferencias étnicas y de clase, fueron catalizadores para la sublevación nativa conocida como la Guerra de Castas. Este conflicto armado, que comenzó en 1847, tuvo su pico en 1848 cuando los rebeldes mayas lograron sitiar Mérida, pero tuvieron que regresar a sus milpas para atender sus cultivos antes de que la victoria final

fuera alcanzada. Las fuerzas criollas reagrupadas fueron capaces de desafiar a los mayas, haciendo que muchos de ellos huyeran al área boscosa poco habitada al este de la península, que corresponde hoy a Quintana Roo. Estos mayas, conocidos como el Cruzob, establecieron ahí una sociedad independiente bajo dirección indígena, con instituciones y estructuras de organización basadas en una mezcla de formas pre-hispánicas, coloniales y del s. XIX. Ellos continuaron luchando hasta que fueron derrotados por las fuerzas yucatecas en 1901.

La Guerra de Castas y el conflicto subsiguiente disminuyeron enormemente la producción de caña de azúcar. Sin embargo, el norte de Yucatán está también bien adaptado al crecimiento del henequén, una variante del cactus del agave, cuyas hojas fibrosas y espinosas fueron utilizadas para producir cordaje y textiles para propósitos industriales y marítimos. El henequén fue un importante producto de exportación en las grandes haciendas a fines del s. XIX hasta principios del s. XX (figura 1.5). La intensa producción del henequén aumentó el comercio y los contactos entre Yucatán y los Estados Unidos, quienes compraron cantidades substanciales de cordaje (particularmente después de la invención del segador de McCormick en 1878). Como cosecha comercial, el henequén produjo un "boom" económico para los hacendados adinerados quienes construyeron impresionantes mansiones a lo largo del Paseo de Montejo, la amplia calle principal que se extiende desde el norte de Mérida y que fue diseñada para emular el Champs Elysees en París (figura 1.6). Sin embargo, tal abundancia fue lograda a expensas de la explotación de los peones mayas quienes trabajaron las tierras de las haciendas bajo duras y paupérrimas condiciones. Las reformas agrarias instituidas después de la Revolución Mexicana de 1910 fueron adoptadas en Yucatan, pero de manera imperfecta, en los años 30 bajo la presidencia de Lazaro Cárdenas.

El s. XX y el principio del s. XXI han sido testigos de transformaciones importantes en la vida maya en el norte de Yucatán y en la gran región maya. La

caída de la producción del henequén tuvo un fuerte impacto económico en la región. Ésta fue el resultado de múltiples factores como la expropiación de grandes haciendas privadas y de su redistribución en ejidos en los años 30, la Gran Depresión, la nacionalización de los molinos del cordaje (que culminaron en la formación de Cordemex en 1964) y la competencia con los productos de fibras sintéticas que coparon aproximadamente la mitad de los mercados mundiales por los años 70.

Como respuesta a la pérdida de los ingresos por el henequén Yucatán ha buscado diversificar su economía. La crianza del ganado y el cultivo de productos especiales son comunes en el campo, mientras que la pesca profesional es más importante entre quienes viven en comunidades aledañas a la costa. Desde los años 80 ha habido una fuerte oferta para atraer a las maquiladoras (fábricas que se dedican a la producción de mercancías de exportación) y dicho proceso intensificado por el paso del NAFTA en 1993. El turismo, centrado particularmente en sitios arqueológicos monumentales tales como Uxmal y Chichén Itzá y en la herencia colonial y tradicional de los mayas (en comparación con Cancún y la Riviera Maya que se enfocan en el turismo de playa y los clubs nocturnos), también ha tenido un papel fundamental en el creciente rédito y ha generado nuevos y diversos trabajos para los mayas de Yucatán.

Las presiones y los cambios creados por un aumento en la globalización, los acuerdos del comercio (NAFTA) y la afluencia de visitantes extranjeros están afectando la identidad cultural de los mayas. No obstante, hasta hace unos años, esta situación no impacto a aquellos mayas que vivían en pueblos rurales más pequeños, debido a su relativo aislamiento y tradicionalismo. Allí las formas antiguas de "ser maya", por ejemplo el uso regular de la lengua maya yucateca, la importancia del (J)Meen local (shaman o curandero) y la práctica de rituales agrícolas que mezclan conceptos católicos y tradicionales mayas, fueron mantenidas a pesar de la introducción de mejoras tecnológicas tales como la electrificación,

la capacidad de comprar maquinarias y equipos que ahorran trabajo o los caminos mejorados. Sin embargo, en los últimos años cada vez es más difícil que el sistema agrícola tradicional pueda mantener a la gente en estos lugares más distantes, por lo que los pobladores buscan fuentes de ingreso en efectivo en ciudades más grandes o en la zona turística en la costa oriental, en donde la "modernización" y un deseo por adoptar nuevas modos de vida erosionan la identificación con la vida tradicional. No obstante, en el pasado los mayas han sabido negociar y adaptarse a las fuertes interrupciones a sus tradiciones culturales, y actualmente la formación de varias organizaciones culturales indígenas que promueven un sentido de panmayanismo contemporáneo y un orgullo en los logros culturales mayas muestran que continúan conservando el conocimiento de su pasado, a la vez que se esfuerzan por lograr un eficaz reconocimiento político, económico y social en el presente.

Contexto histórico y social de los artesanos y sus tallados

Hoy la mayoría de los productores contemporáneos de artesanías en México se sostienen por la industria del turismo, y en algunos casos, por los comerciantes internacionales que compran y revenden artes populares mexicanas en tiendas y galerías de arte en Europa, Estados Unidos y Canadá. Además de los incentivos económicos actuales, algunas industrias de las artesanías mexicanas, tales como los complejos diseños de los textiles de Chiapas, se arraigan también en las técnicas y tradiciones prehispánicas. Tales artesanos encuentran una motivación adicional al preservar una parte de su cultura indígena perpetuada desde épocas antiguas. Otros, como la tradición oaxaqueña de los animales tallados de madera y pintados en colores brillantes, o la tradición de los tallados de madera del Puuc—que es el centro de esta exposición—son "tradiciones inventadas" dado que no tienen ninguna tradición precursora precolombina directa, surgiendo sólo en las últimas décadas. En los

años que siguieron a la revolución mexicana de 1910, el gobierno promovió el concepto de indigenismo, celebrando tanto el pasado precolombino y sus culturas regionales precolombinas como las tradiciones populares para forjar una nueva identidad nacional en un esfuerzo por integrar a la población indígena diversa a la sociedad mestiza. Desde otro sentido, los turistas también dependen en un conocimiento de las antiguas imágenes mesoamericanas, así como de las artesanías más recientes y de otras formas de "arte turístico" indígena, sea éste el resultado de tradiciones "inventadas" o de tradiciones más duraderas, para conectarlas así con su percepción de una cultura indígena auténtica.

Los tallados de madera de la región Puuc, elaborados y acabados cuidadosamente, no representan una tradición artística continua e intacta del norte de Yucatán. Como señala Quetzil Castañeda en su ensayo en este catálogo, estos trabajos son consecuencia de un desarrollo reciente del tallado de madera representando varios temas "mayas" que emergieron en la ciudad de Pisté como respuesta al creciente número de turistas que visita el sitio cercano de Chichén Itzá. Dado que tales tallados carecen de una larga herencia, no fueron considerados como ejemplos genuinos de "arte popular" o de la cultura popular yucateca, y por lo tanto fueron considerados como expresiones inauténticas de la cultura maya. Estas posturas fueron desafiadas en los años 80 por Alfredo Barrera Rubio, entonces director del Centro Regional de Yucatán del Instituto Nacional de Antropología e Historia (CRY-INAH), en una charla que ayudó a cambiar las perspectivas negativas hacia los artesanos de Chichén (conocidos despectivamente como "chac mooleros"), siendo un importante momento histórico para los productores de artesanías en todo el estado.

Aunque la tradición de tallar madera en Chichén, y por extensión en la región Puuc, haya ganado sólo recientemente la aceptación dentro de la principal corriente artesanal, ellas representan un renacimiento de una tradición prehispánica de tallado en madera

documentada por Diego de Landa, quien refirió a la fabricación de "ídolos" (las imágenes de una deidad) de madera. Ejemplos de tales artefactos, incluyendo ídolos y otras figuras, se han recuperado del Cenote Sagrado en Chichén Itzá. Los tallados de madera también fueron utilizados como dinteles en los templos de Tikal en Guatemala, en la casa del gobernador en Uxmal y como jambas en Kabah (figura 1.8). Por ende se encuentran precedentes antiguos para los tallados modernos hechos por los artesanos mayas en Yucatán, no obstante la tradición de hacer tales esculturas fue abandonada después de la Conquista. Las tallas más recientes producidas en Chichén Itzá o en la región Puuc representan un fenómeno relativamente nuevo no siendo ésta una tradición continua. Los artesanos modernos en estos sitios producen sus trabajos sobre todo para la venta a los extranjeros y no los consideran sagrados. Sin embargo, la tradición moderna de tallar de los mayas yucatecos, además de tener características de una tradición "inventada" también expresa deliberadamente símbolos de sus antepasados que adquieren significados polivalentes en un contexto moderno.

Los artesanos

Una breve introducción a los principales artesanos del Puuc, quienes fueron informantes de esta investigación, ayudará a contextualizar su trabajo así como a la industria de la artesanía del Puuc. Miguel Uc Delgado de Santa Elena (figura 1.10) es el hombre de negocios del grupo, ya que trabaja para el gobierno municipal local como miembro del consejo y ha sido elegido como Secretario General de Trabajadores de Yucatán en el Instituto Nacional de Antropología e Historia (INAH). En el pasado esta oficina fue ocupada sólo por personas que vivían en Mérida, por lo que Miguel se siente muy orgulloso al ser el primero del interior elegido para este cargo. Además, entre su abuelo, su padre y sus 26 años de trabajo tienen colectivamente más de 100 años trabajando para el INAH, siendo ello una fuente

de orgullo para la familia. Miguel también posee y administra con su esposa, Estela, el restaurante y el hotel de Chacmool en Santa Elena. El restaurante abre sus puertas de 8 am a 9 pm, y el hotel cuenta con ocho dormitorios dobles, dos de los cuales han sido recientemente construidos. Hay también una pequeña tienda de artesanías anexa al restaurante en donde Miguel vende no sólo sus tallados de madera, sino también estatuillas de cerámica del estilo de Jaina, figuras hechas a molde y dibujos en cuero elaborados por otros artesanos (generalmente miembros de su familia extensa). También vende las hamacas y los huipiles bordados por Estela, así como postales, cajas de cerámica decorativas y joyería moldeada. Miguel es también uno de los guardianes de Sayil, un sitio arqueológico del Puuc, en donde también vende algunos de sus tallados. Sin embargo, su sobrino, Edwin Mas Uc que vive en Muna, hace la mayoría de los tallados para la venta en Sayil. Debido a sus diversas responsabilidades Miguel ha tenido poco tiempo para hacer sus tallados en los últimos años, pero ha empezado a tallar con más frecuencia desde que concluyó su cargo con los trabajadores de Yucatán en el 2008.

Jesús Marcos Delgado Kú, el primo de Miguel, vive en Muna, un pueblo de mediano tamaño ubicado en el noreste de la zona arqueológica del Puuc, en donde posee una parcela que utiliza para plantar árboles de cedro y lima y obtener un ingreso adicional. En Kabah ofrece visitas guiadas a los turistas que hablan español y cuando no presta sus servicios como guía realiza y atiende sus tallados de madera, siendo el único artesano en el sitio (figura 1.9). Jesús está muy interesado en su herencia maya y las tradiciones de sus antepasados, por lo que ha puesto gran esfuerzo por aprender sobre los antecedentes históricos de los temas que talla, tanto en términos de la historia antigua como de las interpretaciones de investigadores actuales. Jesús, como los otros artesanos del Puuc, es privilegiado al tener cierto acceso a distintos investigadores y arqueólogos que trabajan en los sitios arqueológicos del Puuc, una

relación que él ha sabido aprovechar completamente al trabajar en Kabah.

Angel Ruiz Novelo de Oxcutzcab es el guardián en la zona arqueológica de Labná, en donde también tiene un pequeño sitio que sirve como su taller (figura 1.12). Como artista autodidacta, sus tallas a menudo tienen una apariencia más rudimentaria en términos de las proporciones de sus figuras, pero esto, junto con su estilo rústico de tallar, es parte del encanto de sus piezas. Para Angel, el poder hacer una vida apegada a sus tallados es una gran bendición y se siente honrado continuando la tradición iniciada por Antonio Salazar, el primer artesano moderno en el área del Puuc. De esta forma tiene la oportunidad de perpetuar la iconografía sagrada de sus antepasados.

Wilbert Vázquez, también de Muna, es el hermano de Juan Vázquez, un guía turístico radicado en Mérida, quien ha sido también un informante clave para este estudio. Wilbert, que es conocido localmente por su apodo "Shibata" (por su corte de pelo que se asemeja al estilo del famoso luchador japonés) es también un guía turístico. Como su hermano habla alemán, italiano e inglés, además de español y maya, su lengua madre (figura 1.11). Wilbert es un artesano con un fino estilo de tallar que le gusta deconstruir las formas antiguas mayas y a partir de ahí reinventar totalmente nuevas imágenes. Debido a su demandante horario como guía, Wilbert tiene menos tiempo para sus propias creaciones y se ha convertido en una especie de comerciante de los trabajos artesanales de otros productores de Muna. Él no tiene una tienda formal pero a veces vende sus piezas en su casa sin mayor publicidad. En los últimos años Wilbert estuvo haciendo solamente marcos de madera para las obras de los otros artesanos, estos son maravillosamente tallados con representaciones de diseños geométricos y simbólicos que se encuentran en varios de los monumentos arquitectónicos del Puuc. Hoy en día Wilbert ha retomado el tallado de sus complejas obras escultóricas.

Los Tallados

DESARROLLO DE LA TRADICIÓN

Debido al aislamiento relativo de la región del Puuc de otras áreas turísticas en Yucatán, la producción de artesanías en esta zona se ha desarrollado con bastante independencia. Mientras que las tendencias estilísticas de las artesanías producidas en Pisté y Chichén Itzá se han expandido a lo largo de Yucatán, la variante Puuc del "estilo" réplica (o reproducción) se ha mantenido relativamente en esta área, con solo unos cuantos ejemplos de tallados semejantes en otras partes del estado. En algunos casos estos similares estilos de tallar pueden estar ligados a los individuos que de alguna manera están vinculados con Muna o la región Puuc.

Los orígenes de la tradición del tallado en el Puuc pueden examinarse como parte de una tendencia económica más amplia y en relación al crecimiento de los viajes a México. El turismo aumentó dramáticamente durante el período de 1970 a 2000 y es hoy la segunda fuente más grande de empleo en México, y con frecuencia se ubica como uno de los tres recursos principales de intercambio transcultural. Según Alfonso Escobedo, director de Ecoturismo, una agencia de viajes en Mérida, el turismo anual en México ha aumentado constantemente desde 1968, cuando los XIX Juegos Olímpicos habían sido llevados a cabo en la Ciudad de México, D.F. Históricamente, las únicas naciones consideradas como anfitriones potenciales de los Juegos eran aquellas que podían solventar un evento de tal alto nivel y costo. La cobertura de los medios internacional de las Olimpiadas retrató a México en la capacidad de poder competir con las otras naciones industrializadas del globo, aunque las contradicciones entre esta imagen pública y la realidad de la vida para la mayoría de los mexicanos llevarían a protestas, culminando en los ataques trágicos de los estudiantes en Tlatelolco. A pesar del lado más oscuro de las Olimpiadas de 1968, éstas se pueden considerar como uno de los importantes catalizadores en el desarrollo de muchos servicios y sectores comerciales ligados a la industria de turismo en México, incluyendo el mercado creciente de las artesanías.

La "tradición" del tallado en la región Puuc parece haberse originado en las prácticas artísticas de la persona específica de Antonio Salazar, quien vivía en el área y enseñó su proceso y técnica a los otros pobladores. Según Escobedo, Salazar comenzó a tallar desde joven, en los años 60, sin ninguna instrucción formal. Escobedo recuerda que Salazar disfrutaba tallar figuras de monumentos antiguos de los mayas, especialmente caras y glifos, y la popularidad que alcanzaron estas piezas entre los turistas le permitió abrir una tienda cerca de la carretera principal en Muna. Posteriormente, mientras el conjunto de sus obras y su reputación como artesano crecieron, Salazar comenzó a enviar sus tallados a Uxmal para ser vendidos en una tienda en el mismo sitio.

Con el tiempo, Salazar fue empleado en la escuela técnica local en Muna, la Escuela Secundaria N16 Doctor Jaime Torres Bodet, donde enseñó a los estudiantes las técnicas de tallado. Como hombre soltero y sin una familia que sostener, las necesidades financieras de Salazar eran mínimas. Además con la seguridad de una renta fija del gobierno ya no tenía que depender en la venta de su artesanía para sobrevivir. Consecuentemente, poco después de obtener la posición de maestro en la Secundaria, Salazar cerró su tienda y se dedicó solamente a enseñar a otros su arte. Miguel Uc Delgado, Wilbert Vázquez y Jesús Marcos Delgado Kú, así como otros en Muna, estudiaron con Salazar en la Secundaria antes de trabajar independientemente. Escobedo ha señalado que a cambio ellos "enseñaron a otros, así que se abrió un comercio en la región Muna-Puuc".

Jesús recuerda que la Secundaria "era realmente un taller de tallados de madera", donde las personas se reunían para aprender a dibujar, a conocer las técnicas básicas de tallar y a saber las proporciones del cuerpo. Él precisa que mientras que Antonio Salazar es generalmente considerado de ser autodidacta, no teniendo ningún entrenamiento artístico formal en

una escuela como en la que enseñó, él pudo haber tenido cierto tipo de entrenamiento con el famoso artista colombiano-italiano Rómulo Rosso. Rosso es principalmente conocido en Yucatán por su comisión de 1956, el *Monumento a la Patria* en Mérida, una larga pared semicircular en una glorieta en el Paseo Montejo. Jesús indica que Rosso compró una hacienda antigua en Muna como casa de vacaciones y empleó al padre y al abuelo de Antonio para trabajar en la propiedad, y es posible que el joven Antonio les pudiera haber acompañado. Jesús especula que Salazar pudo haber recibido lecciones informales de arte por parte de Rosso, despertando su chispa creativa y ayudándole a desarrollar su talento natural que influenciaría más adelante a toda una generación de artesanos en la región Muna-Puuc.

Los tallados del Puuc se trabajan en maderas duras de alta calidad y son individualmente diseñados y tallados por los artesanos. El gran tiempo y la atención que los artesanos dedican a sus tallados reflejan las preferencias de sus principales compradores, viajeros que tienden a hacer un esfuerzo especial para ver los sitios arqueológicos locales. Ya sea con estudios formales o informales, muchos de estos visitantes tienden a estar bien informados de diversos aspectos sobre los mayas precolombinos y/o modernos, por lo que los tipos de reproducciones altamente detalladas y cuidadosamente ejecutadas de los monumentos antiguos mayas que los artesanos del Puuc producen están dirigidas a este tipo de compradores. Si bien, aunque el estilo replica y los cuidadosos métodos de trabajo están destinados a atraer a los principales compradores, los artesanos también tienen motivaciones y metas personales que les inspiran a crear. En entrevistas con Mary Katherine Scott los artesanos indicaron que se sienten orgullosos de su herencia y son privilegiados en tener la oportunidad de recrear las imágenes de sus antepasados mayas. Ellos encuentran placer en el proceso de tallar, son talladores talentosos, y como artesanos disfrutan de una forma de vida relativamente más próspera y tienen contactos más cosmopolitas que otros habitantes de la región.

SUJETOS Y FUENTES

Los tallados de madera del Puuc muestran un conjunto de temas, fuentes y formas comunes en que los artesanos reinterpretan estos temas a través de sus influencias artísticas y estilo característico de tallar. Los temas preferidos entre los artesanos del Puuc son las representaciones altamente detalladas en piedra de los gobernantes de Yaxchilán y Palenque, así como imágenes de las deidades del códice Dresden y de la cerámica policroma maya. Los artefactos de Yaxchilán que son elegidos con frecuencia incluyen los dinteles 24 y 25. El primer de estos representa al gobernante Iztamnaaj Balam II ("Escudo Jaguar") y a su esposa, dama K'ab'al Xook, en un ritual de derramamiento de sangre (figuras 1.13, 1.14), mientras que el segundo dintel demuestra las repercusiones de tales rituales como la aparición de un antepasado lejano que es evocado y emerge de una "serpiente de la visión" en forma de 'S' (figuras 1.1, 1.15). Los temas de Palenque incluyen las representaciones del gobernante Janaab' Pakal I. Una de ellas es la de este gobernante entrando por la quijada del mundo de los espíritus, y esta escena está representada en el árbol del mundo cruciforme que aparece en la tapa de su sarcófago (figuras 1.22, 1.23). También está representado fusionando sus rasgos con los del dios del maíz en su famoso retrato en estuco (figuras 1.24–1.27). Estos temas tomados de fuentes clásicas mayas son populares entre los compradores debido al gran naturalismo de las figuras que se representan, que difieren ampliamente de las imágenes más geométricas y estilizadas encontradas en los sitios del Puuc. A pesar de que los artesanos reproducen varios de los mismos temas, no hay dos figuras exactamente semejantes. Existen marcadas diferencias en la representación de una figura, que es resultado de diferencias en el estilo de tallar, de influencias artísticas y del proceso mismo.

Las representaciones de las deidades mayas en el códice Dresden, cuyo tratamiento curvilíneo de las figuras se presta al estilo preferido de los artesanos,

son elegidas como temas para los tallados más pequeños. Éstos incluyen el dios Chaak (dios B), dios de la lluvia con el hocico largo cuyo rostro también aparece en máscaras en las fachadas arquitectónicas del Puuc, y el dios del maíz (dios E) también conocido como Yum K'aax (figuras 1.44, 1.45). Otros tallados que son populares incluyen el dios viejo Itzamnaaj (dios D) y la diosa de la creación Ix Chel (diosa O, también conocida como Chak Chel), representada con frecuencia con su tocado de serpiente y sosteniendo un florero invertido (figuras 1.46, 1.47). Las figuras talladas de madera son facsímiles casi exactos del códice Dresden, aunque como ocurre con otras figuras, cada artesano las modifica según su estilo personal de tallar. Si bien mucho de ello refleja preferencias estéticas, cada artesano hace también estas modificaciones para reforzar el diseño del tallado para que sea menos susceptible de romperse o agrietarse en las zonas más frágiles.

Otros adornos y figuras incluyen jeroglíficos, dioses del tipo que aparecen en las estructuras de Tulum, jaguares (particularmente los que están en la plataforma de las Águilas y los Jaguares en Chichén Itzá) y el dios L (representado fumando un cigarro, el "fumador", en la jamba del Templo de la Cruz en Palenque), entre otros (figuras 1.37, 1.38, 1.49, 1.50, 1.51). Un número significativo de relieves y de esculturas de tres dimensiones representan a los llamados chacmools (nombre dado por el excéntrico explorador del s. XIX, Augustus Le Plongeon). Con su postura reclinada y sosteniendo una placa o tazón encima de su estómago estas figuras han sido interpretados como intermediarios que llevan mensajes a los dioses (figura 1.52). La prominencia de los chacmools en Chichén Itzá, junto con su uso en la publicidad para Cancún, ha hecho de esta figura una imagen popular en varios tipos de productos artesanales.

Las fuentes de las imágenes para los tallados de los artesanos provienen de conocidos textos escolares o de catálogos de exposiciones de arte y arqueología maya, así como de sus fotografías de los sitios arqueológicos durante sus propias experiencias de viaje. Sin embargo, ellos también utilizan fuentes menos convencionales tales como cuadernos de colorear para niños o guías turísticas más populares con dibujos de los monumentos y adornos mayas. Los artesanos del Puuc tienen generalmente un relativo conocimiento del significado y de la historia de las imágenes que tallan, obtenido de sus estudios personales así como de sus contactos y conversaciones con arqueólogos, antropólogos e historiadores que trabajan en la región Puuc y en otras partes de la región maya. Esta relación íntima con personas que están implicadas personalmente en estudios arqueológicos sobre los mayas ubica a los artesanos del Puuc en una posición especial que les ofrece una sólida comprensión de la iconografía maya reflejada en sus obras.

IDENTIDAD CULTURAL MAYA Y LOS TALLADOS PUUC COMO IMÁGENES DE "LOS MAYAS"

En los años 80, académicos tales como Nancy Farriss (1984: 147) sostuvieron que la identidad maya dependía en gran parte de la relación que los campesinos mayas tenían con la clase dominante respectiva: el linaje indígena dirigente o la clase política dominante en la antigüedad, los funcionarios españoles de los pueblos y los encomenderos durante el período colonial, o los mestizos funcionarios del gobierno y otra gente con poder en el presente en México y Guatemala. A pesar que el carácter de la élite dirigente ha cambiado a través de los siglos, los campesinos mayas (milperos) estuvieron condicionados a apoyar y a obedecer las leyes de aquellos en posiciones de autoridad política. Así, mientras fuerzas externas creaban cambios en el régimen que afectaba a la gran mayoría de la gente maya no era que ellos eran subordinados a ciertos grupos directivos (desde que esto había sido una práctica desde generaciones), sino que la posición de los campesinos mayas dentro de la sociedad (es decir, distinción de clase) cambiaría dependiendo de quién estaba en el poder y los tipos de categorías sociales que imponían. Tales categorías variables de clase y de status social durante los siglos

han tenido un importante impacto en formular una aceptada definición de la identidad maya.

Siguiendo esta argumentación, además de las categorías sociales introducidas por la élite gobernante, el carácter de la organización política de los mayas yucatecos antes de la conquista española tuvo también un efecto en la identidad maya. Como Farriss (1984: 12, 147) precisa, la estructura política de la sociedad maya en Yucatán antes de la conquista era altamente autónoma, diferente a la autoridad imperial centralizada que caracterizó a los Aztecas de Tenochtitlán en México central. A la hora de la conquista, Yucatán estaba dividida al menos en dieciséis provincias regidas independientemente, y algunas estaban incluso subdivididas al nivel de aldea. Esto no sólo hizo difícil la conquista de la región norteña maya para los españoles (puesto que tuvieron que negociar individualmente con cada gobernante, o conquistarlos en forma separada), sino que también significó que no existía un sentido compartido de identidad "maya" entre los residentes de las diversas provincias de Yucatán (véase también Restall 2004). En lugar de esto, la identidad cultural maya en Yucatán estaba, y en cierto grado sigue estando, arraigada a un lugar, a la familia y a la comunidad, y a las experiencias que son parte de la historia personal de uno. Estas experiencias son moldeadas también por fuerzas externas vinculadas con la globalización y la modernización. Tales fuerzas también afectan las nociones de identidad maya a la par que los individuos responden a y adoptan aspectos del mundo moderno. Con todo a pesar de la infiltración de las fuerzas culturales externas, tecnológicas, económicas y políticas, es posible mantener las costumbres tradicionales, la lengua y las creencias mayas, y es este tipo de preservación interna y de adaptación estratégica que determina en gran parte qué es "maya" y qué no es.

El historiador latinoamericano Ben Fallaw (1994: 574) observa que Lázaro Cárdenas, presidente de México entre 1934–1940, intentó unificar y movilizar a los campesinos rurales mayas de Yucatán sobre bases de clase social e identidad étnica, pero éste

no tuvo mayor éxito. Incluso la introducción de proyectos culturales que promovían una identidad indígena así como los incentivos (bajo la forma de concesiones de tierra y oportunidades educativas) para los que se identificaran como mayas fueron ampliamente infructuosos. Fallaw (1997: 577) sugiere que esta respuesta limitada fue debida al hecho que "los pobres rurales en Yucatán carecían de una única identidad indígena unificada que el estado nacional en expansión podría utilizar". Además, "las definiciones de lo maya no eran absolutas ni universales, y resistieron a la incorporación facilista en el proyecto Cardenista", aunque los marcadores étnicos tales como lengua, vestimenta tradicional, y otros elementos tradicionales persistieron en las comunidades mayas. Preservar, promover, y apoyar las tradiciones de la gente maya es la misión del Instituto Nacional Indigenista (INI), una filiación del gobierno fundada en 1948. Sin embargo, como Wolfgang Gabbert (2001: 479) precisa, los proyectos culturales del INI "fueron restringidos a la preservación de 'sitios sagrados', de la medicina 'tradicional', de danzas, ritos y otras prácticas, a la difusión de mitos y leyendas, etcétera", que promovieron la idea de que los mayas y sus tradiciones eran "estáticos" e inmutables en el paso del tiempo. En efecto, el INI estaba fomentando la misma relación esencialista entre la antigua y moderna cultura maya yucateca que había dominado los discursos elitistas entre los funcionarios gubernamentales y los intelectuales no-mayas interesados en los asuntos indígenas. Pero como LaBrecque (2005: 101) menciona "está en el interés del estado, ahora más que nunca, que las poblaciones sean estática mientras que simultáneamente sean parte del proceso de globalización—es decir, que sigan siendo "Maya" pero no demasiado "Maya".

Ni con las tentativas de Cárdenas de movilizar a los campesinos mayas de Yucatán ni con los esfuerzos posteriores del INI, se ha forjado una conciencia étnica universal o una identidad "pan-Maya" (como existe en Guatemala). Ésta no ha existido nunca en

Yucatán, a pesar que algunos funcionarios del gobierno e intelectuales "indigenistas" hayan promovido la idea romántica de un nacionalismo unificado basado en ciertas características culturales compartidas. En su lugar, cualquier tipo de división étnica o social desde la conquista provino principalmente desde las distinciones de clase (por ejemplo, indio, mestizo, criollo, etc.) y no de una evidente diferencia étnica. Mientras que algunas de estas designaciones siguen siendo todavía útiles en sentido amplio, Hervik ha reexaminado algunas de estas categorías sociales como se utilizan actualmente en Oxkutzcab, la misma ciudad donde vive Ángel Ruíz Novelo en la región Puuc de Yucatán. Al ser una de las pocas etnografías que se centra en la región Puuc, resumimos algunos de los resultados de Hervik, aunque debe tenerse en cuenta que no todas las categorías que él define existen o se utilizan de la misma manera en otras partes del norte de Yucatán. Donde el término mestizo antes denotaba a una persona de raza mezclada (indio maya y español), Hervik (2003: 95, 107) sostiene que *mestizo* es hoy el término preferido entre la gente de la región Puuc de Yucatán para describir a alguien que es maya (aunque los investigadores y los estudiosos occidentales siguen refiriéndose a ellos como "maya"), puesto que los términos "indio" e "indígena" son considerados actualmente en Yucatán como algo ofensivo.

Sin embargo, Hervik (2003: 96) también nota que algunos mayas que fueron criados en zonas rurales del Puuc pero se marcharon para conseguir trabajos asalariados en los centros más urbanos también rechazan el término *mestizo*, porque en las ciudades y los centros turísticos donde trabajan también se adhiere un significado despectivo a este término. Gabbert (2001: 476) indica que en Yucatán hay un segmento cada vez mayor de gente de clase media con educación—profesores, empleados del gobierno, trabajadores de desarrollo cultural y social—que acepta más fácilmente el término "Maya" como auto-identificación en lugar de *mestizo*, y es dentro de este grupo más políticamente activo que "la noción

de una etnicidad pan-Maya está más desarrollada".

Basados en las tradiciones culturales mencionadas anteriormente, ¿cómo se identifican los mismos artesanos de la región Puuc? Ángel se considera "maya-yucateco", es decir, él es sobre todo maya mientras que lo "yucateco" simplemente designa la región donde vive. Miguel se llama a sí mismo "maya-*mestizo*" porque lo que habla es un "maya amestizado" que no es la forma original de la lengua, pero dice que él "sigue estando orgulloso de ser maya, un maya-yucateco". Como Ángel, esta designación de "yucateco" refiere a la localización geográfica de Yucatán en vez de implicar una etnicidad. Wilbert admite que la gente de Yucatán es "mexicana" en el sentido que todos viven en la República de México, pero como Ángel, Wilbert se identifica como "maya-yucateco". Él considera la designación de "mestizo" como sólo un aspecto cultural, es decir, relacionado con la mezcla de idiomas y costumbres españoles y mayas, en lugar de cualquier clase de identidad étnica. Wilbert también señala que cuando él dice que él es "Yucateco", prefiere precisar que él es de Muna debido a su conexión con su familia y sus amigos de este lugar. Esta conexión al "lugar" vuelve a la idea que la identidad maya está imbuida en un sentido de comunidad a nivel local, en vez de a un sentido más universal de lo "maya". Para Jesús, su auto-identificación es "yucateco maya", y él enfatiza que está muy orgulloso de ser "yucateco". En este caso, "Yucateco" parece ser tanto una designación regional como un identificador cultural. Jesús siente que es maya, pero no directamente. Aunque él posee un apellido maya ("Kú") que demuestra la descendencia directa de su familia a lo largo de un linaje maya, él no siente una conexión tan fuerte a su herencia maya como la tiene, por ejemplo, Ángel.

Como se puede ver de la auto-identificación de los artesanos del Puuc, las nociones de identidad maya en Yucatán no están claramente delimitadas ni acordadas por todos, incluso ni entre los mismos pobladores. Quetzil Castañeda (2004: 39) ha precisado que las políticas de identidad y los proyectos de

revitalización cultural que existen entre los mayas de Yucatán del norte no se comparan con los programas más amplios y altamente organizados de Guatemala (con los pan-Mayanistas) y de Chiapas (con los Zapatistas). Esto es debido a que la trayectoria histórica y las circunstancias actuales de los mayas de Yucatán del norte se diferencian considerablemente de las de otros grupos en Guatemala o Chiapas. Aunque su historia se haya ciertamente marcado por períodos de persecución, de trabajo forzado, y de marginalización política y cultural, los mayas de Yucatán "tienen una historia completamente distinta de la conquista, colonia, independencia y de la incorporación en un estado-nación más amplio" y así "una diversa relación con el mundo" que aquella de sus vecinos mayas del sur (Castañeda 2004: 38). Castañeda (2004: 37) observa que "los discursos que celebran los mayas como una cultura y un pueblo que sobreviven a la opresión, modernidad, y capitalismo a través de sus luchas contra la élite nacional, crean un estereotipo monolítico que borra la heterogeneidad y la diversidad cultural maya".

Aunque el turismo malinterprete o sobre-simplifique algunos aspectos de la cultura maya precolombina y contemporánea, puede ser realmente el responsable de la preservación de algunas tradiciones culturales mayas "de otro modo condenadas por la modernización de la mayoría de la sociedad" (Ehrentraut 1996: 28). Las personas mayas encuentran nuevas razones para preservar estas tradiciones en el contexto de la industria del turismo, que estimula el desarrollo económico en áreas rurales y empobrecidas. Sin embargo, algo de esta "preservación" toma la forma de acontecimientos organizados para el turismo, que a menudo representa casos de "autenticidad actuada" performada o creada para los visitantes en lugar de responder a propósitos locales (MacCannell 1973). Por consiguiente, Ehrentraut (1996: 28) postula que, "al mayor éxito del desarrollo turístico de la Ruta Maya, lo más complejo, intenso y extenso el etno-nacionalismo [es decir, la identidad cultural colectiva] de los mismos mayas se volverá". En otras palabras, Ehrentraut sostiene que el turismo en masa, posible por la globalización, motiva un creciente sentido de identidad cultural maya. Esta idea está en conflicto con el modelo de aculturación presentado por Redfield y apoyado por muchos académicos desde entonces. Éste postula que la modernización y la globalización aumentan la homogeneización hacia la cultura occidental. Otros académicos tales como Castañeda (1996; 2004), Hervik y Kahn (2006), y Cocom (2005) han contradicho esta argumentación con perspectivas e investigaciones más actuales sobre la identidad maya en la península de Yucatán. Ellos han mirado las maneras en que la identidad maya es primero y sobre todo una designación personal más que algo tan dependiente a las presiones y desarrollos del mundo moderno. Cualquier énfasis puesto en la celebración de los logros de las culturas mayas antes de la conquista, y en la preocupación por las luchas por preservar los aspectos "tradicionales" de la cultura "popular" en Yucatán, es limitado. Mientras que presiones externas han dado lugar a algunas actividades de base entre los mayas yucatecos (que podría estar relacionado con una clase de reclamo cultural "pan-Maya"), éstas no representan una gran tendencia entre el amplio espectro de gente de habla maya que vive hoy en Yucatán.

Para muchos turistas que visitan Yucatán, sus nociones de la identidad maya se centran en opuestas o traslapadas visiones del pasado distante (que les ha sido presentado por los medios de comunicacion, la industria turística, y un poco de publicaciones académicas de gran importancia). En cuanto tienen un interés turistico o del patrimonio cultural es ese pasado hecho visible dentro del presente que los atrae. A un menor grado, las percepciones de los visitantes con respecto a la identidad maya también son formadas por la conservacion de elementos de una cultura "popular" tradicional mas antigua, cual es manifiesta en estas "zonas de contacto" de confluencia intercultural.

Muchos han observado la manera en que los discursos arqueológicos y turísticos construyen una

imagen maya misteriosa y como viviendo fuera de tiempo. Esto ha llevado a la formación de varias concepciones sobre los mayas antes de la conquista, todas de las cuales han estado organizadas alrededor de imagenes particulares, algunas de las cuales podrían ser caracterizadas (obviamente de una manera abreviada) como una "civilización perdida", los "mayas esplendorosos", los "mayas misteriosos", y más recientemente los "mayas militaristas" (véase nota 259 en sección 1 del catálogo).

Como Castañeda (1996: 128–29) ha observado, estas imagenes se refuerzan sistemáticamente por ellas mismas entrando a una zona turística o a sitios arqueológicos y con el despliegue de textos, guías turísticas, arte turístico, y recuerdos. Como Magnoni, Ardren, y Hutson (2007: 365–66) observan "El Mundo Maya, . . . promueve a los mayas por esencialismo ocultando las discontinuidades entre la gente maya contemporánea y la prehispánica. . . . Estas nociones de continuidad recurren a las interpretaciones esencialistas y exóticas de los mayas del pasado y del presente para satisfacer las fantasías occidentales en lugar de centrarse en los procesos complejos del cambio cultural histórico que los grupos sociales experimentan a traves del tiempo".

Aunque los proyectos del Mundo Maya y de la Ruta Maya fueron diseñados sobre todo para promover el viaje turístico y el consumo a lo largo de la región maya, y los folletos promocionales turísticos retratan imágenes de la gente y la cultura maya diseñados para apelar a los foráneos, los promotores de tales imágenes pueden también incluir a los mayas locales de Yucatán. Esta situación parece contradictoria; ¿por qué la gente maya querría promover ideas acerca de sí mismos que los exotiza y que presenta solamente una imagen parcial de su vida actual y su cultura? La respuesta obvia es que es económicamente ventajoso hacerlo, dado que los turistas visitan los sitios arqueológicos de Yucatán en busca de las imágenes de y los encuentros con la cultura "auténtica" maya que ellos han visto en los folletos promocionales, en las páginas de *National Geographic* o en conocidos libros

académicos. Un visitante que ha leído textos que se centran en la historia y la iconografía generales de los mayas—tales como *The Maya* (Los Mayas) de Michael Coe y *The Blood of Kings (La Sangre de los Reyes)*, éste último catálogo de una exposición (1986)—llega con ciertas presunciones sobre lo que constituye la "cultura maya" más genuina y no contaminada, ya sea la del pasado precolombino, o la tenencia de la "cultura popular" que mantiene las tradiciones. Los sitios arqueológicos se convierten en marcadores de una "cultura viva" en los cuales se incorporan, para el turista, la identidad colectiva de los grupos indígenas modernos cuyos antepasados fueron responsables de su construcción. El maya moderno se vuelve así "invisible" para el turista; ellos son vistos a través del lente de la antigüedad como los descendientes de una civilización ancestral en vez de encarnaciones de una cultura contemporánea maya.

En cierto grado, esta situación permite a los artesanos mayas que trabajan en las zonas arqueológicas capitalizar su identidad maya y su patrimonio cultural. Por ejemplo, algunos artesanos promoverán intencionalmente la idea de los mayas como parte de una "cultura viva" acentuando su conexión con el pasado. Esto lo logran compartiendo partes de su herencia indígena y conocimiento de la historia maya con sus potenciales compradores de tallados. Por ejemplo, para atraer a compradores, Jesús Delgado Kú le gusta conversar en maya con otras guías de Kabah como marcador de su identidad indígena. Watanabe (1995: 33) indica que hablar una lengua maya no define necesariamente lo que es "maya", pero distingue a los mayas de los no-mayas que hablan solamente español y les ayuda a transmitir su identidad cultural a los foráneos. En relación a ello, a Jesús incluso le gusta enseñar a los visitantes algunas palabras o frases mayas para que las lleven de regreso y realzar así su experiencia cultural. Siguiendo el planteamiento de Hervik (1999: 171) con respecto a la tendencia de *National Geographic* de retratar una cultura en base a la preexistente comprensión sobre ella de parte de su audiencia, la técnica de Jesús puede

no ofrecer a los visitantes una real comprensión de la cultura contemporánea maya, pero sus métodos lo ayudan a asegurar una venta si es que el comprador duda de su herencia, y por tanto a asegurar la "autenticidad" del objeto como producto artístico de un "verdadero maya". Por supuesto, como nota Graburn (1976: 19), si los estereotipos que son perpetuados por los visitantes culturales no son corregidos o clarificados por los mismos habitantes, existe el peligro que los miembros del grupo local "pueden llegar a creer las mismas cosas sobre ellos mismos o sobre su pasado que cree el mundo exterior".

Estilo de la escuela Puuc y comparación con la escuela Pistéño

Luego de esta discusión sobre la identidad maya en Yucatán queremos retomar el enfoque sobre los tallados de madera del Puuc. Además de mostrar temas basados estrechamente en modelos del arte clásico maya o en los códices maya del posclásico, la mayoría de los tallados de madera del Puuc demuestran un estilo local de tallar especializado que está caracterizado por la meticulosa atención al detalle, el refinamiento del acabado, y el uso de maderas duras, tales como cedro, caoba y chico zapote. Sin embargo, como hemos mencionado antes, estas cuidadosas reproducciones en madera de las deidades antiguas mayas y de los personajes de las elites no son copias a carbón, sino que son reinterpretaciones de estas figuras por parte de los artesanos a través de la elección de los materiales, de su proceso artístico y de su estilo propio de tallar. Sin embargo, a pesar de lo evidente del carácter personal en la selección y el énfasis en formas y adornos particulares, hay una marcada diferencia entre las réplicas del Puuc y varias de las piezas híbridas talladas de manera sencilla, pintadas en colores brillantes y estilísticamente innovadoras que son exhibidas y vendidas por los vendedores en Chichén Itzá, así como los tallados similares producidos y vendidos en otras partes del estado (por ejemplo, Mérida, Valladolid, etc.) (figuras 2.5–2.7).

Mientras que los artesanos del Puuc han podido tener un amplio desarrollo de sus artesanías y refinar sus habilidades en el tallado, muchos artesanos fuera de la región Puuc, en las zonas de alto tráfico turístico (por ejemplo, Chichén Itzá, Mérida, etc.) están bajo una intensa presión económica por vender, ya que a más desarrollada la industria del turismo hay más vendedores de artesanía en la zona y mayor competencia entre ellos. En muchos casos, esto ha dado lugar a un mayor número de artesanías producidas en serie que muestran formas y figuras simplificadas, en vez de los motivos altamente detallados e individualizados en la región Puuc. Mencionar que estas diferencias existen no significa que los tallados del Puuc son de manera intrínseca mejores o más dignos de contemplación que otros ejemplos de artesanías en Yucatán. Ni por el contrario creemos en el hecho de que las esculturas del Puuc que están basadas estrechamente en modelos antiguos, pero que no representan una herencia continua, son menos "auténticas" o inferiores a las que provienen de tradiciones con historias locales más extensas (por ejemplo los huipiles bordados). En su lugar, estas diferencias reflejan su emergencia en y respuesta a diversas oportunidades y circunstancias sociales, económicas y políticas presentadas dentro de un contexto de globalización y turismo creciente.

Mientras que "los turistas culturales", del tipo examinado anteriormente, también visitan Chichén Itzá, su ubicación en las llanuras del norte de la península significa que este también visitado en excursiones de un día por los turistas provenientes de Cancún o de los balnearios de la otra costa oriental. El interés de estos otros turistas en el sitio es en gran parte secundario a otras de sus actividades vacacionales y sus conocimientos de la sociedad maya y de sus tendencias artísticas tienden a ser limitados. Comprender las distinta naturaleza de los tipos de turistas es crucial porque los tallados de madera y otras artesanías vendidos en las respectivas áreas se ajustan para atraer las preferencias del consumidor. Además de ser fabricados en maderas blandas más baratas, tales como piich o chakah, muchos de los

tallados para la venta en Chichén toman la forma de figuras compuestas e híbridas, con frecuencia pintadas de manera estridente. Éstos tallados son conocidos como máscaras o mascarones y combinan múltiples elementos precolombinos en una imagen. Diferentes a los tallados del estilo replica del Puuc, tales imágenes híbridas no duplican imágenes históricas únicas, pero se podría afirmar que su combinación de diversos motivos permite que adquieran un nuevo significado, mediante esta fusión de formas que re-definen los símbolos mayas, o más generalmente, la cultura mexicana prehispánica en un contexto global moderno. Visto desde esta perspectiva alterna, tales tallados se pueden ver como imágenes dinámicas, innovadoras que comunican complejos mensajes sobre la identidad cultural contemporánea en Yucatán. Tales nociones están expresadas por la combinación de motivos diversos que crean un bricolaje que refleja las percepciones de los foráneos sobre la cultura "maya-mexicana" basadas en el conocimiento limitado y las expectativas creadas por las descripciones de medios de comunicación populares sobre sociedades precolombinas (por ejemplo, en las películas tales como Apocalypto o en la serie de Indiana Jones).

A pesar de que las comparaciones entre tema y estilo de las "escuelas" del Puuc y del Chichén Itza se aplican en un sentido amplio, los tipos más simples de tallados en el último sitio no representan el corpus completo de los tallados producidos. Como Quetzil Castañeda ha documentado, un estilo de tallar realista y de acabados finos (conocido como *réplica*) similar al producido por los artesanos de la "escuela" Muna-Puuc, también existe y es practicado por selectos artesanos de la ciudad de Pisté, situada junto al sitio arqueológico de Chichén Itzá (véase figuras 2.2, 2.3). Estos tallados pisteños son casi idénticos en estilo, forma, escala, tema y materiales a los producidos por los artesanos del Puuc. Sin embargo, es interesante notar que tales tallados de replicas no se venden en Pisté o en Chichén Itzá con el resto de las máscaras y los mascarones. En vez de ello, se crean a

comisión o encargo, como obras para presentar en los concursos de arte u otras competencias, o se venden en galerías y tiendas turísticas de arte y artesanía en Mérida. El hecho de que tales tallados estén producidos especialmente para la venta en diversos lugares es especialmente interesante, puesto que indica que estas reproducciones técnicamente más refinadas y casi idénticas a las imágenes antiguas mayas son más deseables entre una audiencia de turistas más especializada y exigente (o quizá de gente local) en la Mérida cosmopolita que entre los millares de turistas internacionales que arriban a Chichén Itzá cada mes. En relación a ello, el hecho de que las sorprendentes reproducciones de las imágenes de Yaxchilán o de Palenque hechas por los artesanos del Puuc y vendidas en sus tiendas en la región Puuc tengan un precio muy por debajo de los artesanos de Piste en Mérida no implica que los artesanos del Puuc sean menos talentosos o cualificados, sino que refleja las oportunidades que se presentan a unos pocos artesanos a través de su capacidad de encontrar redes de venta que les permitan beneficiarse de las tendencias económicas en un mercado internacional del arte cada vez más globalizado.

Los tallados y conceptos contestados del arte

Existe el romántico estereotipo de que las artes étnicas y populares deben emerger de una continua tradición "viva" y de seguir sirviendo para fines rituales o utilitarios para ser consideradas como "auténticas". Aunque se reconoce que no han sido creadas puramente como "arte por arte", existe la expectativa de que son creadas para incorporar conceptos culturales indígenas y no hechas solamente para obtener una ganancia comercial. Sin embargo, la realidad en comunidades actuales donde se produce artesanías revela mercados dinámicos, vendedores capaces y experimentados, y objetos ingeniosos e innovadores que, aunque pueden o no estar basados en formas tradicionales, no responden a algún propósito "tradicional" fuera de que son creados para la venta a los visitantes y

compradores extranjeros. Para entender mejor por qué la gente indígena actual produce artefactos estéticos y artesanía para obtener una ganancia económica en vez de por motivos culturales o espirituales, y quizás para acabar con los más persistentes estereotipos, Nelson Graburn (1976) propuso las siete categorías siguientes para clasificar la producción de las artes étnicas y turísticas: (1) la extinción de las artes tradicionales, (2) las bellas artes tradicionales o funcionales, (3) las bellas artes comerciales, (4) los recuerdos o souvenirs, (5) las artes reintegradas, (6) las bellas artes asimiladas, y (7) las artes populares. Estas categorías no son mutuamente excluyentes. Una parte del arte turístico incorpora ciertos aspectos de varias categorías. Aplicando éstas a los varios tipos de artefactos mayas ofrecidos en esta exposición, podemos considerar los tallados contemporáneos más simples y producidos en masa de Chichén Itzá bajo la categoría de "souvenirs", que Graburn define como objetos producidos que tienen el potencial de ganancia económica en los cuales la calidad estética es omitida por el deseo de satisfacer al consumidor en vez de contentar al artista. Aunque ello excluya a tales artefactos de ser clasificados como "bellas artes", según las definiciones occidentales tradicionales, no elimina su valor como tema de estudio para la sociología del arte y de la estética. Las combinaciones particulares de formas y temas vistas en las máscaras y en las figuras del dios del maíz ilustran que tales tradiciones estéticas tienen historias condicionadas por factores culturales, sociales, y económicos específicos que obligan y/o amplían las posibilidades de los artesanos. La predominante motivación económica de los artesanos de Chichén Itzá los ha llevado a invertir menos esfuerzo en el acabado de sus tallados y más en el impacto visual, pero también ha dado lugar a un nuevo y dinámico mercado del arte que desafía las categorías occidentales contemporáneas de "arte" versus "artesanía" y nos obliga a reconsiderar las maneras en que valoramos y entendemos las expresiones artísticas de otras culturas.

Los tallados del Puuc discutidos en este catálogo posiblemente entran en el rubro de "bellas arte comerciales" de acuerdo a lo definido por Graburn. Sin embargo, porque se consideran "arte turístico", se relacionan con distintos tipos de artes marginados y sub-representados, incluyendo el arte comercial, el kitsch, y el arte popular. Éstos generalmente han sido categorizados como arte "bajo", o incluso como "no-arte" por los académicos e investigadores desde la fundación de la historia del arte como disciplina en los s. XVIII y XIX hasta el Modernismo en Europa y los E.E.U.U. en la primera mitad del s. XX. En décadas recientes, no obstante, primero como resultado del impacto que el Arte Pop tuvo en el reconocimiento del valor de la cultura popular como fuente de imágenes para las "bellas artes", y luego debido al efecto que la "Guerra Cultural" (Culture Wars) tuvo en la celebración del arte de grupos previamente marginados, tales artefactos estéticos han comenzado a ser aceptados si no celebrados por miembros del mundo del arte como formas positivas de expresión visual. Donde los críticos modernistas, como Clement Greenberg, vieron lo kitsch como una amenaza para el vanguardismo y la alta cultura, estudiosos más recientes sostienen que el kitsch ha realmente revigorizado los gastados paradigmas asociados al "arte culto", e incluso se ha convertido en la base para el trabajo de muchos artistas contemporáneos.

Iniciándose en los años 70 del s. XX, pero desarrollándose en los años 80 y 90 en el clímax de la Guerra Cultural, los Estudios Culturales Visuales emergieron como una escuela de pensamiento interdisciplinaria que apuntó a ensanchar el estudio de una gama amplia de objetos y medios comúnmente considerados de estar fuera de las categorías establecidas de "bellas artes" (Howells 2003; Sturken y Cartwright 2000). La cultura visual se suele referir a todos los aspectos visuales de la cultura con los que interactuamos y a los que respondemos, incluyendo "las bellas artes, las artes tribales, la publicidad, las películas y videos populares, el arte popular, la televisión y otras presentaciones, el diseño de interior y de prendas de vestir, el diseño de juegos de computación y de juguetes, y otras formas de producción y

comunicación visuales" (Freedman 2003: 1). Según Kerry Freedman, la cultura visual proporciona el contexto para el objeto visual al mismo tiempo que genera conexiones entre las bellas artes y las artes populares, categorías que hasta hace poco tiempo se han definido estrictamente en la disciplina de la historia de arte no permitiendo ninguna movilidad de los objetos entre ellas.

La disciplina de la historia de arte en sí misma ha experimentado un cambio significativo en los últimos cuarenta años, dando por resultado lo que a veces se ha llamado la Nueva Historia de Arte. Este término incluye una gama de nuevas teorías, métodos y acercamientos que están menos referidos a estudios detallados de estilo e iconografía, y están más centrados en lo que en el pasado se había denominado como acercamientos "extrínsecos". Estos están basados en estudios marxistas, en la "historia social del arte", en las discusiones psicoanalíticas de como las representaciones visuales han construidos identidades sociales y sexuales, y en conceptos y métodos semióticos para analizar los significados de los signos. En muchos casos, los libros y artículos producidos representaron estudios "activistas", interesados en desafiar las jerarquías y los cánones tradicionales, haciendo evidente las fuerzas históricas que los habían creado, las presunciones subyacentes, y los prejuicios de clase, género, o raciales y éticos que encubrieron, a la vez que ubicaron en primer plano a artistas, movimientos, temas, o media que previamente habían estado fuera del foco de atención (véase por ejemplo Berger 1972, Rees y Borzello 1986, Harris 2001b).

Mientras que las teorías referente al mundo visual continúan cambiando, se ha vuelto cada vez más común entender las obras de arte dentro de la "experiencia" de un acontecimiento visual en lugar de como un objeto visual aislado. Dentro de esta perspectiva, lo que resulta más importante para los Estudios Visuales y también cada vez más para la historia del arte no es el objeto de arte, sino su rol en la producción de significados y mensajes social y culturalmente construidos y en la forma(s) en que se transmiten y perciben por el espectador/ consumidor, así como el papel que ellos juegan en construir identidades. Tal comprensión de la visualidad también se puede aplicar a los estudios de producciones visuales de otras culturas, incluyendo las esculturas de madera producidas para la venta a los turistas consideradas en esta exposición.

Los cambios en el gusto y cómo entendemos una obra de arte reflejan la manera en la cual los objetos están clasificados en un sistema jerárquico de culturas que surge como parte de la historia de la expansión colonial europea, del descubrimiento y exploraciones científicas, y de la aparición de disciplinas académicas modernas, por ejemplo la historia de arte y la antropología. James Clifford (1988: 215) ha discutido estos temas y ha propuesto que estos han dado como resultado el establecimiento de un "sistema de arte-cultura, . . . por el cual en el siglo pasado los objetos exóticos han sido contextualizados y obtenido valor en occidente". En este sistema, objetos particulares están categorizados y evaluados ya sea como "arte", entendido como algo más original y singular, o como "artefacto", entendido como tradicional y colectivo y como representación de "una cultura". Clifford subdivide esta oposición binaria de arte-artefacto/cultura en cuatro "zonas semánticas": (1) obras maestras auténticas; (2) artefactos auténticos; (3) obras maestras no-auténticas, y (4) artefactos no-auténticos. Los tipos de tallados expuestos en esta exposición hasta hace poco tiempo habrían estado ubicados en la última categoría. Sin embargo, como Clifford (1988: 225) nota, es posible que tales trabajos emigren hacia arriba, transformándose de "arte turístico" en expresiones más auténticas de estrategias "culturales-artísticas" En muchos casos, esto implica un nuevo reconocimiento de la calidad estética de tradiciones previamente ignoradas, aunque en muchos casos se valore no simplemente, o no sobre todo, como el producto de un artista individual, pero por su asociación con un grupo cultural o una tradición histórica (por ejemplo, los tallados de piedra Inuit, las pinturas australianas aborígenes, las pinturas haitianas,

etc.). Uno podría sostener que este proceso se está implementando en esta exposición centrada en la exhibición y análisis de elaborados tallados realizados por cuatro artesanos mayas de Yucatán.

Varios estudiosos contemporáneos reconocen que las distinciones hechas entre estas categorías no son fijas, sino algo arbitrarias y contingentes, y dependen en cómo están enmarcadas y discutidas dentro de un discurso institucional. Este acercamiento sociológico ha sido abordado por Pierre Bourdieu (1984) en su libro Distinction: A Social Critique of the Judgement of Taste (*La Distinción: Una Crítica Social del Juicio del Gusto*), así como por Howard Becker (1982) en su libro *Art Worlds (Mundos del Arte)*. Los dos escritores observan no sólo que la producción de obras de arte dependen de redes sociales y de la actividad colectiva, sino que también las obras de arte están categorizadas de acuerdo a criterios estéticos que están determinados y son aplicados por miembros de subgrupos sociales que comparten intereses mutuos, o por lo menos, económicos y de "clase", así como comparten un mismo "gusto".

Con el final del Modernismo, las nociones de orden social, belleza y buen gusto fueron redefinidas para incluir diversos géneros, estilos y formas de arte no considerados por lo general como arte (por ejemplo, graffiti, arte comercial, etc.), y "el arte de toda la gente [se convirtió] igualmente digno de preservación y presentación" (Lipman 1992: 217). Como Arthur Danto (1996) ha precisado en *After the End of Art (Después del Fin del Arte)*, la noción modernista de que el arte tiene una narrativa central, ejemplificada por estéticas formalistas y por la verdad de las concepciones materiales, ha sido substituida por la noción de que el arte puede basarse en múltiples fuentes y crear una diversidad de estilos. En vez de consistir un solo mundo integrado del arte que lo abarca todo y define la categoría y el valor apropiado para toda la producción artística, el mundo del arte posmoderno es visto como "muchos distintos mundos del arte, cada uno con una distinta relación con la cultura mas amplia, cada uno con una distinta agenda, una

distinta forma de discurso, y una distinta audiencia" (Bolton 1992: 24).

Como otros tipos de expresiones marginadas y sub-representadas de la cultura visual, el "arte turístico", como el presentado en esta exposición, se ha beneficiado de los paradigmas más inclusivos que han reemplazado a los modelos formalistas anteriores para la clasificación del arte.

Reflexiones finales

Esta exposición se ha esforzado por comprender las distintas esculturas de madera producidas por cuatro talladores—Miguel Uc Delgado, Angel Ruíz Novelo, Jesús Marcos Delgado Kú, y Wilbert Vásquez—de la región Puuc de Yucatán. A pesar que los tallados técnicamente refinados y visualmente complejos de la región Puuc se suelen describir como artesanía o "arte turístico", ya no parece apropiado seguir etiquetándolos con las connotaciones peyorativas asociadas a tales términos. En su lugar, estos trabajos proveen importante información sobre como una "tradición" artística relativamente reciente ha surgido en y respondido a un contexto histórico particular, y comunican importantes mensajes sobre el carácter cambiante de la identidad cultural contemporánea de estos artesanos mayas, y como esta identidad es representada y negociada en el contexto de contactos transculturales y de interconexiones globales.

Las esculturas de madera talladas por los artesanos del Puuc, así como otros tallados producidos por aquellos que trabajan en otros lugares de Yucatán, se pueden apreciar tanto por sus cuidadosos acabados y por ser reinterpretaciones personales de la iconografía antigua así como por la síntesis de forma y significado que resultan de tal inspiración. La emergencia de esta dinámica tradición de producción artística demuestra que los efectos del turismo son complejos. La afluencia de turistas culturales a los sitios arqueológicos en la región Puuc, unida a la inspiración proporcionada por una semejante tradición de tallados del estilo "réplica" desarrollada en Pisté, proveyó el ímpetu

para que un grupo de emprendedores artesanos locales combinaran las oportunidades de obtener una ganancia económica con las posibilidades de desarrollar su expresión creativa. Los tallados del Puuc son un fenómeno complejo y presentan imágenes problemáticas de la identidad "maya". Muchos turistas las reconocen como facsímiles exactos de las imágenes antiguas mayas. Esto, unido al hecho de que son elaboradas a mano por un artesano "maya" local, les otorga cierta "autenticidad" entre los turistas mientras que les proveen de un recordatorio tangible de un contacto directo con el "mundo maya". Los mismos artesanos reconocen que una brecha histórica y cultural los separa a ellos de los mayas precolombinos, no obstante, sienten un sentido de orgullo sobre su lejana herencia ancestral. Mientras que los tallados se hacen para completar los ingresos y varían de tamaño, detalle y nivel de acabado, Miguel Uc Delgado, Ángel Ruíz Novelo, Jesús Marcos Delgado Kú y Wilbert Vázquez ponen en claro que fabricar estos tallados les da un sentido de satisfacción y de expresión creativa personal. Así, aunque el turismo tiende a reforzar las ideas de los visitantes acerca de que la imagen más auténtica de la cultura maya reside en el pasado precolombino, el incentivo económico que éste ofrece también fomenta los esfuerzos de estos artesanos para reclamar tales imágenes culturales, dándoles nuevos significados que conllevan un aspecto de su identidad cultural contemporánea.

Aunque ha sido común clasificar los tipos de tallados creados por los artesanos del Puuc como "arte turístico", considerados por lo general como una forma de "arte bajo", esta exposición sostiene que, como todos los artefactos estéticos, estos tallados emergen y revelan aspectos de la matriz histórica, cultural, social, y económica en la cual se generan. Por lo tanto, como formas de expresión cultural estas esculturas merecen reconocimiento y seria investigación por parte de la historia del arte, incluso porque éstas desafían las limitaciones que les han sido impuestas por criterios y clasificaciones de la historia del arte occidental actual. Estas piezas son creadas por individuos talentosos y bien informados que, como en el caso de otros artistas, son motivados por complejas combinaciones entre un deseo de ganancia económica, de reconocimiento social y de expresión personal, y a la vez comunican mensajes importantes sobre como la identidad cultural maya es negociada y expresada visualmente en un mundo cada vez más afectado por las fuerzas de la globalización.

Bibliography

Andrews, Anthony P. 1993. Late Postclassic Lowland Maya Archaeology. *Journal of World Prehistory* 7 (1): 35–69.

Appadurai, Arjun. 1986. *The Social Life of Things: Commodities in Cultural Perspective*. Cambridge: Cambridge University Press.

Ardren, Traci. 2002. Conversations about the Production of Archaeological Knowledge and Community Museums at Chunchucmil and Kochol, Yucatán, México. *World Archaeology* 34 (2); Community Archaeology (October): 379–400.

Ardren, Traci. 2004. Where Are the Maya in Ancient Maya Archaeological Tourism? Advertising and the Appropriation of Culture. In *Marketing Heritage: Archaeology and the Consumption of the Past*, ed. Yorke Rowan and Uzi Baram: 103–13. Walnut Creek, CA: Altamira Press.

Ardren, Traci. 2006. Is "Apocalypto" Pornography? Online review in *Archaeology*, 5 December 2006 (http://www.archaeology.org/online/reviews/apocalypto.html).

Ardren, Traci. 2006. Mending the Past: Ixchel and the Invention of a Modern Pop Goddess. *Antiquity* 80: 25–37.

Arguëlles, José. 1987. *The Mayan Factor: Path beyond Technology*. Rochester, VT: Bear and Company.

Arnold, Matthew. 1883. *Culture and Anarchy: An Essay in Political and Social Criticism*. New York: MacMillan and Co. (originally published 1869, London).

Austin, A. 1994. Fonatur Leads Efforts to Mold México's Resorts. *Hotel and Motel Management* 209 (9): 4–6.

Aveni, Anthony F. 1980. *Skywatchers of Ancient Mexico*. Austin: University of Texas Press.

Babcock, Barbara, Guy Monthan, and Doris Monthan. 1986. *The Pueblo Storyteller: The Development of a Figurative Ceramic Tradition*. Tucson: University of Arizona Press.

Baklanoff, Eric N. 2008. Introduction: Yucatán since the 1982 Mexican Debt Crisis. In *Yucatán in an Era of Globalization*, ed. Eric N. Baklanoff and Edward H. Moseley: 1–19. Tuscaloosa, University of Alabama Press.

Bancroft, Hubert Howe. 1893. *The Book of the Fair: An Historical and Descriptive Presentation of the World's Science, Art, and Industry, as Viewed through the Columbian Exposition at Chicago 1893*, Vol. 7. Chicago and San Francisco: The Bancroft Company Publishers.

Banta, Melissa, and Curtis M. Hinsley. 1986. *From Site to Sight: Anthropology, Photography, and the Power of Imagery*. Cambridge, MA: Peabody Museum Press, Harvard University.

Baram, Uzi, and Yorke Rowan. 2004. Archaeology after Nationalism: Globalization and the Consumption of the Past. In *Marketing Heritage: Archaeology and the Consumption of the Past*, ed. Yorke Rowan and Uzi Baram: 3–23. Walnut Creek, CA: Altamira Press.

Barnet-Sanchez, Holly. 1993. The Necessity of Pre-Columbian Art in the United States: Appropriations and Transformations of Heritage, 1933–1945. In *Collecting the Pre-Columbian Past*, ed. Elizabeth Hill Boone: 177–207. Washington, DC: Dumbarton Oaks Research Library and Collection.

Barrera Rubio, Alfredo. n.d. Balance de 12 años de labores del INAH en el Estado: Ayer y hoy del trabajo arqueológico en Yucatán. *Diario Yucatán, el periodico de la vida peninsular*. (www.yucatan.com.mx/especiales/arqueologia/010.asp).

Barrera Rubio, Alfredo. 1985. Uxmal. Mexico, D.F.: Instituto Nacional de Antropología e Historia/SALVAT.

Barrera Rubio, Alfredo. 2002. El patrimonio cultural desde la perspectiva de un centro INAH. *Revista de Arqueología Americana*, núm. 1: 123–53.

Barthes, Roland. 1972. *Mythologies*, trans. Annette Lavers. New York: Hill and Wang.

Batkin, Jonathan. 2008. *The Native American Curio Trade in New Mexico*. Santa Fe: The Wheelwright Museum.

Baudez, Claude, and Sydney Picasso. 1992. *Lost Cities of the Maya*. New York: Harry N. Abrams.

Baudrillard, Jean. 1983. *Simulations*. New York: Semiotext(e).

Baudrillard, Jean. 1995. *Simulacra and Simulation (The Body, In Theory: Histories of Cultural Materialism)*, trans. Sheila Faria Glaser. Ann Arbor: University of Michigan Press.

Becker, Howard S. 1982. *Art Worlds*. Berkeley: University of California Press.

Becker, Marshall Joseph. 1979. Priests, Peasants and Ceremonial centers: The Intellectual History of a Model. In *Maya Archaeology and Ethnohistory*, ed. Norman Hammond and Gordon R. Willey: 3–20. Austin: University of Texas Press.

Ben-Amos, Paula. 1977. Pidgin Languages and Tourist Arts. *Studies in the Anthropology of Visual Communication* 4 (2):128–39.

Benjamin, Walter. 1969. The Work of Art in the Age of Mechanical Reproduction. In *Illuminations*, intro. and ed. Hannah Arendt, trans. Harry Zohn, pp. 59–67. New York: Shocken Books (originally published in 1936).

Benson, Elizabeth P., ed. 1972. *The Cult of the Feline: A Conference on Pre-Columbian Iconography.* Washington, DC: Dumbarton Oaks Research Library and Collections.

Berger, John. 1972. *Ways of Seeing.* Harmondsworth, Penguin Books.

Berke, Arnold. 2002. *Mary Colter, Architect of the Southwest.* Princeton, NJ: Princeton Architectural Press.

Berlo, Janet C. 1990. Portraits of Dispossession in Plains Indian and Inuit Graphic Arts, *Art Journal* 49, no. 2 (Summer): 133–41.

Berlo, Janet C., ed. 1996. *Plains Indian Drawings 1865–1935: Pages from a Visual History.* New York: Harry Abrams and the Drawing Center.

Berlo, Janet. 1999. Drawing (upon) the Past: Negotiating Identities in Inuit Graphic Arts Production. In *Unpacking Culture: Art and Commodity in Colonial and Post-Colonial Worlds,* eds. Ruth Phillips and Christopher Steiner: 178–93. Berkeley: University of California Press.

Berlo, Janet C. 2007. Creativity and Cosmopolitanism: Women's Enduring Traditions. In *Identity by Design: Tradition, Change, and Celebration in Native Women's Dresses,* ed. Emil Her Many Horses, 97–147. Washington DC: National Museum of the American Indian.

Bernal, Ignacio. 1980. *A History of Mexican Archaeology: The Vanished Civilizations of Middle America.* London: Thames and Hudson.

Bernal, Ignacio. 1983. *A History of Mexican Archaeology: The Vanished Civilizations of Middle America.* New York: W. W. Norton & Company, Inc.

Bhabha, Homi K. 1994. *The Location of Culture.* London: Routledge.

Bhabha, Homi. K. 2003. Making Difference: Homi K. Bhabha on the Legacy of the Culture Wars. *Artforum* 41 (April): 73.

Blake, Patricia. 1985. "Treasures from the Jungle." *Time Magazine* (15 July).

Boas, Franz. 1897. *The Social Organization and the Secret Societies of the Kwakiutl Indians.* Report of the U. S. National Museum for 1895. Washington, DC: Smithsonian Institution.

Bolton, Richard, ed. 1992. *Culture Wars: Documents from the Recent Controversies in the Arts.* New York: New Press.

Bonfil Batalla, Guillermo. 1996. *Mexico Profundo: Reclaiming a Civilization,* trans. P. A. Dennis. Austin: University of Texas Press.

Bourdieu, Pierre. 1984. *Distinction: A Social Critique of the Judgement of Taste.* London: Routledge.

Bourdieu, Pierre. 1990. *The Logic of Practice.* Stanford , CA: Stanford University Press.

Bourdieu, Pierre. 1993. *The Field of Cultural Production.* New York: Columbia University Press.

Brabesh, and Lucien Taylor, filmmakers. 1993. *In and Out of Africa.* Berkeley: Berkeley Media, LLC.

Brah, Avtar, and Annie E. Coombes, eds. 2000. *Hybridity and Its Discontents.* London: Routledge.

Braudel, Fernand. 1992a. *Civilization and Capitalism, 15th–18th Century, Vol. I: The Structure of Everyday Life.* Berkeley: University of California Press.

Braudel, Fernand. 1992b. *Civilization and Capitalism, 15th–18th Century, Vol. II: The Wheels of Commerce.* Berkeley: University of California Press.

Braudel, Fernand. 1992c. *Civilization and Capitalism, 15th–18th Century, Vol. III: The Perspective of the World.* Berkeley: University of California Press.

Braun, Barbara. 1993. *Pre-Columbian Art and the Post-Columbian World: Ancient American Sources for Modern Art.* New York: Harry N Abrams.

Breglia, Lisa C. 2006. *Monumental Ambivalence: The Politics of Heritage.* Austin: University of Texas Press.

Brody, J.J. 1971. *Indian Painters and White Patrons.* Albuquerque: University of New Mexico Press.

Bernstein, Bruce, and W. Jackson Rushing. 1995. *Modern by Tradition: American Indian Painting in the Studio Style.* Santa Fe: Museum of New Mexico Press.

Bricker, Victoria Reifler. 1981. *The Indian Christ, the Indian King: The Historical Substrate of Maya Myth and Ritual.* Austin: University of Texas Press.

Broude, Norma, and Mary Garrard. 1982. *Feminism and Art History: Questioning the Litany.* Boulder, CO: Westview Press.

Brown, Denise Fay. 1999. Mayas and Tourists in the Maya World. *Human Organization* 58 (3): 295–304.

Brunhouse, Robert L. 1973. *In Search of the Maya.* Albuquerque: University of New Mexico Press.

Cameron, Duncan. 1972. The Museum: A Temple or a Forum. *Journal of World History* 14 (1): 197.

Carmack, Robert M., ed. 1992. *Harvest of Violence: Maya Indians and the Guatemala Crisis.* Norman: University of Oklahoma Press.

Carmack, Robert M., Janine Gasco, and Gary H. Gossen. 1996. *The Legacy of Mesoamerica: History and Culture of a Native American Civilization.* Upper Saddle River, NJ: Prentice Hall.

Carmichael, Elizabeth. 1970. *Turquoise Mosaics from Mexico.* London: The Trustees of the British Museum.

Carrasco, David. 1982. *Quetzalcoatl and the Irony of Empire: Myths and Prophecies in the Aztec Tradition.* Chicago: University of Chicago Press.

Bibliography

Carrier, David. 1987. *Artwriting*. Amherst: University of Massachusetts Press.

Castañeda, Quetzil E. 1995. The Progress that Chose A Village: A Mysterious Impact and the Scandal of Zero-Degree Culture. *Critique of Anthropology* 15 (2): 115–47.

Castañeda, Quetzil E. 1996. *In the Museum of Maya Culture: Touring Chichén Itzá*. Minneapolis: University of Minnesota Press.

Castañeda, Quetzil E. 1997. On the Correct Training of Indios at the Handicraft Market at Chichén Itzá. *Journal of Latin American Anthropology* 2 (2): 106–43.

Castañeda, Quetzil E. 2000a. Approaching Ruins: A Photo-Ethnographic Essay on the Busy Intersections of Chichén Itzá. *Visual Anthropology Review*, 16 (2) (Fall/Winter):. 43–70.

Castañeda, Quetzil E. 2000b. The Topography of Maya Culture: On the Political and Scriptural Economy of the Modernizing Maya. *Estudios de Cultura Maya* 21: 249–65.

Castañeda, Quetzil E. 2003. New and Old Social Movements. *Ethnohistory* 50 (4): 611–42.

Castañeda, Quetzil E. 2004a. Art-Writing in the Maya Art World of Chichén Itzá. *American Ethnologist* 31 (1): 21–42.

Castañeda, Quetzil E. 2004b. We Are *Not* Indigenous! An Introduction to the Maya Identity of Yucatán. In "The Maya Identity of Yucatan, 1500–1935: Re-Thinking Ethnicity, History and Anthropology," theme issue guest edited by Quetzil E. Castañeda and Ben Fallaw. *Journal of Latin American Anthropology* 9 (1): 36–63.

Castañeda, Quetzil E. 2005a. Between Pure and Applied Research. *UNAPA Bulletin*, no. 23: 87–118.

Castañeda, Quetzil E. 2005b. Community Collaboration and Ethnographic Intervention: Dialogues in the Pisté Maya Art World. *Practicing Anthropology* 27 (4): 31–34.

Castañeda, Quetzil E. n.d. Heritage and Indigeneity: Transformations in the Politics of Tourism. In *Heritage and Cultural Tourism in Latin America*, ed. Michele Baud and Annelou Ypeji: Amsterdam: CEDLA. Forthcoming.

Castañeda, Quetzil E. and Ben Fallaw, eds. 2004. Theme issue, "The Maya Identity of Yucatan, 1500–1935: Re-Thinking Ethnicity, History and Anthropology." *The Journal of Latin American Anthropology* 9 (1).

Castañeda, Quetzil E., Fernando Armstrong Fumero, and Lisa Breglia. 1999. *Ah Dzib P'isté: Modern Maya Art in Ancient Tradition*. Exhibition Catalog. Lake Forest, IL: Lake Forest College.

Castillo Cocom, Juan A. 2005. 'It Was Simply Their Word': Maya PRInces in YucaPAN and the Politics of Respect. *Critique of Anthropology* 25 (2): 131–55.

Castillo Cocom, Juan A. 2007. Maya Scenarios: Indian Stories In and Out of Context. *Kroeber Anthropological Society Papers* 96: 13–35.

Castillo Cocom, Juan A. and Quetzil E. Castañeda, eds. 2004. *Estrategias Identitarias: Educación y la antropología historica en Yucatán*. Mérida, México: Universidad Pedagógica Nacional-Mérida, The Open School of Ethnography and Anthropology, and the Secretaría de Educación-Yucatán.

Catherwood, Frederick. 1844. *Views of Ancient Monuments in Central America, Chiapas and Yucatan*. Bartlett and Welford, New York.

Century of Progress, Chicago World's Fair, UIC Website: (http://collections.carli.illinois.edu/cdm4/item_viewer.php?CISOROOT=/uic_cop&CISOPTR=535&CISOBOX=1&REC=9).

Charnay, Désiré. 1863. *Cités et Ruines Americaines*. Paris, Chez Bonaventure et Ducessois.

Charnay, Désiré. 1887. *Ancient Cities of the New World*, trans. J. Gonino and Helen S. Conant. Harper & Brothers, New York.

Chibnik, Michael. 2003. *Crafting Tradition: The Making and Marketing of Oaxacan Wood Carvings*. Austin: University of Texas Press.

Clancy, Michael. 2001. Mexican Tourism: Export Growth and Structural Change since 1970. *Latin American Research Review*. 36. (1):128–50.

Cleere, Henry. 1984. World Cultural Resource Management: Problems and Perspectives. In *Approaches to the Archaeological Heritage: A Comparative Study of World Resource Management Systems*, ed. Henry Cleere: 125–31. Cambridge: Cambridge University Press.

Clifford, James. 1988. *The Predicament of Culture: Twentieth Century Ethnography, Literature, and Art*. Cambridge, MA: Harvard University Press.

Clifford, James, and George E. Marcus, eds. 1986. *Writing Culture: The Poetics and Politics of Ethnography*. Berkeley: University of California Press.

Cline, Howard F. 1948. The Henequen Episode in Yucatán, 1830–1890. *Journal of Inter-American Economic Affairs* 2: 30–51.

Coe, Michael D. 1973. *The Maya Scribe and His World*. New York: Grolier Club.

Coe, Michael D. 1975. *Lords of the Underworld: Masterpieces of Classic Maya Ceramics*. Princeton, NJ: Princeton University Press.

Coe, Michael D. 1999a. *The Maya*, 6th ed. New York: Thames and Hudson.

Coe, Michael D. 1999b. *Breaking the Maya Code*, rev. sub edition. New York: Thames and Hudson.

Coe, Michael D. 2005. *The Maya*, 7th ed. New York: Thames and Hudson.

Coe, Michael D., and Rex Koontz. 2002. *Mexico*, 5th ed. New York: Thames and Hudson.

Coggins, Clemency. 1987. New Fire at Chichén Itzá, *Memorias del Primer Coloquio Internacional de Mayistas*, Instituto de Investigaciones Filológicas, Centro de Estudios Mayas: 427–84. México, D.F.: UNAM.

Coggins, Clemency C., and Orrin Shane III. 1984. *Cenote of Sacrifice: Maya Treasures from the Sacred Well at Chichen Itza*. Austin: University of Texas Press.

Cohen, Erik. 1984. The Sociology of Tourism: Approaches, Issues, and Findings. *Annual Review of Sociology* 10: 373–92.

Cohen, Erik. 1988. Authenticity and Commoditization in Tourism. *Annals of Tourism Research* 15: 371–86.

Cohodas, Marvin. 1986. Tradition and Native American Art. In *The Arts of the North American Indian: Native Traditions in Evolution*, ed. Edwin Wade: 203–20. New York: Hudson Hills Press.

Cohodas, Marvin. 1997. *Basket Weavers for the California Curio Trade*. Tucson: University of Arizona Press.

Cohodas, Marvin. 1999. Elizabeth Hickox and Karuk Basketry: A Case Study in Debates on Innovation and Paradigms of Authenticity. In Art, Authenticity and the Baggage of Cultural Encounter. In *Unpacking Culture: Art and Commodity in the Colonial and Postcolonial Worlds*, ed. Phillips, Ruth B. and Christopher B. Steiner: 143–61. Berkeley: University of California Press.

Cole, Douglas. 1985. *Captured Heritage: The Scramble for Northwest Coast Artifacts*. Seattle: University of Washington Press.

Comisión Empresarial MundoMaya. 1995. Bienvenido al Mundo Maya/Welcome to the Maya World. *Mundo Maya* 3 (2): 4.

Coombes, Annie E. 1994. *Reinventing Africa: Museums, Material Culture and Popular Imagination*. New Haven: Yale University Press.

Craik, Jennifer. 1997. The Culture of Tourism. In *Touring Cultures: Transformations of Travel and Theory*, eds. Chris Rojek and John Urry, 113–37. London: Routledge.

Crouch, David, and Nina Lübbren, eds. 2003. *Visual Culture and Tourism*. New York: Oxford University Press.

Culbert, T. Patrick. 2004. Continuities and Changes in Maya Archaeology: An Overview. In *Continuities and Changes in Maya Archaeology: Perspectives at the Millennium*, eds. Charles W. Golden and Greg Borgstede, 311–20. New York and London: Routledge.

Danly, Susan, ed. 2002. *Casa Mañana: The Morrow Collection of Mexican Popular Arts*. Albuquerque, NM: University of New Mexico Press.

Danto, Arthur. 1964. The Artworld. *Journal of Philosophy* 61 (19): 571–84.

Danto, Arthur. 1996. *After the End of Art: Contemporary Art and the Pale of History*. Princeton, NJ: Princeton University Press.

Davis, Keith F. 1981. *Désiré Charnay: Expeditionary Photographer*. Albuquerque: University of New Mexico Press.

Dean, Carolyn. 2006. The Trouble with (the Term) Art. *Art Journal* 65 (2) (Summer): 25–32.

Decter, Joshua. 1989. The Greenberg Effect: Comments by Younger Artists, Critics, and Curators. *Arts Magazine* 64 (December): 58.

Delpar, Helen. 1992. *The Enormous Vogue of Things Mexican: Cultural Relations Between the United States and Mexico, 1920–1935*. Tuscaloosa: University of Alabama Press.

Demarest, Arthur. 2004. *Ancient Maya: The Rise and Fall of a Rainforest Civilization*. Cambridge: Cambridge University Press.

Demarest, Arthur, Prudence Rice and Don S. Rice, eds. 2004. *The Terminal Classic in the Maya Lowlands: Collapse, Transition, and Transformation*. Boulder: University Press of Colorado.

Desmond, Lawrence G. 2001. Chacmool. In *Oxford Encyclopedia of Mesoamerican Cultures*, Vol. 1, ed. Davíd Carrasco: 168–69. New York: Oxford University Press.

Desmond, Lawrence G., and Phyllis Mauch Messenger. 1988. *A Dream of Maya*. Albuquerque: University of New Mexico Press.

Diamond, Jared M. 1999. *Guns, Germs, and Steel: The Fates of Human Societies*. New York: W. W. Norton & Company.

Diehl, Richard A. 1983. *Tula: The Toltec Capital of Ancient Mexico*. London and New York: Thames and Hudson.

Dilworth, Leah. 1998. *Imagining Indians in the Southwest: Persistent Visions of a Primitive Past*. Washington DC: Smithsonian Institution Press.

Dirks, Nicholas B., Geoff Eley, and Sherry B. Ortner, eds. 1993. *Culture/Power/History*. Princeton, NJ: Princeton University Press.

Dirks, Nicholas B., Geoff Eley, and Sherry B. Ortner. 1994. Introduction. In *Culture/Power/History: A Reader in Contemporary Social Theory*, eds. Nicholas B. Dirks, Geoff Eley, and Sherry B. Ortner, 3–45. Princeton, NJ: Princeton University Press.

Doremus, Anne. 2001. Indigenism, Mestizaje, and National Identity in Mexico during the 1940s and the 1950s. *Mexican Studies/Estudios Mexicanos* 17 (2): 375–402.

Drucker-Brown, Susan. 1995. Review of *The Quest for the*

Other: Ethnic Tourism in San Cristobal, Mexico, by Pierre L. van den Berghe. *The Journal of the Royal Anthropological Institute* 1 (3): 652–53.

Dubin, Margaret. 2001. *Native America Collected: The Culture of an Art World.* Albuquerque: University of New Mexico Press.

DuBois, Constance Goddard. 1904. The Indian Woman as a Craftsman. *The Craftsman* 6 (4): 391–93.

Dumond, Don E. 1997. *The Machete and the Cross: Campsino Rebellion in Yucatán.* Lincoln, NE: University of Nebraska Press.

Duncan, Carol, and Alan Wallach. 1980. The Universal Survey Museum. *Art History* 3 (4) (December): 451.

Duncan, Carol. 1995. *Civilizing Rituals: Inside Public Art Museums.* London: Routledge.

Duncan, Kate. 2000. *1001 Curious Things: Ye Old Curiosity Shop and Native American Art.* Seattle: University of Washington Press.

Dunning, Nicholas P. 1992. *Lords of the Hills: Ancient Maya Settlement in the Puuc Region, Yucatan, Mexico.* Madison, WI: Prehistory Press.

Dunning, Nicolas P., and Jeff K. Kowalski. 1994. Lords of the Hills: Classic Maya Settlement Patterns and Political Iconography in the Puuc Region, Mexico. *Ancient Mesoamerica* 5: 63–95.

Earenfight, Phillip, ed. 2007. *A Kiowa's Odyssey: A Sketchbook from Fort Marion.* Seattle: University of Washington Press.

Eco, Umberto. 1986. Travels in Hyperreality. In *Faith in Fakes: Travels in Hyperreality,* Umberto Eco: 3–58. London: Secker and Warburg.

Ehrentraut, Adolf W. 1996. Maya Ruins, Cultural Tourism, and the Contested Symbolism of Collective Identities. *Culture* XVI (1): 15–32.

Errington, Shelly. 1993. Progressivist Stories and the Pre-Columbian Past: Notes on Mexico and the United States. In *Collecting the Pre-Columbian Past,* ed. Elizabeth Hill Boone, 209–49. Washington, DC: Dumbarton Oaks Research Library and Collections.

Errington, Shelly. 1998. *The Death of Authentic Primitive Art and Other Tales of Progress.* Berkeley: University of California Press.

Errington, Shelly. 2005. History Now: Post-Tribal Art. In *Anthropologies of Art,* ed. Mariët Westermann. 221–41. Clark Studies in the Visual Arts. Williamstown, MA: Sterling and Francine Clark Art Institute, Distributed by Yale University Press, New Haven and London.

Ettawageshik, Frank. 1999. My Father's Business. In *Unpacking Culture: Art and Commodity in the Colonial and Post-colonial Worlds,* ed. Phillips, Ruth B. and Christopher B. Steiner, 20–29. Berkeley: University of California Press.

Evans, R. Tripp. 2004. *Romancing the Maya: Mexican Antiquity in the American Imagination 1820–1915.* Austin: University of Texas Press.

Fabian, Johannes. 1983. *Time and the Other: How Anthropology makes its Object.* New York: Columbia University Press.

Fallaw, Ben W. 1997. Cárdenas and the Caste War That Wasn't: State Power and Indigenismo in Post-Revolutionary Yucatan. *The Americas* 53 (4) (April): 551–77.

Fallaw, Ben W. 2001. *Cárdenas Compromised: The Failure of Reform in Postrevolutionary Yucatán.* Durham, NC: Duke University Press.

Fane, Diana. 1993. Reproducing the Pre-Columbian Past: Casts and Models in Exhibitions of Ancient America, 1824–1935. In *Collecting the Pre-Columbian Past,* ed. Elizabeth Hill Boone, 141–76. Washington, DC: Dumbarton Oaks Research Library and Collections.

Fanon, Frantz. 2005. *The Wretched of the Earth.* New York: Grove Press.

Farriss, Nancy M. 1984. *Maya Society under Colonial Rule: The Collective Enterprise of Survival.* Princeton, NJ: Princeton University Press.

Fash, William L. 1994. Changing Perspectives on Maya Civilization. *Annual Review of Anthropology* 23 (1994): 181–208.

Fernea, Robert A. 1996. Photographic Politics. Review of *Contesting Images: Photography and the World's Columbian Exposition* by Julie K. Brown, and *Reading National Geographic* by Catherine A. Lutz; Jane L. Collins. *Current Anthropology* 37 (1, Supplement: Special Issue: Anthropology in Public) (February):183–84.

Fischer, Edward F. 1999. Cultural logic and Maya identity: Rethinking Constructivism and Essentialism. *Current Anthropology* 40 (4): 473–99.

Flinn, John J. 1893. *Official Guide to the World's Columbian Exposition.* Chicago: John Anderson Publishing Company.

Florescano, Enrique. 1993. The Creation of the Museo Nacional de Antropología of Mexico and its Scientific, Educational, and Political Purposes. In *Collecting the Pre-Columbian Past,* ed. Elizabeth Hill Boone: 81–103. Washington, DC: Dumbarton Oaks Research Library and Collections.

Foncerrada de Molina, Marta. 1965. *La escultura arquitectónica de Uxmal.* México, D.F.: Universidad Nacional Autónoma de México.

Foster, Robert J. 2008. *Coca-globalization: Following Soft Drinks from*

New York to New Guinea. New York: Palgrave Macmillan.

Fourneau, J., and L. Kravetz. 1954. Le pagne sur la Côte de Guinée et au Congo du XVeme siècle à nos jours. *Bulletin de l'Institut d'Etudes Centrafricaine* 7–8: 5–22.

Fowler, Don D. 1987. Uses of the Past: Archaeology in the Service of the State. *American Antiquity* 52 (2): 229–48.

Frank, Andre Gunder, and Barry K. Gills, eds. 1996. *The World System: Five Hundred Years or Five Thousand?* London and New York: Routledge and Kegan Paul.

Fraser, Grace. 1948. *Textiles by Britain*. London: George Allen and Unwin.

Freedman, Kerry. 2003. *Teaching Visual Culture: Curriculum, Aesthetics, and the Social Life of Art*. New York and London: Teachers College, Columbia University.

Freidel, David, Linda Schele, and Joy Parker. 1993. *Maya Cosmos: Three Thousand Years on the Shaman's Path*. New York: William Morrow.

Fussell, Paul. 1987. The Eighteenth Century and the Grand Tour. In *The Norton Book of Travel*, ed. Paul Fussell, 127–32. New York: W. W. Norton and Company.

Gabbert, Wolfgang. 2001. Social Categories, Ethnicity and the State in Yucatán, Mexico. *Journal of Latin American Studies* 33 (3) (August): 459–84.

Gabbert, Wolfgang. 2004. *Becoming Maya: Ethnicity and Social Inequality in Yucatán since 1500*. Tucson, AZ: University of Arizona Press.

Ganz, Cheryl R. 2007. *Building a Century of Progress: The Architecture of Chicago's 1933–1934 World's Fair*. Minneapolis: University of Minnesota Press.

Ganz, Cheryl R. 2008. *The 1933 Chicago World's Fair: A Century of Progress*. Urbana-Champaign: University of Illinois Press.

García Canclini, Nestor. 1993. *Transforming Modernity*. Austin: University of Texas Press.

García Canclini, Nestor. 1995. *Hybrid Cultures*. Minneapolis: University of Minnesota Press.

Garrett, Wilber E., and Kenneth Garrett. 1989. La Ruta Maya. *National Geographic* (October): 424–79.

Garrett, Wilber E. 1993. The Maya Route—La Ruta Maya. In *The Maya Route: "La Ruta Maya,"* ed. Richard Harris and Stacy Ritz: xii–xv. Berkeley: Ulysses Press.

Gates, William. 1992. *The Dresden Codex: Drawings of the Pages and Commentary in Spanish*. Walnut Creek, CA: Aegean Park Press [facsimile of 1932 edition].

Gathercole, Peter, and David Lowenthal. 1990. *The Politics of the Past*. London: Unwin Hyman.

Gebhard, David and Anthony Peres. 1993. *Robert Stacy-Judd: Maya Architecture and the Creation of a New Style*. Santa Barbara, CA: Capra Press.

Geertz, Clifford. 1973. *The Interpretation of Cultures*. New York: Basic Books, Inc.

Geismar, Haidy. 2001. What's In a Price: An Ethnography of Tribal Art at Auction. *Journal of Material Culture* 6 (1): 25–47.

Gell, Alfred. 1998. *Art and Agency: An Anthropological Theory*. Oxford and New York: Oxford University Press.

Gendrop, Paul. 1983. *Los estilos Rio Bec, Chenes y Puuc en la arquitectura maya*. Mexico, D.F.: Universidad Nacional Autónoma de Mexico.

George, Kenneth M. 1999. Objects on the Loose: Ethnographic Encounters with Unruly Artefacts. Theme issue. *Ethnos* 64 (2): 149–50.

Gibson, James. 1992. *Otter Skins, Boston Ships, and China Goods*, McGill-Queens University Press.

Giddens, Anthony. 1991. *Modernity and Self-Identity: Self and Society in the Late Modern Age*. Stanford, CA: Stanford University Press.

Giddens, Anthony. 2003. *Runaway World: How Globalization is Reshaping our Lives*, 2nd ed. London: Routledge.

Giddens, Anthony, and Mitchell Duneier. 2000. *Introduction to Sociology*, 3rd ed. New York and London: W. W. Norton & Company, Inc.

Gilroy, Paul. 1994. Sounds Authentic: Black Music, Ethnicity, and the Challenge of a *Changing* Same. In *Imagining Home: Class, Culture and Nationalism in the African Diaspora*, ed. Sidney Lemelle and Robin D. G. Kelley, 93–118. London: Verso.

Girshick, Paula D. 2008. Envisioning Art Worlds: New Directions in the Anthropology of Art. In *World Art Studies: Exploring Concepts and Approaches*, ed. Kitty Zijlmans and Wilfried van Damme, 219–233. Amsterdam: Valiz.

Gluek, Grace. 1985. Art: Maya Treasures, the Tiny and the Vast. *New York Times* (26 April).

Goffman, Erving. 1959. *The Presentation of Self in Everyday Life*. New York: Anchor Books.

Golden, Charles W., and Greg Borgstede, eds. 2004. *Continuities and Changes in Maya Archaeology: Perspectives at the Millennium*. New York and London: Routledge.

Goldwater, Robert J. 1967. *Primitivism in Modern Art*. New York: Random House (originally published as Primitivism in Modern Painting, 1938).

Graburn, Nelson H. H. 1976. *Ethnic and Tourist Arts: Cultural Expressions from the Fourth World*. Berkeley: University of California Press.

Graburn, Nelson. 1984. The Evolution of Tourist Arts. *Annals of Tourism Research*. 11: 393–419.

Graburn, Nelson. 1999. Ethnic and Tourist Arts Revisited. In *Unpacking Culture: Art and Commodity in Colonial and*

Postcolonial World, eds. Ruth B. Phillips and Christopher B. Steiner, 335–53. Berkeley, Los Angeles, London: University of California Press.

Graburn, Nelson H. H., Molly Lee, and Jean-Loup Rousselot. 1996. *Catalogue Raisonné of the Alaska Commercial Company Collection, Phoebe Apperson Hearst Museum of Anthropology*. Berkeley: University of California Press.

Graham, Mark Miller. 1986. Review of the Blood of Kings: Dynasty and Ritual in Maya Art. *African Arts* 20 (1) (November): 95–97.

Greenberg, Clement. 1939. Avant-Garde and Kitsch. *Partisan Review* 6 (5): 34–49.

Greenberg, Reesa, Bruce W. Ferguson, and Sandy Nairne, eds. 1996. *Thinking about Exhibitions*. London: Routledge.

Greenblatt, Stephen. 1991. Resonance and Wonder. In *Exhibiting Cultures: The Poetics and Politics of Museum Display*, ed. Ivan Karp and Steven D. Lavine, 42–56. Washington DC: Smithsonian Institution Press.

Greenhalgh, Paul. 1988. *Ephemeral Vistas: The Expositions Universelles, Great Exhibitions and World's Fairs: 1851–1939*. Chicago: Chicago Historical Society.

Gugliotta, Guy. 2007. The Maya, Glory to Ruin, Saga of a civilization in three parts: The rise, the monumental splendor, and the collapse. *National Geographic* (August): 68–109.

Gruzinski, Serge. 2002. *The Mestizo Mind: the intellectual dynamics of colonization and globalization*. New York: Routledge.

Guth, Christine M.E. 2004. *Longfellow's Tattoos: Tourism, Collecting, and Japan*. Seattle: University of Washington Press.

Hall, Colin Michael. 1994. *Tourism and Politics: Policy, Power and Place*. Chichester, NY: Wiley Publishers.

Hall, Stuart, ed. *Representation: Cultural Representations and Signifying Practices*. London: Sage Publications and Open University, 1999.

Hall, Stuart, and Paul du Gay, eds. 1996. *Questions of Cultural Identity*. London: Sage Publications, Ltd.

Hanks, William F. 1990. *Referential Practice: Language and Lived Space Among the Maya*. Chicago: University of Chicago Press.

Harris, Jonathan, ed. 2001a. *Globalization and Contemporary Art*. Blackwell Publishers.

Harris, Jonathan. 2001b. *The New Art History: A Critical Introduction*. London and New York: Routledge.

Haviland, William. 1991. *Anthropology* (6th ed.). Philadelphia: Holt, Rinehart, and Winston.

Heatherington, Edna E. 1986. The Influence of Mayan Architecture in the United States. In *The Maya Image in the Western World: A Catalog to an Exhibition at the University of New Mexico*, ed. Peter Briggs: 33–37. Albuquerque: University of New Mexico Art Museum/Maxwell Museum of Anthropology.

Hemingway, Seán. 2002. Posthumous Copies of Ancient Greek Sculpture. *Sculpture Review* 51 (2) (Summer): 27–32.

Herring, Adam. 2005. *Art and Writing in the Maya Cities, AD 600–800: A Poetics of Line*. Cambridge and New York: Cambridge University Press.

Hervik, Peter. 1999. The Mysterious Maya of National Geographic. *Journal of Latin American Anthropology* 4 (1): 166–97.

Hervik, Peter. 2003. *Mayan People Within and Beyond Boundaries: Social Categories and Lived Identity in Yucatán*. New York: Routledge.

Hervik, Peter, and Hillary Kahn. 2006. Scholarly Surrealism: The Persistence of Mayanness. *Critique of Anthropology* 26 (2) (London): 209–32.

Herzog, Melanie. 1996. Aesthetics and Meanings: the Arts and Crafts Movement and the Revival of American Indian Basketry. In *The Substance of Style: Perspectives on the American Arts and Crafts Movement*, ed. Bert Denker: 69–91. Winterthur, DE: Winterthur Museum.

Hewison, R. 1988. Great Expectations—Hyping Heritage. *Tourism Management* 9 (3): 239–40.

Hiernaux, Daniel, ed. 1989. *Teoría y praxis del espacio turístico*. Mexico City: UNAM-Xochimilco.

Higgins, John, ed. 2001. The Raymond Williams Reader. Malden, MA: Blackwell Publishers, Inc.

Hinderliter, Edward. 1971. The Maya Temple of the 1933 Chicago World's Fair. In Abstracts of Papers Presented at the Twenty-Fourth Annual Meeting of the Society of Architectural Historians. *The Journal of the Society of Architectural Historians* 30 (3) (October): 238–48.

Hinsley, Curtis M.. 1993. In Search of the New World Classical. In *Collecting the Pre-Columbian Past*, ed. Elizabeth Hill Boone: 105–121. Washington, DC: Dumbarton Oaks Research Library and Collections.

Hobsbawm, Eric, and Terence Ranger, eds. 1985. *The Invention of Tradition*. Cambridge: Cambridge University Press.

Hodder, B.W. 1980. Indigenous Cloth Trade and Marketing in Africa. In *Textiles of Africa*, ed. Dale Idiens and K.G. Ponting: 201–10. Bath, England: The Pasold Research Fund.

Hoerig, Karl. 2003. *Under the Palace Portal: Native American Artists in Santa Fe*. Albuquerque: University of New Mexico Press.

Bibliography

Holm, Bill, ed. 1989. *Soft Gold: The Fur Trade and Cultural Exchange on the Northwest Coast of America*. Portland: The Oregon Historical Association.

Holt, Elizabeth Gilmore. 1957. *A Documentary History of Art*, Vol. 1. Garden City, N.Y.: Doubleday Anchor Books.

Houston, Stephen, David Stuart, and Karl Taube. 2006. *The Memory of Bones: Body, Being, and Experience among the Classic Maya*. Austin: University of Texas Press.

Howells, Richard. 2003. *Visual Culture*. Cambridge, UK: Polity Press.

Heusinkveld., Paula R. 2008. Tinum, Yucatán, A Maya Village in the Lights of Cancún. In *Yucatán in an Era of Globalization*, ed. Eric N. Baklanoff and Edward H. Moseley, 112–33. Tuscaloosa: University of Alabama Press.

Inda, Jonathan, and Renato Rosaldo. 2002. A World in Motion. Introduction to *The Anthropology of Globalization*, ed. Jonathan Inda and Renato Rosaldo: 1–34. Oxford: Blackwell.

Ingle, Marjorie. 1989. *The Mayan Revival Style: Art Deco Mayan Fantasy*. Albuquerque: University of New Mexico Press.

Jarozombek, Mark. 1994. De-Scribing the Language of Looking: Wolfflin and the History of Aesthetic Experientialism. *Assemblage: A Critical Journal of Architecture and Design Culture* 23 (Summer): 28–69.

Jonaitis, Aldona. 1988. *From the Land of the Totem Poles: The Northwest Coast Indian Art Collection at the American Museum of Natural History*. New York: American Museum of Natural History.

Jonaitis, Aldona, and Aaron Glass. Forthcoming in 2009. *The Totem Pole: An Intercultural Biography*. Seattle: University of Washington Press.

Jones, Christopher, and Linton Satterthwaite. 1982. *The Monuments and Inscriptions of Tikal*, Tikal Report, no. 33, pt. A. Philadelphia: University of Pennsylvania Press.

Jones, Grant D. 1977. *Anthropology and History in Yucatan*. Austin, TX: University of Texas Press.

Jones, Grant D. 2000. The Lowland Mayas, from the Conquest to the Present. In *The Cambridge History of the Native Peoples of the Americas,* Volume II, Mesoamerica, Part 2, ed. Richard E. W. Adams and Murdo J. Macleod: 346–91. Cambridge: Cambridge University Press.

Joseph, Gilbert. 1986. *Rediscovering the Past at Mexico's Periphery: Essays on the History of Modern Yucatán*. Tuscaloosa, AL: University of Alabama.

Joseph, Gilbert M., ed. 2002. *The Mexico Reader: History, Culture, Politics*. Durham, NC: Duke University Press.

Jules-Rosette, Benetta. 1990. Simulations of Postmodernity: Images of Technology in African Tourist and Popular Art. *Visual Anthropology Review* 6 (1): 29–37.

Kakutani, Michiko. 1986. Books of the Times. *New York Times* (6 August).

Kant, Immanuel. 1951. *The Critique of Judgment*, translated with an introduction by J. H. Bernard. New York: Hafner Press.

Karp, Ivan, and Steven D. Lavine, eds. 1991. *Exhibiting Cultures: The Poetics and Politics of Museum Display*. Washington, DC: Smithsonian Institution of Washington.

Karp, Ivan, Corinne A. Kratz, Lynne Swaja, and Tómas Ybarra-Frausto, eds. 2007. *Museum Frictions: Public Cultures/ Global Transformations*. Durham, NC: Duke University Press.

Kearney, Michael. 1995. The Local and the Global: The Anthropology of Globalization and Transnationalism. *Annual Review of Anthropology* 24: 547.

Keen, Benjamin. 1971. *The Aztec Image in Western Thought*. Brunswick, NJ: Rutgers University Press.

Keen, Benjamin. 1994. Review of *Collecting the Pre-Columbian Past* by Elizabeth Hill Boone. *Ethnohistory*, 41 (3) (Summer): 486–88.

Kent, Rachel, and Robert Hobbs. 2008. *Yinka Shonibare, MBE*. New York: Prestel.

Kepecs, Susan, Gary Feinman, and Sylviane Boucher. 1994. Chichen Itza and its Hinterland, a World-Systems Perspective. *Ancient Mesoamerica* 5: 141–58.

King, J.C.H. 1986. Tradition and Native American Art. In *The Arts of the North American Indian: Native Traditions in Evolution*, ed. Edwin Wade: 65–92. New York: Hudson Hills Press.

Kirshenblatt-Gimblett, Barbara. 1995. Theorizing Heritage. *Ethnomusicology* 39 (3) (Autumn): 367–80.

Kirshenblatt-Gimblett, Barbara. 1998. *Destination Culture: Tourism, Museums, and Heritage*. Berkeley, Los Angeles, London: University of California Press.

Klein, Cecelia F. 1988. Mayamania: 'Blood of Kings' in Retrospect. *Art Journal* 47 (1) (Spring): 42–46.

Klein, Cecelia F., Eulogio Guzmán, Elisa C. Mandell, and Maya Stanfield-Mazzi. 2002. The Role of Shamanism in Mesoamerican Art: A Reassessment. *Current Anthropology* 43 (3): 383–420.

Kleinbauer, W. Eugene. 1971. *Modern Perspectives in Western Art History*. New York: Holt, Rinehart, and Winston.

Kohl, Philip L. 1998. Nationalism and Archaeology: On the Constructions of Nations and the Reconstructions of the Remote past. *Annual Review of Anthropology* 27: 223–46.

Kohl, Philip L. 2004. Making the Past Profitable in an Age of Globalization and National Ownership: Contradictions and Considerations. In *Marketing Heritage: Archaeology*

and the Consumption of the Past, ed. Yorke Rowan and Uzi Baram: 295–301. Walnut Creek, CA: Altamira Press.

Kohl, Philip L., and Clare Fawcett, eds. 1995. *Nationalism, Politics, and the Practice of Archaeology.* Cambridge: Cambridge University Press.

Kohler, Gernot, and Emilio José Chaves, eds. 2003. *Globalization: Critical Perspectives.* Hauppauge, NY: Nova Science Publishers.

Kowalski, Jeff Karl. 1987. *The House of the Governor: A Maya Palace at Uxmal, Yucatan, Mexico.* University of Oklahoma Press, Norman.

Kowalski, Jeff Karl. 1994. The Puuc as Seen from Uxmal. In *Hidden among the Hills: Maya Archaeology of the Northwest Yucatan Peninsula,* ed. Hanns Prem: 93–120. Acta Mesoamericana 7. Möcksmühl, Germany: Verlag von Flemming.

Kowalski, Jeff Karl, and Nicholas Dunning. 1999. The Architecture of Uxmal: The Symbolics of Statemaking at a Puuc Maya Regional Capital. In *Mesoamerica as a Cultural Symbol,* ed. Jeff K. Kowalski: 274–97. Oxford and New York: Oxford University Press.

Kowalski, Jeff Karl. 2003a. Evidence for the Functions and Meanings of some Northern Maya Palaces. In *Maya Palaces and Elite Residences: An Interdisciplinary Approach,* ed. Jessica Joyce Christie: 204–52. Austin: University of Texas Press.

Kowalski, Jeff Karl. 2003b. Collaboration and Conflict: An Interpretation of the Relationship between Uxmal and Chichén Itzá during the Terminal Classic/Early Postclassic Periods. In *Escondido en la Selva: Arqueología en el norte de Yucatán,* ed. Hanns J. Prem: 235–72. Colección Obra Diversa. México, D.F.: Instituto Nacional de Antropología e Historia y Universidad de Bonn.

Kowalski, Jeff Karl, and Cynthia Kristan-Graham, eds. 2007. *Twin Tollans: Chichén Itzá, Tula, and the Epiclassic to Early Postclassic Mesoamerican World.* Washington, DC: Dumbarton Oaks Research Library and Collections.

Krasniauskas, John. 2000. Hybridity in a Transnational Frame. In *Hybridity and Its Discontents,* ed. Avtar Brah and Annie E. Coombes, 235–56. London: Routledge.

Krauss, Rosalind. 1981. The Originality of the Avant-Garde: A Postmodern Repetition. *October* 18 (Autumn): 47–66.

Kristan-Graham, Cynthia, and Jeff Karl Kowalski. 2007. Chichén Itzá, Tula and Tollan: Changing Perspectives on a Recurring Problem in Mesoamerican Archaeology and Art History. In *Twin Tollans: Chichén Itzá, Tula, and the Epiclassic to Early Postclassic Mesoamerican World,* eds. Jeff Kowalski and Cynthia Kristan-Graham, 13–83. Washington, DC: Dumbarton Oaks Research Library and Collections.

Kubler, George. 1962. *The Shape of Time: Remarks on the History of Things.* New Haven, CT: Yale University Press.

LaBrecque, Marie France. 2005. "Cultural Appreciation and Economic Depreciation of the Mayas of Northern Yucatán, Mexico," translated by Mary Richardson. *Latin American Perspectives* 143 Vol. 32 (4) (July): 87–105.

Lapointe, Marie. 1983. *Los Mayas Rebeldes de Yucatán.* Zamora, Michoacan: El Colegio de Michoacán.

Lavine, Stephen D., and Ivan Karp. 1991. Introduction: Museums and Multiculturalism. In *Exhibiting Cultures: The Poetics and Politics of Museum Display.* Washington and London: Smithsonian Institution Press.

Lea, John. 1988. *Tourism and Development in the Third World.* London: Routledge.

Lerner, Jesse. 2000. A Fevered Dream of Maya: Robert Stacy-Judd. La tortuga marina: Historia en extinción, Año 2001 (http://tortugamarina.tripod.com/articulos/lerner/stacy-judd.html).

Lethbridge, Alan. 1921. *West Africa the Elusive.* London: John Hale, Sons and Danielsson.

Lichtenstein, Roy, et al. "What Is Pop Art?" Interviews by Gene Swenson. *Art News* (November 1963 and February 1964): 102–15.

Lipe, William D. 1984. Value and Meaning in Cultural Resources. In *Approaches to the Archaeological Heritage: A Comparative Study of World Resource Management Systems,* ed. Henry Cleere: 1–11. Cambridge: Cambridge University Press.

Lipman, Samuel. 1992. "Backward and Downward with the Arts," *Commentary,* May 1990. In *Culture Wars: Documents from the Recent Controversies in the Arts,* ed. Richard Bolton. New York: New Press.

Little, Kenneth. 1991. On Safari: The Visual Politics of a Touristic Representation. In *The Varieties of Sensory Experience,* ed. David Howes, 148–63. Toronto: University of Toronto Press.

Little, Walter E. 2004. *Mayas in the Marketplace: Tourism, Globalization, and Cultural Identity.* Austin: University of Texas Press.

Lo Cotidiano y lo Ritual en las Artesanías Yucatecas. Cuadernos de Cultura Yucateca no. 2. Mérida, Yucatán: CULTUR Servicios, Talleres Gráficos del Sudeste, 1993 various authors.

Lockhart, James. 1969. Encomienda and Hacienda: The Evolution of the Great Estate in the Spanish Indies. *Hispanic American Historical Review* 49 (3): 411–29.

Long, Veronica. 1991. Government-Industry-Community Interaction in Tourism Development in Mexico. In *The Tourism Industry: An International Analysis,* ed. M.

Thea Sinclair and M. J. Stabler: 205–22. Oxford: CAB International.

Lorenzo, José Luis. 1981. Archaeology South of the Rio Grand. *World Archaeology* 13: 190–208.

Lorenzo, José Luis. 1984. Mexico. In *Approaches to the Archaeological Heritage: A Comparative Study of World Resource Management Systems*, ed. Henry Cleere: 89–100. Cambridge: Cambridge University Press.

Lutz, Catherine A., and Jane L. Collins. 1993. *Reading National Geographic*. Chicago: University of Chicago Press.

MacCannell, Dean. 1973. Staged Authenticity: Arrangements of Social Space in Tourist Settings. *American Journal of Sociology* 79 (3): 589–603.

MacCannell, Dean. 1976. *The Tourist: A New Theory of the Leisure Class*. New York. Schocken Books.

MacCannell, Dean. 1999. *The Tourist: A New Theory of the Leisure Class*. Berkeley, CA: University of California Press.

MacKenzie, Norman Ian, ed. 1958. *Convictions*. London: MacGibbon & Kee.

Magiciens de la terre: Centre Georges Pompidou, Musee national d'art moderne, La Villette, la Grande Halle. Paris: Editions du Centre Pompidou, 1989.

Magnoni, Aline, Traci Ardren, and Scott Hutson. 2007. Tourism in the Mundo Maya: Inventions and (Mis)Representations of Maya Identities and Heritage. *Archaeologies: Journal of the World Archaeological Congress* 3 (3): 353–83.

Marcus, George E., and Fred R. Myers. 1995. The Traffic in Art and Culture: An Introduction. In *The Traffic in Culture: Refiguring Art and Anthropology*, ed. George E. Marcus and Fred R. Myers: 1–51. Berkeley: University of California Press.

Marcus, George E., and Michael M. J. Fischer, eds. 1999. *Anthropology as Cultural Critique: An Experimental Moment in the Human Sciences*. Chicago: University of Chicago Press.

Marken, Damien B. 2007. *Palenque: Recent Investigations at the Classic Maya Center*. Lanham, MD: AltaMira Press.

Marling, Karal Ann. 1992. Writing History with Artifacts: Columbus at the 1893 Chicago Fair. *The Public Historian* 14 (4). Imposing the Past on the Present: History, the Public, and the Columbus Quincentenary (Autumn): 13–30.

Marquis, Alice Goldfarb. 1991. *The Art Biz: The Covert World of Collectors, Dealers, Auction Houses, Museums, and Critics*. Chicago: Contemporary Books.

Martin, Simon, and Nikolai Grube. 2000. *Chronicle of the Maya Kings and Queens: Deciphering the Dynasties of the Ancient Maya*. New York: Thames & Hudson.

Masson, Marilyn A. 2001. *In the Realm of Nachan Kan: Postclassic Maya Archaeology at Laguna de On, Belize*. Niwot, CO: University Press of Colorado.

Maudslay, Alfred P. 1889–1902 (1974). *Biología Centrali-Americana: Archaeology*, 5 vols. London: Dulau and Co.; Reprint edition, New York: Milpatron Publishing Corp..

McBryde, Isabel, ed. 1985. *Who Owns the Past?* Melbourne, Australia: Oxford University Press.

McEvilley, Thomas. 1990. Thomas McEvilley on the Global Issue. *Artforum* 28 (March): 19–21.

McEvilley, Thomas. 1992. *Art and Otherness: Crisis in Cultural Identity*. Kingston, NY: McPherson & Company.

McMaster, Gerald, ed. 1998. *Reservation X: The Power of Place in Aboriginal Contemporary Art*. Hull, Quebec: Canadian Museum of Civilization.

Meech-Pekarik, Julia. 1986. *The World of the Meiji Print: Impressions of A New Civilization*. New York: Weatherhill Press.

Meyer, Michael C., and William L. Sherman. 1991. *The Course of Mexican History*, 4th ed. New York and Oxford: Oxford University Press.

Milbrath, Susan, and Carlos Peraza Lope. 2003. Revisiting Mayapan: Mexico's Last Maya Capital. *Ancient Mesoamerica* 14 (1): 46.

Milbrath, Susan, and Peraza Lope. n.d. Survival and Revival of Terminal Classic Traditions at Postclassic Mayapán. Manuscript submitted for publication to *Latin American Antiquity*.

Miller, Angela, Janet Berlo, Bryan Wolf, and Jenifer Roberts. 2008. *American Encounters: Art, History, and Cultural Identity*. Upper Saddle River, N.J.: Pearson/Prentice Hall.

Miller, Arthur G. 1982. *On the Edge of the Sea: Mural Painting at Tancah-Tulum, Quintana Roo, Mexico*. Washington DC: Dumbarton Oaks Research Library and Collections.

Miller, Mary Ellen. 1985. A Re-Examination of the Mesoamerican Chacmool. *The Art Bulletin* 67 (1): 7–17.

Miller, Mary Ellen. 1999. *Maya Art and Architecture*. London: Thames and Hudson.

Miller, Mary Ellen, and Stephen D. Houston. 1987. The Classic Maya Ballgame and Its Architectural Setting. *RES: Anthropology and Aesthetics* 14: 47–65.

Miller, Mary E., and Karl Taube. 1993. *An Illustrated Dictionary of the Gods and Symbols of Ancient Mexico and the Maya*. London and New York: Thames and Hudson.

Miller, Mary E., and Simon Martin, eds. 2004. *Courtly Art of the Ancient Maya*. New York: Thames & Hudson and the Fine Arts Museums of San Francisco.

Millet Cámara, Luis. 1984. De las estancias y haciendas en el Yucatán colonial. In *Hacienda y cambio social in Yucatán, contributors: Luis Millet Cámara, et al., 11–37.* Mérida: Colección Raices, INAH.

Molina Montes, Augusto. 1982. Archaeological Buildings: Restoration or Misrepresentation? In *Falsifications and Misreconstructions of Pre-Columbian Art,* ed. Elizabeth H. Boone: 125–41. Washington, DC: Dumbarton Oaks).

Morales Valderrama, Carmen, Ella Fanny Quintal, Maria Elena L. Peraza, y Lourdes Rejón P. 1989. Las artesanías del oriente de Yucatán: su proceso de cambio a partir de las setentas. Ponencia, Congreso de Mayistas. San Cristobal de las Casas.

Morley, Sylvanus G. 1956. *The Ancient Maya,* 3rd ed. Revised by George W. Brainerd. Stanford, CA: Stanford University Press.

Morphy, Howard. 1995. Aboriginal Art in a Global Context. In *Worlds Apart: Modernity Through the Prism of the Local,* ed. Danny Miller: 211–39. London: Routledge.

Morris, Walter F. 1984. *Mil Años del Tejido en Chiapas.* Tuxtla Gutierrez: Instituto de la Artesanía Chiapaneca.

Moseley, Edward H., and Edward D. Terry. 1980. *Yucatán: A World Apart.* Tuscaloosa, AL: University of Alabama.

Moseley, Edward H., and Helen Delpar. 2008. Introduction: Yucatán's Prelude to Globalization. In *Yucatán in an Era of Globalization,* ed. Eric N. Baklanoff and Edward H. Moseley: 20–41. Tuscaloosa: University of Alabama Press.

Mullin, Molly H. 1995. The Patronage of Difference: Making Indian Art 'Art', Not Ethnology. In *The Traffic in Culture: Refiguring Art and Anthropology,* ed. George E. Marcus and Fred R. Myers: 166–200. Berkeley: University of California Press.

Mullin, Molly H. 2001. *Culture in the Marketplace: Gender, Art and Value in the American Southwest.* Durham, N.C.: Duke University Press.

Myers, Fred R. 2003. *Painting Culture: the Making of an Aboriginal High Art.* Durham: Duke University Press.

Nash, Denison. 1981. Tourism as an Anthropological Subject [and Comments and Reply]. *Current Anthropology* 22 (5): 461–481.

Nash, June C., ed. 1993. *Crafts in the World Market: The Impact of Global Exchange on Middle American Artisans.* Albany, NY: State University of New York Press.

Nelson, Mary Carroll. 1971. *Pablita Velarde: the Story of an American Indian.* Minneapolis: Dillon Press.

Nelson, Robert S. Appropriation. In *Critical Terms in Art History,* ed. Robert S. Nelson and Richard Shiff. Chicago University Press, 116–28.

Newsome, Elizabeth. 1998. The Ontology of Being and Spiritual Power in the Stone Monument Cults of the Lowland Maya. *Res. Anthropology and Aesthetics* 33 (Spring): 115–36.

Nicholson, Henry B. 2001. Feathered Serpent. In *The Oxford Encyclopedia of Mesoamerican Cultures: The Civilizations of Mexico and Central America,* ed. Davíd Carrasco, 397–400. New York: Oxford University Press.

Nielsen, Ruth. 1974. The History and Development of Wax-Printed Textiles Intended for West Africa and Zaire. Master's Thesis, Department of Human Environment and Design, Michigan State University.

Nielsen, Ruth. 1979. The History and Development of Wax-Printed textiles Intended for West Africa and Zaire. In *The Fabrics of Culture,* ed. Justine M. Cordwell and Ronald A. Schwarz: 467–98. The Hague: Mouton Publishers.

Nunley, John, and Janet Catherine Berlo. 1991. Native North American Art. *St. Louis Art Museum Bulletin XX* (1):. 29.

Oettinger, Marion. 1990. *Folk Treasures of Mexico.* New York: Harry N. Abrams Publishers.

Osborne, Peter D. 2000. *Travelling Light: Photography, Travel and Visual Culture.* Manchester: Manchester University Press.

Owens, Craig. 1982. Representation, Appropriation and Power. *Art in America.* 70 (5): 9–21.

Owens, Craig. 1992. *Beyond Recognition: Representation, Power, and Culture.* Berkeley: University of California Press.

Parezo, Nancy. 1983. *Navajo Sandpainting: From Religious Act to Commercial Art.* Albuquerque: University of New Mexico Press.

Parker, Rosika, and Griselda Pollock. 1982. *Old Mistresses.* New York: Pantheon Books.

Pasztory, Esther. 2005. *Thinking with Things: Toward a New Vision of Art.* Austin: University of Texas Press.

Patterson, Thomas C. 1995a. Archaeology, History, Indigenismo, and the State in Peru and México. In *Making Alternative Histories: The Practice of Archaeology and History in Non-Western Settings,* ed. P. R. Schmidt and T. C. Patterson: 69–86. Santa Fe: School of American Research Press, Santa Fe.

Patterson, Thomas C. 1995b. *Toward a Social History of Archaeology in the United States.* New York: Harcourt Brace.

Patterson, Thomas C. 1999. The Political Economy of Archaeology in the United States: An Appreciation. *Annual Review of Anthropology* 28: 155–74.

Pearlstone, Zena. 2001. *Katcina: Commodified and Appropriated Images of Hopi Supernaturals.* Los Angeles, The Fowler Museum, UCLA.

Peraza López, María Elena y Lourdes Rejón Patrón. 1989. *El comercio de artesanías en Chichén Itzá y algunos efectos del turismo en la región*. Mérida: Centro Regional de Yucatán, INAH.

Peraza López, María Elena, Lourdes Rejón Patrón, y Julio Piña Loeza. 1987. La invasión de vendedores de artesanías en la zona arqueológica de Chichén Itzá, Yucatán. *Boletín de ECUAdY14*: 17–30.

Pérez Firmat, Gustavo. 1994. *Life On the Hyphen*. Austin: University of Texas Press.

Phelan, John L. 1960. Neo-Aztecism in the 18th Century and the Genesis of Mexican Nationalism. In *Culture in History. Essays in Honor of Paul Radin*, ed. Stanley Diamond: 760–770. New York: Columbian University Press.

Phillips, Ruth. 1989. Souvenirs from North America: The Miniature as Image of Woodlands Indian Life. *American Indian Art Magazine* 14 (2): 52–63, 78–79.

Phillips, Ruth. 1991. Glimpses of Eden: Iconographic Themes in Huron Pictorial Tourist Art. *European Review of Native American Studies* 5 (2): 19–28.

Phillips, Ruth. 1994. Why Not Tourist Art? Significant Silences in Native American Museum Representations. In *After Colonialism: Imperial Histories and Post-Colonial Displacements*, ed. Gyan Prakash: 98–125. Princeton: Princeton University Press.

Phillips, Ruth. 1998. *Trading Identities: The Souvenir in Native North American Art from the Northeast, 1700–1900*. Seattle: University of Washington Press.

Phillips, Ruth. 1999. Nuns, Ladies, and the "Queen of the Huron." In Art, Authenticity and the Baggage of Cultural Encounter. In *Unpacking Culture: Art and Commodity in the Colonial and Postcolonial Worlds*, ed. Ruth B. Phillips and Christopher B. Steiner: 33–50. Berkeley: University of California Press.

Phillips, Ruth, and Dale Idiens. 1994. A Casket of Curiosities: Eighteenth-Century Objects from Northeastern North America in the Farquharson Collection. *Journal of the History of Collecting* 6 (1): 21–33.

Phillips, Ruth B., and Christopher B. Steiner. 1999a. Art, Authenticity and the Baggage of Cultural Encounter. In *Unpacking Culture: Art and Commodity in the Colonial and Postcolonial Worlds*, ed. Ruth B. Phillips and Christopher B. Steiner: 3–19. Berkeley: University of California Press.

Phillips, Ruth B., and Christopher Steiner, eds. 1999b. *Unpacking Culture: Art and Commodity in Colonial and Post-Colonial Worlds*. Berkeley: University of California Press.

Piña Chan, Roman. 1968. *Jaina: La Casa en el Agua*. Mexico, D.F.: Instituto Nacional de Antropología e Historia.

Podro, Michael. 1982. *The Critical Historians of Art*. New Haven, CT: Yale University Press.

Pointon, Marcia. 1994. *Art History: A Student's Handbook*. London and New York: Routledge.

Pollini, John. 1995. The Augustus of Prima Porta and the Transformation of the Polykleitan Heroic Ideal: The Rhetoric of Art. In *Polykleitos, the Doryphoros, and Tradition*, ed. Warren G. Moon, 262–82. Madison, WI: The University of Wisconsin Press.

Pollock, H. E. D. 1980. *The Puuc: An Architectural Survey of the Hill Country of Yucatan and Northern Campeche, Mexico*. Memoirs of the Peabody Museum of Archaeology and Ethnology, Harvard University, Vol. 19. Cambridge, Harvard University.

Price, Sally. 2001. *Primitive Art in Civilized Places*, 2nd ed. Chicago: University of Chicago Press.

Proskouriakoff, Tatiana. 1960. Historical Implications of a Pattern of Dates at Piedras Negras, Guatemala. *American Antiquity* 25 (4): 454–75.

Pyburn, Anne K. 2004. We Have Never Been Post-Modern: Maya Archaeology in the Ethnographic Present. In *Continuities and Changes in Maya Archaeology: Perspectives at the Millenium*, ed. Charles W. Golden and Greg Borgstede, 287–93. New York and London: Routledge.

Ramírez, Luis Alfonso Entrepreneurial Elite from the Revolution to Globalization. In *Yucatán in an Era of Globalization*, ed. Eric N. Baklanoff and Edward H. Moseley: 69–91. Tuscaloosa: University of Alabama Press.

Ray, Dorothy Jean. 1989. Happy Jack and his Artistry. *American Indian Art* 15 (1): 40–53.

Re Cruz, Alicia. 1996. *The Two Milpas of Chan Kom: Scenarios of a Maya Village*. Albany, NY: State University of New York Press.

Re Cruz, Alicia. 2003. Milpa as an Ideological Weapon: Tourism and Maya Migration to Cancún, *Ethnohistory* 50 (3) (Summer): 489–502.

Redfield, Robert. 1964. *A Village that Chose Progress: Chan Kom Revisited*. Chicago: University of Chicago Press.

Redfield, Robert, and Alonso Villa Rojas. 1962. *Chan Kom: A Maya Village*. Chicago: University of Chicago Press (originally published as Publication no. 448 by the Carnegie Institution of Washington, 1934).

Redfield, Robert, Ralph Linton, and Melville J. Herskovits. 1936. Memorandum for the Study of Acculturation. *American Anthropologist* 38 (1): 149–152.

Reed, Nelson. 1964. *The Caste War of Yucatán*. Stanford, CA: Stanford University Press.

Rees, A. L., and Frances Borzello, eds. 1986. *The New Art History*. London: Camden Press.

Reindel, Markus. 1998. El abandono de las ciudades Puuc en el norte de Yucatán. In *50 años de estudios americanistas en la Universidad de Bonn: nuevas contribuciones a la arqueología, etnohistoria, etnoligüística y etnografía de las Américas*, ed. Sabine Dedenbach-Salazar Sáenz, 239–57. Bonner Amerikanistische Studien 30. Saurwein: Markt Schwaben.

Reis, Brian A. 2005. The Nineteenth-Century Photographs of Désiré Charnay: Images and Interpretations of a Pre-Columbian Past. Masters Thesis, Art History, Northern Illinois University.

Restall, Matthew. 1997. *The Maya World: Yucatec Culture and Society, 1550–1850*. Stanford, CA: Stanford University Press.

Rhodes, Colin. 1994. *Primitivism and Modern Art*. New York: Thames and Hudson.

Richter, Dolores. 1980. *Art, Economics, and Change: The Kulebele of Northern Ivory Coast*. La Jolla, Calif.: Psych/Graphic Publishers.

Rickard, Jolene. 1992. *Cew Ete Haw I Tih*: The Bird that Carries Language Back to Another. in *Partial Recall: Photographs of Native North Americans*, ed. Lucy Lippard: 105–11. New York: The New Press.

Ringle, William M. Tomás Gallareta Negrón and George J. Bey III. 1998. The Return of Quetzalcoatl: Evidence for the Spread of a World Religion during the Epiclassic Period. *Ancient Mesoamerica* 9 (2): 183–232.

Robinson, Mike, and Melanie Smith. 2006. Politics, Power and Play: The Shifting Contexts of Cultural Tourism. In *Cultural Tourism in a Changing World: Politics, Participation and (Re)presentation*, eds. Melanie Smith and Mike Robertson, 1–17. Bristol, GB: Channel View Publications.

Rodee, Marian. 1981. *Old Navajo Rugs: Their Development from 1900–1940*. Albuquerque: University of New Mexico Press.

Roys, Ralph L. 1939. The Titles of Ebtun. Carnegie Institution of Washington, Publication 505. Washington, DC.

Roys, Ralph L. 1943. *The Indian Background of Colonial Yucatan*. Carnegie Institution of Washington, Publication 548. Washington, DC.

Roys, Ralph L. 1962. Literary Sources for the History of Mayapan. In *Mayapan, Yucatan, Mexico, ed.* H. E. D. Pollock, Ralph L. Roys, Tatiana Proskouriakof, and A. Ledyard Smith, Carnegie Institution of Washington, Publication 619. Washington, DC.

Rubinstein, Mayer Raphael. 1989. Contributor to "The Greenberg Effect: Comments by Younger Artists, Critics, and Curators." *Arts Magazine* 64 (December): 63.

Ruch, Marcella. 2001. *Pablita Velarde, Painting Her People*. Albuquerque: University of New Mexico Press.

Rugeley, Terry. 1996. *Yucatán's Maya Peasantry and the Origins of the Caste War*. Austin: University of Texas Press.

Ruppert, Karl A., J. E. S. Thompson, and Tatiana Proskouriakoff. 1955. Bonampak, Chiapas, Mexico. Carnegie Institution of Washington Publication 602. Washington, DC, Carnegie Institution of Washington.

Rushing, W. Jackson. 1995. *Native American Art and the New York Avant-Garde: A History of Cultural Primitivism*. Austin: University of Texas Press.

Rutsch, Mechthild. 2004. Natural History, National Museum and Anthropology in Mexico: Some reference points in forging and re-forging of national identity. *Perspectivas Latinoamericanas* 1: 89–122.

Ruz Lhuillier, Alberto. 1998. *El Templo de Las Inscripciones, Palenque*. San Diego, CA: Fondo de Cultura Economica USA.

Rydell, Robert W. 1993. *World of Fairs: The Century-of-Progress Expositions*. Chicago: University of Chicago Press.

Rydell, Robert W., John E. Finding, and Kimberly D. Pelle. 2000. *Fair America: World's Fairs in the United States*. Washington, DC: Smithsonian Books.

Sáenz, César A. 1972. Exploraciones y Restauraciones en Uxmal (1970–1971). *Boletín del INAH*, Epoca II (2): 31–39l.

Sabloff, Jeremy A., and C. C. Lamberg-Karlovsky, eds. 1975. *Ancient Civilization and Trade*. Albuquerque: University of New Mexico Press.

Sabloff, Jeremy, and E. Wyllys Andrews, V, eds. 1986. *Late Lowland Maya Civilization: Classic to Postclassic*. Albuquerque: School of American Research and University of New Mexico Press.

Sabloff, Jeremy A., and William J. Rathje. 1975. The Rise of a Maya Merchant Class. *Scientific American* 233 (4): 72–82.

Said, Edward. 1978. *Orientalism*. London: Routledge.

Saunders, Nicholas J., ed. 1998. *Icons of Power*. New York: Routledge.

Saville, Marshall H. 1921. *Bibliographic Notes on Uxmal, Yucatan. Museum of the American Indian, Heye Foundation, Indian Notes and Monographs* 9 (2). New York, NY.

Sayer, Chloe. 1990. *Arts and Crafts of Mexico*. London: Thames & Hudson.

Schele, Linda, and Mary E. Miller. 1986. *The Blood of Kings: Dynasty and Ritual in Maya Art*. New York: George Braziller, Inc., in association with the Kimbell Art Museum, Fort Worth.

Schele, Linda, and Mary E. Miller. 1988. Letter to the Editor. *Art Journal* 47 (3) (Autumn): 253.

Schele, Linda, and David Freidel. 1990. *A Forest of Kings: The Untold Story of the Ancient Maya*. New York: William Morrow and Company.

Schele, Linda, and Peter Mathews. 1998. *The Code of Kings: The Language of Seven Sacred Maya Temples and Tombs*. New York: Scribner.

Schellhas, Paul. 1904. Representation of Deities of the Maya Manuscripts. *Papers of the Peabody Museum of American Archaeology and Ethnology*, vol. 4, no.1. Cambridge, MA: Harvard University.

Schmidt, Peter, Mercedes de la Garza, and Enrique Nalda, eds. 1998. *Maya*. New York, NY: Rizzoli International Publishers.

Schrenk, Lisa D. 2007. *Building a Century of Progress: The Architecture of Chicago's 1933–34 World's Fair*. Minneapolis: University of Minnesota Press.

Scott, Mary Katherine. Rethinking the Art in Artesania. M.A. thesis, Art History, Northern Illinois University, 2008.

SECTUR (SECRETARIA DE TURISMO). *Estadísticas básicas de la actividad turística*. Mexico City: SECTUR and Bancomer.

Seler, Eduard. 1917. Die Ruinen von Uxmal, *Abhandlungen der Königlich Preussischen Akademie der Wissenschaften, Phil.-Hist. Klasse,* Nr. 3. Berlin.

Sharer, Robert J.1995. *The Ancient Maya* (5th ed.). Stanford, CA: Stanford University Press.

Sharer, Robert J., with Loa Traxler. 2005. *The Ancient Maya* (6th ed.). Stanford, CA: Stanford University Press.

Shepp, James W., and Daniel B. Shepp. 1893. *Shepp's World's Fair Photographed*. Chicago and Philadelphia: Globe Bible Publishing Co.

Shiff, Richard. 1996. Originality. In *Critical Terms in Art History*, ed. Robert S. Nelson and Richard Shiff: 103–15. Chicago: University of Chicago Press.

Shiner, Larry. 1994. "Primitive Fakes," "Tourist Art," and the Ideology of Authenticity. *Journal of Aesthetics and Art Criticism* 52 (2) (Spring): 225–34.

Shonibare, Yinka. 2002. Give and Take Conversations [interview with Janet A. Kaplan]. *Art Journal* 61 (2): 82–83.

Silberman, Neil Asher. 1995. Promised Lands and Chosen Peoples: The Politics and Poetics of Archaeological Narrative. In *Nationalism, Politics, and the Practice of Archaeology*, ed. Philp L. Kohl and Clare Fawcett: 249–62. Cambridge: Cambridge University Press.

Silverstein, Rhonda. 1998. The Maya Jaguar Throne in Ancient Mesoamerica. M.A. thesis, Art History, Northern Illinois University.

Smith, Carol A. 1990. Introduction: Social Relations in Guatemala over Time and Space. In *Guatemalan Indians and the State, 1542–1988*, ed. Carol A. Smith, 1–30. Austin: University of Texas Press.

Smith, Carol A., ed. 1990. *Guatemalan Indians and the State, 1542–1988*. Austin: University of Texas Press.

Smith, Joshua P. 1992. Why the Corcoran Made a Big Mistake. *Washington Post* (18 June 1989). In *Culture Wars: Documents from the Recent Controversies in the Arts*, ed. Richard Bolton. New York: New Press, 38.

Smith, Melanie, and Mike Robinson, eds. 2006. *Cultural Tourism in a Changing World: Politics, Participation and (Re)presentation*. Bristol, GB: Channel View Publications.

Smith, Mike K. 2003. *Issues in Cultural Tourism Studies*. London: Routledge.

Solanes C., María del Carmen, and Enrique Vela Ramírez. 1993. El Mundo Maya. *Arqueología Mexicana* 1 (2): 11–19.

Spinden, Herbert J. 1913. A Study of Maya Art. *Memoirs of the Peabody Museum of Archaeology and Ethnology, Harvard University*, vol. VI. Cambridge, MA: Harvard University.

Steggerda, Morris. 1941. *Maya Indians of Yucatán*. Publication 531. Washington DC: Carnegie Institution of Washington.

Steiner, Christopher B. 1985. Another Image of Africa: Toward an Ethnohistory of European Cloth Marketed in West Africa, 1873–1960. *Ethnohistory* 32 (2): 91–110.

Steiner, Christopher B. 1994. *African Art in Transit*. Cambridge: Cambridge University Press.

Steiner, Christopher B. 1995. The Art of the Trade: On the Creation of Value and Authenticity in the African Art Market. In *The Traffic in Culture: Refiguring Art and Anthropology*, ed. George E. Marcus and Fred R. Myers: 141–65. Berkeley: University of California Press.

Steiner, Christopher B. 1996. Can the Canon burst? *Art Bulletin* 78 (2): 213–18.

Steiner, Christopher B. 1999. Authenticity, Repetition, and the Aesthetics of Seriality: The Work of Tourist Art in the Age of Mechanical Reproduction. In *Unpacking Culture: Art and Commodity in Colonial and Postcolonial Worlds*, ed. Ruth B. Phillips and Christopher B. Steiner: 87–103. Berkeley: University of California Press.

Stephens, John Lloyd. 1963. *Incidents of Travel in Yucatan*, vol. 1. New York: Dover Publications, Inc. (originally published by Harper & Brothers, New York, 1843).

Stiglitz, Joseph E. 2003. *Globalization and its Discontents*. W.W. Norton and Company.

Stuart, David, and George E. Stuart. 2008. *Palenque: Eternal City of the Maya*. London: Thames & Hudson.

Sturken, Marita, and Lisa Cartwright. 2001. *Practices of Looking: An Introduction to Visual Culture*. New York: Oxford University Press.

Szabo, Joyce. 2007. *Art from Fort Marion: The Silberman Collection*. Norman: University of Oklahoma Press.

Tate, Carolyn E. 1992. *Yaxchilán: The Design of a Maya Ceremonial City*. Austin, TX: University of Texas Press.

Taube, Karl A. 1985. The Classic Maya Maize God: A Reappraisal. In *Fifth Palenque Round Table, 1983*, ed. Virginia M. Fields: 171–82. San Francisco: Pre-Columbian Art Research Institute.

Taube, Karl A. 1992. *Major Gods of Ancient Yucatán*, Studies in Pre-Columbian Art and Archaeology, No. 32. Washington DC: Dumbarton Oaks Research Library and Collections.

Taube, Karl. 2004. Flower Mountain: Concepts of Life, Beauty, and Paradise Among the Classic Maya. *Res: Anthropology and Aesthetics* 45: 69–98.

Therkelsen, Anette. 2003. Imagining Places: Image Formation of Tourists and its Consequences for Destination Promotion. *Scandinavian Journal of Hospitality and Tourism* 3 (2), 134–50.

Thompson, J. Eric S. 1966. *The Rise and Fall of Maya Civilization* (2nd ed.). Norman, OK: University of Oklahoma Press. [1st ed. 1954].

Thompson, J. Eric. S. 1970. *Maya History and Religion*. Norman, OK: University of Oklahoma Press.

Thompson, Richard A. 1974. *The Winds of Tomorrow: Social Change in a Maya Town*. Chicago and London: University of Chicago Press.

Tilly, Charles. 1995. Globalization Threatens Labor's Rights. *International Labor and Working Class History* 47: 1–23.

Tozzer, Alfred M. 1941. *Landa's Relación de las Cosas de Yucatán: A Translation*. Papers of the Peabody Museum of American Archaeology and Ethnology, vol. 18. Cambridge, Massachusetts: Harvard University Press.

Tozzer, Alfred M. 1957. *Chichen Itza and Its Cenote of Sacrifice. A Comparative Study of Contemporaneous Maya and Toltec*. Memoirs of the Peabody Museum of Archaeology and Ethnology, vols. 11 and 12. Cambridge: Harvard University.

Trigger, Bruce G. 1989. *A History of Archaeological Thought*. Cambridge: Cambridge University Press.

Turner, John Kenneth. 1914. *Barbarous Mexico*. Chicago: C.H. Kerr.

Turner, Wilson G. 1980. *Maya Designs*. Mineola, NY: Dover Publications.

Turner, Victor W. 1974. *Dramas, Fields, and Metaphors: Symbolic Action in Human Society*. Ithaca, NY: Cornell University Press.

Turner, Victor W., and Edward M. Bruner, eds. 1986. *The Anthropology of Experience*. Urbana: University of Illinois Press.

Tylor, Edward B. 1873. *Primitive Culture*, 2 vols. (2nd ed.). New York: Harper & Brothers. (originally published London: John Murray, 1871).

Urry, John. 1995. *Consuming Places*. London: Routledge.

Vargas Arenas, Iraida. 1995. The Perception of History and Archaeology in Latin America: A Theoretical Approach. In *Making Alternative Histories: The Practice of Archaeology and History in Non-Western Settings*, ed. Peter R. Schmidt and Thomas Patterson, 47–68. Santa Fe, NM: School of American Research.

Villacorta, C., J. Antonio, and Carlos A. Villacorta, 1977. *Códices Mayas*, 2nd ed. Guatemala, C.A.: Tipografía Nacional (originally published 1930).

Wahl, Kenneth. 1989. Contributor to "The Greenberg Effect: Comments by Younger Artists, Critics, and Curators." *Arts Magazine* 64 (December): 64.

Wallerstein, Immanuel. 1974. *The Modern World System: Capitalist Agriculture and the Origins of the European World-Economy*. New York: Academic Press.

Wardwell, Allen. 1986. The Brilliance of Mayan Culture is seen in a Dark New Light. *New York Times* (20 July).

Warren, Kay B. 1998. *Indigenous Movements and Their Critics*. Princeton: Princeton University Press.

Watanabe, John. 1995. Unimagining the Maya: Anthropologists, Others, and the Inescapable Hubris of Authorship. *Bulletin of Latin America Research* 14 (1): 33.

Wauchope, Robert. 1974. *Lost Tribes and Sunken Continents*. Chicago: University of Chicago Press.

Weigle, Martha, and Barbara Babcock, eds. 1996. *The Great Southwest of the Fred Harvey Company and the Santa Fe Railway*. Phoenix: The Heard Museum.

Wells, Alan. 1985. *Yucatán's Gilded Age: Haciendas, Henequen, and International Harvester, 1860–1915*. Albuquerque: University of New Mexico Press.

Westermann, Mariët, ed. 2005. *Anthropologies of Art*. Clark Studies in the Visual Arts. Williamstown, MA: Sterling and Francine Clark Art Institute, Distributed by Yale University Press, New Haven and London.

Welsch, Robert L. 2004. Epilogue: The Authenticity of Constructed Art Worlds. *Visual Anthropology* 17: 401–6.

Westfall, Stephen. 1989. Contributor to "The Greenberg Effect: Comments by Younger Artists, Critics, and Curators" *Arts Magazine* 64 (December): 64.

Wilk, Richard R. 1991. *Household Ecology: Economic Change and Domestic Life among the Kekchi Maya in Belize*. DeKalb: Northern Illinois University Press.

Bibliography

Willey, Gordon R., and Jeremy A. Sabloff. 1993. *A History of American Archaeology* (3rd ed.). New York: W. H. Freeman.

Williams, Raymond. 1958. *Culture and Society: 1780–1950*. New York: Columbia University Press.

Williams, Raymond. 1976. *Keywords*. New York: Oxford University Press.

Wilson, Alexander. 1994. The Betrayal of the Future: Walt Disney's EPCOT Center. In *Disney Discourse: Producing the Magic Kingdom* (Afi Film Readers), ed. Eric Smoodin: 118–30. London: Routledge.

Wilson, Christopher. 1997. *The Myth of Santa Fe: Creating a Modern Regional Tradition*. Albuquerque: University of New Mexico Press.

Wittkower, Rudolph, and Margot Wittkower. 2006. *Born under Saturn: The Character and Conduct of Artists*. New York: NYRB Classics (originally published by Random House, New York, 1963).

Wolf, Eric. 1982. *Europe and the People Without History*. Berkeley: University of California Press.

Wood, Paul. 1996. Commodity. In *Critical Terms for Art History*, ed. Robert S. Nelson and Richard Shiff, 257–80. Chicago: University of Chicago Press.

Wood, W. Warner. 2008. *Made in Mexico: Zapotec Weavers in the Global Ethnic Art Market*. Bloomington: Indiana University Press.

Yaeger, Jason, and Greg Borgstede. 2004. Professional Archaeology and the Modern Maya: A Historical Sketch. In *Continuities and Changes in Maya Archaeology: Perspectives at the Millenium*, ed. Charles W. Golden and Greg Borgstede, 259–85. New York and London: Routledge.

Young, Robert J. C. 1994. *Colonial Desire*. London: Routledge.

Photo Credits

JEFF KOWALSKI

1.1, 1.3, 1.4, 1.6, 1.7, 1.13, 1.16, 1.17, 1.20, 1.21, 1.22, 1.23, 1.24,
1.25, 1.28, 1.29, 1.33, 1.34, 1.35, 1.36, 1.37, 1.39, 1.42, 1.45, 1.47,
1.50, 1.51, 1.52, 1.53, 1.54

JESÚS DELGADO KÚ

1.26, 1.44

ANGEL RUÍZ NOVELO

1.12, 1.38, 1.48,

MARY KATHERINE SCOTT

1.2, 1.10, 1.18, 1.27, 1.31, 1.40, 1.43, 7.2, 7.3, 7.4

MATT SIEBER

2.1, 2.2, 2.3, 2.4, 2.5, 2.7, 5.4

CHRISTOPHER B. STEINER

4.2, 4.3

NADIA VÁZQUEZ

1.11

WILBERT VÁZQUEZ

1.9, 1.32, 1.41, 1.49, 1.55, 7.1

Index

acculturation (adaptation to culture contact), 3, 4, 18, 41, 43, 45, 56n.31, 63n.244, 111, 120n.23, 117, 161, 175

aesthetics: and the market, 9, 48, 126–27, 138–39, 146, 150n.28, 150n.40, 183; attributes of "tourist arts," 5, 7–9, 12, 29, 33, 48, 50, 54, 56n.35, 57n.41, 57n.42, 66n.278, 85–86, 116, 133, 136, 138–47, 149n.28, 183, 185, 189n.75; culturally relative standards of judgment of, 11, 48, 50–51, 54, 66n.290, 126–27, 130, 147, 183, 186–87; as philosophical field of study, 49; formalist approaches to, 49, 53, 55, 65n.273, 65n.275; Kantian definition of, 49; of high art versus low art, 11–12, 48–50, 54, 66n.275; of post-modernist period, 52; of contemporary Yucatecan Maya carvings, 139–46, 148n.5; of ancient Maya art, 144, 146, 178; of tourist art, 3–5, 8–9, 48

Africa: Anoh Acou (artist of; see Acou, Anoh), 108-fig.4.4; arts of appreciated by European modernist artists, 127; associated with the primitive, 125, 129; British cloth trade designed to appeal to, 126, 128–29; European colonial cloth trade with, 125–26, 128, 129; Kulebele carvers of, 128; production of tourist arts in, 127–29; references to in work of Yinka Shonibare,

129–30; stereotyped European conceptions of, 125–26, 128; tourist arts of as representations of stereotyped conceptions of, 125, 127–30, 128

Anoh Acou (African wood carver, Ivory Coast), 108-fig.4.4, 128

anthropology: and culture change as a result of globalization (see acculturation), 56n.31, 111, 120n.23; and the construction of knowledge, 7, 45, 50, 55n.19, 56n.31, 58, 64n.255, 135–36, 138, 147, 156, 170n.40, 176, 186; and the culture concept, 5–6; and notions of cultural identity 6, 7, 11, 41, 43, 45, 64n.255, 135, 137, 147, 149n.18, 170n.40, 176, 186; and culture change and tourism, 4, 150n.29; and tourist arts, 4–5, 11, 50, 55, 115, 120n.23, 135–38, 147, 150n.29, 186, 187

appropriation: definition of, 184, 189n.74; of African art by European modernist artists, 9, 127, 130n.7; in ancient western art, 184; in modern and contemporary western art, 10, 49, 52, 66, 184; of ancient Maya imagery by contemporary Yucatecan Maya artisans, 10, 38, 52, 184–85, 189n.74; of Mesoamerican cultural achievements as hemispheric heritage, 158

archaeological sites: as

cultural commodity, 10, 38, 45, 160, 162–63, 166; as cultural heritage, 9, 17, 38, 45–47, 64n.256, 148, 155, 158, 160–62, 171n.46, 171n.52; as locations for sale of tourist arts, 9, 12, 23–25, 38, 39, 85, 95-fig.1.9, 133–34, 137, 146; as national or cultural patrimony, 158–59, 166, 168n.11; as outdoor museums, 46–47, 65n.262, 159, 162–63; as simulacra, 163, 171n.47; as "theme parks," 163–64; as tourist destinations, vii, 3, 9, 12, 17, 21, 38, 47, 53, 64n.253, 133, 159–62, 166, 170n.46

archaeology: and changing paradigms of ancient Maya civilization, 45–46, 64n.259, 161, 167n.9, 174–75; and the framing of Maya identity, 38, 43, 45–47, 64n.256, 64n.259, 175, 65n.262, 161–63, 167n.9; and the marketing of heritage, 162–63; and national identity, 158–59, 167n.9, 168n.11, 168n.20; and popular culture, 164, 171n.55; and tourist development, vii, viii, 12, 17, 19, 25, 45, 53, 169n.33, 64n.253, 64n.255, 146, 159–60, 170n.46; as resource for Yucatecan artisans, 36, 47, 53, 65n.265, 85, 133–34, 146, 166; impact on economy, 25, 47, 64n.255, 159–60, 166, 169n.33, 171n.52; New Archaeology, 46, 64n.259; of Puuc region, viii, 18, 57n.43, 156, 167n.1; of Chichén Itzá, vii, 57n.47, 137, 156

Ardren, Traci, xiii, 47, 55n.14, 59n.101, 61n.165, 161, 171n.52, 171n.55, 187

Argüelles, José (see New Age spirituality), 165, 172n.56

art: aesthetic/formalist

approaches to, 49, 53, 65n.273, 65n.273, 138, 144–46; and the communication of cultural meanings, 5–7, 12, 23, 46–49, 51–52, 54, 62n.199, 66.278, 113–16, 119, 125, 127–30, 135–36, 145–47, 164, 179; art world(s), 50, 51, 53, 67n.303, 138, 147; art writing, 138, 149n.27; "aura" ot, 138, 148, 149n.28, 163, 181; changing conceptions of, 3, 7, 11–13, 49–54, 57n.42, 114, 117, 147–48; development of fine arts tradition, 48–49, 53; culturally relativist conceptions of, 3, 5, 10–11, 13, 48, 50–54, 66n.278, 112, 130, 133, 186–87; "high" versus "low," 10–13, 48–52, 54, 65n.275, 147, 174, 184–87; institutional definitions of, 5, 9, 11, 50 51, 138, 147, 185–86; non-western aesthetic artifacts as, 111, 112, 114, 116, 117, 118, 119, 119n.9, 127, 128, 138, 139, 150n.29, 185, 186; originality as characteristic of, 183, 184; problems in defining boundaries of, 5, 7, 10–11, 13, 50–53, 66n.278, 112, 133, 136, 138, 147, 184, 186–87; sociological approaches to study of, 5, 11–12, 50–52, 67n.298, 111; versus "artifact," 5, 8, 55n.19, 66n.278, 112, 114–15, 117, 135, 187; viewer response to, 52–53, 128, 136, 139, 147, 178, 181; Yucatecan wood carvings as, ix, 3, 7–13, 22, 26–27, 37–40, 52, 53–54, 57n.41, 57n.42, 85, 133–38, 144–48, 149n.23, 149n.24, 174, 178, 180–81, 185

artesanias (handicrafts): associated with traditional culture, 133–35, 137–39,